ROMANIZATION AND THE CITY

JOURNAL OF ROMAN ARCHAEOLOGY

SUPPLEMENTARY SERIES NUMBER 38

GENERAL EDITORS OF THIS VOLUME: J. H. HUMPHREY AND S. B. HOLMAN

AN INTERNATIONAL JOURNAL

ISBN 1-887829-38-5 ISSN 1063-4304 (for the supplementary series)

This and other supplements to the *Journal of Roman Archaeology*® may be ordered from:
JRA®, 95 Peleg Road, Portsmouth, RI 02871, U.S.A.
Telephone (USA) 401 683 1955 telefax (USA) 401 683 1975 e-mail: jra@wsii.com
Web site: JournalofRomanArch.com

ROMANIZATION AND THE CITY

CREATION, TRANSFORMATIONS, AND FAILURES

Proceedings of a conference held at the American Academy in Rome
to celebrate the 50th anniversary of the excavations at Cosa,
14-16 May, 1998

edited by

Elizabeth Fentress

with contributions by

S. Alcock, A. Bowman, G. Caruso, S. Downey, M. Downs,
S. Dyson, E. Fentress, P. Gros, H. Hurst, E. La Rocca, F. Rakob,
D. Romano, R. Volpe, G. Woolf, F. Yegül, and P. Zanker

PORTSMOUTH, RHODE ISLAND
2000

Table of Contents

Preface and Acknowledgements

May of 1998 marked the 50th anniversary of the first excavations at the site of Cosa. Chosen by Frank E. Brown from a number of possible sites around Rome, Cosa became the flagship dig of the Academy, and a fundamental source for Roman colonization in the Republic. As early as 1951 Brown wrote, "In the ruins of Cosa we discern the lineaments of a Latin colony of the old style, scarcely retouched by Hellenism, expunged by no later hand", while in his Jerome lectures of 1979 he argued that Norba, Alba Fucens, and Cosa showed "a premeditated design for what a functioning Roman environment ought to be. The unplanned, radial prototype was Rome itself".

The American Academy in Rome held a conference between the 14th and 16th of May to mark this anniversary, and to examine the idea of the city as an instrument of Romanization. In Martin Carver's elegant formulation cities were "arguments in stone". Rather than focus on the argument at Cosa itself, the subject was the extent to which Brown's ideas may be applied to other colonial settlements. How far did they map the essential elements of the Urbs and its society? How did the model change from Republic to Empire? How did Romanization modify existing urban contexts? How was it modified by them? Under what conditions did the colonial city fail, and a fully urban society fail to develop? We aimed at a geographic range that would represent most of the empire, although the Danube frontier and the northeastern provinces were neglected. The chronological range was necessarily limited, roughly from the 4th c. B.C. through the 1st c. A.D., although the eastern empire provided later evidence for the effects and memory of the Roman urban experience.

The contributors travelled far and worked hard, and I am most grateful to them all. The printed volume differs somewhat from the conference itself. Giusto Traina's contribution on Armenia and Richard Reece's meditations on Britannia failed to reach the press, as did two excellent contributions on modern urbanism, one from Mark Schimmenti discussing the relationship between Roman and modern planning, and one from Mia Fuller who recounted the experience of the Italian colonial cities in Libya. Jeffrey Burden's paper on the Romanization of Athens and Emanuele Papi's book-length study, "*Ob munificentiam eius. Nobiles, equites, domi nobiles, liberti e la trasformazione delle città dell'Etruria meridionale nel primo Impero*", will be published elsewhere. Several papers were changed and expanded to take in elements of the discussion at the conference. It is regrettable that it was not possible to reproduce that discussion here: I think in particular of the stimulating contrast between the papers of Mary Downs and Fikret Yegül — to what degree did an indigenous family change their culture to suit the occasion? Did the colonized become a happy blend of their own and Roman culture, or did they use them each by turn?

* * *

The conference was the result of the efforts of many people, including many of the Academy staff. The director, Caroline Bruzelius, gave her enthusiastic approval to the project. Sarah Hartmann created a brilliantly smooth organization. Sofia Bosco contributed her considerable talents to raising support for the conference, while Pina Pasquantonio arranged housing for many of the speakers. Outside support came from the Monte dei Paschi di Siena and from a peculiarly appropriate source: the three companies which have followed in the traditions of ancient Cosa and made the shores of Ansedonia one of the most productive centers of pisciculture in Italy. We are grateful to Cosa s.r.l., Ittima and Il Vigneto for their support, and particularly to Ilaria Venturini who made it possible. On Saturday May 18th the conference participants went to Cosa for a tour, led by Russell T. Scott, and a splendid lunch under the olive trees, provided by Vinicio of the Best in Tuscany and the united Cantine. As ever, the owners of the site, Gianserio and Georgio Sanfelice, provided their exceptional hospitality. To them, to the Comune of Orbetello, and to the Soprintendenza delle Antichità della Toscana, the Cosa excavations owe many years of productive work.

8

The creation of this volume has involved both textual and graphic editing. We have tried to reproduce the figures to comparable scales: where possible, *coloniae* are shown at 1 : 5000 or 1 : 2500 and public buildings at 1 : 2500 or 1 : 1000. I am grateful to Susan Alcock for sage advice on number of difficult points, to Shawna Leigh for her sensitive work on the illustrations and assistance at all stages of the compilation of the manuscript, and (as ever) to John Humphrey for his efficiency and extraordinary attention to detail.

American Academy in Rome, July 1999

Cosa and her territory in the Roman and mediaeval periods:
A selected bibliography

FINAL PUBLICATIONS

Brown, F. E., *Cosa I, History and topography* (*MAAR* 20, 1951) 5-113.

Brown, F. E., Richardson E. H. and Richardson, L. jr, *Cosa II, The temples of the Arx* (*MAAR* 26, 1960).

Brown, F. E., *Cosa, the making of a Roman town* (Ann Arbor 1980).

Brown, F. E., Richardson E. H. and Richardson, L. jr., *Cosa III, The buildings of the Forum* (*MAAR* 37, 1993).

Bruno, V. J. and Scott., R. T., *Cosa IV, The Houses* (*MAAR* 38, 1993).

Collins Clinton, J., *A late antique shrine of Liber Pater at Cosa* (Etudes préliminaires aux religions orientales dans l'Empire romain 64, Leiden 1977).

McCann, A. M., *The Roman port and fishery of Cosa: a center of ancient trade* (Princeton 1987).

MATERIALS

Brendel, O., "A Ganymede group from Cosa," *AJA* 73 (1969) 232.

Buttrey, T. V., "Cosa: the coins," *MAAR* 34 (1980) 11-153.

Fitch, C. R. and Goldman, N., *The lamps* (*MAAR* 39, 1994).

Hobart, M., "Ceramica invetriata di Cosa (Ansedonia–Orbetello)," in L. Paroli (ed.), *La ceramica invetriata tardoantica e altomedievale in Italia* (Florence 1990) 304-9.

Hobart, M., "La maiolica arcaica di Cosa (Orbetello)," in *Atti del XXIV convegno internazionale della ceramica* (Albissola 1991) 71-89.

Lyding-Will, E., "The Sestius amphoras. A reappraisal," *JFA* 6 (1979) 339-51.

Marabini Moevs, M. T., *The Roman thin walled pottery from Cosa (1948-1954)* (*MAAR* 32, 1973).

Marabini Moevs, M. T., "Italo-Megarian ware at Cosa," *MAAR* 34 (1980) 161-227.

Marabini Moevs, M. T., "Aco in northern Etruria: the workshop of Cusonius at Cosa," *MAAR* 34 (1980) 231-80.

Scott, A., *Cosa: the Black-Glaze pottery revisited* (unpublished Ph.D. diss., Bryn Mawr College 1994).

Scott, R. T. "A new fragment of "serpent ware" from Cosa," *JGS* 34 (1992) 158-59.

Taylor, D. M., "Cosa, black-glaze pottery," *MAAR* 25 (1957) 65-193.

Tondo, L., "Monete medievale da Ansedonia," *ArchMed* 4 (1977) 300-5.

EPIGRAPHY

Babcock, C., "An inscription of Trajan Decius at Cosa," *AJP* 83 (1962) 147-58.

Manacorda, D., "Considerazioni sull'epigrafia della regione di Cosa," *Athenaeum* 57 (1979) 73-92.

Saladino, V., "Iscrizioni del territorio di Cosa," *Epigraphica* 39 (1977) 142-51.

Scott, R. T., "A new inscription of the emperor Maximinus at Cosa," *Chiron* 11 (1981) 309-14.

Tongue, W., "The brick stamps of Cosa," *AJA* 54 (1950) 263.

STUDIES

Brown, F. E. and Zancani Montuoro, P., "Il faro di Cosa in ex-voto a Vulci?," *RIA* 2 (1979) 5-29.

Fentress, E., Richardson jr. L. and Scott, R., "Excavations at Cosa: the first fifty years," *American archaeology in classical lands: the next one hundred years* (Philadelphia, forthcoming)

Gerkan, A. von, "Zur Datierung der Kolonie Cosa," in *Scritti in onore di Guido Libertini* (Florence 1958) 149-56.

Hesberg, H. von, "Coloniae maritimae," *RömMitt* 92 (1985) 127-50.

Manacorda, D., "The *ager cosanus* and the production of the amphorae of Sestius: new evidence and a reassessment," *JRS* 68 (1978) 122-31.

Richardson Jr., L., "Cosa and Rome, comitium and curia," *Archaeology* 10 (1957) 49-55.

Scott, R. T., "The decorations in terracotta from the temples of Cosa," *La coroplastica templare etrusca fra il IV e il II secolo a.C.* (Florence 1992) 91-128.

Scott, R. T., "The Latin colony of Cosa," *DialArch* 6 (1988) 73-77.

INTERIM REPORTS (given only when the final publication is not complete)

Brown, F. E., "Scavi a Cosa - Ansedonia 1965-66," *BdA* 52 (1967) 37-41.

Brown, F. E., "The northwest gate of Cosa and its environs," *Studi di antichità in onore de G. Maetzke* (Rome 1984) 493-98.

Ciampoltrini, G., "Orbetello (Grosseto) località Ansedonia. Ricerche sui monumenti d'età traianea e adrianea del suburbio orientale di Cosa," *Bolletino di Archeologia* 7 (1991) 67-85.

Ciampoltrini, G., "Orbetello (Grosseto). La necropoli di Cosa. Ricerche e recuperi 1985-1991," *Bolletino di Archeologia* 7 (1991) 59-66.

Fentress, E., Hobart, M., Clay, T., Webb, M., "Late Roman and Medieval Cosa I: the Arx and the structure near the Eastern Height," *PBSR* 59 (1991) 197-230.

Fentress, E., "Cosa in the empire: the unmaking of a Roman town," *JRA* 7 (1994) 208-22.

Fentress, E. and Celuzza, M. G., "La Toscana centro-meridionale: i casi di Cosa–Ansedonia e Roselle," in R. Francovich and G. Noyé (edd.), *La storia dell'Alto Medioevo* (Florence 1994) 601-13.

Fentress, E. and Rabinowitz, A., "Excavations at Cosa 1995: Atrium Building V and a new Republican temple," *MAAR* 41 (1996 [1998]).

Hobart, M., "Cosa–Ansedonia (Orbetello) in età medievale: da una città romana ad un insediamento medievale sparso," *ArchMed* 22 (1995) 569-83.

Scott, R., "The Arx of Cosa (1965-1970)," *AJA* 73 (1969) 245.

THE TERRITORY OF COSA AND THE LOWER ALBEGNA VALLEY IN THE ROMAN PERIOD

Attolini, I. *et al.*, "Political geography and productive geography between the valleys of the Albegna and the Fiora in northern Etruria," in G. Barker and J. Lloyd (edd.), *Roman landscapes* (British School at Rome 1991) 142-53.

Bisconti, F., "Tarda antichità ed alto medioevo nel territorio orbetellano. Primo bilancio critico," *Atti del VI congresso nazionale di archeologia cristiana* (Florence 1986) 63-77.

Bronson, R. and Uggieri, G., "Isola del Giglio, Isola di Giannutri, Monte Argentario, Laguna di Orbetello," *StEtr* 38 (1970) 201-30.

Cambi, F. and Fentress, E., "Villas to castles: first millenium A.D. demography in the Albegna Valley," in K. Randsborg (ed.), *The birth of Europe* (Analecta Romana Suppl. 16, 1989) 74-86.

Carandini, A., "Il vigneto e la villa del fondo di Settefinestre nel Cosano. Un caso di produzione per il mercato trasmarino," *MAAR* 36 (1980) 1-10.

Carandini, A. (ed.), *La romanizzazione dell'Etruria: il territorio di Vulci* (Cat. Exhib. Orbetello 1985; Florence 1985).

Carandini, A. and Ricci, A. (edd.), *Settefinestre: una villa schiavistica nell'Etruria romana* (Modena 1985).

Carandini, A. and Settis, S. (edd.), *Schiavi e padroni nell'Etruria romana* (Bari 1979).

Carandini, A., Cambi, F., Celuzza, M. G. and Fentress, E. (edd.), *Paesaggi dell'Etruria tra l'Albegna et la Fiora* (forthcoming).

Carlsen, J., "Considerations on Cosa and the *ager Cosanus*," *AnalRom* 13 (1984) 49-58.

Castagnoli, F., " La centuriazione di Cosa," *MAAR* 25 (1957) 149-65.

Cavallo, D., Ciampoltrini, G., Shepherd, E. J., "La pesca nell'agro di Cosa in età romana. Prospettiva di ricerca e nuove acquisizioni," *V.Rassegna di archeologia subacquea* (Messina 1992) 103-14.

Celuzza, M. G. and Regoli, E., "La Valle d'Oro nel territorio di Cosa. *Ager Cosanus* and *Ager Veientanus* a confronto," *DialArch* 1 (1982) 31-62.

Ciampoltrini, G., "Un insediamento tardo-repubblicano ad Albinia," *Rassegna di Archeologia di Piombino* 4 (1984) 149-80.

Ciampoltrini, G., "Una statua–ritratto di età imperiale dalla foce dell'Albegna," *Prospettiva* 43 (1985) 43-47.

Ciampoltrini, G. and Rendini, P., "L'agro cosano fra tarda antichità e alto medioevo. Segnalazione e contributi," *ArchMed* 15 (1988) 519-34.

Ciampoltrini, G. "Orbetello (Grosseto): gli scavi in località La Parrina," *Studi e Materiali. Scienza dell'antichità in Toscana* 6 (Rome 1991) 260-69.

Dyson, S., "Settlement patterns in the *ager cosanus*. The Wesleyan University Survey," *JFA* 5 (1978) 251-63.

Fentress, E., "Via Aurelia – Via Aemilia," *PBSR* 52 (1984) 72-77.

Manacorda, D., "Produzione agricola, produzione ceramica e proprietari nell'*ager cosanus* nel I sec. a.C.," in *Società romana e produzione schiavistica* (Bari 1981) 3-54.

Pasquinucci, M., "Contributo allo studio dell'*ager cosanus*: la villa dei muraci a Porto Santo Stefano," *SCO* 32 (1982) 141-49.

Quilici-Gigli, S. and Quilici L., "Ville dell'agro cosano con fronte a torrette," *RIA* 1 (1978) 11-64.

Quilici-Gigli, S., "Portus Cosanus. Da monumento archeologico a spiaggia di Ansedonia," *BStorArt* 36 (1993) 57-63.

Peacock, D., "Recent discoveries of amphora kilns in Italy," *AntJ* 57 (1977) 262-71.

Rathbone, D., "The development of agriculture in the *ager cosanus* during the Roman Republic. Problems of evidence and interpretation," *JRS* 71 (1981) 10-23.

Uggeri, G., "Il popolamento del territorio cosano nell'antichità," *Aspetti e problemi di storia dello stato dei presidi in Maremma* (Grosseto 1981) 37-53.

Introduction: Frank Brown, Cosa, and the idea of a Roman city

Elizabeth Fentress

When in May of 1948 Frank E. Brown started the excavation at Cosa, the principal aim of the project was quite simply a long-term archaeological excavation for the Classical School of the American Academy in Rome. Other institutions had had their own projects for years — the American School in Athens had just celebrated the 50th anniversary of its excavations at Corinth, while the British School in Athens had been digging at Knossos for almost as long. In Italy this sort of initiative was impossible until the end of the Second World War. An excavation in Rome itself was equally out of the question, for the archaeology of the *Urbs* remained a sensitive subject.[1] Brown sought a site in which to study Etruscan town-planning as well as the impact of Rome on urban design.[2] Cosa seemed ideal: untouched on its still-undeveloped hill, with possibly Etruscan walls, and slight, but precious, references in Roman sources. These showed that the first colony was sent to Cosa in 273 B.C., seven years after the conquest of Vulci.[3] A second deduction was sent at the colony's request in 197 B.C.[4] In the late Republic, figures such as the Sestii and the Domitii Ahenobarbi owned estates in the territory.[5] Rutilius Namatianus, sailing past in A.D. 416, noted that the city was deserted.[6]

The site thus promised a fruitful excavation, as well as a training site for young American archaeologists. The *soprintendente* in Florence, Antonio Minto, was enthusiastic, and the owner of the site, the Marchesa San Felice di Monteforte, was marvelously hospitable.

As we all know, Cosa proved to be a purely Roman foundation and a fundamental source for Roman colonization in the Republic. In many ways it is an odd colony, small and irregular in plan, with only the barest of civic structures. However, the extent of the excavations and the clarity of their publication has made an important type-site of Cosa. Brown perceived it as an idealized version of the essential elements of the plan of Rome, "a premeditated design for what a functioning Roman environment ought to be. The unplanned, radial prototype was Rome itself".[7] Cosa was, *mutatis mutandis*, an edited version of Rome.

The following abbreviations are used for frequently cited works:

Cosa I　　　　　F. E. Brown, *Cosa I: History and topography* (*MAAR* 20, 1951) 5-113.

Cosa II　　　　 F. E. Brown, E. H. Richardson, and L. Richardson, jr., *Cosa II: The Temples of the Arx* (*MAAR* 26, 1960).

Cosa III　　　　F. E. Brown, E. H. Richardson, and L. Richardson jr., *Cosa III: The buildings of the forum* (*MAAR* 37, 1993).

Cosa Roman town　F. E. Brown, *Cosa, the making of a Roman town* (Ann Arbor 1980).

1　 I am grateful to W. V. Harris and J. T. Peña for their comments on this paper and to Larry Richardson jr. for his meticulous, if dissenting, corrections. For the history of Italian archaeology see M. Barbanera, *L'archeologia degli Italiani: storia, metodi e orientamenti dell'archeologia classica in Italia* (Rome 1998).

2　 On the history of the excavations and the Academy's involvement, see E. Fentress, L. Richardson jr. and R. T. Scott, "Excavations at Cosa: the first fifty years," in K. Vanderpool (ed.), *American archaeology in classical lands: the next one hundred years* (forthcoming). Excavations from 1990 to 1997 were directed by E. Fentress and carried out with support from the American Academy in Rome, the Kress Foundation, the British School at Rome, and the Craven Committee of Oxford University. The full publication of the results of the excavations will appear as E. Fentress, *Excavations at Cosa 1991-1997* (*Cosa V*).

3　 Vell. Pat. 1.14.7; Livy, *Per.* 14. A discussion of the sources for the history of the site is found in *Cosa I*.

4　 Livy 39.55; Ptol., *Geog.* 3.1.43.

5　 For a discussion of the landowners in the *ager cosanus*, see D. Manacorda, "The *ager cosanus* and the production of the amphorae of Sestius: new evidence and a reassessment," *JRS* 68 (1978) 122-31.

6　 Rut. Namat., *De reditu* 1.285 f.

7　 *Cosa Roman town* 12.

Fifty years later, Brown's accomplishment is clear, not only in the publication of much of the excavations, the construction of the museum, and the numerous archaeologists he trained, but also in the general diffusion of his ideas, particularly through his Jerome Lectures of 1979, entitled *Cosa: The making of a Roman town*.[8] The idea that Roman colonies reproduced elements of the urban form, and by this reproduction encouraged the formation of aspects of the Roman character, has been a commonplace in discussions of Romanization. Just as it lay at the center of its empire, Rome lies at the center of our thoughts. We have only to think of the general reaction to the Colle Oppio fresco, the subject of the papers below by La Rocca, Volpe and Caruso; when it was first found, almost everyone gasped, '*è Roma!*' The connection with Romanization is obvious. The Roman town created a habitus, to use Bourdieu's term, which formed and informed the growth of a Roman citizen.[9] This habitus, in some ideal sense, was Rome itself. What I want to do in this paper is to re-examine the equation at Cosa itself, both in the light of new knowledge and in that of the context in which Brown's work was carried out. It is important to ask ourselves exactly what this idea might mean, and the ways in which its application has transformed our vision not only of Cosa but also of Rome.

The first question is whether Cosa was in any sense intentionally created to effect the 'romanization', or cultural transformation, of the surrounding population. The answer must be no. Quite apart from the recent criticism of the whole concept of romanization, we must look at the specific historical context of the city's foundation.[10] The conquest of Vulci in 280 B.C. was apparently followed by the wholesale ethnic cleansing of its population. Survey of the territory has revealed that of the over 58 farms occupied in the 4th c. B.C., only 16 farms remained by the mid 3rd c., along with two small peripheral villages.[11] The vast majority of those sites which survived are in the territory of Saturnia: in the territory of Cosa only two farms show continuity. The town of Orbetello was probably destroyed, while Ghiaccioforte and Doganella on the right bank of the Albegna were certainly burned and not re-occupied.[12] Some new 3rd-c. settlement also on the right bank of the Albegna might indicate forcible displacement of the population. The only area in the whole of the Albegna valley that shows any settlement continuity is found in the hilly region to the north of Saturnia. This is more than the exception which proves the rule, in that it demonstrates that 3rd-c. settlement is not difficult to recognize when it exists. Further, such continuity would be logical in this area if the principal displacements took place further toward the coast. Whether the Etruscan inhabitants of

8 A bibliography of the Cosa excavations appears at the end of the preface to this volume.

9 P. Bourdieu, *Outline of a theory of practice* (Cambridge 1977) passim. On the rôle of the city as a 'conveyancer' of Roman imperialism, see C. R. Whittaker, "Imperialism and culture: The Roman initiative," in D. J. Mattingly (ed.), *Dialogues in Roman imperialism* (JRA Suppl. 23, 1997) 143-63. Against the indiscriminate use of the concept *simulacrum Romae* for Republican colonies, see M. Torelli, "Aspetti ideologici della colonizzazione romana più antica," *DialArch* 6 (1988) 65-77, and P. Gros and M. Torelli, *Storia dell'urbanistica antica: il mondo romano* (Roma–Bari 1988). See also Zanker's reading of Gellius in this volume.

10 On Romanization see most recently J. C. Barrett, "'Romanization', a critical comment" in Mattingly ibid. 51-64; P. W. M. Freeman, "'Romanisation' and Roman material culture," *JRA* 6 (1993) 438-45; W. V. Harris, in *Rome in Etruria and Umbria* (Oxford 1971) 98, argues that "assimilation was not in any case among the conscious purposes of Roman colonization of the third century".

11 For a detailed treatment of the Romanization of the territory, see M.-G. Celuzza in F. Cambi, A. Carandini, M.-G. Celuzza and E. Fentress, *Paesaggi dell'Etruria dall'Albegna alla Fiora* (forthcoming), from which these data are taken.

12 For Orbetello cf. G. Ciampoltrini, "Orbetello," in A. Carandini (ed.), *La romanizzazione dell'Etruria: il territorio di Vulci* (cat. exhib. Orbitello 1985; Florence 1985) 91-95. Celuzza in Cambi *et al.*, ibid. suggests some limited survival of the town. For Ghiaccioforte cf. P. Rendini, "Ghiaccioforte," in Carandini ibid. 131-32. For Doganella, see P. Perkins and L. Walker, "Survey of an Etruscan city at Doganella in the Albegna valley," *PBSR* 58 (1990) 1-144. For Etruscan settlement in the Albegna Valley see P. Perkins, *Etruscan settlement, society and material culture in central coastal Etruria* (BAR Int. Ser. 788, Oxford 1999).

the territory of Cosa were killed or driven off is, of course, not clear, but their displacement is hardly without precedent in Roman history — one has only to look at the fate of Volsinii and of Falerii in subsequent decades.[13] The modern term 'ethnic cleansing' has a clear application here.

Cosa was thus founded in a very barren landscape. Its settlers came from areas allied with Rome, and there are only one or two hints that Etruscans were present at any time in the first two centuries of the life of the colony. The splendid polygonal masonry of its walls mirrors that of Latin towns and need hardly be attributed to local stonecutters. The immigrants were Latin-speakers whose town would have reflected their own expectations. Indeed, as Torelli has suggested, the possible dedication of the first temple to Jupiter can be seen as an expressly Latin phenomenon.[14]

The almost total lack of building in the town during the 3rd c. can best be explained by the Punic Wars, which in all probability depopulated the town. Only 16 new 3rd-c. farms are found in the territory of Cosa, and thus the situation of the new settlers at the beginning of the 2nd c. was hardly dissimilar to that of 273. In 197 B.C. 1000 families arrived, and their farms are to be found throughout the territory.[15] Whether or not the town was replanned at that time, it was thus designed to support a well-integrated community whose expectations it would, most probably, have met. The basic political, religious and economic needs were served by the *curia/comitium*, the temples, and the markets of the new town, which could also have provided housing for *c.*25% of the newcomers. None of this, of course, has anything to do with a conscious desire to 'Romanize' the settlers. Nor is there any visible intent to affect the lives of whatever Etruscans may have returned to the area. The town of Cosa, both in the 3rd and at the beginning of the 2nd c. B.C., must be examined in the light of other Latin colonies of the period. The question of whether these are 'little Romes' is intricately tied to our knowledge of the whole set.

If we were to put ourselves in the position of entirely alien observers, Martian archaeologists perhaps, examining the two plans of Rome and Cosa without preconceived ideas, we would find it difficult to see what Brown meant. That Cosa presents an *effigia parva*, or a *simulacrum*[16] of Rome or its people is, to say the least, not immediately clear. The plans of the two cities have little in common beyond the essential elements of classical urban furniture. Cosan public buildings in the middle of the 2nd c. B.C. included 4 temples, 1 basilica, the *comitium-curia* complex, a gaol and a putative market. Its plan is regular, its forum rectangular. Indeed, as P. Zanker points out in this volume, even Gellius did not intend the *coloniae* to be exact copies of Rome. Yet Cosa's identity with Rome on some deeper level is a fundamental tenet of Brown's thinking, although in many cases his desire to find Roman prototypes for Cosan realities led to circular arguments. Solutions proposed for Cosa were then used to support similar solutions for Roman questions that could not be solved directly due to the difficulty of excavation in Rome itself.[17] The very nomenclature that Brown gave to the town — the *'arx'* and the *'atria publica'* — begs the question, how do we know that they were perceived as such by the Cosan colonists?

13 M. Torelli, *Storia degli Etruschi* (Roma–Bari 1981).

14 Torelli 1988 (supra n.9) 65-77. However, Richardson (pers. comm.) points out that there is no evidence whatsoever for the dedication of the earliest temple.

15 M.-G. Celuzza and E. Regoli, "La Valle d'Oro nel territorio di Cosa. *Ager cosanus* e *ager veientanus* a confronto," *DialArch* 1 (1982) 31-36; I. Attolini *et al.*, "Political geography and productive geography between the valleys of the Albegna and the Fiora in northern Etruria," in G. Barker and J. Lloyd (edd.), *Roman landscapes* (London 1991) 142-53.

16 Gell. 16.13.8 f.

17 In his obituary of Brown, Scott argues that Cosa is "a template for the archaeology of Latin colonies and mid-Republican Rome itself" (R. Scott, "Frank Edward Brown, 1908-1988," *AJA* 92 [1988] 577).

First, however, it is necessary to review very briefly the evidence from the last seven years of excavation insofar as it sheds new light on the Republican colony. The excavations which started in 1990 were intended to examine the Imperial and Mediaeval phases of the town, and it was only in the last few seasons that significant new information was recovered on the first centuries of the colony's existence. Two aspects of this concern us here, the religious buildings and the planning of the forum.

M. Torelli, speaking of Cosa in the context of other Latin colonies, has remarked on the poverty of the city's religious structures.[18] This observation is perhaps confirmed by evidence from the new excavations that at least two of the temples were later insertions built on the sites of earlier housing. A large trench to the southeast of Temple B on the forum revealed that a block of housing had been removed to create an empty space in which to build the temple.[19] On the Eastern Height a new temple was found in 1995.[20] Like Temple D on the 'Arx', it is a small structure, although its temenos seems to have measured 100 feet in width. Again, it seems to have replaced a block of earlier housing. Finally, on the Arx itself were found traces of a house aligned with the town plan. Its chronological relationship to Temple D is not clear, but they may have co-existed until the destruction of the town in 70 B.C.[21]

The presence of domestic structures on the Arx from the beginning of the 2nd c. B.C. suggests at the very least a mixed use of the space. The only temple that can be attributed to the 3rd c. is the hypothetical early Temple of Jupiter, whose identification is based on terracottas and, perhaps, some cuttings in the bedrock of the hill.[22] With the exception of Temple D on the Arx, the 2nd-c. temples — the temple on the forum and the new temple on the Eastern Height — are both late additions to the town plan, for whose construction houses had to be sacrificed.

The other major change we find in Republican Cosa comes from the forum itself. Here, excavations revealed that one of the buildings on the edge of the forum was a private house constructed, like the temples, in the first quarter of the 2nd c. B.C.[23] The plan is that of a typical early 2nd-c. atrium house, with a substantial kitchen garden in back and a small bath-house. Its proportions are similar to those of the House of Sallust in Pompeii, with two *tabernae* opening onto the forum on either side of the entrance. Its façade, like those of the other buildings on the forum, is 17.5 m wide. Its subsequent history, too, follows that of the Pompeian atrium houses, with the construction of a loggia to the rear of the building in the Augustan period, but this does not for the moment concern us.

It is fair to propose that this plan was reproduced in the buildings on all three sides of the forum (fig. 1). What we can see of Atrium Building II, to the southwest of the entrance to the forum, conforms exactly to this scheme, except in the gardens and service areas. However, there is space for these in the block beside the building, which separates it from the large cistern. The same is true for Atrium Building I, where a plot of the same size separates the building from street 7. All of the other buildings could conform exactly to the plan recovered in our excavation of Atrium Building V.

The presence of these large houses on three sides of the forum is an anomaly, however, at least if it is compared to what R. T. Scott's excavations have shown about Republican housing

18 Torelli 1988 (supra n.9) 72.

19 Fentress in *Cosa V* forthcoming.

20 An interim report on the building appears in E. Fentress and A. Rabinowitz, "Excavations at Cosa 1995: Atrium building V and a new Republican temple," *MAAR* 41 (1996) 221-36.

21 Fentress in *Cosa V* forthcoming. It is also possible that the house had been destroyed to make room for the temple.

22 *Cosa II*, 19-24; L. Richardson, ibid. 151-66 (on the terracottas). The position of the temple had moved by 1979: see *Cosa Roman town* 25 and fig. 25.

23 Fentress and Rabinowitz (supra n.20).

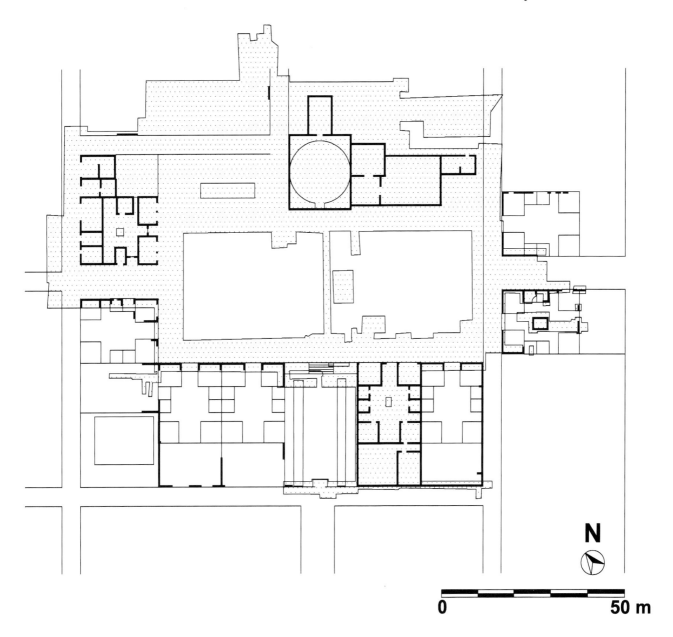

Fig. 1. The forum of Cosa. Excavated areas are shown in stippling. The house numbers correspond to those of Brown's excavations (*del.* S. Leigh).

elsewhere in Cosa.[24] Near the museum, the long *insulae* were divided into house plots 8.5 m wide, just under half the width of those on the forum plaza. On the SW side of each plot a simple house with a courtyard or atrium at the center was built. A *tablinum* and at least one *cubiculum* opened off this space. Behind the houses the plots were terraced at a lower level, with steps leading down to a garden and service areas. The basic layout here is similar to what we have seen on the forum but on a smaller scale. The houses measure half the width of those on the forum. We are dealing, almost certainly, with houses for two classes of colonists, some of whom received plots exactly twice as large as the others.

If we examine the plan of the city as elucidated by Brown, it becomes clear that this hierarchy is inscribed in the streets as well. The ordinary streets are 6 m wide. However, the street leading from the forum to the Arx, and the street which leads from the SW gate to the Eastern Height, are each 9 m wide. Brown called these 'processional' streets, and certainly by the mid-

24 Scott in V. J. Bruno and R. T. Scott, *Cosa IV: The houses* (*MAAR* 38, 1993) 13-63.

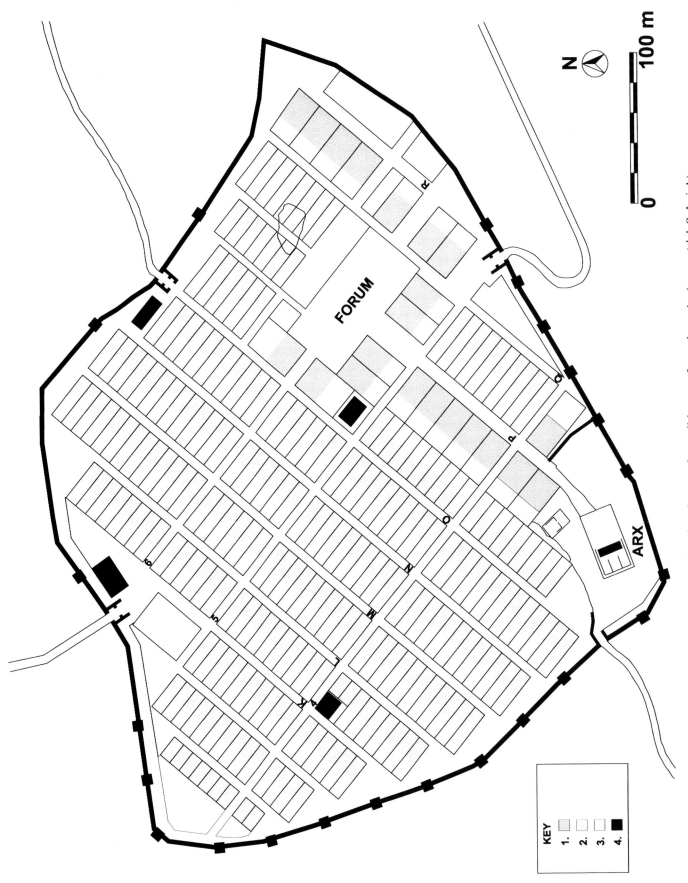

Fig. 2. Cosa: reconstructed plan of the original settlement. 1: atrium houses. 2: small houses. 3: gardens. 4: cisterns (*del.* S. Leigh).

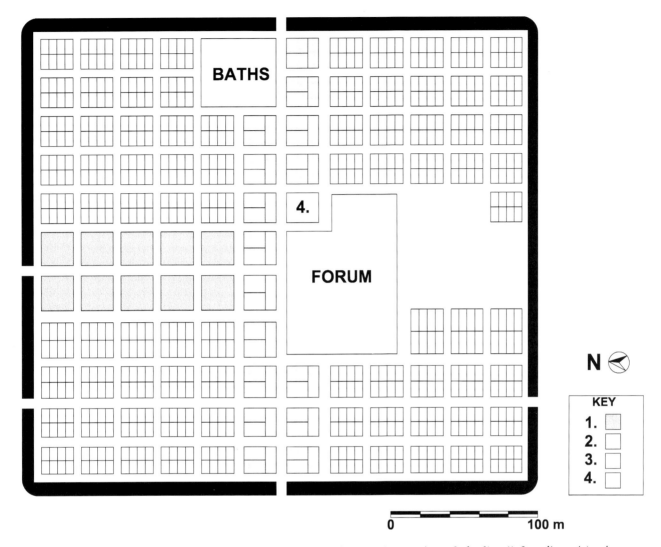

Fig. 3. Timgad: reconstructed plan of the original settlement. 1 centurions; 2 *duplicarii*; 3 *pedites*; 4 'maison des jardinières': the house of the designated *rector* of the *colonia*? After Fentress (infra n.28) fig. 8 (*del.* S. Leigh).

dle of the 2nd c. they both led to temples. However, their extra width may also indicate higher-status housing along their route. Figure 2 illustrates this hypothesis, with the areas occupied by the larger houses colored a darker grey and those occupied by the small houses represented in a lighter color. The best estimate suggests 21 larger houses and approximately 238 smaller ones. Thus the proportion between larger and smaller houses is slightly less than 1 : 10 and these could have housed 259 of the 1000 new colonists, assuming one colonist per house.

These figures resemble those for a series of colonies sent out in the first two decades of the 2nd c. B.C. At Thurii Copia, *Castrum Frentinum*, in 193 B.C., 300 *equites* received plots of 40 *iugera*, while 3000 *pedites* received 20.[25] Again this represents a proportion of 1 : 10, with the *equites* receiving twice as much land as the *pedites*. At *Vibo* in 192, where there were 300 *equites* and 3700 *pedites*, again the *equites* received double-sized allotments.[26] Similar proportions applied at *Bononia* and *Aquileia* in 190 and 181.[27] The pattern is strikingly similar to that found at Cosa, suggesting that the Latin colonies in the period after the Second Punic War followed a consistent pattern, with colonies designed to accept two or three orders of colonists, and plots assigned by rank. It follows that the detailed plan of the settlement at Cosa dates not to

25 Livy 35.9.7-8.
26 Livy 35.40.5-6.
27 Livy 40.34.2-4.

the 3rd c. but to the first decade of the 2nd, or precisely to the second deduction of colonists in 197 B.C. The settlers, as we know from Livy, were drawn from the allies of Rome in the Second Punic War and were probably veterans. The settlement, with its two orders of streets and two orders of houses, clearly reflects the difference in rank of its settlers.[28] At *Thamugadi* almost 300 years later, a clear division by rank into three orders of houses is visible, and here again the houses of the uppermost class (the centurions?) flank the *cardo* leading to the forum (fig. 3).[29] The military origin of the colony and its Imperial date make this mapping of rank onto the fabric of the city more intuitively obvious, but there is no reason not to locate the genesis of such a scheme in the colonies of the Republic. In both colonies the larger houses are drawn up along the processional ways like the officers of troops on review, with the common soldiers in orderly ranks behind them. Polybius' description of a marching camp in the 2nd c. suggests parallels to such an arrangement.[30] Although many details of this plan remain obscure, it is clear that *the via praetoria* was laid out at right-angles to the forum, that the tents of the cavalry were drawn up along it, and the tents of infantry and auxiliaries were behind these. Centurions were placed at the ends of the maniples, along the *via principalis* which ran along the side of the forum.[31] Keppie suggests that this scheme derived from civilian settlements. However, rather than deriving the city from the camp, or the camp from the city, we should look at both as products of the same mind-set in which social or military hierarchies are inscribed in an orderly fashion onto the natural disorder of the chosen ground.

The Cosan plan suggested here is, of course, difficult to relate to Republican Rome. It is also a far cry from the city Brown described, with its forum surrounded by *atria publica*.[32] Brown's forum is an entirely public space, with shops, offices and the structures of local government. The forum suggested here was surrounded on three sides by the houses of the decurions, with the civic buildings limited to the fourth side.

Brown's interpretation arose, of course, from his work on the first of these buildings to be excavated, Atrium Building I.[33] Its plan is indeed anomalous, as the NW rooms do not seem to connect to the atrium. However, even if that division was original, and the section of the building fronting street O was devoted to commercial space, there is ample domestic space inside the structure, and room for a garden and service buildings if the plot on its NE side is included. The man who received the plot may have simply chosen to sacrifice his *tablinum* to more profitable shops. Soundings made in Buildings II and VII show plans that conform in every way to those of a standard atrium house.

What were Brown's reasons for the identification of all these structures as 'atria publica'? He argued that

> [Although] the atrium with its *alae* takes the forms of the core of a contemporary Roman house, yet they were obviously not designed as dwellings. The most striking feature is the absence of regular living quarters [...] Room 18 of AB I had the position of a cubiculum but was simply a nondescript room with doors, except for its arrangements for drainage, whatever its function. In short, what we

28 Reconstructions of the original plans of Roman *coloniae* are regrettably rare: see, for example, E. Fentress, *Numidia and the Roman army* (BAR Int. Ser. 50, Oxford 1979) fig. 8 (here fig. 3), and H. Lohmann, "Beobachtungen zum Stadtplan von Timgad," in *Wohnungsbau im Altertum* (Berlin 1980) 167-87, on Timgad; and H. von Hesberg, "Zur Plangestaltung der coloniae maritimae," *RömMitt* 92 (1985) 127-50 on the *coloniae maritimae* including Cosa. For late 3rd and early 2nd-c. B.C. houses similar to those of Cosa, see S. Nappo, "Urban transformation at Pompeii in the late 3rd and early 2nd c. B.C." in R. Laurence and A. Wallace-Hadrill (edd.), *Domestic space in the Roman world* (JRA Suppl. 22, 1997) 91-120, and A. Wallace-Hadrill, "Rethinking the Roman atrium house," ibid. 219-40.
29 Fentress ibid.
30 Polyb. 6.27-30. For commentary, see L. Keppie, *The making of the Roman army* (London 1984) 38 f.
31 Polyb. 6.30.5.
32 *Cosa III*, 103.
33 Ibid. 59-77.

have exposed or conjectured about the eight atria may best be defined as an adaptation of the central component of a typical atrium house for public or commercial purposes.[34]

He goes on to argue that "They can, however, be related to certain buildings in republican Rome known by the term *atrium* specifically mentioned by ancient writers: the Atrium Publicum, the public record office on the Capitoline, predecessor of the Tabularium." Others included the Atrium Libertatis, Sutorium, Licinium, Maenianum and Titium, the last two certainly on the forum, as they were replaced by the Basilica Porcia.[35] They appear to

> record a stage in Roman architecture when the central space of the house ... was adapted to a wide range of public uses. In the Rome of the third century these atria seem to have been both various and scattered. In the colonial early second century of Cosa the atria had been brought together in the master plan for its forum, or so it seems. In any case, where none of the Roman atria have survived, the atria of Cosa can provide their pattern, and conversely the atria of Rome can suggest some of the functions that those at Cosa may have acquired.

Two points are worth noting here. First, the fact that there were no known plans of the Roman public *atria* made it possible to discover their parallels at Cosa. The evident possibility that the word 'atrium' was, by metonomy, an occasional synonym for 'domus' was never considered.[36] Brown was, as we will see in other cases, 'excavating' the inaccessible Rome while excavating Cosa. And Roman texts could in this way be adduced to shed light on Cosan buildings. Second, the fact that the buildings on the Cosan forum could have served a domestic purpose was dismissed out of hand — witness the dismissal of the small room as a *cubiculum* on the grounds that it was "non-descript space". In discussions of the other buildings their nonconformity to the plan of Atrium Building I was simply ignored. Richardson comments that he never understood Brown's "fixation on excluding houses from around the forum of Cosa".[37] In short, our only evidence for an 'atrium publicum' is Livy's mention of a building struck by lightning in 214 B.C. (24.10). Analogous to the Atrium Libertatis, it probably served as a record-office. But nothing allows us to reconstruct its architecture or to assume the generalization of the type.

I suppose — but can offer no outside support for the theory — that Brown's rejection of the domestic hypothesis was based on a rejection of such a clear correspondence between rank and housing within the body of the original settlers. Greek colonial cities were egalitarian in design and conception. In mainland Greece, Olynthus, excavated in the late 1920s and early 1930s, revealed just such planned blocks of housing, all of identical size.[38] In Sicily we now have the example of Megara Hyblaea.[39] However quickly this egalitarian ideal was to disappear after a colonial foundation, its initial symbolic impact was massive. And, of course, America's own colonial cities, especially those with the most elegantly conceived plans, were based on rigorously equal layouts. The best-known example is that of Savannah Georgia (fig. 4).[40] The image of the sturdy veteran farmers settled in Cosa sat uncomfortably with distinctions of

34 Ibid. 101.

35 Livy 39.44.7.

36 So D. Palombi, s.v. Atrium Septem, in E. M. Steinby (ed.), *Lexicon Topographicum Urbis Romae* 1 (Rome 1993), although F. Coarelli, s.v. Atrium Maenium, ibid., follows Brown's interpretation. However, as he notes, the Pseudo-Asconius records that this building was, in fact, a *domus* (ps. Ascon., *div.* in Caec. 16.50). I am grateful to S. Butler for his comments on the reliability and probable 1st c. A.D. date of the commentary in Pseudo Aasconius.

37 Pers. comm.

38 D. M. Robinson, *Excavations at Olynthus* 2. *Architecture and sculpture, houses and other buildings* (Princeton 1930). Plato, of course, prescribes equal lots (*Law* 5.740) whose number would remain fixed, each being left to a single heir.

39 G. Vallet, F. Villard and P. Auberson, *Megara Hyblaea I. Le quartier de l'Agora antique* (MEFRA suppl. 1, 1978). On the egalitarian plan of Greek colonies see P. Zanker, *Pompeii: Public and private life* (Cambridge, MA 1998) 5 f.

40 On Ogilthorpe's egalitarian plan of Savannah of 1733, see P. Russell and B. Hines, *Savannah: A history of her people since 1733* (Savannah 1992): see also J. W. Reps, *The making of urban America: A history of*

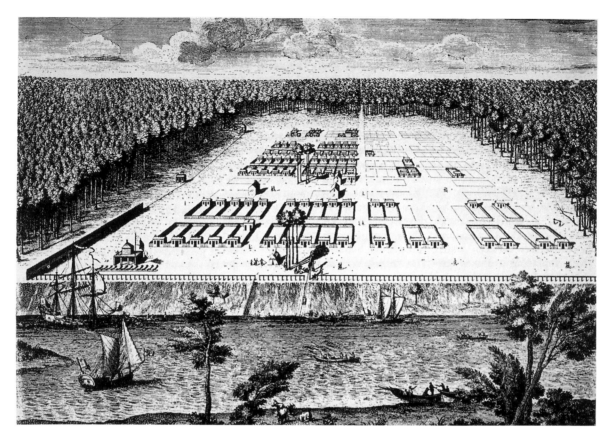

Fig. 4. Savannah, Georgia in 1734 (from J. W. Reps, *The making of urban America* fig. 112).

rank. M. I. Finley wrote of Sicilian colonization that "People who had chosen or had been forced to migrate because of an inequitable condition were not likely to have slavishly respected that condition when they had a free hand".[41] Equality, the pristine condition of Rome itself, ought to have been echoed in the original settlement of Cosa.

Whether or not Brown consciously formulated this idea, the egalitarian view of the settlement was eagerly taken up by American reviewers. For example, P. Lockhart notes how "Brown's discerning eye peoples Cosa with 200 years' worth of Roman colonists, as they gradually develop a bourgeois aristocracy out of their original egalitarian colonia."[42]

Of course, in proposing that Cosa simply mapped in an orderly fashion Rome's own foundations in rank and order I, too, seem to be finding Rome in Cosa. But at Cosa the excavator's habit of finding a Roman prototype for every detail was general, and the so-called *atria publica* were not the only places where the equation was made to work. Across the forum, Temple B was identified as the temple of Concordia on the basis of a fragmentary Republican inscription reading '*concordiae*' that was found re-used in a mediaeval grave nearby. Just as in Rome, the temple which celebrated the unity of the orders would have stood near the Comitium. Here at Cosa its significance would have been the unity of the Latins. The fragment of a terracotta pig found near the temple could also be interpreted as a Latin symbol.[43] However, E. Richardson's study of the terracottas from the temple throws the interpretation into serious doubt: the

city planning in the United States (Princeton 1965). I am grateful to M. Bell for bringing Savannah's plan to my attention.

41 M. I. Finley, *Ancient Sicily* (New York 1979) 38. However, he comments elsewhere that the ancient world accepted "human inequality ... as natural and immutable"("Utopianism ancient and modern," in *The use and abuse of history* [London 1975] 187).

42 P. Lockhart in a review of recent work on Cosa, *Pennsylvania Classical Association Newsletter* 1995, 12

43 *Cosa Roman town*, 39. See also Torelli 1988 (supra n.9) 65-77.

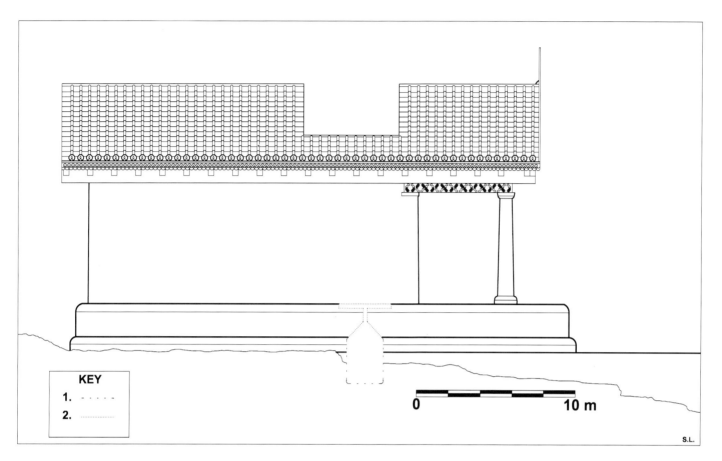

Fig. 5. The Temple of the Capitoline Cult on the Arx, reconstructed with an *impluvium* and a cistern. 1 *in situ* section of the cistern; 2 reconstructed profile. After *Cosa II*, fig. 74 (*del.* S. Leigh).

multiple fragments of votive terracottas show that they consisted of several life-sized female busts, one of which is a figure holding a pig. She suggests that the most plausible dedication for the temple, based on these terracottas, is to Ceres, either with Persephone or, perhaps more likely, with Liber and Libera.[44] The implications of the terracottas were only examined at the time of the publication of *Cosa III*. Comparison with Rome is also the basis for the identification of the port temple as that of Portunus.[45] Here again other explanations are possible; A. M. McCann has argued plausibly that Neptune is a far more likely deity for the dedication of a temple at a coastal port, especially considering the horse and trident on Cosan coinage.[46]

At the temple to the Capitoline cult, on the other hand, the evidence from Cosa was applied to Rome. A particular feature of the existing temple is the large cistern built into the podium under the porch of the building. Brown suggests that it was filled from a *compluvium* in the roof of the building, rather than from guttering and a downspout as, for instance, at Lavinium.[47] To construct this *compluvium* it would have been necessary to suppress the *columen*

44 E. Richardson in *Cosa III*, 206. Note that a 1st-c. A.D. statue of Liber was found re-used in a small Severan(?) sanctuary to Liber Pater: J. Collins Clinton, *A late antique shrine of Liber Pater at Cosa* (Leiden 1977) 49 and E. Fentress, "Cosa in the empire: the unmaking of a Roman town," *JRA* 7 (1994) 208-22.

45 *Cosa II*, 45-47; *Cosa Roman town* 49.

46 A. M. McCann, *The Roman port and fishery of Cosa* (Princeton 1987) 132 f.

47 *Cosa II*, 62-65, 93-99, 108. The catchment for the downspout in the forum temple at Lavinium was kindly shown to me by M. Fenelli. The pool next to the Portonaccio temple at Veii was certainly filled from the whole of the roof, while the apparent cistern under the steps of the temple at Gabii seems to have been filled by a system similar to that which I propose for Cosa.

between the inner columns of the *pronaos* and the front wall of the *cella*, leaving an uncomfortable hole in the roof (fig. 5). From this hole an inner shaft of light would have fallen into the *pronaos*. This solution is problematic for many reasons: for one thing, the perforation of the truss by the *compluvium* seems both structurally unsound and aesthetically disturbing. For another, such a *compluvium* would collect only the rain which fell on it, rather than that from the roof as a whole: the expected rainwater for an entire year would barely have filled the cistern.[48] If the water were regularly used, refills from the whole area of the roof would have been necessary to keep the cistern filled. For this reason a standard downspout carried by a channel to the cistern would seem a more satisfying solution. The destruction of the top layers of the podium has destroyed the pipe or channel, but the find of a substantial terracotta pipe from the area of the Capitolium in 1949 supports this hypothesis.[49]

The suggestion of a *compluvium* at Cosa is thus inherently unlikely. It is even more surprising to find the same solution suggested for the Capitoline Temple in Rome itself. Brown argues that

> Cisterns, already ancient at the time of its first rebuilding, underlay the paving of its forecourt and were known as the *favissae Capitolinae*. ... It is a fair guess that the persistent legend of the irremovable Terminus in the pronaos of the Roman temple, above which in later versions of the building the roof was pierced by an *exiguum foramen*, reflects an original arrangement of *compluvium, impluvium* and *favissa* ... the presence of a *compluvium* in the original pronaos might well have given rise after 140 to the explanation that it was there, because *nefas esse putarent Terminum intra tectum consistere*, as well as to its survival in the little skylight in later times.[50]

Thus, if the Cosan temple had a cistern fed from a hole in the roof, so did the Roman Capitolium, even if the word *favissa* must be forced to stand in for that of cistern.

A final, and much-quoted, instance of the discovery of a Roman monument at Cosa is that of the *comitium*. The circular structure, almost identical to those found at Paestum,[51] at Fregellae,[52] and at Alba Fucens,[53] has been generally interpreted as based on the *comitium* in the Roman forum.[54] It was not until the publication of P. Carafa's recent, exhaustive study of the Roman *comitium* that this hypothesis was seriously questioned.[55] He shows that the Roman monument cannot possibly have had such a regular shape, bounded as it was by the Rostra, the Via Sacra, the Tribunal, the Basilica Porcia and the Volcanal. The fact remains, however, that four Latin colonies have produced evidence for similar round structures. If we remove the original prototype on the Roman forum, how can we explain this? At this point it would perhaps be wise to return to Cosa the Latin colony, and to consider it not only on its own terms but also in the context of what we know of the other Latin colonies quite apart from that of an ideal Rome. Alba Fucens and Cosa, as Brown pointed out, are clearly part of the same planning process, even though their very different terrains produced superficially different results, and their planners juggled rather differently with the single elements. In both *coloniae* the forum occupies the central saddle of land, oriented so as to provide a view of the territory below. At

48 Calculations in *Cosa II*, 60.

49 Now in the deposits of the Museum of Cosa.

50 *Cosa II*, 108.

51 L. Richardson jr., *Cosa III*, 253-93; E. Greco, "Archeologia della colonia latina di Paestum," *DialArch* 6 (1988) 79-86.

52 F. Coarelli and P. G. Monti, *Fregellae 1. Le fonti, la storia, il territorio* (Rome 1998).

53 J. Mertens, *Alba Fucens* (Brussels 1981) 98-101.

54 The bibliography is vast. An exhaustive discussion is found in F. Coarelli, *Il foro romano. Periodo arcaico* (Rome 1983) 166-288; see also E. Gjerstad, "Il comizio romano dell'età repubblicana," *OpusArch* 2 (1941); E. Sjöqvist, "Pnyx and comitium," in G. E. Mylonas (ed.), *Studies presented to D. M. Robinson* 1 (St. Louis 1951) 400-11; L. Richardson jr., "Cosa and Rome, comitium and curia," *Archaeology* 10 (1957) 49-55.

55 P. Carafa, *Il Comizio di Roma dalle origini all'età di Augusto* (*BullCom* Suppl. 5, 1998). The circular plan of the *comitium* was also doubted by G. Lugli, *I monumenti minori del foro romano* (Rome 1947).

Alba Fucens the *comitium* was located at the end of the forum, rather than in the center of its long side, while the nature of the terrain seems to have excluded the presence of houses behind the shops which lined the plaza. Neither site originally possessed other civic buildings beside the *curia* and *comitium*. In both cases the Republican temples occupied the heights above the forum — a prescription we can find echoed in Vitruvius, who recommends that the forum be placed in the middle of the town while the temples should be seen to be protecting the city *in excelsissimo loco*.[56] Rather than concentrating the religious structures in the civic center, as was increasingly to be the formula in Imperial cities, the Republican colonies linked them to it by major axes, both of sight and of circulation. Vitruvius, too, provides the formula for the walls with their towers, the hierarchy of the streets, and their pragmatic orientation *vis à vis* the prevailing winds. His work seems to reflect the previous three centuries of urban practice, in which the plan of each new colony, and of its individual buildings, was informed by its predecessors. Just as the Latin colonies at the beginning of the 2nd c. seem to have shared similar proportions of *pedites* and *equites*, so their basic plans shared a certain number of basic elements. This is hardly surprising if we consider the number of colonies founded in those years. We do not need to adduce exact prototypes in Rome itself for each of these elements: the fact that each colony was being planned in Rome is explanation enough for their similarities. In the same way, the shape of the 3rd- and 2nd-c. *comitia* in the Latin colonies is easily explained as a development of the idea, including, as Brown himself suggests, a substantial input from the Greek *ekklesiasterion*.[57]

Yet neither Roman society nor Roman urbanism can be reduced to its merely empirical and functional reality. Roman society was based as much on rite and religion as on rank and economy. Although these are far less accessible to the archaeologist than urbanism and building types, it is in the relationship between Roman ritual and the Roman town that Brown's influence will perhaps have the most lasting effects, both from his own work and from that of his close associate, Joseph Rykwert, whose arguments in *The idea of a town* mirror and expand on ideas developed by Brown.[58]

Brown's book on Roman architecture begins as follows:

> The architecture of the Romans was, from first to last, an art of shaping space around ritual. It stemmed directly from the Roman propensity to transform the raw stuff of experience and behavior into rituals, formal patterns of action and reaction.[59]

Cosa provides splendid examples of the application of this view to archaeological evidence. In the city Brown describes, everything has a meaning as well as a function, a ritual significance that underpins its form. Brown's city is precisely the 'holistic' city about which O. Murray has recently written, in which ritual and social behavior inform and create the town's political institutions.[60] Nowhere, perhaps, is this clearer than in Brown's reconstruction of Cosa's foundation.

Under the central *cella* of the Capitoline temple was found a roughly square pit with a deposit of dark, carbonized earth at the bottom.[61] Next to it were traces of a square structure, 25 feet on a side, with its median line oriented on the pit. Brown suggests that these traces represent a level platform of stone or an open enclosure surrounded by a wall. Together, the ritual space so defined would have constituted the religious center of the colony in the first years of its existence.

56 Vitr. 6.1.2.
57 *Cosa Roman town* 24.
58 J. Rykwert, *The idea of a town* (London 1976).
59 F. E. Brown, *Roman architecture* (New York 1961).
60 O. Murray, "Cities of reason," in id. and S. R. F. Price (edd.), *The Greek city from Homer to Alexander* (Oxford 1990) 5.
61 *Cosa II*, 9-16.

Brown's interpretation of this arrangement as the *'mundus'* of a *'Cosa quadrata'*, on the model of the elusive *'Roma quadrata'*, is well known, and a close reading of his first publication will show how it progressed in the period between the publication of the structures on the Arx in 1960 and his Jerome lectures of 1979. We have no idea of the historical truth of the account, indeed, perhaps its greatest attraction is the way it encourages us to suspend our disbelief. As it is one of the most evocative pieces of archaeological writing I know, I would like to end this brief look at Brown's work at Cosa by citing it in full:

> In front of the leveled platform of rock, on the highest peak of the hill and a little below it, a natural cleft in the rock had been shaped into a deep, squarish pit. There, before dawn, the augur, accompanied by one of the Commissioners, took his stand, facing the highest mountain peak on the horizon a little east of north over the pit. On this line of sight his field of vision, coincident with the surveyor's grid of the land, encompassed the town site and its territory. He traced his sacred square on the platform, projected it on the landscape and the tract of sky above, calling upon the god and naming the signs that would declare his presence and approval. Then, as the sun rose and the right signs were sent, the colonists, crowded below the peak, knew that on this their founding day they were the center of the god's attention and that in time to come he would attend them, whenever and as long as he was rightly summoned.
>
> Next, to plant the best of their old lives together in the ground of their new, they filed past the pit, casting into it the first fruits of the yield of their former homes and on top of these handfuls of earth they had brought with them. We found the pit dug out almost to the bottom by treasure seekers. What they had left in the last few inches above the floor was a powdery black deposit, soft and sooty, which under the microscope and upon analysis proved to be naturally carbonized vegetable matter. Finally, the ancient ritual of plowing the boundary, however it may have been accomplished on the rocky hillside, enclosed the town with its magic circle of furrow and ridge. It evoked as well the town's fertility and prosperity, as it enacted the penetration of mother earth by the bronze plowshare and by the coupling of harnessed bull and heifer. Cosa's life had begun.[62]

The Romulean imagery and the rites evoked have little archaeological support, but that hardly matters. Positivist criticism is unnecessary: Brown kept his listeners alive to what they did not, or could not, know. That Cosa was, in some sense, Rome seems to us unproven. This is important if evidence from Cosa is to be used to support interpretations of buildings from Rome. But it is far less important than the splendidly complete picture which Brown's imagination allowed him to create of Cosa's foundation and its early years. There are parts of the picture, particularly in the later years of the colony's existence, which must now be changed — Cosa's housing reflects Republican Rome's preoccupation with rank and order rather than an egalitarian ideal.[63] There are places where his wonderful prose skims lightly over a complete lack of evidence. But the publication of the site is a lesson in the sort of imaginative reconstruction and representation which makes archaeology worthwhile. It is Brown's ability to build on the evidence he recovered, as well as to publish it clearly, that makes Cosa an enduring example of Roman colonization.

American Academy in Rome

62 *Cosa Roman town* 16-17.

63 Nicolet comments that "les règles du droit et surtout des finances publiques ne faisant que de laisser en quelque sorte jouer, dans un climat semi-libéral, les inégalités économiques"("Economie, société et institutions au II siècle av. J.C., de la *Lex Claudia* à l'*ager exceptus*," *AnnESC* 35 [1980] 871-94).

The city as symbol:
Rome and the creation of an urban image
Paul Zanker

The topic of this colloquium — the Romanization of the city — can be approached from very different perspectives, from the political or legal to the social and cultural. In this paper I will be concerned with one specific phenomenon, the realization of certain abstract ideals in the built environment. I wish to investigate the external characteristics that mark the "typical" Roman city. How did the Roman city differ in appearance from a Mediaeval or, more to the point, a Hellenistic city? When and how did these visual peculiarities arise, and what cultural traditions and values — if any — do they embody? This approach focuses on, and thus privileges, the largest, most striking and evident structures, their origins and obvious high points, rather than the slow process of development, the minor variants and marginal phenomena. I shall concentrate exclusively on Italy and the western part of the empire, and focus primarily on newly founded cities, since these ought to provide the clearest instances of what is typically Roman. Further, I shall limit myself to public spaces and ignore the residential.

As recent scholarship has amply demonstrated, the historical development of the city can be seen as the product and the expression of the society at large, its governmental forms, social organization, ideological priorities, its ways of life and daily requirements.[1] We need only compare a Mediaeval cityscape — dominated by a plethora of churches — with images of a baroque one serving as the residence of a worldly prince, to understand how the urban image expresses a particular historical situation. The characteristic ordering of space is the result of both deliberate planning by the state and a long-term, anonymous process of historical evolution. At opposite ends of the spectrum, both urban planning generated from the drawing board of an autonomous ruler and the appearance of a district that has evolved through social and economic processes of long duration represent structures that may be understood as historical city plans.

In looking for the characteristically Roman urban image, it is important first to distinguish between state-sponsored building activity and that funded by private initiative, as well as between deliberate planning or intervention and anonymous alterations. By "anonymous alterations" I mean the many individual changes, independent of each other and of any overall plan, such as, for example, construction or renovation of houses due to changing conditions, the spread of communal dwellings in particular districts, or the addition of *tabernae* or rental space in upper storeys. Another example would be the Roman tomb streets, a phenomenon I shall return to shortly. By state-sponsored planning I mean primarily the founding of colonies, as well as decisions by communities and patrons to erect particular public buildings, lay out streets, or build walls. All these activities reflect changes in the social, economic, and cultural situation that gradually give rise to a new and different street- and townscape.

The significance of the early citizen colonies for the later Roman urban image

Rome itself grew very slowly and over the centuries took on a very individual form. Residential districts were spread over the different hills since the flooding of the Tiber made the Campus Martius unsuitable for this purpose. Early on, two principal areas were established: the Capitoline, like an acropolis with the main temple, and the swampy valley between Palatine, Velia and Capitoline as a central place of assembly. But in both the Republic and the Empire, political and social characteristics of the Roman state led to certain peculiarities in

1 See most recently P. Zanker, *Pompeii. Public and private life* (Cambridge, MA 1998) 1 ff. W. L. MacDonald, *The architecture of the Roman empire II: An urban appraisal* (New Haven 1986) offers important observations on the idea of the cityscape from a more formal perspective.

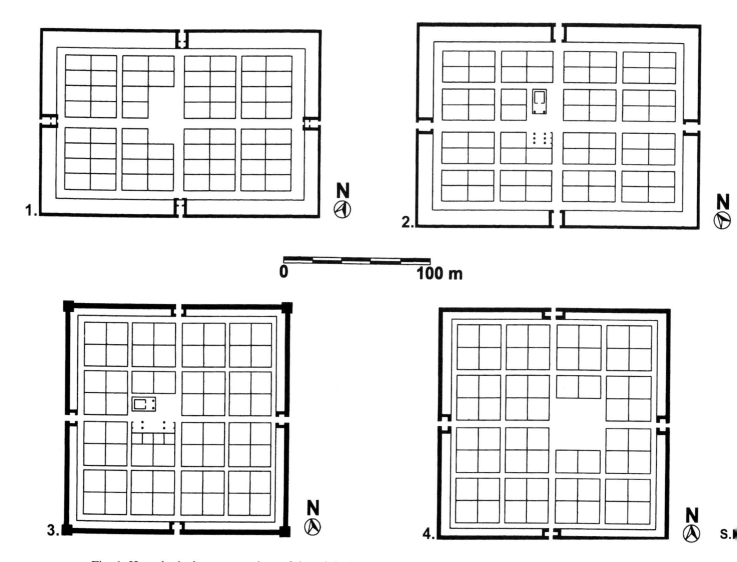

Fig. 1. Hypothetical reconstructions of the original plans of the *coloniae maritimae*: 1 Ostia; 2 Terracina; 3 Minturnae; 4 Puteoli. (After H. v. Hesberg, *RömMitt* 92 [1985], *del.* S. Leigh).

in the city's image that have no parallels elsewhere. Among these I would include, for the Republic, the numerous monuments of victorious generals in the Campus Martius, the *Via triumphalis*, and the *domus* of the great families in the Forum and on the Palatine; and for the Empire, the massive public buildings erected by the emperors.[2]

The slow and unusual development of Rome's urban fabric meant that the city was hardly a rôle model to be copied in concrete ways. Thus if we understand 'Romanization' as an assimilation to the city's outward appearance, then this must be limited merely to the borrowing of specific political structures and settings, such as that portion of the Forum in which the *Comitium* and *Curia* are located, or particular architectural forms, such as the basilica or the baths. But 'Romanization' can also be understood as something abstract and idealized, that is, the notion of how a Roman imagined the ideal city (or certain elements of this ideal city) ought to look, what F. E. Brown called, "a premeditated design for what a functioning Roman environment ought to be."[3]

If we are to find such an ideal anywhere, it would be in the colonial foundations sponsored by the Senate. In this context, it seems to me that a fundamental importance attaches to the

2 P. Zanker, *Der Kaiser baut fürs Volk* (Opladen 1997).
3 F. Brown, *Cosa, the making of a Roman town* (Ann Arbor 1980).

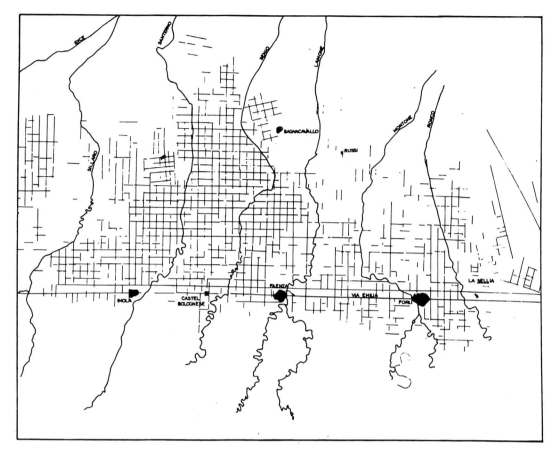

Fig. 2. Centuriation in the territory of Forli (from P. Gros and M. Torelli, *Storia dell'urbanistica. Il mondo romano* [Bari 1988] 146 fig. 55 a, after Chevallier).

citizen colonies as precursors of the 'typical' Roman city of the future, especially the *coloniae maritimae* planted along the coast of Latium starting in the 4th c. B.C.: *Ostia* c.380, *Antium* in 338, *Tarracina* in 329, *Minturnae* in 296, and *Pyrgi* in 264 (fig. 1).[4] As far as we can tell, all of these 4th- and 3rd-c. colonies follow the same basic plan,[5] one that must have been formulated in Rome and approved by the Senate for these small, outlying cities. Given their diminutive proportions (each *colonia* was meant to accommodate a population of 300 Roman citizens), only a rudimentary plan was needed. Apart from a strictly axial-symmetrical grid of streets, such as we find in early Greek cities from the 7th c. on, this plan is marked by three important features that do not conform to those of early Greek foundations:

1. The city not only lies on one of the Roman long-distance roads, but has its principal axis, the *cardo* or the *decumanus* (fig. 2), literally woven into that road like a thread.

2. This main road going through the city leads to, or past, the Capitolium situated at the intersection of *cardo* and *decumanus* (fig. 3).

3. The gathering place of the community lies in front of the Capitolium. In these early colonies, this area did not yet have the character of a fully developed Forum, since Roman citizens could still exercise their political rights only in Rome itself. But it is clear that the orientation of the Capitolium at the central square of the city, which would later become such a common feature and indeed canonical in Italy and the western provinces, is already implicit in this early city plan.

This basic principal of city-planning would be repeated in later foundations, with many variations but always adhering rigorously to the same basic idea. We can still see this especial-

4 H. Drerup, "Zur Plangestalt römischer Fora," in P. Zanker (ed.), *Hellenismus in Mittelitalien* (Göttingen 1976) 398-412.

5 H. von Hesberg, "Zur Plangestaltung der coloniae maritimae," *RömMitt* 92 (1985) 127-68.

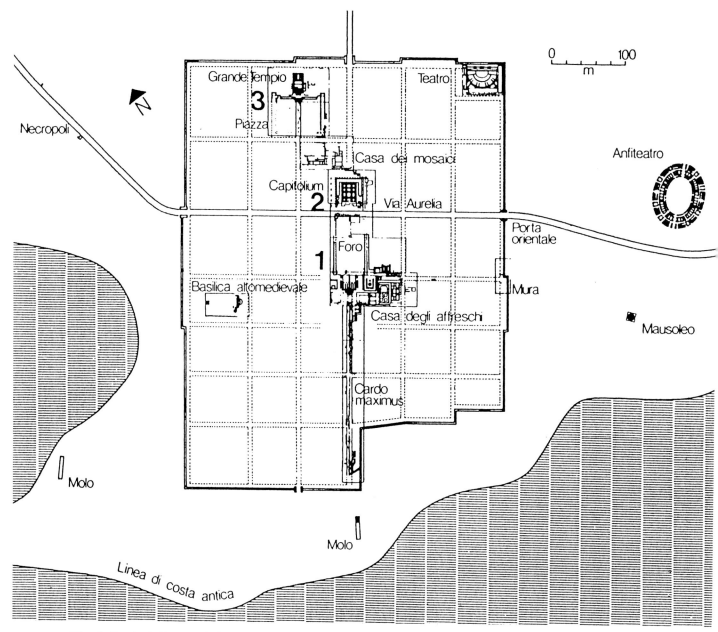

Fig. 3. Luni: 1 Forum; 2 Capitolium; 3. Large temple (from O. Scagliarini-Corlàita in *Die Stadt in Oberitalien* [Mainz 1991] 162 fig. 2).

ly clearly in the Augustan colonies for veterans such as Aosta (fig. 4) and *Saragossa–Caesaraugusta*.[6] The three characteristics outlined above from the beginning reflect not only practical considerations but certain ideologically-tinged notions as well. The long-distance road traversing the city implies a sense of belonging to a large entity. The same is true of the siting of the Capitolium in the center of the community, which clearly defines it, both for the locals themselves and for visitors, as belonging to Rome. In early times in particular, this novel form of city plan, made more evident through repetition, must have taken on the character of a deliberate message. On the one hand, it bespoke Rome's political policy of permanently incor-

6 On the history of the forum see most recently P. Gros, *L'architecture romaine I* (Paris 1996) 207 ff., with earlier bibliography. On the fora of the Augustan period see the scale drawings of M. Pfanner, "Modelle römischer Stadtentwicklung am Beispiel Hispaniens und der westlichen Provinzen," in W. Trillmich and P. Zanker (edd.), *Stadtbild und Ideologie. Die Monumentalisierung hispanischer Städte zwischen Republik und Kaiserzeit* (Munich 1990) 59-116.

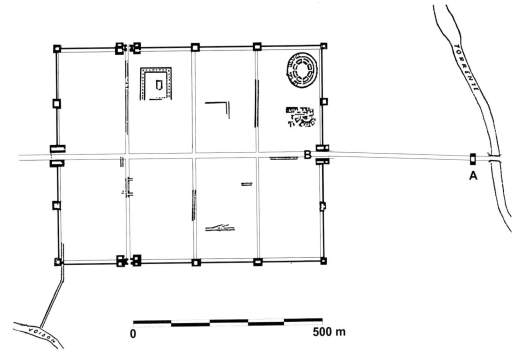

Fig. 4. Aosta, plan. A Arch of Augustus; B City Gate. (after S. De Maria, *Gli archi onorari* [Rome 1988] fig. 11).

porating the site in question, securing road traffic, and making the land a Roman settlement. On the other, from the viewpoint of the settlers it expressed their direct sense of belonging to the *res publica romana*. The dominant setting of the principal temple naturally emphasizes the sense of *pietas* as the highest civic virtue. The orientation of Forum and Capitolium that we find in later cities derived from this concept and was likewise laden with ideological implications, as we shall see. In what follows, I would like to describe more fully each of the three characteristic elements of the typical Roman city plan.

The self-representation of individual and community before the gates

Let us first try to imagine what impact the new roads leading to and from Rome had on individual cities. These great long-distance roads, commissioned first by the Senate, later by the emperor, were distinguished not only by their unprecedented quality in construction: the durability of the pavement, the bridges, dams, and rock-cut passageways. They were first and foremost a symbol of the conquest and organization of newly-won territory. Their strict linearity, stretching to the horizon and seeming to tame the irregularities of the natural landscape with one grand gesture of subjugation, made plain the military character of the new network of roads. Milestones identified these roads over their entire course as "Roman" roads, thus fundamentally different from all earlier ones (fig. 5). Roman roads made visible not only the power emanating from the capital, but also a sense of security. Extending seemingly endlessly into space, toward destinations of which the individual could only dream, such roads demonstrated that the long arm of the state reached out to the borders of the empire. Relay stations, inspections, and — at least in peace time — regular repairs and renovations all embodied the state's concern for permanence and efficiency, while the constant flow of trade bespoke a sense of belonging in cities and provinces.

Milestones at regular intervals not only constantly reminded the traveller of the center of the empire, but also gave an indication of the distances between cities and thus a better idea of the length and extent of the land, its geographical features, and the economic power of individual territories. Since the traveller typically traversed the country from city wall to city wall, his own experience would have encouraged reflection, comparisons, evaluation, and a kind of ranking. At the same time, the process of repeatedly encountering the same elements of city life must have impressed itself deeply upon his consciousness.

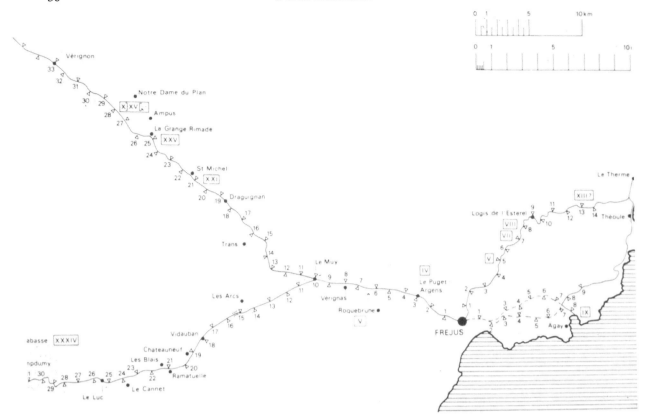

Fig. 5. Milestones on roads around Fréjus (from R. Chevallier, *Les voies romaines* [Paris 1972] 69 fig. 23).

Just before and after the Social Wars, in which the Italian allies fought for legal equality with Rome and a full share of the empire, there arose in the older cities of central Italy and Campania a need to display a more powerful profile. In this situation, the long-distance roads offered both the cities and their leading families and citizens a means of showing themselves off directly at the city gates. The typical cityscape that resulted is different in the Late Republic from that of the Principate. The city of the Late Republic is marked above all by three phenomena: large new public buildings in the cities of central Italy,[7] funerary monuments on the long-distance roads,[8] and villas at the edge of the city, again preferably within sight of the road.[9]

The grand new public buildings, mostly sanctuaries, are usually oriented outward, to the road or the plain. Their architecture is designed to have its maximum effect when viewed from a distance, to impress the passer-by. Such projects, which first appear in the later 2nd c., represent communal projects of an entire city, as is made clear, for example, in the inscriptions from the Sanctuary of Fortuna at Praeneste.[10] These projects depended first on the wealth that flowed into the coffers of the city's leading families, the *domi nobiles*, from the long-distance trade made possible by the Roman conquest. They also emerged as a result of these families' need to rival other cities in projecting the importance of their own city, now that they were increasingly involved in politics at Rome after the Social Wars.

While these terraced, urban sanctuaries represent a systematic means of self-promotion by the city as a whole, the tomb monuments along the main roads and before the city gate reflect

7 F. Coarelli, *I santuari del Lazio in età repubblicana* (Rome 1987); P. Gros, *Architettura e società nell'Italia romana* (Rome 1987); Zanker (supra n.1) 68 ff.

8 H. von Hesberg and P. Zanker (edd.), *Römische Gräberstrassen* (Munich 1987); H. von Hesberg, *Römische Grabbauten* (Darmstadt 1992) 19 ff.

9 H. Drerup, "Die römische Villa," *Marburger Winckelmannsprogramm* 1959, 1-24; V. Kockel and B. F. Weber, "Die Villa delle colonne a mosaico in Pompeji," *RömMitt* 90 (1983) 51-84; Zanker (supra n.1) 80 f.

10 Coarelli (supra n.7) 63.

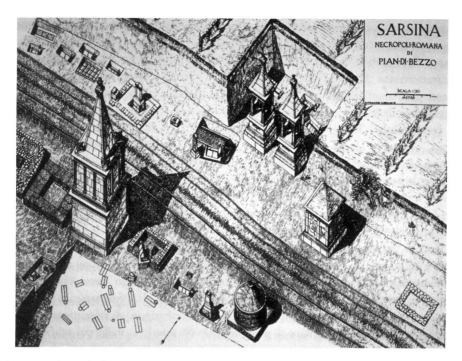

Fig. 6. Sarsina: a tomb road (from Ortalli in H. v. Hesberg and P. Zanker [edd.], *Römische Gräberstrassen* [Munich 1987] 161).

rather a series of separate and autonomous decisions (fig. 6). Each individual project was, of course, shaped by the particular social and economic constraints to which the patron was subject. But they may also be seen collectively as constituting a crucial element of the urban landscape. The location, size, and form of each grave monument expressed the status and achievements of each individual family or family member, from all strata of society. The façade of the monument, with its portraits, pictures, and inscriptions, was directed at an audience of passers-by on the street. The enormous and subtle variety of architectural forms, dimensions, and details all correspond to the highly competitive social situation of the late Republic. As a whole, these monuments would have conveyed to locals and visitors alike a rather vivid picture of the town's citizenry, of its leading families and their numbers, prosperity, status, and social dynamism, as well as of the more or less successful middle class. This outwardly-directed form of self-presentation overshadows all known earlier examples of public funerary display in the Greek world, whether in Classical Athens or the cities of Hellenistic Asia Minor.[11]

Much the same is true of the villas built on the edges of the city, before or above the walls, except that here, of course, only the wealthy took part in the competition. Unfortunately, the archaeological evidence is quite limited. The cityscape depicted on the well-known relief from Lake Fucino near *Alba Fucens* gives a fine impression of such an urban vista before the walls, with the viewer looking from the lake toward the town.[12] In Pompeii we find both the villa-like houses built on the slope over the city walls by Sulla's veterans after his conquest of the city and a dense row of villas in front of the Herculaneum Gate (fig. 7).[13] The close relationship to the road continued to play an important rôle in Imperial times, as for example in the huge Villa of the Quintilii, which opens onto the Via Appia with a *nymphaeum* while the residential quarters and baths, raised on tall substructures, are oriented toward the Via Latina.[14]

11 Hesberg and Zanker (supra n.8); Hesberg (supra n.8) 19-25.
12 *Antike Denkmäler* III, pl. 31 (P. Nachod); cf. F. Coarelli in id. and A. La Regina, *Abruzzo-Molise* (Guide Archeologiche Laterza, Rome 1984) 58.
13 See the general plan in V. Kockel, *Die Grabbauten vor dem Herkulaner Tor in Pompeji* (Mainz 1983); cf. also Kockel and Weber (supra n.9) 51-89.
14 F. Coarelli, *Dintorni di Roma* (Guide Archeologiche Laterza, Rome 1981) 55-59; U. Schädler, "Antiken für das neue Museum. Ausgrabungen Pius' VI in der Villa der Quintilier," *AntW* 1992, 201-17.

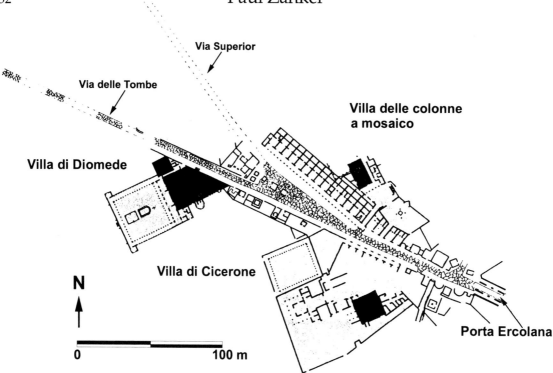

Fig. 7. Pompeii: road outside the Herculaneum Gate (after Kockel-Weber, *RömMitt* 90 [1983] p. 54 fig. 1).

But the area before the city gates did undergo at least a partial change under the Empire. Lavish display of expensive tomb monuments lost its appeal. Instead, standard forms for each class were created. Most tombs and grave precincts were closed off from the street, and greater attention was lavished on the interior.[15] Likewise, the large terraced sanctuary as a vehicle of urban display came to an end. In its place we find buildings in honor of the imperial family or for the use of the citizenry, always inside the city. In their own patronage, the *domi nobiles* model themselves on that of Augustus and his successors at Rome. Outside the city, the new spirit is expressed in city gates and arches in honor of the emperor. Set often hundreds of meters from the city walls, these arches announce the inhabitants' loyalty and gratitude toward the emperor. Among the most impressive examples are those still preserved in Aosta (fig. 4) and Orange.[16]

In the early Principate the walls themselves take on a symbolic meaning above and beyond their practical function. In the small town of *Saepinum*, for example, the imperial family donated an extensive city wall, including gates decorated with captured barbarians, all at a time of Augustan peace when such a town did not really need a defensive wall (fig. 8).[17] And the city of Turin provides a good example of impressive towers built solely for effect, out of all proportion to the defensive strength of the gate complex.[18] The newly-discovered fresco from the substructure of the Baths of Trajan shows an as-yet-unidentified city with the clearly symbolic use of powerful walls as a metonymic representation of the city itself.[19]

für das neue Museum. Ausgrabungen Pius' VI in der Villa der Quintilier," *AntW* 1992, 201-17.

15 Hesberg (supra n.8) 37 ff.

16 Gros (supra n.6) 26-94, with bibliography; S. De Maria, *Gli archi onorari di Roma e d'Italia romana* (Rome 1988); H. von Hesberg, "Bogenmonumente und Stadttore in claudischer Zeit," in V. M. Strocka (ed.), *Die Regierungszeit des Kaisers Claudius* (Mainz 1994) 245-60.

17 For *Saepinum* see P. Gros and M. Torelli, *Storia dell'urbanistica. Il mondo romano* (Bari 1988) 155; Coarelli and La Regina (supra n.12) 210.

18 P. Gros, "*Moenia*. Aspects défensifs et aspects représentatifs des fortifications," in S. van de Maele and J. M. Fosse (edd.), *Fortificationes antiquae* (Amsterdam 1992) 211-25.

19 See E. La Rocca in this volume.

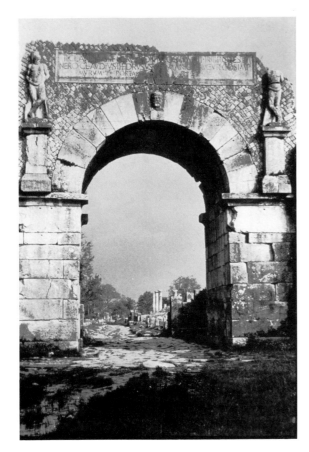

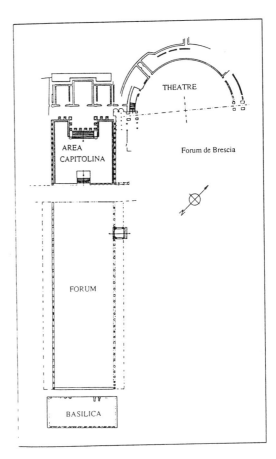

Fig. 8. Saepinum, the Boianum gate (Neg. DAI Rome 78.1471).

Fig. 9. Brescia, Capitolium and Forum, 1: 2500 (from P. Gros, *L'architecture romaine* I [Paris 1996] fig. 253).

The *centro monumentale*: forum and sanctuary united

I come now to the second feature of the early *coloniae*, the central location of the principal sanctuary (often the Capitolium), oriented from the beginning toward the city's major place of assembly, later the Forum. This meant that the Forum became a kind of forecourt of the temple, and the actual forecourt of the temple a kind of Forum. The subordination of the open square to the temple was gradually expressed first by placing the temple on a high podium, sometimes also by the addition of an elevated temple forecourt, as at Ostia, Brescia (figs. 9-10), *Baelo*, *Conimbriga*, and *Lugdunum*.[20] This new definition of public space, as mentioned earlier, emphasized the central importance of Roman *pietas* in the Roman value system, in an enclosed monumental entity which, even in Rome, was true of only a few temple complexes.

This close linking, or rather intertwining, of sacred and political space is undoubtedly a specifically Roman concept, expressing an ideological notion of central importance. We need only recall that the Curia was inaugurated as a *templum* (Varro, *apud* Gell. 14.7.7) and that the Senate used to meet in a variety of temples. The close association of Forum and Capitolium thus also conveys some notion of how in a Roman city the political decision-making process was conducted. We can best appreciate this by way of contrast. T. Hölscher has recently demonstrated that many Greek cities of the Archaic and Classical periods took pains to define the Agora as a political space kept separate from the city's main sanctuaries.[21] Hölscher is persuasive in linking the needs and considerations underlying this state of affairs with the issue of the rise

20 See the examples collected in Gros (supra n.6) 210 ff.; Gros and Torelli (supra n.17) 209 ff., with references; J. Ch. Balty, *Curia ordinis. Recherches d'architecture et d'urbanisme antiques sur les curies provinciales du monde romain* (Brussels 1991).

21 T. Hölscher, *Öffentliche Räume in frühen griechischen Städten* (Heidelberg 1998).

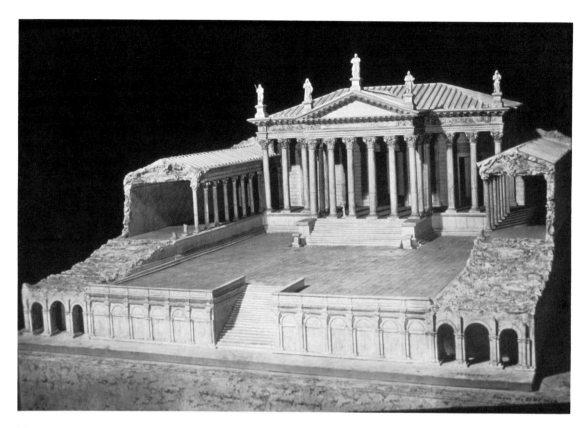

Fig. 10. Brescia, Capitolium, reconstruction in the Museo della Civiltà romana (Alinari 47251).

of the *polis*. The Agora provides an open space in which political conflict is resolved. Here a citizenry responsible only to itself makes its own decisions; here, in early times, the citizens match strength in athletic contests. Significantly, the small altars and sanctuaries found in the Agora belong chiefly to such divinities as Zeus Agoraios or to heroes directly involved in the city's civic and political institutions. Well into the Hellenistic period, the Greek Agora remained a large open space, only vaguely defined architecturally. Meanwhile, the principal sanctuaries of the gods, clearly separated from the Agora, as at the Akropolis at Athens or the Heraion at Argos, with their own festivals and rituals, had an entirely different function. Here in the sanctuaries, irrespective of political rôles and privilege, the entire society came together, including women, children, slaves, and foreigners alongside male citizens. And here the laws laid down in the Agora were deposited. In Hölscher's interpretation, the *polis* in its infancy brought about this separation of the two great public spaces. On the one hand, this separation served to provide a place for political consensus freed from religious traditions and hierarchies; on the other, it created a sacred space for the gods as guarantors of the safety of this vulnerable new civic form, the *polis*.

In Rome the situation was very different. Here the state was hierarchically structured; both political offices and priesthoods were in the hands of the same aristocratic families, and political decision-making was closely tied to religious tradition and ritual. The ruling senatorial aristocracy would never have considered a civic space open to all, in which a *polis*-like structure, much less a democratic government, might develop. In Rome itself, the separation of the open square in the valley from the chief sanctuary on one of the seven hills preserved an archaic urban model similar to that of Greek and other early Italic cities. But in the Forum Romanum, temples to Saturn (501-498) and the Dioscuri (499-484) were set up immediately after the expulsion of the kings. The result was that the space was visually dominated by temples, much more so than in any Greek agora. The same is true of the entire city, whose appearance from the beginning was dominated to an extraordinary extent by the temples and sanctuaries. This phenomenon was only intensified over the centuries, well into the Principate. We need only think of the Campus Martius under the late Republic, the later buildings for the deified emperors, and the vast scale of the great temples of the 2nd and 3rd c. A.D.

Since the fully developed city of Rome could not be imitated elsewhere in its uniquely complex structure, another way had to be found for the colonial cities to express the subordination of their political life to the gods (and to Rome). The formula can be found already, *in nuce*, in the small civilian colonies of the 4th c. B.C. The combination of the Capitolium and a central gathering place in the middle of the city embodied the Roman self-image more perfectly than was the case even in Rome itself. The larger and more ambitious *coloniae latinae*, set in hilly terrain as at Cosa and Alba Fucens, instead retained the traditional separation with the main sanctuary on a hill and forum in the valley, and so do not at first glance look typically 'Roman'. It is hard to say whether this reflects a prescription from Rome, as was presumably the case with the Comitium (see further below). There is in any event, as H. Drerup already recognized, a clear distinction in this respect between the roughly contemporary citizen colonies and the Latin colonies.[22] I will not deny that in Cosa the view from the Forum to the Capitolium could have called to mind for the local inhabitants the topographical situation in Rome, and that this was perhaps even in the mind of the founders when they laid out the Capitolium, especially since it was linked to the Forum by a kind of *via sacra*. But we still cannot describe this topographical constellation as a specifically 'Roman' urban plan, since many ancient cities had an acropolis of this sort.

At the same time, most Roman cities in northern Italy, as well as in the western and northern provinces, are immediately recognizable as 'Roman' thanks to the distinctive Capitolium-Forum complex in the city center. In certain instances, such as the Roman Forum at *Ampurias*, the contrast with the older Greek city makes the point quite explicitly.[23] We cannot know whether the contemporary viewer would have perceived this specifically Roman configuration of a city as a mark of distinction. But I take it as self-evident that the new Roman colonies in the provinces were dramatically different in appearance from the venerable cities of the native inhabitants, and that this difference conferred on the new foundations a special status. The subsequent elaboration of the new politico-religious urban center in later centuries falls outside the limits of this study. The Capitolium-Forum complex will develop into many particular types and individual variants, from the renovation and expansion of older fora, as at Pompeii, to the construction of the big Augustan *coloniae* and other, still later, new foundations in the western provinces. In both East and West, the square was gradually closed off from the network of streets, while certain original functions of the forum, as a market and as the setting for public games (for example, the gladiatorial contests that had been held in the Forum Romanum), were transferred elsewhere. The result was that the forum became increasingly a place where the state and its officials could display their power and the citizens their rank and status. The remaining open space was gradually filled with statuary and other honorific monuments.

Apart from the forum itself, in the larger Roman cities there were, of course, other public squares, likewise dominated by temples and ringed by porticoes. There is not the space here to discuss how these squares were at first subordinate to the Capitolium-Forum complex but in some instances later came to rival it. In some North African cities, such as *Cuicul* and *Lepcis Magna*, the new main square, with its temple to the imperial cult, presented itself as clearly the dominant square, an unequivocal symbol of the importance of the worship and veneration of the imperial family. The same might be said of the relationship between 'city forum' and 'provincial forum' in Tarragona and Mérida. Here too the changing political situation in the provinces during the Principate is clearly inscribed in the urban image.[24]

22 Drerup (supra n.9).
23 J. Ruiz de Arbulo Bayona, "Los inicios de la romanización en Occidente: Los casos de Emporion y Tarraco," *Athenaeum* 69 (1991) 459-93. There is a good general plan in W. Trillmich *et al.*, *Hispania romana*. *Denkmäler der Römerzeit* (Mainz 1993) 73, fig. 28.
24 On the cities of North Africa see Gros and Torelli (supra n.17) 297, 334. On the principal cities of the Hispanic provinces see Trillmich and Zanker (supra n.6) 85 ff., 264. See also Gros and Torelli (supra

Curia and basilica

The appearance of a forum was defined most decisively by the porticoes that marked its boundaries and the buildings that later usually sprang up behind them. In the Latin colonies of the 4th and 3rd c., judging by the evidence excavated at Cosa, Paestum and Alba Fucens, a key element was a Comitium in the form of a circular *cavea*. It was situated in front of and below the Curia, connected with the consecrated part of the Forum. These two structures, evidently so important for the political life of the colonies with Latin rights, were modelled on the Comitium and Curia in the Roman Forum and were presumably prescribed by the Senate at the founding of the colony.[25] Nevertheless, as crucial as these buildings may have been for the political routine and sense of community of the early settlers, they seem rapidly to have lost their significance as autonomous structures, and in the long run play no major rôle in the overall shape of the city. In the case of the Comitium, this is no surprise, considering that the popular assembly had lost its significance by the late Republic. (In Paestum, interestingly, the *cavea* was already partially built over in the 2nd c. B.C.) The picture is somewhat different with the Curia. It retained a certain importance as a gathering place for the *ordines*, and served as an archive for other purposes. But it never attained a dominant place in the public square. Rather, under the Principate we usually find the Curia occupying an annexe behind the porticoes or integrated into the basilicas.[26]

In the case of both the earlier citizen colonies and the Augustan colonies for veterans, the basic plan, as suggested above, was one that originated in Rome. We can thus speak of a process of 'Romanization from above'. However, in the next stage of development (the gradual addition of public buildings, discussed below), the Romanization of each city reflected its individual needs. No doubt citizens outside Rome did look to Rome, but what they drew was more the impetus to erect certain types of buildings rather than specific architectural models. This is especially clear in the case of the basilica. By the 2nd c. B.C., the basilicas set up by aristocratic families in the Forum Romanum were among the most conspicuous and heavily frequented structures in the area. The little city of Cosa built its own basilica just a generation after the earliest ones were built in Rome, thereby 'updating' its forum, as many other Italic cities would do in later times. Thus, by the 2nd c. B.C. the basilica was becoming one of the most characteristically Roman features of any city. It would be worth considering why the cities of the Greek East did not borrow this highly practical building type for their own agoras, or why when they did build a basilica, as at Corinth, it was not in a particularly prominent position nor of much importance in the overall city plan.[27]

The multi-functional basilica was a perfect embodiment of the practical and ideological needs of Roman society. It could be easily subdivided into different compartments and, through the use of an *exedra* or a tribunal, could be articulated hierarchically as well. The important rôle of the basilica is usually reflected in its position in the public square. Often it forms a counterpart to the temple in both size and setting (fig. 11). Under the Principate, the forum functioned less as a general meeting place for Roman society than as the place where one witnessed religious and political ceremonies and rituals, and where business and legal matters were transacted. The latter in fact took place specifically in the basilica, which thus embodied the city's political and juridical identity. To put it another way, the need for a basilica expressed the Roman character of a city. Later on, the embellishment of basilicas with statues and altars contributed significantly to the veneration of the imperial family. The basilica evolved into a counterpart to the Capitolium or the temple for the ruler cult in the monumental city center. This pairing projected an important message. The two poles of urban autonomy and absolute fealty and subservience to Rome and her gods found readily accessible visual expres-

 n.17) 280 f.
25 F. Coarelli, *Il Foro Romano II* (Rome 1985) 22 ff.
26 Balty (supra n.20); A. Nünnerich-Asmus, *Basilika und Portikus* (Cologne 1994).
27 Gros and Torelli (supra n.17) 391.

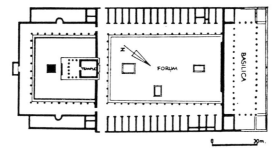

Fig. 11. *Lugdunum* (Lyon): forum, capitolium and basilica (from H. v. Hesberg in *Die Stadt in Ober-italien* [Mainz 1991] 196 fig. 20).

sion in the clear juxtaposition of the Capitolium and the multi-purpose civic building. When the latter housed a tribunal or an *exedra* with statues of members of the imperial household, even on a direct axis extending from the Forum and the temple, the ideological framework was vividly clear to all.

Monumental buildings for leisure and amusement: a new system of public spaces

The fixed structure of the Roman city, conceived as such, is a product of the political and cultural life of the middle Republic. Nevertheless, this remained the standard for later city foundations. That is, the notion of the urban center as a political symbol was not fundamentally revised or altered despite the changed circumstances of the Principate. Nonetheless, starting in Augustus' time, the city's appearance was partly reshaped by monumental structures that were not foreseen in the original structure and therefore had to be integrated into it in various ways. I have in mind primarily the theatres, amphitheatres and bathing establishments, all buildings for leisure pastimes. For the bigger cities we may also add large new temples. The incorporation of these monumental structures into the rigid grid plan proved to be difficult and, on occasion, as in Verona, the decision was made to move these buildings outside the city center entirely. But whether they stood inside or outside the city walls, these monumental buildings permanently changed the face of the city.

The very height and dimensions of the theatres, amphitheatres (fig. 12) and baths exceeded those of any other buildings, and their visual dominance reflected the tremendous rôle they played in the lives of all city-dwellers. Their outward appearance and vast feats of engineering were a vivid expression of the much-touted values of urban life under the Roman empire. Accordingly, these buildings also possessed an explicitly Roman character in terms of their social and cultural background, even if their specific architectural models were not found in Rome at all. Quite different from the case of the basilica, Rome could not have offered any model for a stone theatre or amphitheatre, or a lavish bathing establishment, for, as is well known, senatorial policy attempted for years to prevent the construction of such buildings.[28] By the time Pompey finally defied the Senate's prohibition, the cities of South and Central Italy had long had quite substantial theatres of their own. The same seems to be true for the public baths: here it was Agrippa who first broke the taboo.

The reason why the Theatre of Pompey, and later that of Marcellus built by Augustus, did in fact become models for the cities in the western half of the empire, has primarily to do with the fact that their auditoria, the *caveae*, rested entirely on substructures. This new style had the enormous advantage that the theatre could be built on any kind of terrain, even one that was completely flat. But even this feature is not the only, or perhaps not even the primary, reason for the dazzling success that theatres and amphitheatres based on vaulted construction enjoyed during the Principate. The use of vaults permitted a perfect distribution of theatre-goers into designated rows, so that each one could be led straight to his assigned seat. In the larger theatres and amphitheatres, great care was taken that various groups of visitors could

28 Cf. the relevant bibliography in Gros (supra n.6), in particular G. L. Grassigli, "Sintassi spaziale nei fori della Cisalpina. Il ruolo della *curia* e della *basilica*," *Ocnus* 2 (1994) 79-96.

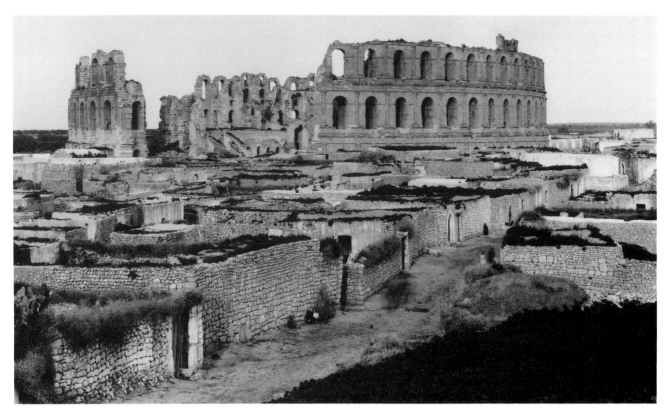

Fig. 12. El Djem, amphitheatre towering over the town (Fototeca Unione neg. 2471).

not mingle at all. Since the audiences in imperial theatres and arenas were required to sit according to social rank and status, the system was extremely useful in guiding them to the proper seat. We may even surmise that the *cavea* resting on a substructure was invented with this kind of socio-political engineering in mind, or at least that it was continually refined to keep up with the requirements of the seating order. Thus both the external appearance of the theatre and its interior were, in a specifically societal sense, 'Roman'.

The rise of the arena as a site of social and political significance also reflects an elemental need in Roman society. Recent scholarship has rightly emphasized the rôle of the amphi-theatre in socializing the Romans of the late Republic and the Principate into the new world of empire and monarchy. Amphitheatres were places where the entire population of a city, including slaves, women and foreigners, came together and, as in the theatre, each received his or her assigned place, a microcosm of the society at large and its social dynamic. While being entertained, people were unconsciously turned into admirers of everything embodied by the word *virtus*: courage, initiative, fearlessness in the face of death, and more. At the same time, by its very presence in such huge numbers and in its united cries at the slaughter of enemies of the state, the audience participated in the 'restoration of order'.[29] The Colosseum may have been the epitome of the arena in terms of its structure and plan, but a number of Roman cities in Italy, southern France and Spain enjoyed stone amphitheatres long before Rome. Although the gradual refinement of the architectural form took place primarily outside the city of Rome, in a socio-political sense there is no building more 'Roman' than the arena.[30]

29 See the papers collected by W. J. Slater (ed.), *Roman theater and society* (Ann Arbor 1996), with bibliography, and most recently P. Zanker, "Die Barbaren, der Kaiser und die Arena," in R. P. Sieferle and H. Breuninger, *Kulturen der Gewalt. Ritualisierung und Symbolisierung von Gewalt in der Geschichte* (Frankfurt 1998) 53-86, with references.

30 K. Welch, "The Roman arena in late-Republican Italy: a new interpretation," *JRA* 7 (1994) 59-80, ar-gues that the characteristic oval form of the arena gradually evolved from the ephemeral wooden structures set up from time to time in the Forum Romanum, which thus became models for the earliest amphitheatres.

We should consider in this same context the bathing establishments and their social significance as centers of leisure enjoyments. Like the theatre and amphitheatre, the baths occupied large stretches of the imperial city and shaped the city's image in the same way as churches did in a mediaeval city. Cities with wealthy patrons often included several public bathing complexes distributed throughout the residential districts. Good examples survive even in the relatively modest cities of Ostia and Timgad. This is not the place for a detailed study of the social significance of these structures or the symbolic meaning of their form.[31] For city-dwellers, these sponsored building complexes no doubt contributed decisively to the quality of urban life. The very existence of these buildings and the enjoyments they offered were the emperors' and patrons' guarantee of a new standard of living. I hardly need mention that these big pleasure palaces of the citizenry were only the most conspicuous donations. Porticoes, fountains, aqueducts, sewers, paved walkways, and other features were all equally essential for daily life and may have contributed in equal measure to defining the urban landscape for residents and visitors alike.

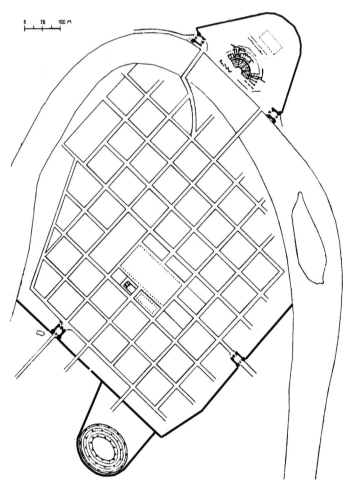

0 30 100 M

Fig. 13. Verona, plan (after F. Zorzi, F. Sartori, L. Beschi, *Verona e il suo territorio* [Verona 1960] fig. 27).

From an urban-planning point of view, it is interesting to note that these large public structures, in contrast to the forum, had no fixed, allotted space within the highly regimented city plan, nor in most cases a specific spatial relationship to the old political and religious center of the city. Instead, the city, or the private patron, determined a location in accordance with local requirements or built wherever there was an available site. Theatre and amphitheatre might be adjacent or far apart, near the forum (figs. 9-10) or, more often, at the edge of a walled city (fig. 13). Baths were usually located in the more thickly populated urban neighborhoods. Amphitheatres were often built near a main thoroughfare outside the city walls, both for reasons of security and to accommodate the many visitors coming from neighboring towns. The important issue was whether a city possessed such entertainment facilities intended to enhance the quality of life, how many facilities it offered, and of what size. Thus cities measured themselves against one another.

The phenomenon of the random placement of such monumental structures within the framework of the city is of course a reflection of the fact that such buildings did not yet exist at the time that the basic city plan was developed in Rome for the early colonies, and that the theatre, in particular, was considered unnecessary. It is striking, however, that the Augustan colonies did include both theatre and amphitheatre from an early date, some-

31 See P. Zanker, "Veränderungen im öffentlichen Raum der italischen Städte der Kaiserzeit," in *L'Italie d'Auguste à Dioclétien* (CollEFR 198, 1994) 259-85; Zanker (supra n.2).

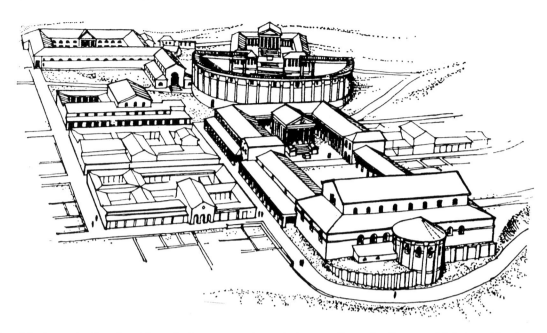

Fig. 14. Augusta Raurica (Augst): forum temple and theater (from P. Gros and M. Torelli, *Storia dell'urbanistica. Il mondo romano* [Bari 1988] p. 323 fig. 175).

times from the founding of the city, as at Mérida, even though they did not have a fixed location. Ideological reasons should probably be excluded, since in the veterans' colony at Mérida, for example, these were in fact donations of Agrippa.

In any event, the construction of these large entertainment complexes created new centers of public life beyond the forum, which they soon overshadowed in terms of vitality and importance. They constitute not only self-contained public spaces with their own routines, but a whole constellation of activities throughout the year which created for the ordinary citizen a world parallel to that of the old Republican cityscape (fig. 14). In this loose association of the two systems we might detect once again a symbolic form linking two ideals: the old politico-religious ordering of public space and the new centers of public munificence that enhanced life in the cities of the Roman empire.

Conclusion

To summarize this brief survey, the typically Roman city plan essentially arose by the second half of the 4th c. B.C. as a state-sponsored notion. While the prescribed plan of the early citizen colonies was later enlarged, embellished and refined, the monumental structures so characteristic of Roman cities under the Principate could never be truly integrated into the rigorously severe template of the early city plan. Rather, these new buildings created their own space, dominated whole quarters with their monumental dimensions, and gave rise to their own buffer zones, with the most varied forms of access to the old network of roads. Each of these buildings was stamped as 'Roman' in terms of ideology and function. That is, they defined public spaces that corresponded to the specific social and political requirements of late Republican and then early Imperial Roman society. New buildings were added as individual donations, and neither their architectural form nor their siting within the city was usually derived from a model in the city of Rome. Aside from the monumental city center, Roman cities of the Principate seem to have been unconcerned with achieving the visual effect so impressive to the modern eye, in which all the individual spaces come together in a carefully interrelated network of roadways and public squares. They were more concerned simply to possess all the necessary public buildings, and that they be built and outfitted in a worthy fashion.[32] In about

32 H. von Hesberg, "Vitruv und die Stadtplanung in spätrepublikanischer und augusteischer Zeit," in H. Geertman and J. J. de Jong (edd.), *Munus non ingratus* (BABesch Suppl. 2, 1989) 134-39.

the middle of the 2nd c. A.D., Aulus Gellius speaks of the privileged status enjoyed by the *coloniae*, as opposed to the *municipia* (*NA* 16.13). He calls the *coloniae* "*quasi effigies parvae et simulacra*", 'small copies and likenesses' — *not*, as we might expect, of the *urbs*, but rather of the greatness (*amplitudo*) and majesty (*maiestas*) of the Roman people. In this famous passage, Gellius is apparently not interested in the concrete physical appearance of these cities, but rather their aesthetic effect and the quality of life that they offered their people. This he expresses in terms of the *maiestas populi Romani.* The cityscape with its monumental buildings makes this concept visible.

The same idea is apparent in the relatively few representations of Roman cities in art. Whether it be on the Column of Trajan, the Avezzano relief (see fig. 10 on p. 64) the glass flasks from Pozzuoli,[33] or the fresco recently discovered under the Baths of Trajan, views of the city always set the most characteristic and large structures proudly next to one another. Only very seldom do we find an attempt to depict a comprehensive city plan, with streets, houses, and large public buildings woven together into a coherent spatial organization. It is the large-scale buildings, which speak of prosperity and a certain way of life, that are the hallmarks of the Roman Imperial city. The old religious and political city center apparently no longer played a very significant rôle. By the time we reach the late-antique and Mediaeval depictions of cities in illustrated books, it is the large defensive walls around the city that constitute its most prevalent feature.[34]

DAI, Via Sardegna 79, 00187 Rome

33 S. Settis *et al.*, *La colonna Traiana* (Turin 1988) pls. 41, 139, 153, 181; on the glass vessels see S. E. Ostrow, "The topography of Puteoli and Baiae on the eight glass flasks," in *Puteoli. Studi di Storia Antica* (Pozzuoli 1974) 77-140; K. S. Painter, "Roman flasks with scenes of Baiae and Puteoli," *JGS* 17 (1975) 54-67.

34 G. Cavallo, "Il segno delle mura. L'iconografia della città nel libro antico," in *Storia di Roma* IV (Turin 1989) 267.

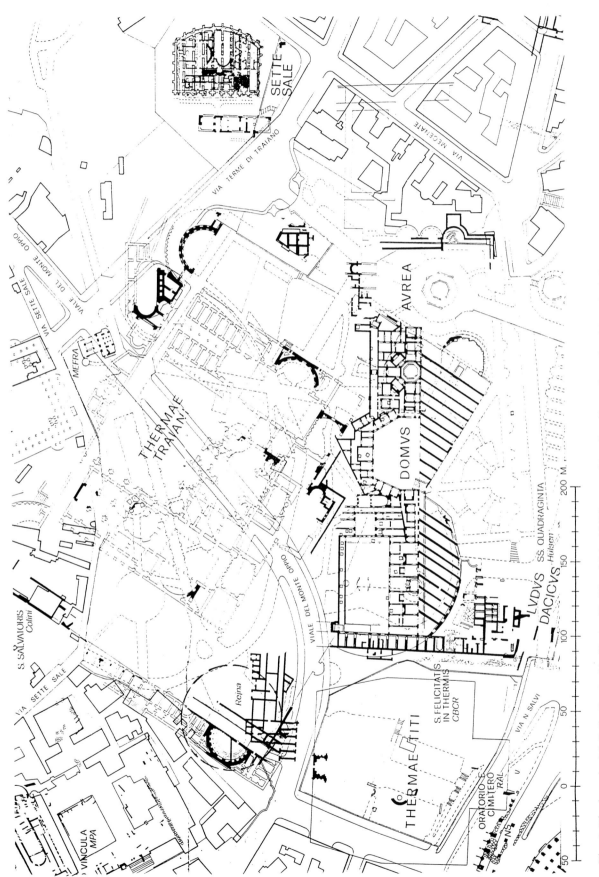

Fig. 1. Planimetria del Colle Oppio (da Cozza–De Fine Licht 1985) con evidenziata l'angolo sudoccidentale delle Terme di Traiano.

Preesistenze e persistenze
delle Terme di Traiano
Giovanni Caruso e Rita Volpe

Questo intervento e quello che segue si occuperanno di una città che pur essendo soltanto dipinta è divenuta in breve tempo una delle più viste e studiate in tutto il mondo;[1] nell'ambito dello studio relativo alla scoperta dell'affresco con raffigurazione di città, avvenuta nelle Terme di Traiano sul Colle Oppio (fig. 1), questa prima comunicazione si vuole occupare della città reale che contiene la "città dipinta", cioè di quella porzione di Roma all'interno della quale si collocava l'edificio su cui era l'affresco, partendo dai dati finora desumibili dagli scavi archeologici che sono ancora in corso, e confrontandoli, anche se ancora a livello di studi preliminari, con ciò che sappiamo della topografia di quest'area.

Sul Colle Oppio, nell'angolo sudoccidentale del recinto esterno delle Terme di Traiano, è ben conservata in alzato una delle esedre (fig. 2), che mostra al suo interno due ordini di nicchie, e viene quindi tradizionalmente identificata con una biblioteca. Sotto di essa, con accesso da viale del Monte Oppio, corre un lungo corridoio sotterraneo, detto forse impropriamente "criptoportico", che segue il lato occidentale del recinto termale (fig. 3); si tratta di una galleria larga oltre 8 metri, le cui pareti in laterizio sono coperte da una volta a sesto molto ribassato; il criptoportico era stato in anni passati usato come deposito dal Servizio Giardini, che si occupa della manutenzione del Parco, e per il suo recupero era stato quindi eseguito un primo intervento tra il 1990 e il 1991.[2]

Lo scavo all'interno del criptoportico[3] (fig. 4) aveva portato all'identificazione di un selciato e di una serie di strutture attribuibili alla Polveriera costruita sul Colle Oppio agli inizi del XIX sec., durante l'occupazione napoleonica di Roma, nell'area intorno all'esedra delle Terme di Traiano, e nei suoi sotterranei, zona dove ancora oggi resta il toponimo di via della Polveriera[4] (fig. 5). Nello scavo si era quindi potuta riconoscere la struttura della Salnitrara, cioè il complesso destinato alla produzione del salnitro, elemento indispensabile della polvere da sparo: si tratta di una serie di piccoli ambienti sotterranei, disposti ai lati di uno stretto corridoio e voltati a botte, all'interno dei quali la permanenza per lunghi periodi di terriccio, detriti, cenere, e residui organici consentiva la formazione dei componenti del salnitro, che venivano periodicamente raccolti e adoperati per la fabbricazione della polvere da sparo (fig. 4).

I lavori all'interno del criptoportico sono stati quindi ripresi nell'ottobre 1997, con l'intento di recuperare l'ambiente e verificare le condizioni della volta, che presentava infiltrazioni

1 Pur consapevoli dell'importanza della scoperta archeologica, avvenuta il 27 febbraio 1998, siamo forse un po' sorpresi dalla velocità con cui questa si è trasformata in "evento", amplificato dai massmedia a livello ormai di "villaggio globale", con il conseguente coinvolgimento emotivo di moltissime persone, che ha portato, per esempio, oltre 1800 persone a visitare l'affresco nella sola giornata del 21 aprile, quando è stata programmata un'apertura straordinaria al pubblico in occasione del Natale di Roma.
2 L'intervento rientrava nell'ambito delle varie iniziative compiute negli anni dalla Sovraintendenza Comunale, cominciando già dall'opera di L. Cozza e G. Sartorio, per la salvaguardia e la riqualificazione del Colle Oppio, centralissima zona verde, oltre che archeologicamente significativa, ma nella quale si sono andati sempre più accentuando gli elementi di degrado (cfr. L. Cozza e K. De Fine Licht, "Colle Oppio," in *Roma. Archeologia nel centro II* [Roma 1985] 467-77).
3 Per i risultati di questa indagine cfr. G. Caruso e R. Volpe, "Terme di Traiano. Scavi nel criptoportico nordoccidentale," *ArchLaz* 12 (1994) 181-84.
4 La complessa serie di edifici che componevano la Polveriera è oggi ricostruibile solo mediante una dettagliata descrizione del 1820 e attraverso vedute e foto precedenti la demolizione definitiva, avvenuta negli anni 1930 per la creazione del "Parco di Traiano" sul Colle Oppio, pubblicate soprattutto in A. Muñoz, *Il parco di Traiano* (Roma 1936).

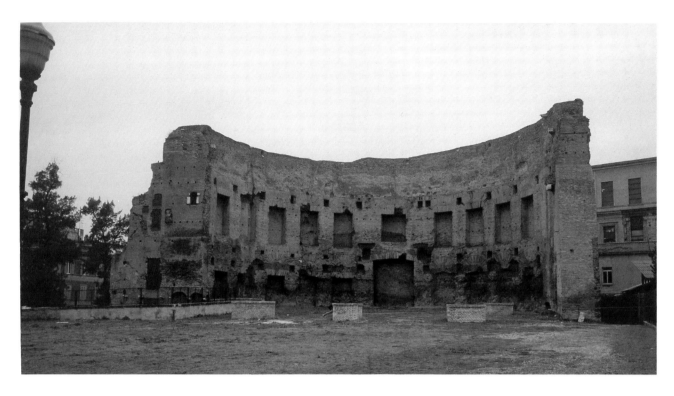

Fig. 2. Veduta dell'esedra sudoccidentale del recinto esterno delle Terme di Traiano.

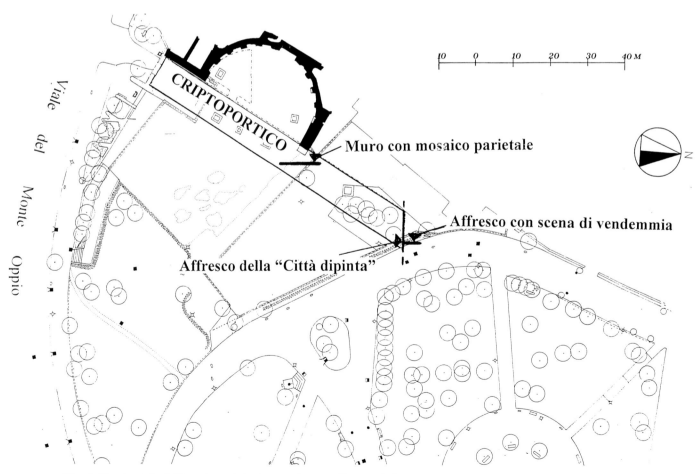

Fig. 3. Planimetria dell'esedra e del criptoportico con il muro dell'affresco (ril. D. Silenzi).

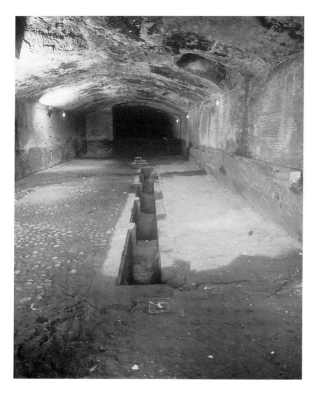

Fig. 4. Veduta dell'interno del criptoportico con l'accesso agli ambienti della Salnitrara.

Fig. 5. Raffigurazione dell'esedra delle Terme e delle strutture circostanti in un dipinto di J. H. W. Tischbein della fine del Settecento.

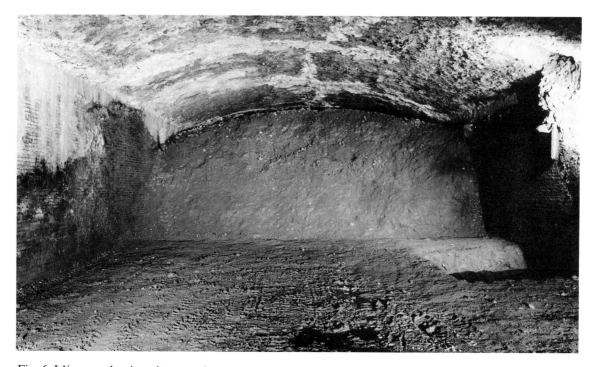

Fig. 6. L'interro che riempiva completamente la parte finale del criptoportico.

d'acqua.[5] Lo scavo, che nel precedente intervento era stato interrotto a circa 30 m dall'ingresso, è stato quindi proseguito nella parte più interna della galleria, dove ha permesso di verificare la situazione stratigrafica, evidenziando, sotto i reinterri più moderni, il piano di calpestio contemporaneo alla costruzione della Polveriera. Al disotto di questo, i saggi recentemente eseguiti, e tuttora in corso, hanno appurato l'esistenza di enormi interri compiuti con materiali di scarico, che sembrano comunque provenire da scavi in aree archeologiche; vale forse la pena di ricordare la numerosa serie di licenze di scavo concesse tra il XVI e il XVII secolo per scavare sul Colle Oppio, soprattutto nell'ampia proprietà dei monaci di S. Pietro in Vincoli, che ne occupava buona parte. Una convenzione risalente al 1567[6] stabilisce con esattezza le condizioni dello scavo e le pertinenze dei ritrovamenti, precisando tra l'altro *"che detti Bernardo e Mario [i concessionari] siano obligati a spianar le cave a loro spese, et portar la terra che portaranno via in luogo che non dia danno alla vigna ne a viali ne a muri"*; quest'ultima specificazione sembra attestare che le terre non venivano portate molto lontano, ed è anzi probabile che almeno parte di esse venissero scaricate nel lungo ambiente vuoto del criptoportico, andandolo progressivamente a riempire. Una dimostrazione di come siano avvenuti gli interri l'abbiamo in uno dei saggi, dove, in corrispondenza di un foro praticato nella volta, la stratificazione presenta un accumulo, evidentemente gettato dall'alto.

Nella parte finale della galleria ci si è presentata quindi la situazione di un grosso interro unitario (fig. 6) che riempiva l'intero criptoportico fino quasi alla volta, senza mostrare al suo interno altra stratificazione che quella delle varie gettate di materiale di scarico che lo componevano.[7]

In alto, in un punto dove il livello del terreno era un po' più basso, era possibile intravedere, dopo alcuni metri, quello che pareva un muro trasversale al criptoportico. Solo l'idea che quella montagna di terra terminasse dopo pochi metri ci ha spinto a proseguire lo scavo; per quanto ne sapevamo, il criptoportico, con il suo riempimento, si sarebbe potuto estendere per varie decine di metri lungo tutto il lato occidentale delle Terme. Non è stata quindi una sorpresa il rinvenimento del muro, quanto, al principio, il fatto che esso fosse non un intervento moderno di chiusura, bensì un muro antico in laterizio, con un orientamento peraltro diverso da quello delle strutture del criptoportico che vi si appoggiavano. La sorpresa più grossa è stata sicuramente quella di trovarvi sopra un affresco, ancora ben conservato e del quale non si era mai neppure sospettata l'esistenza. Ma ancora maggiore stupore, se possibile, provocava il soggetto raffigurato sull'affresco, una città cinta da mura turrite, il cui profilo biancastro era ben visibile entrando nel criptoportico (figg. a colore dopo p.72).

La datazione dell'affresco è legata a quella del muro su cui si trova, e di cui fa strutturalmente parte: l'affresco termina infatti in alto nel punto dove era il soffitto originale, sorretto da travi lignee delle quali si conservano i fori di incastro nella muratura. La muratura può esse-

5 Lo scavo è iniziato alla fine di ottobre del 1997, ed è tuttora in corso; la Direzione dei Lavori è dell'Arch P. Giusberti, che da sempre dirige i nostri cantieri con emozione ed entusiasmo, oltre che con perizia. I lavori sono eseguiti dalla Ditta Pouchain s.r.l., con l'assistenza di D. Germano. Responsabile dello scavo e "scopritrice dell'affresco" è E. Carnabuci, cui si è in seguito affiancata M. Pontani, mentre F. Carboni è responsabile della documentazione grafica. Nel mese di maggio allo scavo ha partecipato anche un piccolo gruppo di studenti della Cattedra di Metodologia e Tecniche dello Scavo archeologico dell'Università "La Sapienza".

6 Il contratto, stipulato dal priore di S. Pietro in Vincoli il 25 gennaio 1567, è ricordato per intero in R. Lanciani, *Storia degli scavi di Roma I* (Roma 1989) 53-54.

7 Lo studio dei materiali postantichi di questo interro viene condotto da S. Pannunzi, che vi ha riscontrato produzioni della metà del Settecento. In base a questo dato, ed all'analisi dei livelli stratigrafici, è possibile affermare che l'interro che copriva l'affresco deve essere stato accumulato durante i lavori della Polveriera: si tratta forse delle terre scavate nel criptoportico stesso per la costruzione delle stanze sotterranee della Salnitrara.

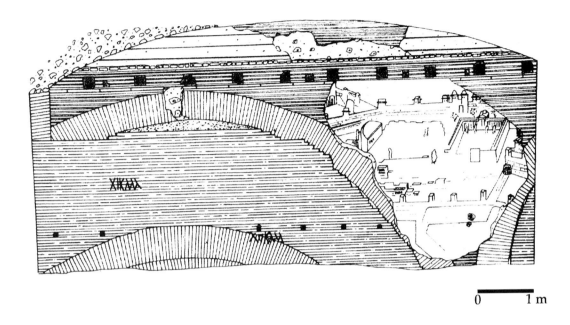

0 ━━━ 1 m

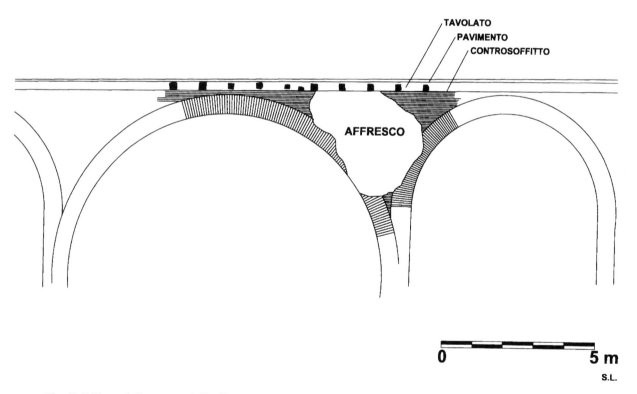

0 ━━━━━ 5 m

S.L.

Fig. 7. Rilievo della parete dell'affresco e della tamponatura traianea (ril. F. Carboni) e ipotesi ricostruttiva della facciata dell'edificio con affresco (elab. R. Volpe, *del.* S. Leigh).

re datata sicuramente ad età precedente alla costruzione delle Terme di Traiano (avvenuta tra il 104 e il 109 d.C.[8]), e quasi certamente posteriore al grande incendio che nel 64 d.C. distrusse gran parte del centro di Roma.

8 Non esiste ancora uno studio monografico dedicato alle Terme di Traiano; per i dati generali cfr. G. Caruso e R. Volpe in *LTUR* V, *s.v. Thermae Traiani.*

Il muro con affresco

Il muro dell'affresco (fig. 7) è in laterizio, interamente costruito in bessali di primo impiego, con uso di lisciatura e a volte stilatura dei giunti, con un modulo piuttosto alto di cm 32 circa, e malta di colore violaceo ricca di inclusi pozzolanici.[9] Il muro presenta un'arcata con ghiera in laterizi, parzialmente coperta dal muro traianeo che ne ha obliterato l'apertura, mentre un'altra arcata simile è visibile sul margine destro della muratura, dove gli si addossa il posteriore muro del criptoportico.

Poco al disopra dell'estradosso dell'arcata è un marcapiano in bipedali gialli, che funge da piano di appoggio per dei travi, di cui sono visibili i fori di incasso. La profondità dei fori per i travi del soffitto, tra i 75 e gli 80 cm, lascia presupporre che lo spessore della struttura muraria sia probabilmente di 120 cm, corrispondente a due bipedali affiancati sul marcapiano.

I travi dovevano reggere un solaio piano, con un soffitto forse rivestito da intonaco su incannucciata, perché di quest'ultima resta una traccia sul margine superiore dell'intonaco affrescato. Al disopra, è un piano di laterizi irregolarmente disposti, che probabilmente costituivano il pavimento del piano superiore. Ancora più in alto si osserva un tratto di muratura, sempre in laterizio, che conserva anch'essa tracce d'intonaco, di tipo e spessore differente da quello sottostante; la volta del criptoportico si addossa a questa muratura, completamente rivestita da uno spesso strato di sali e carbonati dovuti alle infiltrazioni d'acqua.

Il muro traianeo

Prima di passare alle ipotesi di ricostruzione ed identificazione dell'edificio cui appartiene la parete affrescata, è opportuno descrivere brevemente la muratura traianea che sbarra l'accesso: il muro in opera laterizia, con modulo di 26 cm, si lega a sinistra con la muratura del criptoportico mentre a destra mostra un profilo irregolare sfrangiato, dovuto alla necessità di tamponare l'apertura ad arco del muro precedente. L'orientamento irregolare, ad angolo ottuso con il muro del criptoportico, ma non esattamente parallelo a quello del muro precedente, rispetto al quale la muratura risulta sporgente, sembra dettato proprio dalla necessità di fare in qualche modo riavvicinare i due allineamenti differenti. Sulla cresta superiore il muro è coperto da un bauletto di malta pozzolanica, con la funzione di sigillare completamente la parte più alta dell'apertura del muro precedente.

Nella parte inferiore del muro è visibile la doppia ghiera di un arco di scarico in bipedali, a sesto ribassato. Al livello della chiave dell'arco, sui fianchi di esso, si notano 6 fori da ponteggio circolari, all'interno dei quali è misurabile una presumibile larghezza del muro di 120 cm circa (che attesta l'equivalente larghezza dell'arco tamponato e quindi della struttura muraria precedente); oltre questo spessore sembra esserci un ulteriore spazio vuoto, per qualche metro.[10]

Sui margini superiore e destro della muratura sono stati individuati bolli laterizi attribuibili alle *figlinae Sulpicianae*,[11] che rientrano tra quelli già visti dal H. Bloch nelle Terme di Traiano, attestati in particolare nell'esedra soprastante[12] (fig. 8).

Nella parte più vicina all'angolo occidentale è visibile un'iscrizione in lettere capitali dipinte in rosso, alte circa 22 cm: XI K MA = *(die) XI (ad) K(alendas) Ma(ias)*(fig. 9). La sugge-

9 Questa situazione è naturalmente quella visibile sulla porzione di muro non coperta dall'affresco.

10 Nei giorni immediatamente successivi al Convegno, i tecnici dell'Istituto Centrale per il Restauro, F. Aramini e R. Ciabattoni, hanno eseguito una ricognizione con una sonda endoscopica inserita all'interno di uno dei fori da ponteggio del muro traianeo; le riprese effettuate hanno rivelato l'esistenza di un ambiente retrostante il muro con l'affresco (ambiente cui si aveva originariamente accesso dall'ingresso ad arco poi tamponato), dove un muro ortogonale ad esso presenta un tratto di mosaico parietale, con una scena di vendemmia.

11 *CIL* XV 591a; *CIL* XV 574; *CIL* XV 582b.

12 H. Bloch, *I bolli laterizi e la storia edilizia romana* (Roma 1947) 36 ss.

Fig. 8. Bollo laterizio della muratura traianea.

(die) XI (ad) K(alendas) Ma(ias)

(die) XV (ad) K(alendas) Ma(ias)

Fig. 9. Iscrizione dipinta sul muro traianeo. Fig. 10. Iscrizione dipinta sul muro traianeo.

stione creata dal fatto di riconoscervi la data del 21 aprile viene smorzata dalla presenza di un'altra iscrizione dipinta più in basso, subito al disopra della ghiera in bipedali, in tutto simile alla precedente: forse XV K MA = *(die) XV (ad) K(alendas) Ma(ias)* (fig. 10), (e cioè il 17 aprile, a meno che non si debba leggere *XII*) — cioè quattro giorni prima della data precedente.[13] La presenza di almeno due iscrizioni fa comunque pensare a scritte apposte forse per segnalare varie fasi del cantiere di costruzione, senza quindi particolari riferimenti simbolici.[14]

Datazione del muro con affresco

La datazione precedente all'età traianea e l'orientamento simile a quello delle strutture neroniane hanno portato molti studiosi a pensare che il muro dell'affresco facesse parte del complesso della *Domus Aurea*, della quale non è effettivamente noto il limite settentrionale;[15] abbiamo quindi effettuato un'analisi della nostra cortina laterizia, confrontandola con quella

13 Non si può neanche escludere, vista la mancanza della terza lettera nel nome del mese, che si debba leggervi invece marzo, e che le date si riferiscano quindi al 15 e al 19 febbraio.

14 Al momento attuale (settembre 1998), sono state scoperte altre scritte sui muri traianei del criptoportico, per un totale di venti, sempre con date riferibili alle giornate di lavoro del cantiere; è in corso da parte di chi scrive uno studio sui tempi e le modalità di realizzazione del cantiere del criptoportico traianeo, basato sull'analisi comparata di queste scritte, in relazione alla loro posizione e alle altre tracce riscontrabili sulla muratura.

15 Sulla *Domus Aurea* nei suoi vari settori v. da ultimo *LTUR* II (Roma 1995) 49-64.

delle murature del padiglione esquilino della *Domus Aurea*,[16] e delle strutture neroniane rinvenute nell'area della *Meta Sudans*.[17] Confortati anche dal parere di studiosi che si occupano da anni della *Domus Aurea*, possiamo dire che la nostra non somiglia affatto alle murature neroniane, dalle quali differisce soprattutto per l'uso di un marcapiano di bipedali (la presenza dell'affresco impedisce per ora di sapere se ve ne siano altri); l'impiego di ricorsi di bipedali nelle murature viene tradizionalmente datato, sulla scorta di Lugli,[18] all'epoca di Domiziano, ma già nella *Domus Aurea* marcapiani di bipedali sono presenti in una muratura sicuramente e concordemente datata ad età flavia.[19] Il ricorso appare qui funzionale all'appoggio dei travi, per cui potremmo essere in una fase iniziale dell'uso. Ci sembra che la cronologia più probabile per questa muratura sia da cercare, anche in base ad altri dati che esporremo in seguito, in età flavia, e probabilmente vespasianea.

Ricostruzione ipotetica dell'edificio con affresco

Le dimensioni della struttura muraria (larg. 120 cm) fanno pensare che doveva sostenere un alzato notevole; sulla base di quanto visibile è stata tentata una ricostruzione dell'edificio, che mostra almeno due aperture ad arco, di dimensioni differenti, ma comunque notevoli: l'arcata più ampia, la cui larghezza supera i 10 m, fa indubbiamente pensare ad un accesso, forse carrabile, ad un grande edificio (fig. 7); le dimensioni della struttura, il suo sviluppo in lunghezza (solo le due arcate superano i 20 m) e l'assenza di un'altra struttura simile parallela più a Sud (che sembra molto improbabile ipotizzare distrutta dai lavori per il criptoportico) inducono a pensare ad una facciata esterna, come farebbe anche ritenere lo spessore di preparazione dell'affresco (circa 6 cm). Le travi da soffitto, di cui restano i fori per l'alloggiamento, sembrano troppo piccole per sorreggere un solaio di ampiezza adeguata ad una eventuale sala, e vanno quindi piuttosto riferiti ad un porticato, o più probabilmente ad un soppalco sporgente, quasi un meniano, che avrebbe protetto le entrate all'edificio, senza però nascondere le pitture poste a decorare gli spazi a vela tra un'arcata e l'altra, in un progetto decorativo che doveva prevedere vedute di più città.

Le dimensioni e la tipologia dell'edificio riporterebbero quindi ad un edificio pubblico, verso il quale orienta anche il soggetto e soprattutto il tipo di raffigurazione dell'affresco, con funzione sicuramente rappresentativa e non decorativa (v. il successivo intervento di E. La Rocca).

Il contesto topografico

E' ora il caso di riprendere, anche se necessariamente in maniera sintetica, i dati esistenti sulla topografia della zona, per cercare di inquadrare l'edificio scoperto in un contesto riconoscibile.

Il recentissimo lavoro di D. Palombi[20] riprende ed approfondisce le precisazioni già date da F. Castagnoli[21] sull'ubicazione di *Velia* e *Carinae*, posizionando l'una nell'area del taglio di Via dei Fori Imperiali, e l'altra sulla pendice immediatamente adiacente, in un'area che ci riguarda quindi da vicino (fig. 11). Le *Carinae* si situerebbero quindi sulla pendice occidentale del

16 Ringraziamo l'Arch. A. Vodret per la cortesia e la disponibilità con cui ha voluto accompagnarci nella *Domus Aurea* e fornirci ogni possibile chiarimento.

17 Analizzate nell'accurata tesi di laurea di B. M. Malquori, che abbiamo potuto consultare grazie alla cortesia di C. Panella.

18 G. Lugli, *La tecnica edilizia romana* (Roma 1957).

19 Dal lavoro di G. Zander a quelli di L. Fabbrini (v. da ultimo *LTUR* II, *s.v. Domus Aurea* 56-63, fino al recente lavoro di L. Ball, "A reappraisal of Nero's *Domus Aurea*," in *Rome papers* [JRA Suppl. 11, 1994] 182-254).

20 D. Palombi, *Tra Palatino ed Esquilino. Velia Carinae Fagutal* (Roma 1997) 137 ss.

21 F. Castagnoli, "*Ibam forte via Sacra* (Hor. Sat. 1.9.1)," in *Topografia romana. Ricerche e discussioni* (=*QuadTopAnt* 10, 1988) 99-114.

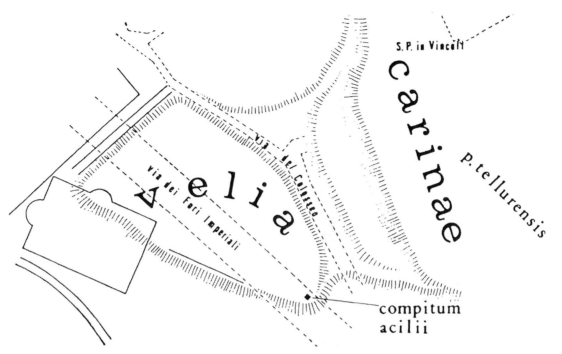

Fig. 11. Posizionamento delle alture di Velia e Carinae (da Castagnoli 1988).

Fig. 12. La sistemazione viaria antecedente l'incendio del 64 d.C. (da Palombi 1997).

Fig. 13. La sistemazione viaria posteriore alla costruzione delle Terme di Traiano (da Palombi 1997).

Fig. 14. Ricostruzione dei tracciati viari in età flavia (elab. R. Volpe).

Colle Oppio,[22] nella zona di S. Pietro in Vincoli, la più elevata, ben visibile dal Palatino, in base alla descrizione virgiliana del panorama che si offriva agli occhi di Enea ed Evandro.[23] Palombi elabora anche una ricostruzione della viabilità precedente all'incendio del 64 d.C. (fig. 12), ed una posteriore alla costruzione della *Domus Aurea* e delle Terme di Traiano[24] (fig. 13). Vi è però tra queste una fase intermedia, cioè quella per l'appunto flavia, che vede già la costruzione della *Domus Aurea*, con il suo orientamento secondo i punti cardinali che condiziona gran parte della topografia circostante, ma non ancora quella delle Terme di Traiano, che interverranno su una superficie di 6 ettari con un cambio di angolazione (v. dopo). Si deve naturalmente accettare l'idea che il tracciato stradale sul lato meridionale della *Porticus Liviae*, ben visibile anche sui frammenti della *Forma Urbis*, dove si arresta all'ingresso delle Terme di Traiano, proseguisse oltre prima della loro costruzione.[25] L'ipotesi più probabile è che si andasse a ricongiungere con il percorso ricostruibile su via della Polveriera, corrispondente ad una delle vie che partivano dal *Compitum Acilii*. Il tracciato così ricostruito (fig. 14) passerebbe proprio sotto l'angolo nordoccidentale delle future Terme di Traiano, ed è probabile che ad un suo inevitabile spostamento, effettuato dopo la loro costruzione, si riferisca il basolato, databile circa ad età adrianea, rinvenuto sotto la Facoltà di Ingegneria.[26] Appare evidente guardando la planimetria che il tracciato passerebbe proprio davanti all'edificio appena ricostruito, anzi davanti alla sua facciata.

Una volta accettata la datazione in età flavia e l'identificazione presumibile con un grande edificio pubblico che si affacciava su un asse stradale, dobbiamo domandarci se sia possibile, in base ai dati già acquisiti, tentare un'ipotesi di riconoscimento.

Nell'ambito dei suoi studi, ed a seguito delle posizioni raggiunte sulla collocazione delle *Carinae*, D. Palombi riprende in esame un frammento della *Forma Urbis* marmorea (cui si aggiunge un frammento noto da disegni rinascimentali), proponendo di tornare alla tradizionale identificazione con il Tempio della *Tellus*[27] (fig. 15). Anche se non si vuole accettare questa identificazione, che sembra comunque più che ragionevole, non si può certo negare che il Tempio della *Tellus* fosse più o meno in questa zona, identificabile con le *Carinae*, alle quali è strettamente legato in tutte le fonti che lo citano. Non è questa la sede per riprendere il discorso sulla posizione precisa di questo tempio, la cui fondazione si data ad età medio-repubblicana, ma che ha forse dei precedenti molto più antichi.[28] La notizia che invece ci interessa è che sicuramente presso il Tempio della *Tellus* (nel vestibolo? In un edificio associato?) era, all'epoca di Varrone, un'*Italia picta in pariete*,[29] che sembra l'antecedente diretto dell'*orbis pictus* nella

22 *Contra* F. Coarelli, "L'urbs e il suburbio," in A. Giardina e A. Schiavone (edd.), *Società romana e impero tardoantico. II* (Roma–Bari 1986) 1-58, che identifica le *Carinae* con l'altura immediatamente retrostante la Basilica di Massenzio.

23 Verg., *Aen*. 8.361. La stessa veduta, anche se in senso contrario, è tuttora possibile sull'asse della via della Polveriera, corrispondente ad un antico percorso, dove, dall'altura su cui è la Facoltà di Ingegneria, è visibile il Palatino.

24 Palombi (supra n.20) figg. 51-52.

25 Il tracciato stradale è sicuramente già esistente all'epoca della costruzione della *Porticus Liviae* che ha lo stesso orientamento (C. Panella, "L'organizzazione degli spazi sulle pendici settentrionali del Colle Oppio tra Augusto e i Severi," in *L'Urbs* [Roma 1987] 611-51), e ne è stata proposta l'identificazione con il *Vicus Sabuci* (E. Rodriguez Almeida, *Forma Urbis Marmorea* (Roma 1981) 78 n.5 e 85).

26 C. Buzzetti e A. M. Colini, "Il Fagutale e le sue adiacenze nell'epoca antica," *RendPontAcc* III.36 (1963-64) 75-91; A. M. Colini e G. Matthiae, "Ricerche intorno a S. Pietro in Vincoli," *MemPontAcc* 9.2 (1966) 7-8 n.4.

27 Palombi (supra n.20) 154-58, contrariamente a quanto sostenuto da tempo da F. Coarelli, che vi riconosce invece i templi del *Tarentum*: v. da ultimo *Il Campo Marzio. Dalle origini alla fine della Repubblica* (Roma 1997) 87-100.

28 Sul Tempio della Tellus v. da ultimo A. Ziolkowski, *The temples of Mid-Republican Rome and their historical and topographical context* (Roma 1992) 156-61 e Palombi (supra n.20) 153-68.

29 Varro, *RR* 1.2.1-3.

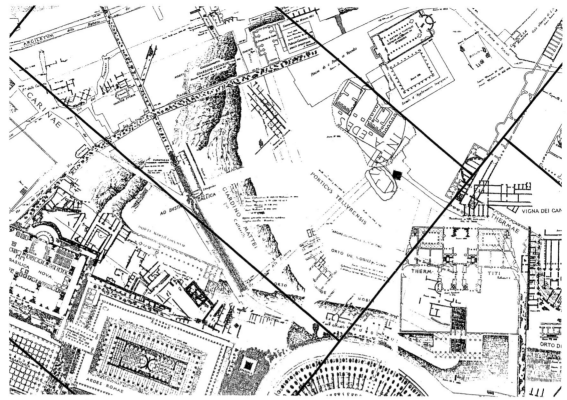

Fig. 15. Posizionamento dei frammenti della *Forma Urbis* marmorea raffiguranti il Tempio di *Tellus* (da Palombi 1997).

Porticus Vipsania di Agrippa in Campo Marzio, e forse della tradizione legata anche alla nostra raffigurazione di città. Ma le notizie che più ci interessano sul Tempio della *Tellus* sono quelle che lo collegano strettamente, in età tarda, alla magistratura del *Praefectus Urbi*.[30] Sono infatti note almeno due iscrizioni che ripetono lo stesso testo con alcune varianti, ricordando il restauro, fatto dal *Praefectus Urbi* Giunio Valerio Bellicio negli anni tra il 408 e il 423, di un portico *"cum scriniis Tellurensis secretarii tribunalib(us) adhaerentem"* (cioè di un portico con gli archivi adiacente i tribunali del *secretarium Tellurense*), e si ricorda inoltre *"restituto specialiter urbanae sedis honore"*[31]. Tutto questo, insieme al ritrovamento di varie dediche e di un editto del prefetto urbano, trovate tutte nella zona intorno a via della Polveriera e S. Pietro in Vincoli, aveva portato già Lanciani ad affermare che, almeno nel IV sec., la sede della prefettura urbana doveva ricercarsi in quest'area.[32]

Non si sa molto (anzi praticamente nulla) della sede del prefetto urbano precedentemente a queste date. Vale forse la pena di ricordare che la magistratura risaliva secondo la tradizione all'età regia, ed era caduta in disuso nella media età repubblicana; fu rinnovata, durante la dittatura di Cesare, da Antonio, e poi ripresa da Augusto, che la rese permanente nel 13 d.C., attribuendogli il controllo dell'ordine pubblico e la giurisdizione criminale. Ci è ignoto dove Augusto abbia posto la sede della prefettura, pur destinandogli una basilica,[33] e nulla si sa di essa fino al IV sec., anche se si è spesso supposto che a partire dall'età flavia la Prefettura avesse sede nel *Templum Pacis*, a causa della presenza della *Forma Urbis* marmorea.[34]

30 Sulla magistratura e la sua storia cfr. G. Vitucci, *Ricerche sulla* Praefectura urbi *in età imperiale, sec. I-III* (Roma 1956) e A. Chastagnol, *La préfecture urbaine à Rome sous le Bas-Empire* (Paris 1962).

31 Un'iscrizione fu trovata presso S. Pietro in Vincoli: *CIL* VI 31959 = 37114; l'altra fu rinvenuta in via Marco Aurelio sul Celio: G. Iacopi, "Nuove iscrizioni di Roma e del Suburbio," *BCom* 1939, 18-20.

32 R. Lanciani, "Gli edifici della Prefettura urbana tra la Tellure e le Terme di Tito e di Traiano," *BCom* 1892, 19-37. F. Coarelli (supra n.22) 23 ss. la pone invece alle spalle della Basilica di Massenzio, e poi nella Basilica stessa, ipotesi che sembra confutata sia dai dati di ritrovamento delle epigrafi sia dal corretto posizionamento di Velia e Carinae.

33 Cfr. un passo di un'opera perduta di Svetonio, citato in Palombi (supra n.20) 150.

34 Così ad es. G. Carettoni, A. M. Colini, L. Cozza e G. Gatti, *La pianta marmorea di Roma antica* (Roma

Tornando alla nostra struttura, databile probabilmente all'età flavia, non si può non ricordare che particolare fu la cura posta da Vespasiano nella riorganizzazione edilizia ed amministrativa di Roma, per la quale assunse addirittura la censura insieme con il figlio Tito; in contrapposizione all'immagine di Nerone, che aveva trasformato la città in *domus*, le aree da questa occupata vennero in gran parte rese all'uso pubblico con edifici monumentali, che si concentrano intorno al nuovo anfiteatro: il *Claudium*, il Tempio della Pace, i portici lungo la via Sacra, e più tardi le Terme di Tito sul Colle Oppio, sì da far dire a Marziale, nel famoso elogio di Tito, che finalmente *"reddita Roma sibi est"*.[35] Nell'ambito di questo programma, un'attenzione particolare dovette essere posta agli aspetti amministrativi della città, in un esplicito richiamo ad Augusto che caratterizza la politica e la logica urbanistica di Vespasiano; fu ampliato il pomerio e fu stabilita un'ampia cinta daziaria (*moenia*, secondo un celebre passo di Plinio il Vecchio che ne misura il perimetro, di poco inferiore a quello delle posteriori Mura Aureliane[36]); l'attività di Vespasiano in favore di Roma è testimoniata anche dalle monete con *Roma resurgens*, e significativa appare la sua definizione, in una dedica del 78 d.C., come *"conservator caerimoniarum publicarum et restitutor aedium sacrarum"*.[37] E' anche possibile che, dopo gli sconvolgimenti derivati prima dall'incendio del 64 e poi soprattutto dalla nuova concezione urbanistica di Nerone, siano stati allora anche ridefiniti i confini delle quattordici regioni, e forse anche i loro nomi, quali compariranno poi nei Cataloghi Regionari: la *IV Regio* deve aver infatti assunto allora infatti il nome di *Templum Pacis* (e non quello dei successivi e più ampi Fori Imperiali), mentre alla *III Regio*, dove dominerà più tardi la mole imponente delle Terme di Traiano, rimase invece il nome legato al repubblicano santuario di Iside e Serapide.[38] Un ulteriore segnale dell'attenzione di Vespasiano a questa parte della città può forse riconoscersi anche nell'ara da lui dedicata a Giove,[39] rinvenuta nel 1509 nella zona delle Sette Sale, che potrebbe riconnettersi al sacello che dava il nome al *vicus Iovis Fagutalis*; di questo ci resta, forse proveniente dalla zona di S. Martino ai Monti, l'iscrizione dell'edicola compitale, ristrutturata (e forse non è casuale se il *vicus* va riconosciuto nella parte superiore del tracciato che abbiamo ricostruito) nel 109, anno di inaugurazione delle Terme di Traiano.[40]

Perché non pensare che Vespasiano abbia costruito una sede ampia e di rappresentanza per la più importante magistratura cittadina, da collocare in un'area centrale, dove sembrano concentrati gli interessi edilizi almeno dei primi due Flavi? La suggestione che il nostro edificio possa rientrare in questa politica urbanistica ed amministrativa di Vespasiano, costituendo forse una delle parti della Prefettura urbana, è forte: come non lasciarsi tentare dalla fonte, benché tarda, che ricorda un portico accanto al Tempio della *Tellus*? Se è verosimile la posizione del Tempio della *Tellus*, la probabile datazione vespasianea dell'edificio con affresco, che abbiamo visto essere di notevole mole e sicuramente di uso pubblico, con un ampio accesso su un tracciato stradale, sembra non lasciare molti dubbi; potrebbe anzi vedersi uno scrupolo traianeo nel lasciare in elevato ed in vista,[41] anche se al piano sotterraneo, un edificio piuttosto importante, che non deve comunque essersi allontanato di molto, seguendo la millenaria consuetudine romana che portava ad una persistenza delle attività, politiche o religiose, sempre negli stessi

1960) 214-17.

35 Sulla politica urbanistica di Vespasiano, cfr. F. Castagnoli, "Politica urbanistica di Vespasiano in Roma," in *Atti del Congresso int. di studi vespasianei I* (Rieti 1979) 261-75.

36 Plin., *NH* 3.5.66.

37 *CIL* VI 934.

38 Il *Templum Telluris* risulta nella *IV Regio*, mentre le Terme di Traiano sono nella *III*; il confine tra *III* e *IV Regio* doveva passare proprio in questa zona, e forse, dopo la costruzione delle Terme, coincidere con il limite occidentale di esse.

39 *CIL* VI 369. Il rinvenimento è ricordato in Lanciani (supra n.6) 194.

40 *CIL* VI 452.

41 Ed accessibile dall'esterno, come constatato nella già ricordata ricognizione con la sonda al di là del muro, dove è stato possibile vedere una porta nel muro di limite delle Terme, che consentiva l'ingresso dall'esterno all'edificio, divenuto ormai sotterraneo.

luoghi. Vale forse la pena di ricordare anche almeno due fonti[42] che ricordano un "portico delle Terme di Traiano", dove erano dei "*sigillaria*" e dove erano conservati dei rescritti; si trattava quindi di una struttura, all'interno o nelle immediate adiacenze delle Terme di Traiano, utilizzata alla metà del III sec. per usi amministrativi e giudiziari, forse in connessione con la Prefettura urbana, la cui localizzazione non dovrebbe quindi essersi spostata di molto dopo la costruzione dell'imponente impianto termale traianeo.

Le Terme di Traiano

Avremmo quindi ricostruito una fase edilizia flavia che continua a mantenere l'orientamento secondo i punti cardinali, che, oltre a caratterizzare la *Domus Aurea*, doveva condizionare, insieme con quello della *Porticus Liviae*, la topografia del Colle Oppio; anche le Terme di Tito mantengono, pur se con qualche grado di spostamento, il vecchio orientamento. Fu Apollodoro di Damasco, progettista del grandioso impianto termale di Traiano, che rivoluzionò gli orientamenti, ruotando di circa 35 gradi verso Ovest l'asse delle Terme, per garantire al calidario la migliore esposizione ed insolazione (fig. 1). Questa diversa angolazione era però strettamente limitata al recinto termale superiore: numerose sono le strutture precedenti di orientamento diverso (di cui il caso più eclatante è quello della *Domus Aurea*, ed ora il nostro muro con affresco), riutilizzate al livello sottostante il piano delle Terme; vi sono però anche casi di murature coeve alle Terme, costruite conservando l'orientamento precedente, situate al piano inferiore o esternamente al recinto termale (di cui l'esempio più visibile è quello della grande cisterna delle Sette Sale), a riprova che la nuova angolazione era strettamente funzionale all'uso termale e quindi limitata agli ambienti ad esso destinati, e non presupponeva un programma di ristrutturazione urbanistica dell'intero quartiere.

Conclusioni

Possiamo solo dire che vere conclusioni ancora non ne possiamo dare: gli scavi sono in corso, e quanto è stato esposto non è che una prima meditazione sui dati finora raccolti. Noi ci auguriamo che l'interesse destato da questa scoperta ci aiuti ad approfondire le ricerche, e ad estendere il nostro lavoro da quest'angolo a tutto il Colle Oppio, per riscoprire, dietro le spalle del Colosseo, un angolo di Roma antica finora dimenticato ma non meno affascinante di altri settori dell'area archeologica centrale.

Sovrintendenza Comunale di Roma

42 Un rescritto rinvenuto in Pannonia (*CIL* III 12336) e uno scoliasta di Giovenale (*Schol. in Iuven.* 6.154).

L'affresco con veduto di città dal colle Oppio

Eugenio La Rocca

L'affresco copre quasi integralmente, nella porzione conservata, lo spazio tra le due arcate (fig. 1). E' una grande veduta a volo d'uccello di città fortificata, dove il punto di visione è a sinistra dall'alto, dal lato dove splende il sole. Per quanto si può immaginare dallo stato di conservazione, la città si stende su una lingua di terra tra distese d'acqua: sicuramente a sinistra sembra evidenziarsi un fiume, o un canale. In basso e a destra si riconosce ancora la presenza dell'acqua. I raggi solari si specchiano sulle murature chiare, in opera isodomica, delle fortificazioni, specialmente sulle pareti delle torri che ne sono rischiarate con un accorto ed impressionistico uso di lumeggiature. Le fortificazioni seguono un tracciato a segmenti lineari che si incontrano ad angolo. Esse sono intercalate, nel tracciato superiore, da torri circolari, con copertura a cono ribassato, ad esclusione di due ai lati dell'unica porta di accesso finora riconosciuta, che hanno una copertura a campana; nel tracciato inferiore sono invece a sezione quadrata. A ridosso delle fortificazioni si scorgono aree sgombre a prato; presso la porta principale sono visibili alcuni alberelli. In basso, all'interno e all'esterno, le si addossano file di case in modo fantasiosamente eterogeneo. Dalle fortificazioni se ne diramano due tratti nell'acqua: uno a segmenti che compongono una sezione poligonale, l'altro a segmento lineare.

A sinistra, lungo il percorso delle fortificazioni, scorre un fiume, o un canale, scavalcato da un altro braccio di muro in opera isodomica avente al centro una sorta di apertura monumentale tra due torri anch'esse con copertura a campana ed attico porticato (fig. 2).

All'interno delle fortificazioni, nella zona centrale, si distinguono due nuclei compatti separati da una fettuccia di colore più scuro, nella quale si dovrebbe riconoscere una delle arterie principali della città, diretta verso la porta delle mura, in alto (fig. 3). Sulla sinistra è perfettamente visibile il teatro con un tempio collocato al suo ingresso. Il teatro è in pietra, ma la parete posteriore della scena, di colore rosso bruno, è forse in laterizio. Il tempio, che con il suo frontone a sesto ribassato sembra essere di tipo greco, mostra alle spalle una statua, probabilmente collocata su una colonna o su un pilastro: potrebbe essere la statua di un Apollo citaredo, in lungo chitone, rivolto verso le fortificazioni e non verso lo spettatore. Affiancato alle fortificazioni corre un portico a colonne. Alle spalle della scena del teatro si osserva una fitta serie di edifici che pare delimitare uno spazio libero su una terrazza rafforzata alle sue pendici: è quasi certamente una sorta di piazzale *post scaenam* costruito su una breve altura livellata. Purtroppo lo stato di conservazione dell'affresco non permette di proporre al momento ipotesi più precise, poiché dopo la pulitura si scorgono tracce di strutture anche al centro dell'area. Gli edifici, collocati sul bordo del piazzale, sono di varia misura e con differenti tipi di copertura. In basso, sulla sinistra, si osserva una struttura colonnata poggiante su un alto podio. L'ingresso al piazzale sembra scandito dalla presenza di una colossale statua di bronzo dorato raffigurante un personaggio maschile con una veste, o un mantello, che gli giunge fino alle ginocchia.

La struttura sulla destra è un vasto quadriportico con ampio portale d'accesso e, sul fondo, innestato entro il porticato, un edificio verosimilmente templare la cui cella si protende oltre il porticato (fig. 4). Il modello strutturale è in qualche modo simile a quello del tempio della Pace, anche se più semplificato. La parete d'ingresso e parte delle trabeazioni dell'edificio sono in pietra; il resto è raffigurato in colore rossastro, al punto da rendere verosimile una realizzazione in mattoni. Entro il quadriportico sono visibili alcune sculture in bronzo dorato.

Ancora più a destra, ma come delimitata dalle acque, si scorge una sorta di isoletta collinare fortificata, fittamente edificata lungo le pendici, e coronata da un tempietto con copertura a falde molto sporgenti, nella tradizione dell'architettura di tipo tuscanico (fig. 5). La terrazza templare è recintata con una serie di barre protese nel vuoto a guisa di carene, quasi un recinto di protezione.

Dinanzi alle due strutture principali, all'altezza della statua colossale di bronzo dorato, corre probabilmente un'altra arteria, ortogonale alla prima, la quale, passando dinanzi alla fronte della grande struttura a quadriportico sulla destra, sembra congiungere il tempio di Apollo sulla sinistra con l'isoletta dell'acropoli a destra. Sarebbero le due direttive principali del centro urbano, il suo cardo ed il suo decumano.

Come si evince da questa rapida descrizione, che attende tuttavia ulteriori chiarimenti da più capillari interventi di restauro e da una documentazione grafica e fotografica più aggiornata, la città raffigurata ha l'apparenza di un centro marittimo con un porto "esterno" fortificato — è difficile stabilire se scavato in corrispondenza di una baia naturale, o interamente artificiale —, il cui bacino è delimitato da due moli radicati alla riva: quello di sinistra, assai più lungo, è realizzato a segmenti lineari secondo un disegno poligonale; quello di destra è invece rettilineo. I moli, per quanto si può giudicare, non sono convergenti, né è possibile dire, al momento, se l'imbocco fosse protetto da un antemurale. Di lato, a sinistra, scorre un canale, che doveva essere protetto da fortificazioni su ambedue i lati. Lo si può ipotizzare dalla presenza di un braccio delle mura che, staccandosi dal complesso centrale, supera il canale con un passaggio coperto su una sola arcata a sesto ribassato. Non è un ponte vero e proprio, che normalmente è sorretto da più arcate su pilastri onde impedire una eccessiva resistenza alle correnti. Il passaggio assume piuttosto la forma di una grande porta d'accesso con galleria superiore, al punto da avere l'impressione che si tratti piuttosto di uno sbarramento inserito entro il sistema difensivo, un modo per controllare l'ingresso al canale dalla terraferma ed assicurare il perfetto controllo del braccio d'acqua direttamente collegato al mare. Al momento opportuno, tale passaggio poteva diventare una barriera di protezione, oppure per regolamentare la portata d'acqua nel canale. Se l'immagine non inganna, vuol dire che il canale svolgeva anche la funzione di darsena, e le navi erano ricoverate al sicuro nelle gallerie visibili ai bordi della riva. Entro il sistema portuale complessivo si inserisce anche la penisola sulla quale sorge l'acropoli; protesa nell'acqua, la breve lingua di terra, circondata anch'essa di mura, è direttamente collegata con la terraferma attraverso un breve tratto di fortificazione. Le mura, a loro volta, seguirebbero da un lato le linee di costa e del fiume (o canale), inglobando nel sistema difensivo il porto, il corso d'acqua, e l'acropoli. Il corpo centrale urbano è composto a sinistra dall'usuale complesso tempio–teatro–piazzale alle spalle della scena, e a destra da un quadriportico con tempio, nel quale si dovrà riconoscere, pur con forti perplessità, il foro cittadino. L'arteria che collega l'accesso alla città con il porto in basso può essere considerata, malgrado lo spostamento verso destra dovuto alla visione a volo d'uccello, la linea mediana della composizione. Vista la posizione dell'affresco sulla parete di collegamento tra due arcate, si desume che della composizione è conservata la cospicua parte centrale. Per una coincidenza fortuita la raffigurazione della città è pressoché completa, e le cadute d'intonaco sui bordi potranno essere nel tempo compensate dalla ricomposizione dei frammenti rinvenuti durante lo scavo a ridosso della parete.

La sapiente regolarità dell'impianto urbanistico nel settore centrale della città contrasta con l'affastellamento delle strutture intorno all'acropoli e lungo le mura, che occupano persino gli spazi esterni alle fortificazioni lungo l'area portuale. Le abitazioni che è possibile riconoscere non hanno in apparenza il razionale respiro delle *domus* tardo-ellenistiche. Con il loro impianto fortemente differenziato per tipologia ed altezza, più simile alle strutture che individuano i quartieri medievali che non i rigorosi impianti urbanistici di tipo residenziale ben noti a Pompei, ad Ercolano e ad Ostia, esse offrono l'immagine di una città popolosa di stampo prevalentemente commerciale. Anche la morfologia degli edifici pubblici è fortemente caratterizzata, dal tempio sull'acropoli, che è in apparenza di tipo etrusco-italico con il suo tetto a larghe falde poco organicamente poggiato sulla trabeazione, al tempio presso il teatro, al contrario realizzato secondo le migliori regole della tradizione greca con l'organica partizione architettonica di tutte le sue membrature, al teatro stesso, interamente realizzato in muratura con pianta semicircolare nella tradizione romana, al quadriportico con tempio sul fondo, memore di una specifica tradizione urbanistica greco-ellenistica, ma come filtrata

attraverso le più tarde esperienze romane di età imperiale. Analizzando l'insieme a colpo d'occhio, l'impressione è di una città di antica fondazione che abbia subito un fondamentale lavoro di ristrutturazione nel suo centro urbano, che ne ha regolarizzato la morfologia contribuendo ad offrirle in parte la caratteristica immagine delle città di nuova fondazione, o fortemente modificate nella prima età imperiale.

Lo stato di conservazione dell'affresco impedisce di offrire dati più certi. Eppure l'impressione è che la città murata sia immersa in un azzurro indistinto che, per la presenza della chiusa e dell'area portuale, può in parte rappresentare acqua e in parte un indistinto "esterno". Il confronto con vedute di città e cartografie di età tardo-antica e medievale suggeriscono la volontà di raffigurare esclusivamente la città entro le mura e non il suo entroterra, con un processo di semplificazione simbolica che contraddice l'effettiva consistenza politica e sociale delle città romane il cui territorio era parte essenziale per la loro sopravvivenza.

La tecnica pittorica è compendiaria, basata piuttosto su un effetto a distanza che non su una minuziosa articolazione delle immagini. Pennellate rapide e nervose definiscono i dettagli con sommaria ma precisa evidenza. Colonne, capitelli e coppi dei tetti sono come schizzati, e l'effetto è ancora più evidente nel tracciato, con linea sottile e tremolante, delle assise murarie o nella definizione come una macchia impressionistica delle finestre e delle arcate. La tavolozza di colori è limitata, dal bianco, adoperato anche per le forti lumeggiature, al giallo crema all'azzurro nelle varie gradazioni fino al bruno-violaceo in molte tonalità per raffigurare le ombre portate. Le case, la scena del teatro, i templi sono raffigurati in colore rosso brunito, col quale può essere definito sia l'uso del mattone sia, forse, di una pietra tufacea più friabile. Un verde leggero è adottato per definire i prati, mentre con un tono più intenso sono rapidamente delineati i radi alberelli alle spalle del quadriportico. In sintesi, la pittura non sembra allontanarsi nei modi di realizzazione da quanto è noto in alcuni settori della Domus Aurea, dove piccole vedute paesistiche sono rappresentate con un analogo stile compendiario. E' una tecnica che, sebbene abbia sicuri addentellati con lavori attribuibili ancora in età repubblicana, ha una larga diffusione nel periodo in cui si afferma il c.d. IV stile pompeiano. Non vanno sottovalutati gli straordinari apporti offerti dalla pittura per definire con maggiore esattezza il colore delle città antiche.

Lo stile del dipinto è in sintonia con la cronologia della parete su cui è applicato. Pur considerando la decorazione un unicum nel suo genere, è durante la fase del c.d. IV stile, quindi tra l'età neroniana e quella flavia, che si incontrano in alcuni *viridaria* raffigurazioni di paesaggio in grande formato con bordi semplici e poco decorati, mentre in precedenza era privilegiato il piccolo quadretto paesistico nell'ambito di composizioni parietali assai più complesse. E' noto che a partire dal IV stile le *domus* borghesi tendono a recepire il modello delle ville aristocratiche, sia pure adattandolo a misure ed a possibilità economiche ben inferiori di una classe agiata, ma certo non opulenta. Sia la pompeiana Casa dei Cei, sia, con ancor maggiore evidenza, la Casa della Fontana Piccola con un paesaggio portuale (fig. 6), ricostruiscono fantasiosamente nei loro *viridaria*, piccoli spazi destinati a giardino, il lussuoso vivere in villa, riprodotto a parete tramite affreschi di grande formato appena intelaiati entro cornici architettoniche che comunque non sono più l'elemento portante della composizione, bensì un elemento di contorno.

Ma, se questo sembra essere l'ambiente dal quale emerge l'affresco del Colle Oppio, le consistenti differenze saltano evidenti all'occhio. I paesaggi di IV stile dei *viridaria* non sono vuoti, bensì abitati da un nugolo di figurine che si muovono nell'ambiente popolandolo: esseri umani, donne, pastori, pescatori, animali domestici, dall'asino alla mucca al cane, barche che scivolano sulle acque, tutto questo inserisce comunque tali raffigurazioni in un contesto ben noto.

Nell'affresco del Colle Oppio non c'è figura umana, non c'è essere animato o manufatto d'uso quotidiano che rompa il silenzio come incantato di una città che risulta spopolata, pur essendo pieno giorno. Lo spazio, che la particolare veduta prospettica già rende indefinito, con le figure quasi librate per aria ed appese ad un terreno mobile come l'aria, risulta anch'esso quasi irreale

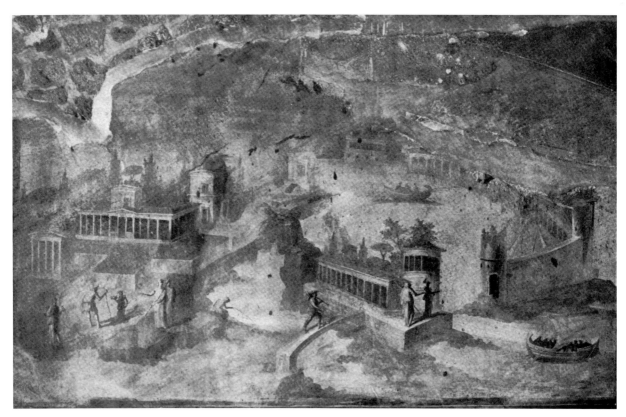

Fig. 6. Pompei, Casa della Fontana Piccola, viridario. Pittura con scena di paesaggio.

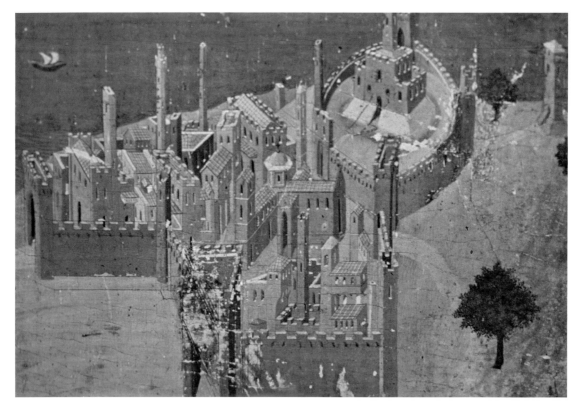

Fig. 7. Siena, Galleria Nazionale: Pittura su tavola con veduta di città marittima, attribuita al Sassetta o alla sua scuola.

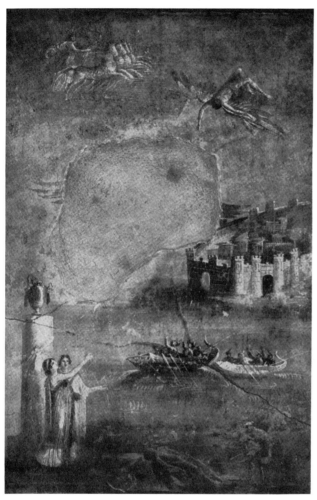

Fig. 8. Pompei, Casa del Sacerdos Amandus. Pittura parietale con raffigurazione della caduta di Icaro nei pressi dell'isola di Creta.

e ghiacciato. Per tale motivo l'effetto complessivo risulta tanto simile a quello di affreschi medievali (fig. 7) e, per effetto anche della particolare copertura delle torri, sembra di essere in un castello medievale incantato, di un medioevo ricostruito nei racconti delle fate di età romantica.

Non v'è immagine di città nel mondo greco-romano che si possa avvicinare alla nostra per misura e per minuzioso realismo descrittivo. La maggioranza di raffigurazioni di città nell'arte greca e romana si riduce ad un'immagine schematica, sintetizzata dalla rappresentazione delle mura e, talvolta, di radi edifici al suo interno. Un esempio è la veduta della città di Cnosso nella larga veduta marina che fa da sfondo alla caduta di Icaro, come bene esemplificato da un affresco, inserito in una decorazione di III stile, nella Casa del Sacerdos Amandus a Pompei (fig. 8).

Non sono confrontabili neppure quelle piccole vedute di paesaggio che sembrano riflettere le esperienze della pittura paesistica maturate nella bottega di Studius (o Ludius) in età augustea, l'artista che, come afferma Plinio (*NH* 35.116), per primo inventò l'assai leggiadra pittura delle pareti raffigurandovi motivi di genere a sfondo paesaggistico (*topiaria opera*), come case di campagna, porti e città marittime.

Da questa tradizione dipendono anche le piccole vedute di ville desunte da decorazioni parietali di fine III e di IV stile, simili ad alcuni dettagli dell'affresco del colle Oppio per la miniaturistica definizione delle strutture, ma di piccolo, o piccolissimo, formato, ed il paesaggio marittimo da una villa di Stabia, fittamente edificato, con il caratteristico molo ad arcate su cui sono collocati archi sormontati da tritoni, e colonne con statue onorarie (fig. 9).

Nessuno di questi affreschi riproduce intenzionalmente un paesaggio reale, pur essendo composto da elementi che possono imitare la realtà. Nella maggioranza dei casi, essi adoperano un repertorio di genere che si ripete e trasmette con relative varianti, spesso smontando e rimontando le singole componenti del quadro per creare nuovi effetti visivi.

Inoltre quasi tutte queste scene paesistiche sono popolate di figurine che si muovono dinanzi agli edifici, trasformati quasi in una quinta fastosa e scenografica di un set teatrale. C'è in esse, normalmente, una vitalità che contrasta con l'assurdo vuoto di una città vista nella luce diurna che ricorda, piuttosto, le fantastiche scenografie del II stile maturo, come gli agglomerati di case sui pannelli del cubicolo M dalla villa di P. Fannio Sinistore a Boscoreale.

Anche l'effetto prospettico complessivo è spesso differente. Nell'affresco del colle Oppio è come se l'esigenza primaria nella raffigurazione fosse quella di mostrare quanto più possibile e con maggiore chiarezza, sì che l'immagine, pur non essendo a veduta zenitale, è ribaltata sul piano verticale della parete secondo una proiezione falsata. L'ottica della raffigurazione, più

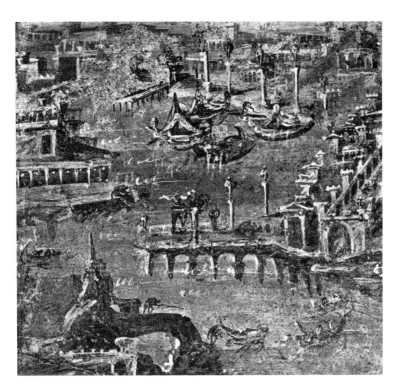

Fig. 9. Napoli, Museo Nazionale. Affresco da *Stabiae* con raffigurazione di una città portuale.

che "atmosferica", è descrittiva e "cartografica", come avviene ancora al giorno d'oggi nelle più diffuse mappe turistiche che mostrano le città in veduta assonometrica, e spesso privilegiando alcuni dettagli — di solito i principali monumenti storici — rispetto all'insieme.

Un brano dell'opera geografica di Tolomeo, dove l'autore illustra le basi metodologiche del suo lavoro, aiuta forse all'individuazione delle coordinate più idonee all'interpretazione dell'affresco (Ptol., *Geogr.* 1.1.1 ff.):

> La geografia è una imitazione ottenuta per mezzo del disegno di una parte della terra. E differisce dalla corografia poiché quest'ultima presenta piccole frazioni di terreno raffigurando anche i particolari minimi come porti, villaggi, demi, ruscelli e simili ... La corografia cura al massimo grado di riprodurre l'aspetto qualitativo dei particolari, laddove la geografia ha la preoccupazione della loro quantità; mentre quest'ultima pensa alla simmetria disegnativa dei dati, l'altra, la corografia, ne cura la somiglianza.

Ambedue i metodi, quello geografico e quello corografico, hanno per i Greci una valenza figurativa, e quindi artistica, di non scarsa rilevanza. E se per le carte corografiche il fatto è in qualche modo intrinseco al sistema adottato per la loro realizzazione, altrettanto si evince complessivamente per ogni tipo di cartografia, come è esplicitato dall'uso dei termini γραφή (γεογραφεῖν) e *pinax* in sua funzione. Nel suo testamento, Teofrasto richiede espressamente che i *pinakes* sui quali erano raffigurati i mappamondi fossero appesi nel portico inferiore del Peripato: un precedente, sembra, dell'*orbis pictus* di Agrippa. A quest'ultima celebrata carta, collocata, come è noto, in una *porticus* nel Campo Marzio, Plinio si riferisce usando il termine *spectare* (Plin., *NH* 3.17). Esso equivale quasi al termine θεασάμενος adottato da Polibio in funzione delle vedute di città di cui parla nella premessa alla sua opera per chiarire le motivazioni per la composizione di una storia universale (Polyb. 1.4.6):

> ... così come non si può credere di avere esattamente compresa la configurazione del mondo e tutte le disposizioni e gli ordinamenti di esso solo per aver visitato le più illustri città una per una, o per averle viste raffigurate l'una separata dall'altra

Sia nella testimonianza pliniana, sia in quella di Polibio, i termini tendono a sottolineare il senso di ammirazione e di contemplazione nel vedere. In Polibio c'è qualcosa di più: una sorta di verifica che nel II sec. a.C. esistevano raffigurazioni di città che potevano essere esaminate secondo serie affiancate pur essendo scollegate l'una dall'altra.

Qualche ulteriore strumento di lettura è desumibile da un'interessante nota di Diodoro (*Exc.* 31.18.1-3). Sempre nel II sec. a.C. era attivo a Roma un *topographos* di nome Demetrios, certamente rinomato se Tolemeo VI Filometore fu suo ospite quando venne a Roma. Non si capisce direttamente dal termine se fosse un pittore di paesaggio oppure un vero e proprio cartografo. Ma Tolomeo può forse aiutare di nuovo (Ptol., *Geogr.* 1.1.6). Egli dice che la geografia si appoggia a semplici linee ed iscrizioni, che la corografia, al contrario, indaga il dominio della topografia, e quindi vuole la mano di un vero pittore. La topografia abbraccia come concetto sovraordinato ogni maniera di pittura di paesaggio; ma di un paesaggio speciale, quello che riproduce la realtà, di contro alla *topothesia* che al contrario imita il verosimile ed è quindi adottata per i paesaggi di fantasia, come si desume da due fondamentali glosse di Servio a commento dell'Eneide (Serv. *ad Aen.* 1.159), e di Lattanzio a commento della Tebaide di Stazio (Lact. *ad* Stat. Theb. 2.32). La corografia perciò assume gli strumenti della *topographia* a servizio della geografia. Il *topographos* è quindi pittore di paesaggi che può anche dipingere corografie, cioè carte territoriali, in fin dei conti come è avvenuto fino al secolo scorso, e come documenta in modo magnifico, per la qualità e la varietà dei prodotti, la Galleria delle Carte Geografiche nei Palazzi Vaticani. Il grande mosaico di Palestrina, che mostra in forme semplificate il percorso del Nilo dalle sorgenti alla foce con le specie animali che lo abitavano e con taluni altri dettagli paesistici, è importante documento di un discorso in tal senso, dove l'elemento squisitamente geografico, ed in realtà assai limitato, quasi un suggerimento, si coniuga con una tecnica pittorica di paesaggio, opera certamente di un artista specializzato in tal senso.

Non credo che ci possano essere dubbi che l'affresco del colle Oppio sia un documento superstite di questa pittura corografica eseguita da un *topographos*, che abbia cioè una funzione non esclusivamente artistica, ma cartografica, quindi eminentemente descrittiva e simbolica. Di qui anche il particolare taglio prospettico e la mancanza di figure che, in tale ambiente, sarebbero state inserite secondo moduli non coerenti con la visione organica dell'arte della cultura figurativa greca.

Tracce di tale genere pittorico erano presenti a Roma già prima di Demetrios. Nel 174 a.C. il consolare Ti. Sempronio Gracco aveva fatto dipingere la *forma* dell'isola Sardinia nel tempio di Mater Matuta (Liv. 41.28.10). All'interno del perimetro dell'isola erano raffigurati *simulacra pugnarum* — secondo la più comune opinione scene di battaglia cui aveva partecipato il console. Un altro Sempronio, P. Sempronius Sophus, nel 268 a.C. aveva dedicato il tempio di Tellus nel quale, almeno nel 59 a.C. circa, secondo la testimonianza di Varrone (*RR* 1.2.1), era visibile una *Italia picta*, che va considerata verosimilmente una carta geografica dell'Italia. Nel 146 L. Ostilio Mancino, che si candidava a console, fece apporre una grande tavola dipinta nel Foro Romano su cui era raffigurata la zona e l'assedio della città di Cartagine durante la terza guerra punica. Il candidato era entrato per primo nella città assediata, e nel foro narrava le sue imprese con l'aiuto della rappresentazione: fu eletto console (Plin., *NH* 35.23). La tecnica figurativa di queste tavole non è conosciuta; ma si dovrà immaginare una soluzione analoga a quella adottata per il mosaico nilotico di Palestrina o meglio, come ha giustamente proposto G. Rodenwaldt, per le *tabulae Iliacae*, dove elementi di paesaggio visti dall'alto si congiungono a raffigurazioni animate viste al contrario ad altezza d'occhio, secondo schemi irregolari a fasce. Da questa tradizione, della quale ci è conservato solo un frammento di affresco dall'Esquilino con scene di espugnazione di una fortezza e di consegna di *dona militaria*, discendono i rilievi della Colonna Traiana, della Colonna di Marco Aurelio e dell'arco di Settimio Severo. Proprio i rilievi della Colonna Traiana mostrano la contraddizione intrinseca al sistema, nella incoerenza dal punto di vista prospettico del rapporto tra figure e paesaggio, una incoerenza che si traduce in una felice, ancorché pericolosissima risoluzione artistica. Di questo enorme campo della cultura figurativa antica, fondamentalmente eclettico, ed i cui derivati rispondono ad esigenze funzionali assai differenti, restano purtroppo scarsissime tracce.

Tornando più specificamente al discorso della veduta "corografica" di città, una eclettica serie di documenti che, a partire dall'età tardo-repubblicana, e pur con differenze talora consi-

Fig. 10. Chieti, Museo Nazionale. Frammento di rilievo da Avezzano con veduta di città (dal calco a Roma, Museo della Civiltà Romana).

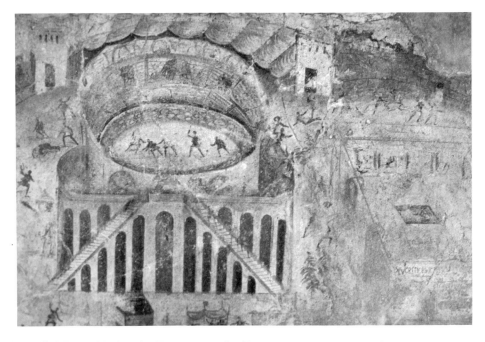

Fig. 11. Napoli, Museo Nazionale. Frammento di affresco da Pompei, con raffigurazione della lotta tra Pompeiani e Nucerini presso l'anfiteatro.

stenti, sembrano ubbidire alla stessa regola, ci convince che raffigurazioni del genere dell'affresco del colle Oppio dovevano esistere.

Un dato molto significativo è offerto dai rilievi detti di Avezzano. Vi era raffigurata, a volo di uccello e con una certa approssimazione, una città fortificata sulle pendici di un colle (si tratta verosimilmente della città di Alba Fucens) ed il suo immediato entroterra, con una villa rustica tra gli alberi e casali ai lati di un sentiero (fig. 10). Altri due frammenti mostrano edifici pubblici ornati da statue. Un quarto rilievo raffigura una distesa d'acqua con barche, alberi ai bordi, ed operai che svolgono un lavoro di estrazione di terra da pozzi verticali a

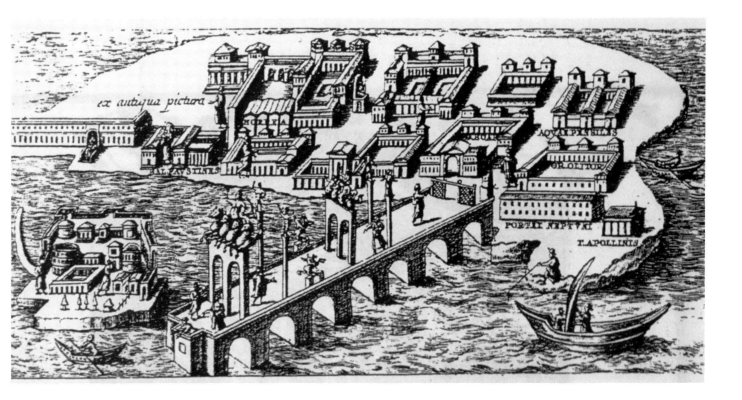

Fig. 12. Roma, Colle Oppio. Affresco (ora perduto) con raffigurazione di città marittima. Stampa da in disegno di Pietro Santi Bartoli.

mezzo di un'armatura e di argani. Nella sua interezza il pannello a rilievo doveva essere simile ad una tavola corografica in prospettiva aerea, rappresentante il territorio del Fucino e contemporaneamente il gigantesco lavoro di bonifica operato da Claudio.

Ai rilievi di Avezzano può essere affiancato il celeberrimo affresco con la zuffa tra pompeiani e nucerini avvenuta nell'anfiteatro pompeiano nel 59, e ricordata anche da Tacito (fig. 11). Non è tanto la qualità pittorica ad interessare nel piccolo affresco, né il tipo di veduta a volo d'uccello, che denuncia modi contraddittori di proiezione e forti deformazioni ottiche, quanto la volontà di descrivere, sebbene con ingenue semplificazioni, un evento realmente accaduto ed inserirlo fedelmente nel suo ambiente naturale.

Ma il documento più significativo di confronto resta in ogni caso la veduta di città marina su un affresco rinvenuto in un corridoio a poche decine di metri di distanza dal criptoportico delle terme di Traiano, ed ora purtroppo conosciuto solo attraverso la documentazione grafica eseguita da Pietro Santi Bartoli che, nel 1668, aveva avuto l'occasione di vedere l'eccezionale scoperta (fig. 12). Il lungo corridoio era pertinente ad una struttura edilizia molto più ampia, ricoperta in origine di mosaici e di affreschi che, in base a quanto è preservato, dovrebbero essere databili nell'ambito del III sec. d.C.

L'affresco ha stupefacenti somiglianze con la veduta di città sull'affresco del colle Oppio. E' raffigurato un centro urbano come su un'isola (ma il disegnatore potrebbe aver confuso il colore neutro del cielo all'orizzonte, collegato alla mediocre conservazione del dipinto, con una distesa d'acqua), di fronte alla quale si colloca un'isoletta molto più piccola. Su ambedue le isole si distribuisce una serie di edifici perfettamente delineati in prospettiva a volo d'uccello, distinti in dettaglio e talvolta identificati tramite una didascalia. Sono così riconoscibili il

bal(neum) Faustines (sic!), gli *horrea*, il *forum Boarium*, le *aquae pensiles*, il *forum Olitorium*, la *portex Neptuni*, il *t(emplum) Apollinis*. La maggioranza degli edifici è composta per lo più da quadriportici con tipologie differenziate sul cui lato di fondo si elevano torrette con tetto piramidale. Dall'isola maggiore si protende nell'acqua un molo ad arcate, secondo lo schema già noto nell'affresco di Stabia e nelle ampolle vitree con raffigurazione di Puteoli. Nel paesaggio sono inserite alcune figure umane; in qualche caso sembrerebbero statue colossali sia per la loro collocazione sia per la misura eccedente il vero rispetto alle strutture che le affiancano.

Non è assolutamente possibile identificare l'affresco disegnato da Bartoli con l'affresco dalla galleria delle terme di Traiano. Si oppongono la cronologia e le differenze iconografiche, a partire dalla mancanza delle mura cittadine, del teatro e degli edifici per abitazione, che nell'affresco conservato sono rappresentati con la massima evidenza. Non v'è traccia, nell'affresco ora rinvenuto, del molo decorato con archi e statue, né v'è traccia di didascalie ai monumenti. Restano alcune analogie dovute al modo di riproduzione della veduta a volo d'uccello, e la possibile identificazione, in ambedue i casi, con città marine aventi complessi monumentali su un'isoletta o su un promontorio circondato dalle acque.

Per il modo della ripresa dall'alto e per il raggelato nitore descrittivo, le opere finora citate sembrano essere state eseguite tutte secondo le tecniche della rappresentazione "corografica", come descritta da Tolomeo.

In questo ambito credo che rientrino anche alcune emissioni monetali repubblicane che, malgrado la sinteticità dell'immagine che rasenta l'ideogramma, compensano in qualche modo la carenza di documentazioni alternative, e fungono da ponte, quasi, tra il riferimento di Polibio a vedute di città e l'affresco del colle Oppio.

Su un denario di C. Considius Nonianus, della metà circa del I sec. a.C., è raffigurato il monte Erice, con il tempio di Afrodite visto sul monte raffigurato come una struttura rocciosa, e circondato dalla cinta muraria in opera quadrata con porta d'accesso centrale (fig. 13). La pianta segue regole elementari di simmetria. Come talora avviene in queste immagini fortemente contratte, alcuni elementi del paesaggio sono visti come di fronte, mentre la curvatura delle mura dà l'impressione di una veduta a volo d'uccello. Simile, ma ancor più semplificata, la coeva veduta di Tusculum su un aureo di L. Servius Rufus, con porta-torre centrale e segmenti di muratura che compongono un anello entro il quale si innestano altre nove torri. La leggenda *Tuscul(um)* è su una targhetta al centro della porta-torre. In un bronzo di Pella in Macedonia,

Fig. 13. Denario di C. Considius Nonianus (57 a.C.). Veduta di Erice con il santuario di Afrodite Erycina.

Fig. 14. Atene. Emissioni in bronzo della metà circa del III sec. d.C., con veduta dell'acropoli dalle pendici occidentali verso l'ingresso principale (a), e dalle pen·dici meridionali verso il teatro di Dioniso (b).

 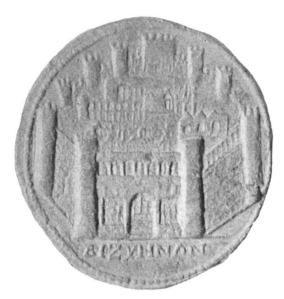

Fig. 15. Neapolis di Samaria. Emissione in bronzo Fig. 16. Bizya (Tracia). Emissione in bronzo dell'età di Antonino Pio, con veduta del monte Gerizim. dell'età di Filippo l'Arabo con veduta della città.

verosimilmente della fine del I sec. a.C., la città è simbolicamente rappresentata dalle sue mura disposte regolarmente a cerchio, con sei torri circolari con tetto a cono.

Gli schemi repubblicani individuano un filone di rappresentazioni di città a veduta dall'alto che avrà una certa diffusione lungo l'intero arco dell'età imperiale, sebbene raramente a Roma stessa, ma piuttosto nel bacino orientale del Mediterraneo.

Secondo la tecnica della veduta a maggiore distanza sono state realizzate le vedute su due bronzi ateniesi della metà circa del III sec. d.C., che raffigurano l'acropoli da due punti differenti, dall'ingresso principale — con talune variazioni nella disposizione dei propilei e della cordonata d'accesso — con uno sguardo sulle pendici settentrionali, e dalla pendice meridionale, dove è collocato il teatro di Dioniso (fig. 14). Non c'è dubbio che, malgrado la semplificazione, inevitabile vista la limitatezza del campo, e l'altrettanto inevitabile riduzione a forme più o meno stilizzate, si sia voluto offrire una riproduzione quanto mai fedele del sito; e, per una circostanza altrettanto fortunata, è possibile verificarne la soluzione.

Di qui a disegnare in formule elementari ma attendibili l'intera città il passo è breve. L'esempio a mia conoscenza più antico è la veduta di Amaseia nel Ponto in un'emissione dell'età di Domiziano, ripetuta poi con talune varianti in bronzi dell'età di Severo Alessandro. La città è individuata attraverso le sue torri merlate non collegate tra loro da mura, e attraverso la collocazione a piani differenti, su uno sperone roccioso, di altari ed edifici templari. In basso, nell'edificio esastilo, dovrà riconoscersi il tempio dedicato agli imperatori romani; al suo fianco, in quello che sembra essere un taglio regolare nella roccia, si deve riconoscere una tomba dei principi del Ponto, forse quella del capostipite della dinastia, Mitridate I. Esclusivamente sui bronzi di Severo Alessandro, più in alto è un tempio tetrastilo visto di tre quarti, con altare sulla fronte: dovrebbe trattarsi del tempio di Zeus Stratios. In un'emissione di Neapolis in Samaria risalente all'età di Antonino Pio, ma in seguito replicata più volte, è raffigurato un paesaggio montagnoso con duplice cima, nel quale deve riconoscersi il monte Gerizim, sacro ai Samaritani, su cui era collocato il tempio adrianeo di Zeus Hypsistos (fig. 15). Si tratta di una autentica veduta paesistica planare, sebbene compressa nel tondo monetale.

Infine le città murate. Può servire da esempio un'emissione di Bizya in Tracia, dell'età di Filippo l'Arabo (fig. 16). In questo caso è data particolare evidenza alle fortificazioni con torri ed alla porta d'accesso alla città, con loggiato superiore dal quale si affacciano busti, riccamente ornata di rilievi alle pareti laterali, e coronata con un gruppo raffigurante verosimilmente Zeus con folgore su quadriga al galoppo. All'interno delle fortificazioni si scorgono edifici a doppio ordine di colonne, forse porticati, una basilica, colonne onorarie con statua sulla cima, infine strutture "a schiera" con falde a doppio spiovente (un edificio termale?).

Minore interesse hanno, ai fini dell'interpretazione dell'affresco del colle Oppio, le vedute di città — e a volte del territorio circostante — sui codici miniati, sia per la loro cronologia, sia perché risultano essere per lo più vedute ideogrammatiche a carattere simbolico e quindi, nella loro effettiva esecuzione, poco naturalistiche. Ma, come nel caso dell'affresco del colle Oppio, le città sono molto spesso spopolate; e l'immagine, anche se ridotta ad ideogramma, contiene alcuni elementi specifici, direi "realistici" che vogliono definire quelle città rappresentate, e solo quelle. Eppure il sistema di trasmissione e la volontà di semplificazione hanno come svuotato di contenuto le vedute, trasformandole in vignette un po' stereotipe, e connettendole con quelle più antiche vedute di città fortificate, delle quali l'affresco della Casa del Sacerdos Amandus con la raffigurazione della caduta di Icaro è un testimone esemplare.

Questo vale, in rapidissima sintesi, per le miniature annesse ai testi dei gromatici, che almeno documentano l'esistenza di una cartografia a carattere eminentemente tecnico tesa a riprodurre piccole porzioni di territorio secondo il metodo corografico, quindi pittorico, e nelle miniature del codice Vaticano Latino 3225, il c.d. Virgilio Vaticano, databile nel IV-V sec. Qui Cartagine è raffigurata idealmente con edifici entro le mura: la fortificazione è esagonale, e al suo interno ci scorgono un teatro, un quadriportico, ed edifici con tetti a doppio spiovente. La novità, in questo caso, è la presenza, come sull'affresco del Colle Oppio, di statue di bronzo dorato, alcune all'esterno (tra cui una quadriga) ed altre all'interno delle strutture. Il nome della città è sulle mura, quasi che le fortificazioni ne definiscano l'essenza.

Scarso rilievo hanno, in questo ambito, sia le vedute cristiane della Gerusalemme celeste, tipologicamente simili e comunque destinate a rappresentare una città ideale, sia le raffigurazioni di città che bordano come una cornice i mosaici pavimentali di alcune chiese giordane, datati tra la metà del VI e la metà dell'VIII secolo, che sembrano derivare da una tradizione parallela. Queste immagini sono simboliche e non aderenti al vero se non per alcuni dettagli. Analogo discorso vale per la "carta di Madaba" della metà circa del VI sec. d.C., un mosaico nel quale era rappresentato, secondo un sistema corografico, ma con una forte semplificazione cartografica memore anche degli *itineraria* romani, il territorio compreso tra Egitto e costa della Fenicia.

Ma deve essere avanzato almeno un altro confronto, perché risulta una sicura testimonianza di una persistenza di modelli di raffigurazione di città concrete dall'antichità al Medioevo. Si tratta della veduta di Verona tratta da un codice contenente un poemetto che canta le lodi di Verona ed altri lavori miscellanei, appartenuto a Raterio vescovo di Verona, e che il prelato avrebbe fatto realizzare al momento di lasciare la sua amata città per andare a Lobbes nel 968. Perduto il codice, si conosce una copia della miniatura eseguita nel XVIII sec. da Scipione Maffei (fig. 17). La tavola è unica nel suo genere; è data maggiore importanza agli edifici antichi, ma con essi sono mescolati quelli cristiani in unità inscindibile. La veduta della città non è "convenzionale", ma sembra voler ricordare al vecchio Raterio i monumenti della "sua" città con diligenza e chiarezza. La città è murata, e le mura sono quelle sia romane sia teodericiane; sono perfettamente delineate le alte torri quasi tutte a copertura cuspidata, rotonde, e la grande porta di travertino d'accesso alla città. All'interno delle mura l'Adige taglia la città ed è superato dal *pons marmoreus*. Ci sono il *theatrum* (l'anfiteatro) in primo piano, i *gradus* che portano alla chiesa di S. Pietro situata sul *mons*; e al di là del fiume l'*arena minor* (il teatro) ancora decorato con fregi a girali, poi il *palatium* di Teoderico, l'*horreum* della città e fuori le mura la chiesa di S. Maria in Organo (scritto *orfanum*). La varietà di forma delle torri e dei tetti indica la volontà di essere simili al vero, ed induce in tal senso anche un verso che fa da cornice alla tavola, in alto: "*de summo montis castrum prospectat in urbem daedalea factum arte viisque tetris*". Passato e presente convivono insieme in questa pianta; anzi, è dato maggior valore agli elementi di un lontano e magico passato, visto e vissuto con ammirazione anche se non abitato dal vero Dio. Mi sembra fin troppo evidente l'immagine per spendere troppe parole sull'assonanza della pianta con l'affresco del colle Oppio. Anche questa tavola dipende, evidentemente, da composizioni precedenti, e la caratteristica presenza della testa di una personificazione fluviale dalla cui bocca scaturiscono le acque dell'Adige non può non essere

Fig. 17. Verona, Biblioteca Capitolare. Veduta di Verona. Copia eseguita da Scipione Maffei dalla miniatura di un codice (perduto) del X secolo appartenuto a Raterio, vescovo di Verona.

Fig. 18. Monaco di Baviera, Bayerisches Hauptstaatarchiv. Bolla d'oro di Ludovico il Bavaro.

memore di modelli romani. Ma l'importanza della raffigurazione è che si tratta di una città vera, riprodotta sì sinteticamente, ma non ridotta ad ideogramma, semplificata rispetto al reale (mancano ad esempio le case) ma non trasformata in puro elemento simbolico. I secoli futuri vedranno molte riproduzioni "semplificate" di città, nelle quali la scelta è oculatamente ridotta alle strutture monumentali essenziali, sia pure perfettamente riconoscibili. Così è, fra l'altro, la celeberrima bolla di Lodovico il Bavaro del 1328 raffigurante una Roma denotata in base a pochi ma chiaramente delineati monumenti (fig. 18). Eppure sarà difficile recuperare un'immagine altrettanto articolata se non verso la fine dell'età medievale. La pianta di Verona è uno dei tanti documenti della rinascenza dell'antico che costellano l'intero percorso medievale.

Direttamente correlato al sistema urbanistico della città sull'affresco del colle Oppio è il problema della sua identificazione. Purtroppo l'entusiasmo per la scoperta, avvenuta nel cuore di Roma e nei paraggi di alcuni tra i più straordinari complessi monumentali della città antica, ha provocato immediatamente una ridda di ipotesi basate su pochissimi elementi e su criteri

fin troppo soggettivi. In realtà, selezionare i dati certi da quelli incerti è impresa rischiosa, compromessa anche dallo stato di conservazione dell'affresco, sul quale stanno ancora procedendo i lavori di restauro e di ricomposizione dei numerosissimi frammenti dei bordi rinvenuti durante lo scavo.

Si possono, tuttavia, offrire alcune coordinate di analisi, pur entro i limiti odierni della ricerca. Si tratta probabilmente, come ho detto, di una città marittima e portuale, con acropoli affacciata sul mare, e fittamente abitata, visto che le case si affollano lungo le mura, ed anche al di fuori di esse, sul porto. In età ellenistica e/o giulio-claudia la città ha subìto un'opera di ristrutturazione del suo centro che ha comportato la costruzione, o il restauro, del teatro e del foro. Altrettanto interessante è quanto sull'affresco non è raffigurato, sempre che le lacune pittoriche non ingannino. Non c'è l'anfiteatro, sebbene si potrebbe supporre una sua presenza periferica. Non ci sono le terme, e questo vuol dire che siamo in un periodo in cui le terme non sono elemento fondante dell'immagine di una città antica.

Sulla base di questi dati, che in linea di principio possono essere attribuiti a numerosissimi centri urbani del Mediterraneo, voler riconosce la città è al momento, secondo il mio parere, prematuro. Conviene piuttosto soffermarsi sul quadro in sé e su quanto ci racconta su come i Romani descrivevano una loro città, sul procedimento mentale che ha prodotto quella particolare scelta di monumenti da rappresentare, sul modo di descrivere lo spazio, sul colore, in una parola sulla percezione dell'ambiente contestualizzato e dell'atmosfera di una città antica. Che poi la città sia Arles, come è stato proposto con buone, ma non interamente persuasive, argomentazioni, o Antiochia o qualsiasi altra città marittima, è in fin dei conti un fatto relativo rispetto all'enorme patrimonio di nuove conoscenze che l'affresco ci ha offerto.

Ma il vero, principale elemento utile ad un eventuale riconoscimento della città sull'affresco potrebbe essere desunto dalla sua collocazione e dall'interpretazione della struttura cui era pertinente. Logica vuole che altre raffigurazioni di città comparissero sulle vele tra le arcate del complesso monumentale pre-traianeo: e le città devono essere state scelte secondo un criterio speciale. L'affresco superstite è a lato di quella che, in base alla sua inusitata larghezza, dovrebbe essere considerata l'arcata principale. Vuol dire che la città raffigurata aveva un'importanza speciale, dato il posto che occupava.

L'ipotesi che qui si avanza con tutte le cautele, concordemente all'intervento precedente, pur essendo conscio delle difficoltà che ne possono derivare, è di riconoscere nella parete ad arcate i resti della fase flavia della *praefectura Urbi* che, come è noto per altre vie, si trovava in età tardo-antica nelle vicinanze del tempio di Tellus e delle terme di Traiano. Alcuni elementi, non probanti ma di sicuro significativi, tendono a riportare nell'area del tempio di Tellus, collegata all'ufficio del *praefectus Urbi*, la presenza di corografie, come deve essere considerata la raffigurazione dell'*Italia picta* citata da Varrone. E' stato visto che non può trattarsi di una personificazione dell'Italia, ma piuttosto di una carta che, essendo *picta*, deve avere qualche addentellato con l'opera dei pittori, esattamente come nel caso delle corografie. Non vedo motivo per non datare la carta al momento stesso dell'erezione del tempio di Tellus ad opera di P. Sempronius Sophus, nel 268 a.C. Come è noto, la data assume simbolicamente un valore fondamentale perché, dopo le vittorie su Pirro (275 a.C.), dopo le conquiste di Taranto (272 a.C.) e di Reggio (270 a.C.), Roma diventava padrona della penisola italiana creando le premesse per la sua unificazione politica ed amministrativa entro quei limiti geografici che avrebbe conservato fino al 42 a.C., quando le fu annessa la Cisalpina. E' anche il momento in cui l'etimo, per ragioni eminentemente politiche, e romane, si trasmetteva dalla Magna Grecia all'intera penisola. In età tardo-repubblicana, dismessa l'originaria valenza, la dea Tellus tende ad identificarsi con la *Saturnia Tellus*, l'Italia generatrice di uomini e di frumenti, come canta Virgilio.

Non so se questa rinnovata valenza abbia fatto privilegiare l'area tellurense, che occupava probabilmente l'area ora compresa tra via della Polveriera e via delle Terme di Tito, per gli uffici del *praefectus Urbi* ubicati a loro volta, almeno in età tardo-antica, tra la chiesa di S.

Pietro in Vincoli, la piazza antistante, via della Polveriera, via del Colosseo e via dei Frangipane (già via di S. Pietro in Vincoli). Basi di statue e dediche a (o di) prefetti rinvenute nell'area, un editto di Turcius Apronianus (prefetto nel 363-64 d.C.) e i frammenti di un secondo editto di Tarracius Bassus, due iscrizioni di Iunius Valerius Bellicius (prefetto tra il 408 cd il 423 d.C.) che menzionano una *porticum cum scriniis Tellurensis secretarii tribunalibus adhaerentem* e lavori di restauro della sede della prefettura (dopo il sacco di Alarico?), gli *acta Martyrum* che riferiscono di processi ed anche di esecuzioni capitali ordinati dal prefetto urbano, assicurano la presenza nell'area della *praefectura Urbi* e più specificamente degli archivi (*porticus cum scriniis*), degli uffici veri e propri e delle sale di udienza normalmente chiuse al pubblico (*secretarium*), inoltre dei luoghi forniti di suggesti dove il prefetto amministrava la giustizia (*tribunalia*). Non doveva mancare, probabilmente, un legame con le terme di Traiano se, come denuncia un'iscrizione tracia del 238 d.C., decreti erano affissi *in porticu thermarum Traianarum*: non labile indizio che copie degli editti conservati negli archivi fossero collocati per visione pubblica in un'area limitrofa. Assai dubbia, ma significativa per la contiguità dei monumenti è un brano della *passio SS. IV Coronatorum*, dalla quale risulta che i *urbanae praefecurae milites* erano obbligati da Diocleziano a sacrificare in un *templum Asclepii in thermas Traianas*.

Certamente, se volessimo guardare nel panorama romano antico, non vi sarebbe uno spazio migliore per presentare, come in sequenza su pareti porticate, forse secondo uno schema non dissimile da quello descritto sommariamente da Polibio, vedute di città che rappresentassero la gloria e l'opulenza dell'Italia antica. Persino l'affresco con satiri vendemmianti intravista con una sonda nel vano a torre alle spalle dell'arcata principale si inserirebbe perfettamente bene entro questo contesto di pacificazione. Di più al momento non mi arrischio di dire.

<div align="right">Sovrintendenza Comunale di Roma</div>

Questo articolo è una versione abbreviata, senza note, di un testo monografico sull'argomento, in avanzato corso di elaborazione, ma che per la pubblicazione definitiva attende il completamento delle indagini tecniche e dei restauri sull'affresco. Nella terra di riempimento del criptoportico sono stati rinvenuti, infatti, centinaia di frammenti, per lo più attribuibili ai bordi del grande dipinto, dei quali è tuttora in corso la ricomposizione.

Referenze fotografiche

Figg. 1-5. Foto Sovraintendenza ai Beni Culturali del Comune di Roma.
Figg. 6, 8 e 11. da G. E. Rizzo, *La pittura ellenistico-romana* (1929) tav. CLXXVIII, CLXVII e CXCVIII,2.
Fig. 7. da *Enciclopedia Universale dell'Arte* X (1963) tav. 191.
Fig. 9. da *Le collezioni del Museo Nazionale di Napoli*, a cura dell'Archivio Fotografico Pedicini I I (1986) tav. a p.74.
Fig. 10. Foto Museo.
Fig. 12. da H. Whitehouse, *PBSR* 63 (1995) p. 225 fig. 7.
Fig. 13. da G. Fuchs, *Architekturdarstellungen auf römischen Münzen* (1969) tav. 3, 29.
Figg. 14-16. da M. J. Price, B. L. Trell, *Coins and their cities* (1977) figg. 130, 133, 302, 24.
Fig. 17. da F. Coarelli, L. Franzoni, *Arena di Verona, venti secoli di storia* (1972) fig. a p. 71.
Fig. 18. da R. Krautheimer, *Roma, profilo di una città, 312-1308* (1981) fig. 160.

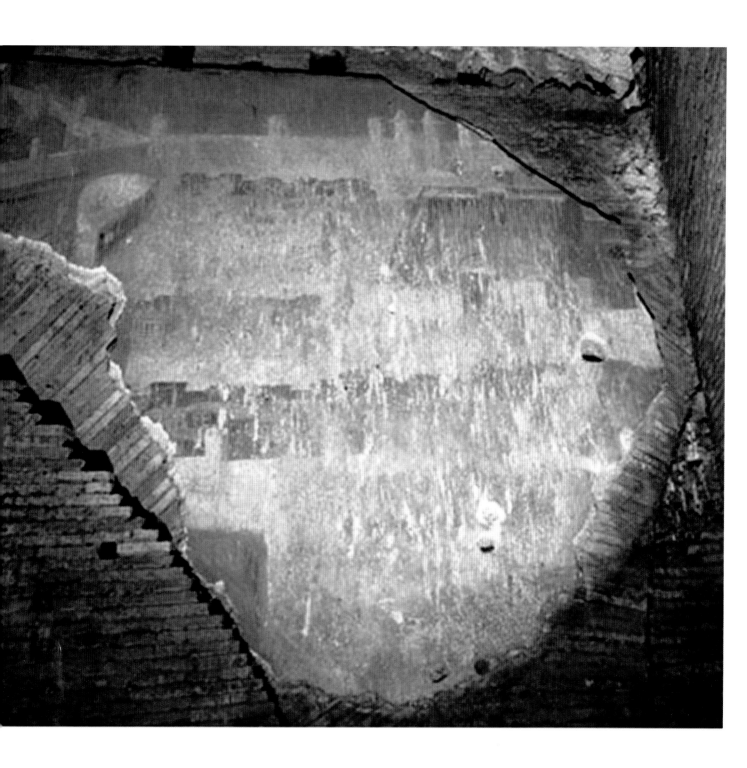

La Rocca fig. 1. Veduta generale dell'affresco rinvenuto nel criptoportico delle terme di Traiano sul colle Oppio.

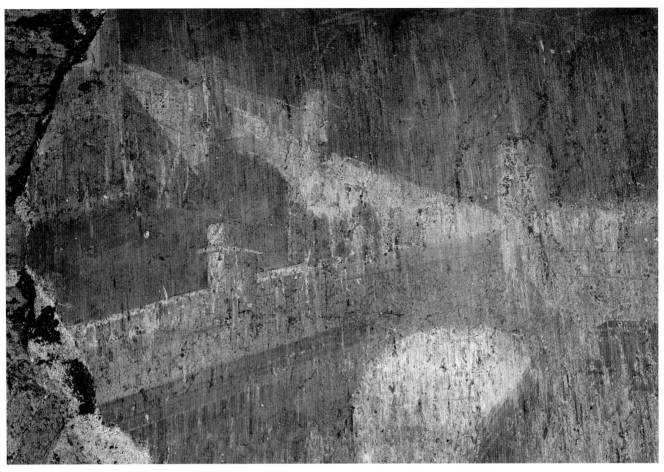

La Rocca fig. 2. Particolare del settore in alto a sinistra dell'affresco.

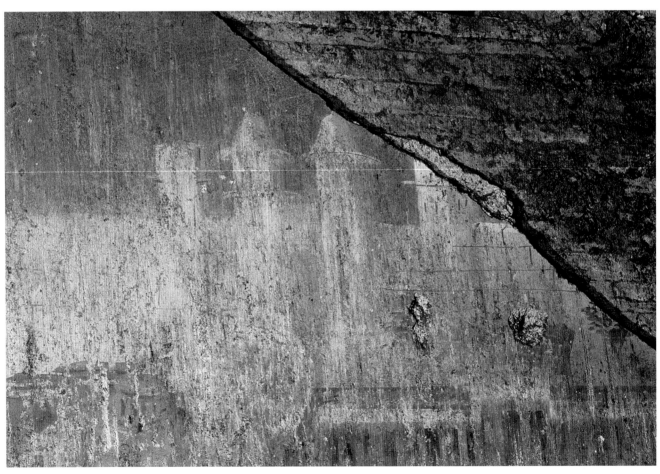

La Rocca fig. 3. Particolare del settore centrale dell'affresco.

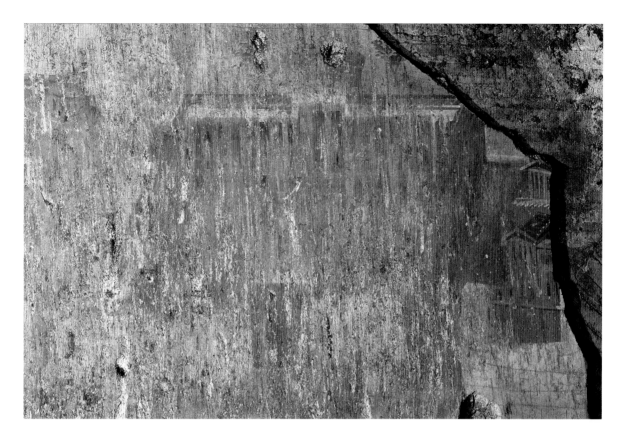

a Rocca fig. 4. Particolare dell'affresco: il quadriportico.

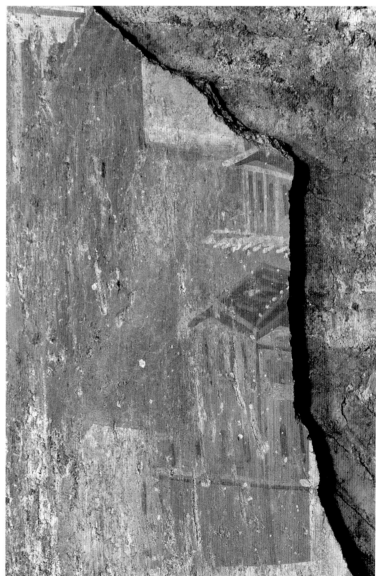

a Rocca fig. 5. Particolare del settore destro dell'affresco.

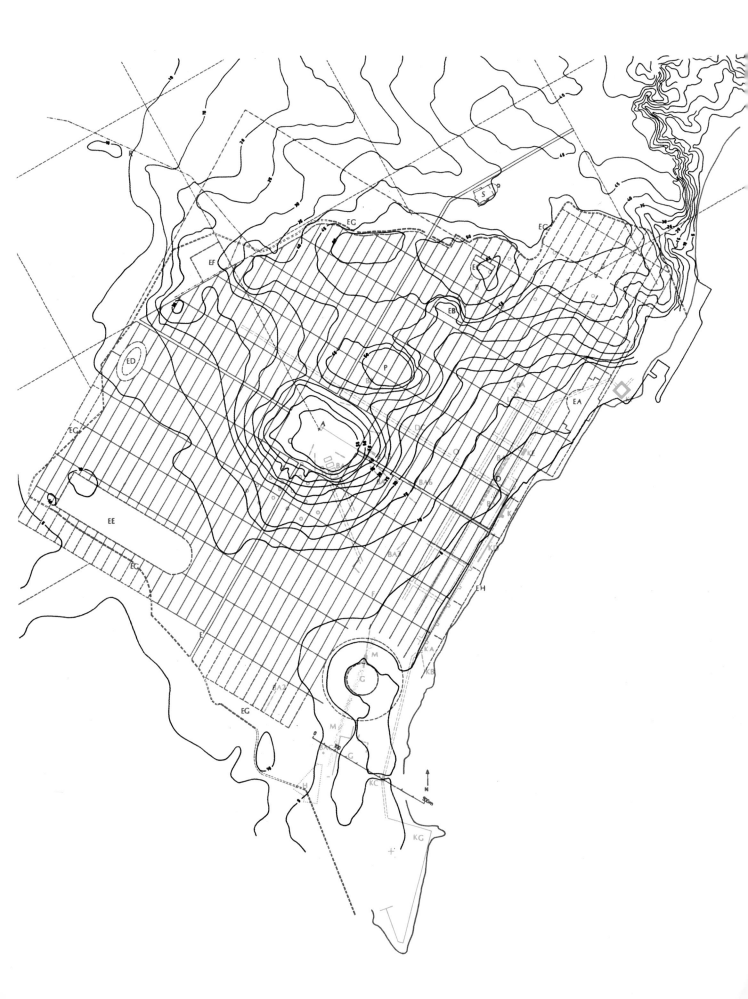

The making of Augustan Carthage
Friedrich Rakob

The *Colonia Concordia Iulia* at Carthage is an exception to the normal pattern of Roman cities.* The new settlement was established neither on previously unencumbered soil nor directly over the obliterated remains of its Punic predecessor. According to Scipio's *devotio* of 146 B.C., the prohibition against settlement lasted over one hundred years, and the finds from excavations in the central area of the city suggest strict compliance with this. The famous anecdote in Plutarch's *Life of Pompey*[1] about his treasure-hunting legionaries gives a vivid image of the state of destruction that characterized Carthage in the 80s B.C. In the central area of the city, between the Byrsa hill and the coast, numerous *sondages* and large trenches have yielded no evidence for settlement activities from these 117 years. The finds show no trace of a Gracchan settlement. This was not situated in the area of the Punic ruins, between the western edge of the Byrsa and the coast, although it might have been established in the northwestern suburban area where the fertile Megara plain, with its evidence of Punic-period residential

Fig. 1 (opposite). Carthage. Punic building alignments (blue) and the plan of the Roman colony (red). Scale 1: 10,000 (from *Karthago* I, plan 34 and Hurst and Roskams [supra n.7] fig. 11).
Key:

A Byrsa position of Roman *groma*

AA Axis of the Roman *decumanus maximus*

B Punic cemeteries

BA 1 ff. Punic building alignments, orthogonal arrangement of settlement in the lower coastal plain, fan-shaped layout on the slopes

C Roman Byrsa plateau

D German excavations

E Outline of the Roman city, end of the 2nd c. A.D.

EA Antonine baths

EB Roman theater

EC Roman odeon

ED Roman amphitheater

EE Roman circus

EF La Malga cisterns

EG Theodosian wall

EH Roman city boundary on coast, second half of 2nd c. A. D.

F Punic agora (?)

G Punic harbors

H Punic tophet

K Punic sea-wall and gate, 5th c. B.C.

KA Foundations of the Punic wall or bastion for gate

KC Foundation of the Punic sea-wall

KD Punic sea-wall, second phase

KE Punic sea-wall, 5th c. B.C.

KF Quadrilateral of Bordj-Djedid

KG Quadrilateral of Falbe

M Canal in the area of the late Punic harbors, filled in the 4th c. B.C.

O Hypothetical prolongation of the Punic sea-gate street

P The hill of Juno

R Roman aqueduct, 2nd c. A.D.

S Extra-urban Basilica of Damous el Karita

U Shoreline in the 5th c. B.C.

* Frequently cited abbreviations:

Gros 1990 P. Gros, "Le premier urbanisme de la Colonia Julia Karthago — Mythes et réalités d'une fondation césaro-augustéenne," *L'Afrique dans l'Occident romain (1er siècle av. J.-C. - IVe siècle ap. J.-C.)*(CollEFR 134, 1990) 547 ff. [with extensive bibliography, description of the state of the excavation and discussion of old and new theories regarding the investigations]

Gros, *Byrsa III* P. Gros, *Byrsa III. Rapport sur les campagnes de fouilles de 1977 à 1980. La basilique orientale et ses abords* (CollEFR 41, 1985)

Karthago I F. Rakob (ed.), *Karthago I. Die deutschen Ausgrabungen in Karthago* (Mainz 1991)

Karthago II F. Rakob (ed.), *Karthago II. Die deutschen Ausgrabungen in Karthago* (Mainz 1997)

Rakob 1991 F. Rakob, "Ein punisches Heiligtum in Karthago und sein römischer Nachfolgebau. Erster Vorbericht" *RömMitt* 98, 33 ff.

Rakob 1995 F. Rakob, "Forschungen im Stadtzentrum von Karthago. Zweiter Vorbericht," *RömMitt* 102, 413 ff.

1 Plut., *Vit. Pomp.* 11.4 ff.

buildings, gardens and agricultural plots, would have offered building ground for constructions on land free of the rubble of the Punic metropolis.

The rural centuriation, on a different orientation than that of the city, is, however, probably contemporary with the Augustan colony.[2] The principal evidence for this is the gigantic La Malga cisterns, located on the edge of the rural centuriation. Its northeastern outer flank, although oriented with the rural centuriation, is exactly aligned with the *groma* of the urban centuriation on the Byrsa[3] (fig. 1, EF). This *groma* thus served to lay out both the rural and the urban centuriation. The fact that both systems are based on this point shows that they must have been contemporary. As we shall see, the building of the Augustan colony entailed truncating the Byrsa hill as much as 9 m. If the rural centuriation had pre-dated this event, it would have been impossible to re-establish the urban centuriation with an identical *groma* position in the new, urban layout with its center on the Byrsa plateau (fig. 1, EF).[4]

In the course of the UNESCO Save Carthage Project,[5] the British, Canadian and Italian excavations on the southern and northern edges of the city yielded unexpected finds. It appears that the urbanization of the northern edges of the city, along the join between the urban and rural centuriations, was completed only in the 2nd c. Around the circular harbour, construction consisted of simple buildings in *pisé de terre*.[6] But it would be ill-advised to consider the earlier Roman colony, established after 29 B.C., as a poorly appointed settlement that only later, during the late Antonine and Severan periods, became one of the greatest metropolises of the ancient world. Information gained from excavations around the periphery of the city cannot be directly applied to its central area.[7] Ancient authors who wrote about the town's character give clear indications of vigorous building that was taking the place of the Punic ruins. Thus Pliny wrote *'colonia Carthago magnae in vestigiis Carthaginis'*.[8] Strabo's description[9] of the glory and prosperity of the new capital can be interpreted, from the results of excavation, not as an ideological transfiguration of a modest present in anticipation of a glorious future, but as the reality of Augustan architectural politics that had not yet been fully carried out.

The fundamental investigations of P. Gros and J. Deneauve on the Byrsa plateau tell another story, for they have revealed the enormous dimensions of the new public center.[10] However,

2 Cf. Gros 1990, 550. For extensive discussion of this hypothesis, these problems, and a summary of investigations, see E. Wightman, "The plan of Roman Carthage: Practicalities and politics," in J. G. Pedley (ed.), *New light on ancient Carthage* (Ann Arbor 1980) 33 ff.

3 There are as yet no datable archaeological finds for this gigantic cistern area. The most recent investigation and bibliography may be found in J. Vérité, *CEDAC Carthage Bulletin* 10 (1989) 41-48, ills. 1-4.

4 Wightman (supra n.3) 38.

5 Summary in A. Ennabli (ed.), *Pour sauver Carthage* (Paris–Tunis 1992) with complete bibliography of the new excavation activities. See L. Anselmino, "Le secteur nord-ouest de la ville," ibid. 125 ff.: "aucune trace de vie urbaine entre 146 - 29 B.C.", but early levels in preparation for urbanization (29 B.C. to 50 A.D): "la trame extrêmement régulière de la colonie a été respecté jusque dans ce quartier périphérique." A preliminary report of this excavation at the city boundary is given by A. Carandini, C. Panella, C. Pavolini *et al.*, in *QAL* 13. The construction of the rural land-register is here dated to soon after the destruction, or a few decades later. For excavations on the northern city border, cf. C. Wells, "Le mur de Théodose," in Ennabli ibid. 115 ff.

6 H. R. Hurst and S. P. Roskams, *Excavations at Carthage: The British Mission* I.1 (Sheffield 1984) 30 ff.; H. R. Hurst, *Fouilles britanniques au port circulaire et quelques idées sur le développement de la Carthage romaine* (CEA 17 = Carthage 7; Québec 1985) 142 ff.; H. R. Hurst with S. Gibson, "Roman and late building material and reconstructions," in Hurst (ed.), *Excavations at Carthage: The British Mission* II.1. *The Circular Harbour, North side. The site and finds other than pottery* (Oxford 1994) 53 ff., with detailed bibliography.

7 Cf. F. Rakob, *Gnomon* 59 (1987) 258 ff.; Gros 1990, 549.

8 Plin., *NH* 5.4.24.

9 Gros 1990, 549 and n.9.

10 For a model of the reconstruction in the Musée National de Carthage, see *CEDAC Carthage Bulletin* 15

apart from the platform itself, no clear building remains from the period of the foundation of the Julian colony are preserved on the hill, and the vaults supporting the SW part of the terrace were replaced in the Antonine period in order to support the huge buildings of the 2nd c. A.D. Thus the building plans from the Augustan period, which are only indirectly accessible on the Byrsa terrace, should be compared with the results of the new excavations carried out between the coast and the Byrsa hill, on either side of the great triumphal route, the *decumanus maximus*. These give us a glimpse, with unbroken stratigraphic sequence, into the procedure followed in the creation of the new town plan, its early building and its chronology. They give a picture of a city whose monumental inventory, despite the radical changes in the middle Imperial period, seems to justify the description of the first period of the settlement after the deduction of 29 B.C. as one of the loveliest and richest of cities.

Gros, in his investigation of the Augustan building programme,[11] presents an interpretation of its architectural repertoire, which culminated in the new monumental Forum on the Byrsa terrace (fig. 1, C). The depiction of Dido's city on the North African coast in the first book of the *Aeneid*[12] is often cited as a description of this new capital city, and it cannot be dismissed as mere literary fiction.[13] The traditional repertoire of architecture, including the *moenia* (in the sense of city walls and monumental buildings),[14] *navalia* and *portus*, the *fastigia*, the gigantic temple of Juno, and the *regia* of the queen, is found among the new buildings; of particular importance is the theater,[15] a building that takes on decisive meaning in the Augustan building programme. Only for this building does Virgil describe the work on the building site itself, the erection of the column shafts for the *scaenae frons*. We must suppose that the latter dates from the foundation of the colony, even though the theater of the provincial capital is known only in its late 2nd-c. form (fig. 1, EB) — however, there were never systematic excavations at Carthage at the theater site.[16] Of the three large *spectaculum* buildings, only the theater uses the south slope of the Odeon hill as a natural substructure. It remains unclear, and cannot be determined from the results of the current excavations, whether the circus in Carthage, the second largest in antiquity after the Circus Maximus at Rome, was located on the same site from the foundation of the colony.[17] In any case, the four quarters of the city defined by the *cardo* and and the *decumanus maximus* are each marked by a monumental public building on their outer edge: the theater (fig. 1, EB), amphitheater (fig. 1, ED), circus (fig. 1, EE), and the *platea maritima*, which will be discussed below; these buildings frame the center of the terrace of the Byrsa hill like a crown.

In only one respect does the Virgilian catalogue of buildings in Dido's city not reflect the results of the excavation. The Augustan settlement, like many other Roman towns of North Africa until the invasion of the Vandals, did not have a city wall, but an open city boundary. In the new capital city, it seems that the former city wall adorned with towers, which had been a signature of the traditional building repertoire of ancient urbanism, as in Punic Carthage, was abandoned.[18] Although Procopius,[19] in his Justinianic catalogue of buildings, wrote that the city of *Vaga*, Tunisian Beja, only seemed to be a real city after the installation of the

(1996) 1-2 (P. Gros and J. Deneauve).

11 Gros 1990, 547 ff.

12 Verg., *Aen.* 1.421-429.

13 Gros 1990, 570, n.8 (bibliography).

14 The gates mentioned in Verg., *Aen.* 1.422 also suggest, however, their relationship to a city wall.

15 Verg., *Aen.* 1.427 f.

16 The history of the construction of the theater of Carthage probably corresponds to that of the amphi-theater, whose first construction was expanded in the middle Imperial period. Recent bibliography in Z. Ben Abdallah, *CEDAC Carthage Bulletin* 10 (1989) 29 ff.

17 N. J. Norman in J. H. Humphrey (ed.), *The circus and a Byzantine cemetery at Carthage* I (Ann Arbor 1988) 31; N. J. Norman, "Le cirque romain," in Ennabli (supra n.6) 162.

18 *Karthago* I, plans 37-39.

19 Procop., *Aed.* 6.5.

Byzantine city wall, the lack of a wall in Carthage, as in other cities, reflects peaceful living conditions in which the inhabitants did not have to consider the possibility of attack. This will be discussed below in connection with the Punic sea-wall on the edge of the Augustan colony (fig. 1, K-KG).

The new Roman city foundation was decisively influenced by its Punic predecessor. The orientation of the city by the *groma* was not determined by astronomical data, the position of the sun on given days, or any impulsively chosen or religiously founded surveying decision. Rather, it was determined by a scheme set out in the Archaic Punic period, following the line of the coast in an orthogonal plan[20] which contrasts with the irregular, adaptable, fan-like division of the hills in the Punic period (fig. 1, BA 2-4).[21] In the planning of the Augustan colony this coastal alignment was emphatically, indeed brutally, forced onto the entire urban area. It may serve as an example of what H. Drerup described as the *"militanter Umgang"* of Roman architecture with the natural requirement of the terrain. The position of the *groma* and the alignment of the axis of the *decumanus maximus* were determined by the Punic city. An urban axis, lying at right-angles to the lower orthogonal arrangement of the coastal plain, can be seen in the plan of the Punic, fan-shaped building construction on the slope and the lower edge of the hill (fig. 1, BA 5-6). This alignment is carried from the sea to the SE foot of the Byrsa terrace and produces, as in the Punic street that runs to the sea gate, a parallel to the direction established by the important Roman street, *decumanus* I N (fig. 1, O). Similarly, the main Roman street of the *decumanus maximus* could be fixed on the northern edge of the Punic axis, a line oriented with that of the Punic buildings but positioned on the new surface of the Byrsa plateau. The layout of the Roman *insulae* was also based on this *groma* (fig. 1, A), since the trace of the Punic sea wall was bounded on the coast by *cardo* XVIII, the last street axis in the beach area during the foundation period (fig. 1, K). The new Byrsa platform fit exactly into the Roman urban plan (fig. 1, C). Punic urban planning, however, included a system of development that Roman Carthage did not take up, namely a second system of parallel streets, determined by a line between the harbours, the agora and the Punic citadel on the Byrsa. This is shown by three broad streets that led to the citadel (fig. 1, BA 4). This second orientation, adapted to the terrain, vanished without a trace in favor of a strictly enforced master-plan. This is how the plans of the Punic and Roman city are distinct from each other, less in their common center of the Byrsa, the site of the Punic citadel and the high Roman forum-platform, than in the replacement of the old, obliquely oriented axes between the harbour, the agora and the Byrsa by a new orthogonal plan applied to the entire town. In this new order, the majestic *decumanus maximus* determined the effective civic spine of the colony (fig. 1, AA). In the Roman city plan, the earlier dominant multipolarity between the harbour and its environs, the agora and its urban connection to the citadel was given up.

The strictly enforced orthogonal order, which did not take the land forms into consideration, had a considerable impact on the circulation of traffic, especially in the case of the *decumani*. Spectacularly high terracing and long flights of steps were needed to resolve the 55-m difference in elevation between the coast and the Byrsa plateau. Moreover, the *decumani* I and II S, the *decumanus maximus* and the *decumani* II, III, IV and V N had to lose their function as traffic-lanes for carts and carriages. The *decumanus* I N, directly beside an important Punic traffic-axis that led up from the sea-gate into the city wall, constituted the most important

20 *Karthago* I, plans 3, 34, 37, 38, 39.

21 *Karthago* I, plan 34. The boundary between the fan-shaped plan of the upper slope, the western coastal plain and the lower orthogonal layout, which was determined by the direction of the sea-walls, seems, at least in the later Punic period, to lie in the area of the Roman *cardo* XIII. In the area of the *decumanus maximus* the sloping orientation of the buildings, already established in the 8th c. B.C. and visible in the alignment of a Punic wall, turns in the early 2nd c. B.C. into a line that lies nearly at right-angles to the Roman axis of the *decumanus maximus*. The orientation of the later Roman plan thus seems to be conditioned by this late Punic layout (cf. Rakob 1991, figs. 5, 8, and 9).

connection between the coast and the northwest edge of the city. It led over the steepest part of the saddle between the Byrsa and the hill of Juno, as did its Punic predecessor (fig. 1, O).[22] Adaptation to local topography was sacrificed for the sake of a regular city plan, based on vertically staggered, strongly orthogonally-ordered substructured terraces that led up from the coast and culminated in the temple summit on the acropolis. This drive for rational order even in the face of uneven terrain is not unusual in Roman urbanism, even if it is not the rule.

In contrast to normal Roman town-planning, the size of the *insulae* in Carthage follows a proportion of 1 : 4, organized by *strigae* into long, narrow *insulae*. A similar settlement pattern had been in use since the 5th c. in the lower coastal plain of Carthage, under the protection of the parallel city walls. Topographic investigations in the area of the *decumanus maximus* show that the Punic dwellings on the coast were also ordered in regular orthogonal *insulae*. Those dwellings that have been excavated along the coast were surrounded by streets that recall the Roman system of *cardines* and *decumani*, while the borders of the houses in this area were party walls of the *paries communis* sort, without any *ambitus* space between them.

It would thus be a mistake to conclude that the ruins of Punic Carthage simply served as a *tabula rasa* for the level ground of the Augustan town. The procedures by which the Augustan town was built were extremely complex. Excavations on the coast have shown that the alignments of the walls of the Punic buildings were copied by the Augustan walls, although they were never simply re-used. A section cut through the Augustan-period buildings shows that each was preceded by the complete removal of rubble down to the latest Punic pavement level. The walls were then built from this level, and the rubble was replaced to make up the Augustan floors. This procedure presupposes the complete exposure of the Punic level of destruction. Punic débris, moved from one place to another, comprised the most important component of the early settlement stratigraphy. Only in the case of certain foundations, for example the street walls and the *insula* borders, do the foundations extend below the last Punic levels down to virgin soil. Thus, certain older ceramic material was found in the finds from the Roman levelling operations alongside the predominantly late Punic material; these date to the Archaic period and come from the excavation of the foundation trenches beneath the destruction levels. Outside the Augustan walls, however, the late Punic pavements were not taken up. These measures, unusual in ancient town-planning, indicate that fill of loose Punic rubble was moved, only in the area between the coast and the Byrsa, to a depth of 1-2 m. In one place on Rue Ibn Chabâat the Romans cut down over 4 m,[23] moving a volume of at least 600,000 cubic meters, from which re-usable building materials for Roman foundations had to be culled. This procedure presented a logistical problem of the first order. I know of no comparable example in the world of ancient town-planning that involves removal, sorting and temporary deposition of rubble on such a large scale. This extravagant preparation for new construction reflects the dearth of stone that renders middle and late Punic and Roman Carthage unique among the metropolises of the ancient world. Carthage is a city without a good source of building material nearby. Every building block had to be transported by sea, whether from the quarries on Cape Bon[24] or from the great sandstone deposits near Korbous on the southern edge of the Gulf of Tunis. Neither the poor limestone crusts of the coast near Carthage, characteristically used only for buildings of the Archaic period, nor the sandstone of Amilcar that occurs in small formations that was extensively used in late antique and Byzantine buildings, could substitute for the building stones from Cape Bon in the great constructions of the Punic metropolis and its Roman successor. The remains of foundation walls which date to the early Roman colony, reddened by the fire of 146 B.C., show clearly that the new capital of the province was to a large extent made of re-used Punic building materials.

22 Rakob 1995, fig. 4.
23 Rakob 1991, figs. 6 and 17, pl. 4.
24 For the subterranean stone quarries of El Haouaria, cf. F. Rakob, *RömMitt* 91 (1984) 15 ff., figs. 2-3, pls. 21-29, cf. plans 14-16.

In the levelled-off heaps of Punic rubble which the Romans moved about, predominantly late Punic finds contrast with a limited number from the Augustan era, suggesting that building projects began in the penultimate decade of the 1st c. B.C. and were concluded before the end of that century. The limited nature of the metal finds, in contrast to ceramic materials, may also be related to this controlled sorting and moving of débris. There is no trace in the destruction débris of the victims of the bitter street combats of the last days of the Roman conquest of Punic Carthage.[25] As for human skeletal remains, most assume that these were disposed of by the Romans after the fall of the metropolis. Only one skeleton has been found to date in the excavations in the central area: an unusually large man, found in the fallen heaps of ashlar of the Punic sanctuary on the Rue Ibn Chabâat. The find spot, of the late Punic level,[26] was a work site for the preparation of Punic stone blocks for re-use in Roman foundation walls; it dates to the time of the completion of the first street level of the Roman *cardo* XIII, which was filled with sorted Punic destruction rubble.

The work of building began after the surveying for the uniform *insulae* starting from the *decumani* ends. The *insulae* were of identical size, the area of one *heredium*, two *iugera* (120 x 480 feet). The building plots served as the dépôts for the sorted rubble and as workshops for refashioning Punic stones to serve new purposes.[27] This led to difficulties in laying down the exact levels between the axes of the *decumani*. This unevenness is visible at several points: certain Augustan walls in the *insulae* between the *decumani* were planned for floor levels that proved too deep. When the Roman pavement level was finally established, parts of the facing of the walls disappeared into the foundations.[28]

The wide area of excavations lying west of the Punic sea-wall provides visible evidence of the settlement's change of character over time. The great Hellenistic houses,[29] created by the joining of older domiciles, were replaced by an artisans' quarter, which was made accessible by a dividing *vicus* that ran the length of the *insula*.[30] The Augustan characteristics of this building area are evident, despite many building measures of later periods, and they remained discernible even in the Byzantine buildings.[31]

Under the Augustan replanning the Byrsa hill fared differently than the coastal plain. Even the preparations for building were gigantic: the entire top of the Byrsa hill below the Punic level had to be removed, and a monumental platform of an area over 30,000 m^2 was established (fig. 1, C). These preparations themselves constitute the greatest intrusion into the geomorphology of the city building area. P. Gros has shown that this area was three times that of the Augustan forum of imperial Rome.[32] The Roman re-organization of the Byrsa did not incorporate the Punic citadel, but abolished it, levelling down to virgin soil for the construction of the new city center. In the spirit of the Roman vow, all traces of Punic construction in that space were definitively extinguished.[33]

In contrast to the careful sorting and levelling of the Punic ruins on the lower slopes of the hill, the resulting hill platform was far below the Punic level. The high vaulted buildings of the Augustan substructure constituted a rectangular enclosure for the hill setting, and could contain the earth excavated during the truncation of the original hill. In contrast to the other areas, the walls of a Punic domestic quarter, preserved to a high elevation, were not plundered

25 App., *Pun.* 129-30, 631-33.

26 Rakob 1995, pl. 110.1.

27 E.g., Rakob 1995, pl. 110.1.

28 E.g., *Karthago* I, pls. 28 and 32.

29 *Karthago* I, plan 39.

30 *Karthago* I, plan 40.

31 *Karthago* I, plan 5.

32 Gros 1990, 553.

33 Gros 1990, 551; for the problem of still-unknown new buildings that preceded the Augustan founding by
 only a few years, compare Gros 1990, 569 f.

before being filled. This failure to rob the ashlar masonry of those late Punic houses[34] may be related to the fact that the work for the new platform, the largest and most important building activity of the foundation period, could not be delayed while workshops were installed for the preparation of stones for re-use. On the SW front of the Byrsa substructure, moreover, the walls of the late Punic houses, standing in rows, could supply additional support for the Augustan terrace, where the vaulted substructures had the difficult task of resisting the force of the deep fill. In contrast to the Roman foundations walls of the lower slope and the coastal plain, the Augustan substructures of the hill used a central-Italian building technique, *opus reticulatum*, foreign to this site. They did not use Punic *spolia*, as the style of those stones was not adaptable to the requirements of reticulate masonry. Thus workshops were required for the most important building sites of the new platform on the levelled-off Byrsa hill. Fresh stone was worked and delivered from the quarries of Cape Bon. The large Roman temple, which may have been preserved at the level of its foundation, was probably located on the site of its Punic predecessor. However, this was not documented at the time of the construction of the Cathedral of Saint Louis in the late 19th c. Thus it can only be hypothesized that the boundary wall of the Cathedral of the White Fathers stands on Roman foundations, which perhaps followed Punic building lines. Although building remains in the area up to the southern edge of the hill are relatively scanty for the early period, many high quality marble architectural decorations[35] and fragments of Julio-Claudian sculptures[36] suggest the existence of structures in this area. We should not, however, conclude that this prodigious platform was laid out in the Augustan period but not furnished with the repertoire of monumental capitol buildings until the Antonine period. The buildings Gros and Deneauve conjecture for the colony and the capital of Africa of course belong to the mid-Imperial development of the site; they have the dimensions of the 2nd c. and cannot date to the foundation period. The frame of the early plateau, however, does suggest the conception of a coherent building programme, its first traces no longer discernible. New Antonine substructures for the huge basilica replaced the Augustan vaults on the SE side of the platform. However, it is clear from the SW side that it would originally have been supported by an *opus reticulatum* wall at least 7 m high, consistent with the Antonine monumental setting. A monumental stairway on the axis of the *decumanus maximus* here is conceivable, as, in contrast to the *cardo maximus* on the SW side, the road would have been cut off from the terrace of the platform by high substructures.

Despite many small excavations, the site of a commercial forum for the lower city, located to best suit the traffic situation, has not yet been determined.[37] The Punic agora was said to lie in the lower city between the harbours and three sloping streets, with 60 steps leading up to the top of the hill.[38] It probably lay between the harbours and the Byrsa (near BA 4 on fig. 1). A Roman forum could have replaced the structure on the same alignment, if it ran parallel to the sea-wall. Otherwise the orientation would necessarily have been changed. In either case, the main concentration of monumental buildings dominated the city from the Byrsa terrace, rather than being concentrated on the commercial forum.

Examination of the construction techniques of the buildings located along either side of the *decumanus maximus* allows us to see individual traits connected with various workshops. Adjacent to the buildings that reveal traditional technique — *opus africanum* with careful coursed masonry in the *petit appareil* of late Punic tradition — one finds the central Italian

34 Rakob 1991, 41 f. and n.45.
35 Today displayed on the ground level of the Musée National de Carthage, with dating descriptions by N. Ferchiou. Regarding a fragment of Augustan building decoration found between *decumani* III and IV S, cf. N. Ferchiou, *CEDAC Carthage Bulletin* 10 (1989) 14 f.
36 Cf. Gros 1990, figs. 3-4.
37 Discussion of the literary testimonia of the various open areas in the city and their topography in Gros, *Byrsa* III, 147 ff.
38 App., *Pun.* 128, 629.

technique of *opus reticulatum*, a technique foreign to Africa and indicating the presence of Italian workshops. This technique was used on official monuments, the Byrsa substructures, the amphitheatre, and a building on the *decumanus* I N directly on the coast.[39] In Utica, the earlier capital of the province, *opus reticulatum* is also found in the areas designated for public buildings. In Bulla Regia a hall, whose function is as yet unidentified, provides an example of the awkward reception of this building technique into the context of traditional *opus africanum*.[40] At Carthage, in the infrastructure of the streets, the Augustan colony also shows continuity between Punic antecedents and Roman constructions. Almost all of the Punic cisterns that have been exposed in the coastal plain, with the exception of the new street spaces, were re-used,[41] evident from the fact that their orientation in this area relates to the Roman plan. Their openings could be adapted to the rising pavement levels, as was done up until the Byzantine period, while older Punic well-shafts could contain overflow from the cisterns. The *decumani* that ran steeply down to the coast were, from the outset, fitted with the usual drains, though no trace of paving stones has been found in the Augustan street levels.[42] In several of the early Roman *cardines*, however, instead of the traditional central drains we find pear-shaped pits,[43] which were in common use in Punic Carthage.[44] This system of waste removal reflects indigenous buildings techniques, as does the adoption of late Punic *opus africanum* for Augustan buildings.

The water-supply of the Augustan city was also well conceived. Even if the theory of an early Roman water-supply system coming from the plain of La Soukra and following the natural topography is not tenable, the cisterns at La Malga (fig. 1, EF), which rank among the largest of the ancient world and which were later supplemented by an overland aqueduct,[45] anticipated and guaranteed the city's need for water. These cisterns are constructed in *opus caementicium* of an early type that is also seen in the amphitheater and can be clearly distinguished from that of the later aqueduct, which is Antonine in period (fig. 1, R). The early cisterns may have relied on water from a nearby spring, whose abundance is suggested by the fact that it still supplied the fortress and the harbour of La Goulette with water in the early 19th c.[46] Thus clichés such as the claim that the Julio-Claudian settlement would have been the only provincial capital of the empire to have had to satisfy its water needs with small cisterns and wells for over 150 years have been put to rest. The position and the alignment of the La Malga cisterns along that of the rural centuriation seem to have been determined, like the northern and northeastern city boundaries, by topography. In this area, in the contact zone between the urban and the rural centuriation, a projecting bluff of 25-30 m provides room for cisterns with multiple outlets. This irregularly-divided northern edge of the settlement is also the location of the so-called 'Triangle of Saumagne' which appears to have been cut out of the

39 *Karthago* I, pl. 54 d (*Insula* E 218).

40 A. Beschaouch, R. Hanoune and Y. Thébert, *Les ruines de Bulla Regia* (CollEFR 28, 1977) 18 ff., figs. 9-11.

41 *Karthago* I, plan 30.

42 Vergil, however, describes the '*strata viarum*' in *Aen.* 1.422.

43 Rakob 1991, fig. 5, pls. 4.1, 5.1.

44 Cf. the construction under a street of the domestic quarter on the S slope of the Byrsa hill (S. Lancel, *La colline de Byrsa à l'époque punique* [Paris 1983] fig. 13).

45 On the aqueduct of Carthage and the sanctuary at its source, cf. F. Rakob, *RömMitt* 81 (1974) 41 ff.

46 On the cisterns of La Malga, cf. Vérité (supra n.4); reference to the modern aqueduct described by Falbe, ibid. 47. From the seams of the buildings, it seems that the construction of these gigantic cisterns preceded the overland aqueduct that comes out of Zaghouan. The size of the gigantic water reservoir probably reflects concern for a water supply that was not permanently guaranteed, rather than a concern to supply water for *naumachia* in the nearby amphitheater; cf. Z. Ben Abdallah (supra n.17) n.32. Thus, even the rainwater was directed *via* the cistern coverings into the vaulted interior. Judging from the cisterns of La Malga, which lay at least 4 m lower than the aqueduct and whose floor level remains unknown, until the 2nd c. A.D. only part of the Roman city in the coastal plain could be provided with water from this vaulted reservoir.

regular plan of the urban grid. However, it is clear that this change is a consequence of the same topographical consideration: the land here forms a natural edge to the town.

Private housing for the wealthy was present in the earlier stages. Traces of the Augustan repertoire of architectural marble decoration are not as meager as the dominance of later 2nd-c. building could lead us to believe. On both sides of the *decumanus maximus* from the coast to the Byrsa plateau, and also on the Odeon hill, there are numerous decorated *opus signinum* floors in the late Hellenistic tradition that date from the foundation period;[47] their pattern and surface decoration distinguish them clearly from Punic pavements. An abundance of Flavian renovations to Augustan buildings equally contradicts the cliché, that the 1st c. A.D. was a period of stagnation.[48] Under an Antonine assembly hall or sanctuary on the *decumanus maximus*, a building of Augustan date with *signinum* pavements was replaced as early as the Claudian period by a monumental structure that has yet to be identified,[49] characterized by a floor in *opus figlinum* and by high-quality paintings of the Third Pompeian style, the only example of this style found in Carthage to date.

The open seaward edge of the town was marked by a *lungomare* almost 1.5 km long.[50] Antonine expansion of the city here involved the construction of a new monumental *platea maritima*, with extended rows of colonnades laid out on more than 40 m depth of new land created through sedimentation. *Cardo* XVIII, located over the Punic sea-wall, was established as the *cardo finitimus* in the Augustan colony and made considerably wider (fig. 1, K). It could thus be considered an Augustan predecessor of the later 2nd-c. *platea maritima*. The displacement of the axes between the street alignments of *cardo* XVIII to the north and south of the *decumanus maximus* is the only demonstrable deviation from Carthage's strictly enforced urbanistic grid-system;[51] it most probably has to do with the rubble of the line of the Punic sea-wall, which followed the line of the first city boundary along the coast. The position of subsequent *insulae* was altered; thus with *cardo* XIII the normal width and axis of the streets were resumed.[52]

Thus, from the time of its foundation as a Roman colony, the new provincial capital offered, on the seaward side, an urban panorama unrivaled in Roman town-planning. This would have included a broad promenade along the beach with the great perpendicular axis of the 48-foot-wide *decumanus maximus* perhaps marked with an arch, its 600-m long axis terminating at the foot of the Byrsa plateau, the promenade leading probably to a pre-Antonine basilica and the temple precinct that crowned the hill.

In contrast to the Punic city plan with its high citadel behind the enclosing wall and bedecked with towers, the Augustan sea-front presented the Roman provincial capital as an open, unfortified, long coastal flank with invisible traces in its foundations of the urban order of the destroyed rival. Gros justly noted that it would be paradoxical if the Julian colony had not taken advantage of the Hellenistic urbanism along the coast, which influenced the city plan even in the construction of *insulae* and streets.[53] Even though it was only in the 2nd c. that the monumental project was fully achieved, we should not be misled by the apparent discrepancy between the archaeological data and what we learn from the sources. The new Antonine constructions could ultimately take over the concepts that had determined the form of the city since its foundation.

47 *Karthago* I, pl. 52 h-k.
48 For example, *Karthago* I, plan 32 (*Insula* E 218).
49 Rakob 1995, fig. 11; W. Ehrhart, "Römische Malerei in Karthago," in *Karthago* II, 229 ff., pls. IV-VI.
50 Compare *Karthago* I, plan 40; Rakob 1995, plan 3, reconstruction of the situation in the later 2nd c.
51 *Karthago* I, plan 33; regarding the gradual slight deviation from the calculated regularity of the axis, see
 G. Stanzl in *Karthago* I, 217 ff.
52 The dimensions of normal streets (24 feet) and the double size of the *decumanus* and *cardo maximus* are
 discussed by Stanzl ibid.
53 Gros 1990, 548 f.

Colonia Concordia Iulia Carthago seems, despite her Punic precedents, the model of an Augustan city that could, through brutal intrusions into the geomorphology of its site and the layout of its predecessor, be set out according to a new plan. The formation of the northern periphery of the town, a part of which was not urbanized until a later period, deviates in no respect from the scheme of orthogonal *insulae* that characterizes the foundation. Many other Roman cities — Lepcis, Cuicul, Timgad and others — show patterns of expansion that depart from their initial layouts, determined by geomorphological circumstances or older streets. The plan of Carthage appears to have been fixed for all time and shows no such deviation, even in the peripheral areas which were not initially built up. Carthage did not become a metropolis because of later developments on its periphery; it was laid out as a unified, structured, large city, without regard for topographical costraints, from its foundation. Three thousand Roman colonists are named in the literature, far too few to fill the expanse of the planned city area;[54] even in its foundation phases, the metropolis apparently allowed for the presence of numerous indigenous inhabitants. The frequently-cited idea of the 'double city' has been invoked as an explanation, but the town plan shows no area which might have been specifically intended for these people. Clearly they were meant to reside in the same urban spaces as the colonists. The co-existence of local and central-Italian building techniques, discussed above, provides concrete evidence for this. The transformation of the Punic citadel into a gigantic platform, 55 m above sea level, for large public buildings, changed the terrace that had heretofore dominated the landscape of the settlement, transforming it into a capitoline hill, the center of the city in the ideal as well as in the geometric sense. In view of the Romans' disregard for the former urban layout, the coast provided a place where, unlike anywhere else in North Africa, the ideal concept of an Augustan colony, with durable and effective Augustan architectural politics, could be realized, establishing city boundaries that survived until the Arab invasion. In other colonies established on level ground, the central capitoline temple on a high podium supplies a missing hill. At Uthina, for example, the capitoline temple far overpowered the natural hill, giving an unsurpassed example of North African architecture. In Carthage, however, the high, levelled platform dominated the coastal plain, providing a summit crowned with large buildings and the main temple. In ancient sources, this second or third city of the empire is compared only to Rome herself. In the new Roman foundation no visible traces of Punic predecessors remained above ground; those precedents disappeared into the foundation of the new settlement. However, the memory remained of what had been Rome's largest rival. In this respect, the North African capital distinguished itself from those built on Greek soil, such as Corinth, whose sack and rebuilding coincided with those of Carthage. Still later, an author of the 5th c. A.D. compared a bravely-fought engagement of the Punic War to the peaceful rivalry of Carthage with the glory and dignity of Rome, naming the colony the mother of all African cities and *"in africano orbe quasi Roma(m)."*[55]

Deutsches Archäologisches Institut Rome

54 Calculation of the population in H. Hurst, "Cartagine la nuova Alessandria" in A. Carandini *et al.* (edd.), *Storia di Roma* III.2 (Roma 1993) 334 ff., where a maximum population of 30,000 is estimated for the Augustan colony, and whose number in the Imperial period, according to Hurst, was not higher than 70,000-100,000.

55 Salvian, *Gub. Dei* 5.15.67-68, following L. Ennabli, *Carthage. Une métropole chrétienne du IVe à la fin du VIIe siècle* (Études d'antiquités africaines 1997) n.238.

A tale of two cities: Roman colonies at Corinth

Colonia Laus Iulia Corinthiensis *Colonia Iulia Flavia Augusta Corinthiensis*

David Gilman Romano

Introduction[1]

The Corinth Excavations of the American School of Classical Studies at Athens, under way since 1896, have contributed much to the understanding of a major Roman colony in Greece (fig. 1). Throughout the history of the excavation, and especially during the past 35 years, much new information has been gained about the Roman city.[2] This paper will consider some of the results of the Corinth Computer Project with respect to questions that relate to the design and planning of the Roman colonies at Corinth and the Romanization of the Corinthia,[3] based on 10 summer field seasons in Corinth between 1988 and 1997 and 12 academic years of laboratory research in Philadelphia.[4]

There is considerable literary, numismatic and epigraphical information concerning the foundation of *Colonia Laus Iulia Corinthiensis* in 44 B.C. by Julius Caesar.[5] Prior to the Corinth

1 The conference at the American Academy in Rome in May 1998 was a provocative as well as an enjoyable experience. One of the major underlying themes of the conference was the relationship of Rome to its colonies, and I came away with questions as well as answers concerning the Roman city that I am most familiar with.

2 For final excavation reports, see *Corinth, Results of excavations conducted by the American School of Classical Studies at Athens*, since 1932. The annual excavation reports of the Corinth Excavations appear in *Hesperia*.

3 This research project under the present author has been undertaken by the Mediterranean Section of The University of Pennsylvania Museum of Archaeology and Anthropology under the auspices of the Corinth Excavations of the American School of Classical Studies at Athens, C. K. Williams, II, Director, whom I thank for his interest in, and support of, the Corinth Computer Project since its inception. During the summer field seasons he and N. Bookidis, Associate Director of the Corinth Excavations, provided friendly and generous assistance with all aspects of the work. The final publication will appear as a volume in the Corinth Excavations series and will include a text volume, a CD-ROM and a gazeteer of maps. Since February 1997, a web page summarizing elements of the research and methodology has been available at http://ccat.sas.upenn.edu/~dromano/corinth.html. For assistance in the preparation of the figures for this manuscript I thank N. L. Stapp.

4 I thank the more than 50 students, most from the University of Pennsylvania, who have assisted me with elements of the work in the field, in the laboratory and in the classroom. Several publications with respect to the project's results and methodology have appeared: D. G. Romano and B. C. Schoenbrun, "A computerized architectural and topographical survey of ancient Corinth," *JFA* 29 (1993) 177-90; D. G. Romano, "Post 146 B.C. land use in Corinth and the planning of the Roman colony of 44 B.C." in T. Gregory (ed.), *The Corinthia in the Roman period* (JRA Suppl. 8, 1993) 9-30; D. G. Romano and O. Tolba, "Remote Sensing, GIS and Electronic Surveying: Reconstructing the city and landscape of Roman Corinth," in J. Huggett and N. Ryan (edd.), *Computer applications and quantitative methods in archaeology 1994* (Tempus Reparatum, BAR Int. Ser. 600, Oxford 1995) 163-74; iid., "Remote Sensing and GIS in the study of Roman centuriation in the Corinthia, Greece," *Computer applications and quantitative methods in archaeology 1995* (Analecta Praehistorica Leidensia 28, 19965) 457-63; D. G. Romano and N. L. Stapp, "Piecing together the city and landscape of Roman Corinth," *Archaeological Computing News-letter* 52 (Oxford, Dec. 1998) 1-7; D. G. Romano, "City planning, centuriation and land division in Roman Corinth: *Colonia Laus Iulia Corinthiensis* and *Colonia Iulia Flavia Augusta Corinthiensis*," in C. K. Williams and N. Bookidis (edd.), *Corinth XX: the centenary, 1896-1996* (ASCSA forthcoming).

5 Strabo 8.6.23; Plut., *Vit. Caes.* 57; Dio Cassius 43.50.3-4; App., *Pun.* 136. A study of the early Roman coins at Corinth has been completed by M. Amandry, "Le monnayage des duovirs corinthiens," *BCH* Suppl. 15 (1988). Amandry has demonstrated the foundation date of the colony as 44 or 43 B.C. based on his detailed study of the duoviral coinage. For epigraphical evidence see J. H. Kent, *Corinth VIII, iii, The inscriptions 1926-1950* (Princeton 1966) nos. 96, 130, 153, 215, 314, 359. For a recent study of the foundation of the early colony, see M. E. H. Walbank, "The foundation and planning of Early Roman

Fig. 1. Map of the Peloponnesos and southern Greece.

Computer Project, the later Vespasianic colony founded in Corinth in the A.D. 70s, *Colonia Iulia Flavia Augusta Corinthiensis*, was known only from epigraphical and numismatic evidence. As a result of the current research, new information has been added about the re-foundation of a Roman colony that also raises questions about the colonial process itself. What follows is a summary of the evidence of the physical planning for the colonies at Corinth, as well as a brief discussion of some of the many other factors that may relate to this process.

The Hellenistic period

In the Hellenistic period, preceding the Roman destruction of 146 B.C., the center of the city was likely to have been the area in and around Temple Hill, the site of the Temple of Apollo, built in *c.*540 B.C. (fig. 2). To the south of Temple Hill was the upper Lechaion road valley, where a number of roadways of the area intersected. Dominating this area was an early Hellenistic stoa known today as the "South Stoa". When it was built, it was the largest secular edifice in the Greek world, a two-storey structure measuring *c.*165 m in length. In front of the stoa, to the north, was a racecourse, running roughly E–W, and to the north of the racecourse was the Sacred Spring, one of several cults in and around the area.[6] The Greek Lechaion road entered the upper Lechaion road valley from the northwest, to the east of Temple Hill. The Greek Peirene fountain was near this intersection to the east. The North Building bordered the Lechaion road on the west. To the west of Temple Hill was the Glauke fountain-house, sculpted out of the bedrock, and further to the northwest was the theater. Immediately to the north of Temple Hill was the North Stoa. Although the location of the Greek agora of Corinth is not known for certain, it is likely that it was to the north of Peirene and the upper Lechaion road valley.[7] Some 400 m to the north of Temple Hill was the area of the Asklepieion and the gymnasium (fig. 3). The Asklepieion was built immediately inside the 5th-c. B.C. Greek circuit wall and near two of its gates. The wall circuit was *c.*10 km in length and enclosed Akrocorinth; two long walls were added to the city circuit by the 4th c. B.C., extending the fortifications to include the port of Lechaion on the Corinthian Gulf. The Demeter Sanctuary was located on the lower slopes of Akrocorinth some 600 m to the southwest of Temple Hill.

Corinth," *JRA* 10 (1997) 95-130.

6 See C. K. Williams, II, *Pre-Roman cults in the area of the Forum of ancient Corinth* (Diss., Univ. of Pennsylvania 1978).

7 R. L. Scranton, *Corinth* I, iii, *Monuments in the Lower Agora and North of the Archaic Temple* (Princeton 1951) 133-34. More recently C. K. Williams II, "Corinth 1969: Forum area," *Hesperia* 39 (1970) 35, has suggested that the location of the Greek agora may be to the north of Temple Hill.

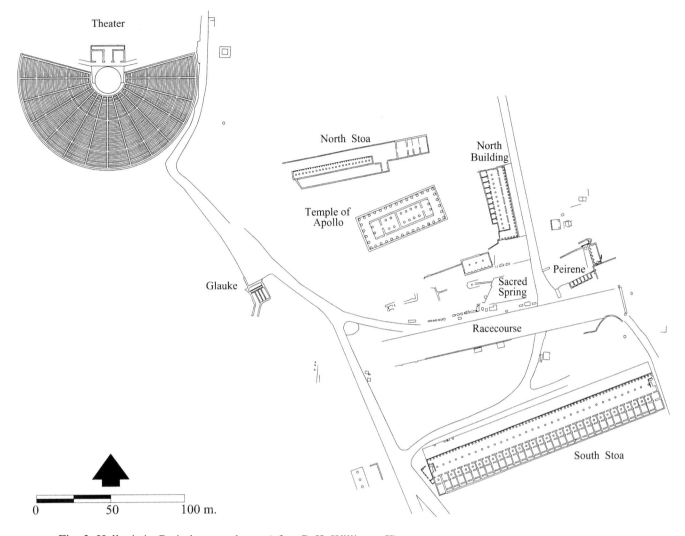

Fig. 2. Hellenistic Corinth, central area (after C. K. Williams, II).

Interim period, 146-44 B.C.

As a leader of the Achaean League in the 2nd c. B.C., Corinth was prominent in the opposition against Rome. After its defeat at the hands of the consul Lucius Mummius in 146 B.C.,[8] Pausanias tells us that the male citizens were killed and the women, children and freed slaves sold into slavery.[9] From the archaeological record, one assumes that there was a partial and selective destruction of the Greek structures and walls of the city.[10] As a result, the former city was deprived of its civic and political identity and the urban functions of the city were evidently eliminated.[11] The Roman colony was not founded for 102 years, or more than three generations following the destruction.[12] The precise timing of the foundation of the colony at Corinth should be considered in the context of the archaeological as well as the historical and literary evidence.

8 Strabo 8.6.23 includes part of the account of Polybius (who was an eye-witness of the destruction of the city by Mummius). He also states that Corinth was restored by the deified Caesar. Livy, *Per.* 52 mentions that the destruction was carried out *ex senatus consulto*.

9 Paus. 7.16.1.

10 A summary of the information concerning the damage to the city is given by J. Wiseman, "Corinth and Rome I: 228 B.C.–A.D. 267," *ANRW* II.7.1 (1979) 491-96.

11 For the question of the possibility of habitation within the area of the former Greek city in the period 146-44 B.C., see Williams (supra n.6) 21-22, and I. B. Romano, "A Hellenistic deposit from Corinth: Evidence for interim period activity," *Hesperia* 63 (1994) 57-104.

12 The same is true of Carthage destroyed by Scipio Aemilianus in 146 B.C. and refounded in 44 B.C.

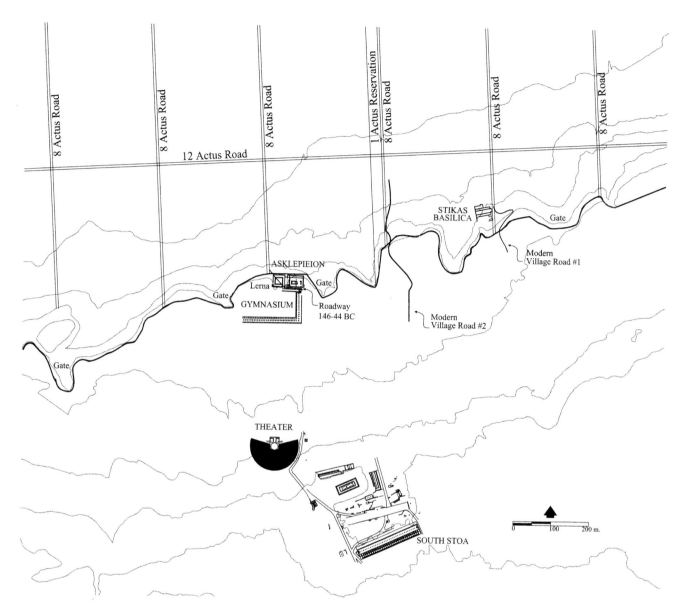

Fig. 3. Greek Corinth, 146-44 B.C. with northern Greek circuit wall, roadway and interim-period Roman land-division to the north of the city. The two modern village roads are included, as well as the Byzantine Stikas Basilica. Contours are at 10-m intervals.

Following the destruction of Corinth, the Roman Senate sent 10 Commissioners to assist Mummius in the settlement of Greece.[13] It is clear that a major administrative re-organization occurred at this time, and it is likely that this would have included a topographical survey, with new maps drawn up to assist with planning use of the land.[14] Did the Romans envisage a colony at Corinth as early as the 2nd c. B.C.? For strategic and commercial reasons it would have been imperative to have a presence at the site; parts of the Corinthia included some of the richest agricultural land in Greece. It is not known exactly why the Romans waited so long to found the colony. However, the most recent archaeological evidence (see below) suggests that preparations for the colony may have been under way at least from the time of the *lex agraria* in 111 B.C.

13 Paus. 7.16.9; Polyb. 39.4.1, 39.5.1. For a detailed consideration of the economic conditions following the Achaean War in Greece, see J. A. O. Larsen, "Roman Greece," in Tenney Frank (ed.), *An economic survey of ancient Rome* IV (Baltimore 1938) 259-498.

14 See E. S. Gruen, *The Hellenistic world and the coming of Rome* (Berkeley 1984) 523-27.

The land that had been under the control of Corinth became largely *ager publicus*, although both Livy and Cicero suggest that Sikyon had taken over care of part of the land of Corinth.[15] From the *lex agraria*[16] of 111 B.C., passed by the assembly of tribes in Rome, it is known that some parts of the Corinthian land were measured out for sale and boundary-stones were erected[17] approximately one generation following the sack. In 63 B.C. Cicero mentions that the confiscated land of Corinth was still *vectigalis* as *ager publicus*[18] and that there were at that time persons living among the city's ruins.[19] The archaeological evidence from the heart of the former Greek city corroborates this, for new and heavily-used roadways appear to date from the interim period, 146-44 B.C. (fig. 6).[20] It is also evident that earlier Greek roadways were maintained and still in use, both through the agricultural land to the north of the city and in the city itself.[21]

Some archaeological evidence exists to indicate that there was a regular and organized division of land (*limitatio*) carried out to the north of the former Greek city that is probably to be related to the work of the *lex agraria* of 111 B.C. The evidence comes from a study of the Roman roads that may be associated with this period: the framework for the organized grid of land to the north of the Roman colony of 44 B.C. may already have existed. The evidence is found in the area of the Asklepieion, where the remains of a road for wheeled vehicles have been traced along the E–W ramp of the *temenos*. The wheel-ruts of this roadway turn and point towards the NW corner of the Lerna colonnade, where the road clearly passed into the plain (fig. 3).[22] This suggests that the Greek circuit wall was broken through in this spot, allowing the road to have a clear route for descent. It must be admitted that the route of the road has not been traced outside the Greek city wall, although it clearly passed there. The archaeological evidence suggests that this road was used in the period 146-44 B.C. One needs to ask why the Romans at this time wanted to have a road in this location, since there were a number of existing roads nearby, passing out of the city through existing (Greek) gates in the circuit wall. The most plausible explanation is that, as part of the work of the *lex agraria* of 111 B.C., the Romans had divided the land to the north of the city in a formal *limitatio*. As a result of this division, there would have been a number of new N–S roadways in the plain connecting the former Greek city with the area to the north. Because the locations of the new Roman roads did

15 Livy 27.1; Cic., *Leg. agr.* 1.2.5, 2.19.51.

16 Several new studies of the *lex agraria* have been published recently, including M. H. Crawford (ed.), *Roman statutes* (BICS Suppl. 64, 1996) 1.39-180 and A. Lintott, *Judicial reform and land reform in the Roman Republic* (Cambridge 1992). For a discussion of the *lex agraria* as it refers to Corinth, see also Walbank (supra n.5) 99-100.

17 I present evidence below to support the argument that the *lex agraria* may have included centuriation of some of the land of the Corinthia. There is another possibility that should be mentioned, that there was no centuriation undertaken by the Roman surveyors as part of the *lex agraria* of 111 B.C., but only a measuring of land that had already been measured and divided in the Greek period, with the installation of new boundary stones. I have noted elements of what I have identified as a pre-Roman land-division in the area to the north of the Greek circuit walls, the principal orientation of which is approximately 9-14° west of north, although it cannot be claimed that the Greek land-division was used in this way by the Romans. See Romano in *The Corinthia* (supra n.4) 26, fig. 9 and also *AJA* 98 (1994) 296.

18 Cic., *Leg. agr.* 1.5, 2.5.1.

19 Cic., *Tusc.* 3.22.53. See the recent article by I. B. Romano (supra n.11) 57-104.

20 There are two roadways in the city center that date to 146-44 B.C. Both run roughly E–W. The first crosses a low foundation at the NE end of the South Stoa: O. Broneer, *Corinth I, iv. The South Stoa* (Princeton 1954) 88-91, pl. 1. The other road is in the area of the Temenos of the Sacred Spring: see C. K. Williams, II and J. Fisher, "Corinth 1970: Forum area," *Hesperia* 40 (1971) 22, 45.

21 This may be similar to the situation in Urso, where it is known from the *lex coloniae Genetivae* LXXIX that public roads that existed prior to the establishment of the colony would need to remain public property. See Crawford (supra n.16) 1.424-25.

22 C. Roebuck, *Corinth XIV. The Asklepieion and Lerna* (Princeton 1951) 82-84.

not necessarily respect the locations of existing Greek gates, the walls would have been dismantled in places where the roads approached the city.

Evidence for land division into units of 16 x 24 *actus* at the orientation of 3° west of north is attested north of the city, and is described below as a part of the discussion of *Colonia Laus Iulia Corinthiensis*.[23] Evidence exists for a subdivision of the 16 x 24 into 8 x 12 units between the Greek long walls, and this would allow a roadway where the Greek circuit wall was broken through near the Asklepieion at Lerna (fig. 3).[24] Since this road probably dates to the interim period, can the other roads be connected to the same system? There are, in addition, two modern village roads spaced at distances that match. Seventeen *actus* to the east of the road at the Asklepieion a modern farm road leaves the plain and ascends the scarp towards the city plateau (fig. 3, village road no. 1). This modern farm road passes immediately to the east of a Roman basilica, excavated by E. Stikas and dated to the 5th c. A.D.[25] Approximately midway between the Asklepieion road and the road near the basilica is a third road that enters the city at the line of the 8 *actus* division (fig. 3, village road no. 2). Without firm archaeological evidence, the association of village roads 1 and 2 with the road at the Asklepieion can be only hypothetical. However, their locations with respect to each other suggest that the three may have been first laid at around the same time.[26]

As part of this system of centuriation to the north of the Greek city, a reservation 120 feet (one *actus*) wide, between the central 16 *actus* strips suggests *iter populo non debetur* ('a public right of way does not exist over private land') (fig. 3).[27] This reservation would become the location and axis of the *cardo maximus* of the Caesarian colony. The centuriation characterized by 16 x 24 *actus* units can be documented as far west as the Longopotamos river, which may have marked the border between Corinthian and Sikyonian land in the 2nd c. B.C.[28] It is difficult to be certain how much of the rest of the Corinthia had been centuriated at this time.[29]

All this suggests that the idea of the new colony was taking shape; the process of centuriation, preceding the actual colonization, can be seen as an event in preparation of the settlement for a new population. A. Lintott has interpreted the *lex agraria* as providing for centuriation of some elements of Corinthian land, suggesting that a colony was planned for the site.[30] If the survey described above dates to 111 B.C., the Roman surveyors may already have been planning the later colony.

23 The 16-*actus*-wide strips of land that have been recognized at Corinth are reminiscent of the 16-*actus*-wide strips of land near Cosa; see F. Castagnoli, "La centuriazione di Cosa," *MAAR* 24 (1956) 147-65.

24 The evidence of the centuriation has been assembled based on study of the 1 : 2000 and 1 : 5000 topographical maps, low-level photographs at an approximate scale of 1 : 6000, and SPOT satellite images. All of this data is rectified to the Total Station survey of the roadways, monuments and structures of the city and nearby areas. See D. G. Romano and O. Tolba in Huggett and Ryan (supra n.4) 460-62.

25 E. Stikas, Ἀνασκαφὴ Κοιμητριακῆς Βασιλικῆς Παλαιᾶς Κορίνθου, *Praktika* 1962, 51-56.

26 The evidence is presented in full by Romano in *Corinth XX* (supra n.4). For the roadway 146-44 B.C. see C. Roebuck, *Corinth XIV, The Asklepieion and Lerna* (Princeton 1951) 82-84. This evidence for the centuriation of 111 B.C. replaces the earlier suggestion I published in Gregory (supra n.4) 23-26, fig. 8.

27 Ch. Saumagne, "Iter populo debetur . . .," *RPhil* 3rd ser. 1928, 320-52. In this instance, the reservation of 120 feet for the *cardo maximus* is crossing agricultural land, but it would appear that this was a part of the planning process for the urban colony and therefore the land being reserved would be public or civic. Two additional 120-foot reservations have been noted for major roadways extending east from the city toward the isthmus.

28 It should be remembered that both Livy 27.1 and Cic., *Leg. agr* 1.5, 2.51, 2.87 and *Tusc.* 3.22.53, suggest that Sikyon had taken over care of part of the land of Corinth.

29 Although the centuriation ends at the Longopotamos river in the plain, at higher elevations to the south the centuriation extends further west (fig. 9).

30 A. Lintott, *Judicial reform and land reform in the Roman Republic* (Cambridge 1992) 54.

Colonia Laus Iulia Corinthiensis

From the archaeological evidence, together with the evidence of the *lex agraria*, the organization and division of the agricultural land north of the city of Corinth is likely to have preceded the *deductio* and the subsequent ground-plan for the urban colony as founded in 44 B.C. However, the orientation of both the rural, agricultural land and the urban colony was the same. The drawing-board plan of the urban area was composed of 4 centuries, 32 x 15 *actus* each, or 240 *iugera* (fig. 4).[31] The original divisions were likely to have been 1 x 2 *actus* units and the principal orientation of the colony was approximately 3° west of north (fig. 5).[32] Each of the 4 centuries of the urban colony was characterized as having the capacity for 29 *cardines* and 29 one-*actus*-wide *insulae*, although the implementation of the colonial design may not have been completed in all aspects of the city.[33] The width of the excavated *cardines* varies from 8 to 24 feet, although the overall average was likely to have been 12 feet. Each century was also likely originally to have had the capacity for 6 *decumani*, with an average width of 20 feet. The urban centuries of the colony were organized according to the legal formula *iter populo non debetur*.[34]

The forum area as a whole was designed to occupy 24 square *actus*, or 12 *iugera*, in the topographical center of the urban colony, with 6 city *insulae* E–W and 4 city *insulae* N–S (figs. 4-7). This large area included elements of the former Greek city in the upper Lechaion road valley (the South Stoa), as well as the area of the Hellenistic racecourse and the precinct of the Sacred Spring. Many of the most important civic, political and religious buildings of the future Roman colony would be constructed within these 12 *iugera* (fig. 7).[35] The ratio of the area of the forum (excluding planned roadways) to the total area of the urban colony (excluding planned roadways) was 12/812 *iugera* or 1.48%. The open area of the forum was eventually paved and measured *c*.13,000 m² between the re-used Greek buildings and the new Roman buildings.[36] The overall size of the planned urban colony was 240 ha.[37] The new colony probably included both an amphitheater and a circus from the 1st c. B.C.[38] These facilities, alongside the regimentation of the urban grid, the centuriated fields and the new roads, contributed strongly to the Romanization of the city. Although there were surely still many Greek families in the area, some farming the land, the organization of the space was clearly different. The change in the land division would have affected individuals in a number of ways and for a number of reasons. First, land of the *territorium* of the colony would have been re-organized with respect to the shapes of individual plots and with respect to the location and direction of new roads. This might also have affected drainage of and access to fields. Second, the specific area of an allotment and its location would have been related to the tax assessment associated with each parcel of land. A *forma*, on file in the record-office of the colony, would have clearly indicated where each parcel of land was located, its area, whose property it was, how much rent or tax

31 The land of each century, exclusive of roadways and the area of the Forum, probably would have been planned for 200 *iugera*. This is calculated as 29 x 14 *actus* or 203 *iugera*. When the area of the planned forum was taken out of each century (3 *iugera* per century), the remaining area for each century was 200 *iugera*.

32 The orientation of the E curb of the Lechaion road has been surveyed as 3° 3′ 46″ west of north.

33 See below under the later Vespasianic colony.

34 In the urban context, this means that the individual *insula* measurements of 1 *actus* width and 2 *actus* length are respected and the road widths are added outside of the *insula* measure. See supra n. 24. In the rural context *iter populo debetur* is usually to be expected.

35 The *rostra* was located at the center of the reserved space of the 6 x 4 *actus*.

36 This is a relatively large area for a forum. For comparison in Rome, the Forum Iulium is *c*.8000 m², the Forum Transitorium *c*.4563 m² and the Forum of Trajan *c*.11,020 m², while the Forum of Augustus is *c*.11,250 m².

37 D. Engels, *Roman Corinth, An alternative model of the classical city* (Chicago 1990) 84, gives a figure of 725 ha in the 2nd c. A.D., although he includes the area of Lechaion harbor. Even so, this is too large.

38 See D. G. Romano, "A Roman circus in Corinth," forthcoming.

David Gilman Romano

Fig. 4. Schematic drawing of the four quadrants of the urban colony of 44 B.C., labelled A, B, C, D, each of which measures 32 x 15 *actus*, with centrally-located Forum and *cardo maximus.*

Fig. 5. Drawing-board plan of the urban colony of 44 B.C.

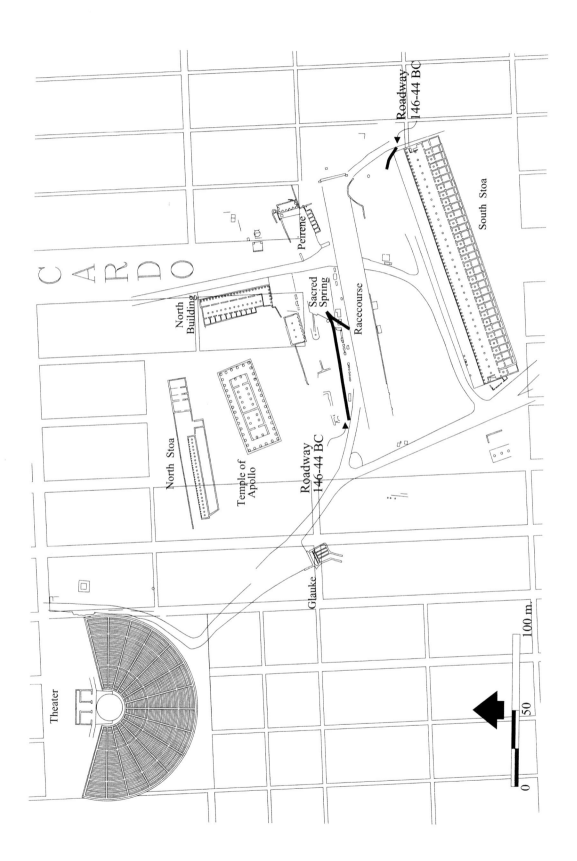

Fig. 6. Superimposition of the drawing-board plan of the urban colony of 44 B.C. over the central area of Hellenistic Corinth.

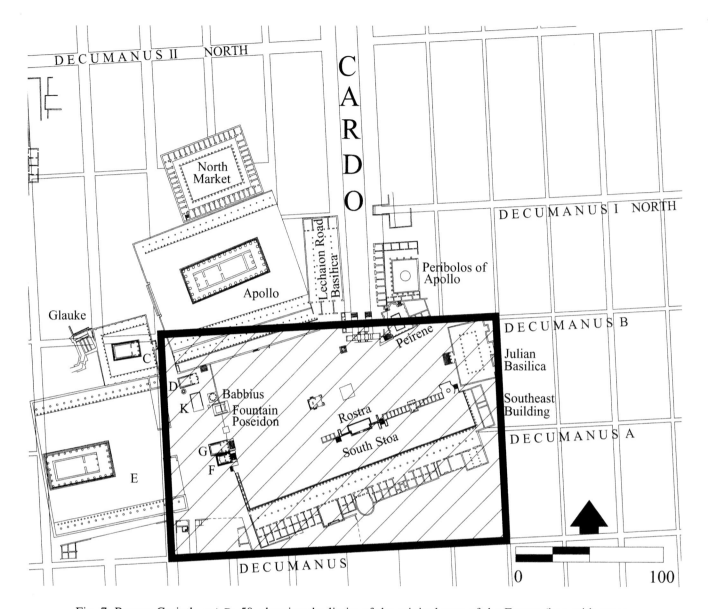

Fig. 7. Roman Corinth, *c*.A.D. 50, showing the limits of the original area of the Forum (box with cross-hatching) as 6 x 4 *actus*.

was due from the property, and any other relevant details. For instance, land that was public property would be listed, as well as property that was exempt from tax, for whatever reasons, and land that had not been allocated.[39]

The *cardo maximus* of the urban colony was the Lechaion road that has been excavated to a distance of *c*.107 m north from the *propylaia* at the entrance to the forum (figs. 5-8).[40] It is described by Pausanias as the roadway which leads out of the forum direct to the Lechaion harbor and the Gulf of Corinth some 3000 m to the north.[41] Although the construction of the *cardo maximus* was not a part of the original rural centuriation of the land north of the city, it was added when the urban colony was designed and laid out. It fell within the 1-*actus* reserva-

39 See below n.63. In the Orange cadasters there are a number of categories of land that are listed, e.g., *rei publicae*, 'state lands', *ex tributario*, 'removed from tribute-paying status', *subseciva*, 'unallotted land', and *reliqua coloniae*, 'remaining in the possession of the colony'.

40 The Lechaion road was paved in the 1st c. A.D. but originally in the 1st c. B.C. would have been an unpaved roadway.

41 Paus. 2.3.4. See Romano and Stapp (supra n.4) 1-7.

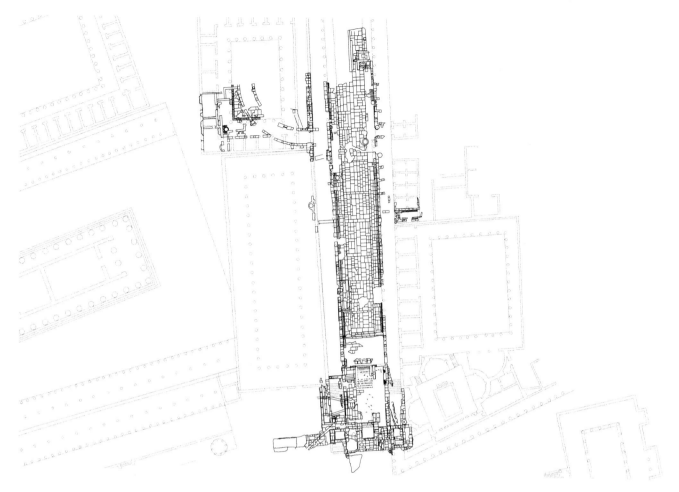

Fig. 8. Plan of the Lechaion road as it leaves the forum to the north with buildings of the Roman city of *c.*A.D. 150 (Lechaion road after H. N. Fowler and R. Stillwell, *Corinth* I, *Introduction, topography, architecture* [Cambridge, MA 1932] pls. X-XI).

tion between the 8-*actus* divisions (fig. 3). The location of the *cardo maximus* may have been planned when the rural land to the north of the city was divided in the 2nd c. B.C., suggesting the possibility of an embryonic urban, as well as rural, plan from that date.

In the area between the Greek circuit walls to the north of the city as far as Lechaion harbor, one finds a large concentration of vestiges of field lines. For the *territorium* of the colony, the characteristics of the centuriation are 16 x 24 *actus* units, with the primary orientation of 3° west of north. The area between the long walls reveals the subdivision into 8 x 12 *actus* units. There is also evidence to suggest that over many years different parts of the Corinthia were centuriated as part of the colonization process.[42] For instance, there is evidence of the centuriation of land in and around Cleonae and Tenea in the southern Corinthia, similar in character to that in the immediate neighborhood of Corinth. Although these areas show the same characteristics of division (figs. 9-10), it is not clear when the land would have been divided and re-allocated. It is known, for instance, that Tenea did not oppose Rome in 146 B.C. so the timing of the land division at Tenea would probably have been later than that around Corinth, although the absolute dates are not clear.[43]

42 Earlier scholars had argued that the colony of 44 B.C. had no agrarian base since no centuriation had been demonstrated; see E. T. Salmon, *Roman colonization under the Republic* (Ithaca 1970) 153; see also Engels (supra n.35) 67. Early notice of centuriation had been made by M. E. H. Walbank, *AJA* 90 (1986) 220-21.

43 This centuriation could have occurred, for example, in 46 B.C. when Greece was converted into a province.

Fig. 9. Extents of the centuriation of the Corinthia, showing restored grid of 16 x 24 *actus* units (colony of 44 B.C.).

Fig. 10. Evidence of centuriation in the southern Corinthia (colony of 44 B.C.). The restored grid is 16 x 24 *actus*.

Colonia Iulia Flavia Augusta Corinthiensis

Physical vestiges both within the city of Corinth and in the surrounding rural area attest to a
second Roman land-division that may be equated historically with *Colonia Iulia Flavia
Augusta Corinthiensis*, a refoundation in the time of Vespasian.[44] This titulature is known from
epigraphical and numismatic sources,[45] although the evidence of a centuriation that can be
associated with this new colony has only recently been presented.[46] The system of centuriation
seems to have extended over a very large area to the south of the Corinthian Gulf. It covered
approximately 220 km[2] of the Corinthian plain, extending from the north of Sikyon to the E
shore of the Saronic Gulf, and north of the modern Corinth canal to the the east of Loutraki
(fig. 11). Additional elements of the same centuriation identified in the southern Corinthia are
not included in this estimate of area (fig. 14). The system is characterized by a fan-shaped grid
that is divided into 10 differently-oriented units in the plain immediately south of the
Corinthian Gulf. These units are designated A1-A10 and A11 (fig. 11).[47] Each of the units
corresponds to a specific area of the coastal plain, and all of the units are linked to one another
and are related by the simple ratio of the tangent of 1 : 4, equal to the angle of 14° 2' 10" (figs.
12-13).[48] Unit A11 is related to the others in a different manner. The progressive change of
orientation in the linked units is visible from the combined evidence of the fieldwork, satellite
images, topographical maps and air photographs.[49] The linked systems extend from beyond
Sikyon to the northwest through Corinth, and as far east as Cenchreai and as far north as the
Perachora peninsula.[50] Additional centuriated land, showing the same characteristics of
division, has been identified in the southern Corinthia in the areas of Cleonae and Tenea. The
density of the field lines and the broad expanse of the evidence in linked systems points to a
new and larger concentration of population in the Corinthia and the Sikyonia.[51] Planning from
the area of Lechaion harbor on the Corinthian Gulf can be associated with the same *limitatio*,
suggesting that a harbor installation had been planned at the same time. The fact that this
installation was not entirely carried out may be related to the possibility that the Flavian
colony was not fully completed. It is known, for instance, that after Domitian's death the name
of the city reverted to *Colonia Laus Iulia Corinthiensis*.[52]

Within and near the city of Corinth a number of buildings and structures may be dated to this
time, and may be associated with the same system of planning. For instance, there are three

44 Detailed evidence for the centuriation of the A.D. 70s is presented by Romano in *Corinth XX* (supra n.4).
45 K. M. Edwards, *Corinth VI, Coins 1896-1929* (Cambridge, MA 1933) 26, nos. 91-93; Kent, *Corinth VIII,
 iii* (supra n.5) 42, no. 82.
46 Romano in *Corinth XX* (supra n.4)
47 A part of the same area to the south of the Corinthian Gulf has been studied and published by P.
 Doukellis: "Le territoire de la colonie de Corinthe," in P. N. Doukellis and L. G. Mendoni (edd.),
 Structures rurales et sociétés antiques (Paris 1994). There are some similarities as well as major
 differences with respect to his study and my earlier study in Gregory (supra n.4).
48 The use of tangents in Roman land-planning is paralleled elsewhere: see, for instance, L. Morra and R.
 Nelva, "Reciproca rotazione di tracciati delle 'centuriatio' romane," *L'Universo* (Firenze 1977) 249-70;
 M. Clavel-Lévêque, "Centuriation, géométrie et harmonie. Le cas de Biterrois," *Mathématiques dans
 l'antiquité* (St. Etienne 1992) 161-84; J. Peterson, "Trigonometry in Roman cadastres," ibid. 185-203. For
 Roman surveying, see O. A. W. Dilke, *The Roman land surveyors, An introduction to the agrimensores*
 (New York 1971).
49 See Romano and Tolba in Huggett and Ryan (supra n.4) 457-63. The use of 1 : 5000 topographic maps
 together with satellite images has facilitated the study of centuriation over a large area.
50 Because of the trigonometric linking of the units it is virtually certain that the units A1-A10 were
 surveyed and laid out by the *agrimensores* in one operation.
51 The fact that the centuriation includes the area of the city and *territorium* of Sikyon suggests that the
 city may have fallen on hard times by the middle of the 1st c. A.D. and that a re-allocation of land could
 have taken place. Paus. 2.7.1 refers to the weakness of the Sikyonians in the mid 2nd c. A.D. See also A.
 Griffin, *Sikyon* (Oxford 1982) 88-91.
52 See above n.45. *Corinth VIII, iii*, nos. 82, 96; *Corinth VI*, pp. 28-29.

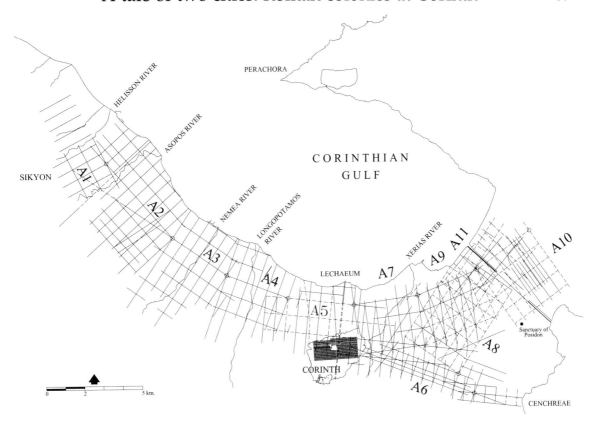

Fig. 11. Reconstruction of the extensive Flavian centuriation to the south of the Corinthian Gulf, *c.*A.D. 70. The restored grid is 16 x 24 *actus* units, A1-A10 and A11. The dashed lines indicate portions of the grids where there is incomplete evidence.

parallel prostyle tetrastyle Ionic temples in the Sanctuary of Demeter[53] south of the city on the lower slopes of Akrocorinth. The temples are datable to the period after the earthquake of the 70s, and have a primary orientation in keeping with the major centuriation of the area, A5 (fig. 15).[54] In the SW part of the forum, the orientation of the building known as the 'Long Rectangular Building', dated by the excavators to the period of Nero, is in keeping with that of the rural centuriation.[55]

It is also clear that the original extent of the drawing-board plan of the Caesarian colony of 44 B.C. had not been realized by the A.D. 70s, and that the limits of the urban colony as originally planned were contracted by about 40%. This would imply that the population of the city had never achieved the promise of the 1st c. B.C. foundation (fig. 16). Also obvious is the fact that the undeveloped areas of the drawing-board plan of the Caesarian colony had been used for agricultural purposes in the Flavian colony. This is clear from elements of the Flavian centuriation that are superimposed inside the original limits of the Caesarian urban plan.[56]

53 See N. Bookidis and R. Stroud, *Corinth XVIII, iii. The Sanctuary of Demeter and Kore: Topography and architecture* (Princeton 1997) 436-37. It should be noted that the three Ionic prostyle tetrastyle temples, the upper terrace and the propylon have a similar orientation to the Hellenistic propylon. The Roman propylon was rebuilt with a change in orientation of approximately 3 1/2°.

54 The orientation of the central of the three parallel temples (a clear setting line on the top surface of the E wall) has been measured with an Electronic Total Station. It is found to be only 3 1/2' of one degree from the orientation of the A5 grid of the centuriation in the same area that was fixed by independent means.

55 See C. K. Williams, II and J. Fisher, "Corinth 1975: Forum Southwest," *Hesperia* 45 (1976) 126-37, figs. 3-5. The building and associated arch are less than 2° different from the A5 orientation of the Flavian survey. I suggest in *Corinth XX* (supra n.4) that the building may date to the period immediately following Nero, to A.D. 70-72.

56 The relative dates of the two centuriations are apparent in the area of the eastern limits of the Caesarian colony. There the roads of the 'earlier' Caesarian colony are visible as 'crop marks'

Fig. 12. Flavian centuriation, *c.*A.D. 70, near Sikyon; detail of units A1, A2, A3, illustrating evidence from field lines, property lines, roads, ledges and paths. The restored grid is 16 x 24 *actus* units.

 Much of the area of the Corinthia and the Sikyonia thus shows the vestiges of a centuriation that may now be associated with a Vespasianic land-division. In size it is considerably larger than the centuriation to be associated with the colony of 44 B.C. including land divided in the time of the *lex agraria.* The heaviest concentrations of vestiges of land-division and

underground, and the field divisions of the 'later' Flavian colony are seen on the surface as modern field lines. See Romano and Schoenbrun (supra n.4) 177-90, figs. 5-7.

Fig. 13. Detail of Flavian centuriation, *c.*A.D. 70, south of the Corinthian Gulf, showing linking of units A2, A3, A4. In each case the joining angle is 14° 2' 10". The restored grid is 16 x 24 *actus* units.

Fig. 14. Detail of Flavian centuriation, *c.*A.D. 70, in the southern Corinthia, orientation of A5. The restored grid is 16 x 24 *actus* units.

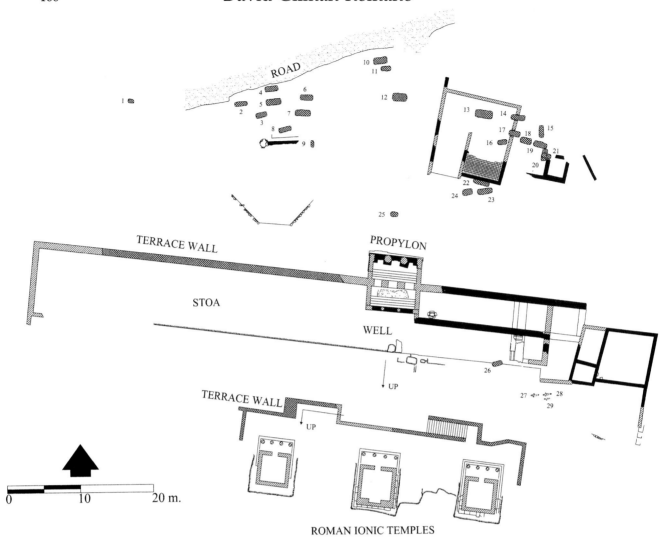

Fig. 15. Roman Demeter sanctuary, restored plan (after D. B. Peck).

centuriation occur in the area of the Corinthian plain between Corinth and Sikyon as well as northwest of Sikyon (fig. 12). There are also concentrations of the presumed Flavian centuriation around Tenea and Cleonai in the southern Corinthia. If one compares the centuriation associated with the colony of 44 B.C. with the colony of the A.D. 70s, there are many more fields to be associated with the Flavian colony.[57] What this means is that when the Flavian colony at Corinth was founded, large tracts (but not all) of the land from areas that formerly belonged to the Caesarian colony at Corinth, as well as to the city and territory of Sikyon, were allocated to the new colony.[58]

57 A quantitative study of this data is under way.

58 This concentration of agricultural activity during the Flavian period in the Corinthia has otherwise not been recorded by archaeologists and historians. See, e.g., S. Alcock, *Graecia capta* (Cambridge 1993) 40-44, 48-49, who, based on analysis of surface surveys in the Corinthia and Argolid, suggests that:

> traces of rural activity for the Late Hellenistic and Early Roman era [in Greece] are everywhere relatively scarce, giving the distinct impression of a deserted "empty" landscape. In several regions (of Greece) the starting point for this decline appears to lie within the second half of the third century B.C. but it may well be later in other areas. The crudity of survey dating prevents the identification of any more "specific" horizon for the downturn, but its effects were virtually ubiquitous by the first century A.D. After the initial drop-off the level of site numbers remains broadly unchanged throughout the next five centuries or more (ca. 200 B.C. – A.D. 300).

To my knowledge, the surface survey method utilized by Alcock and others in Greece has not included the study of patterns of Roman land-division and centuriation which can identify agricultural activity

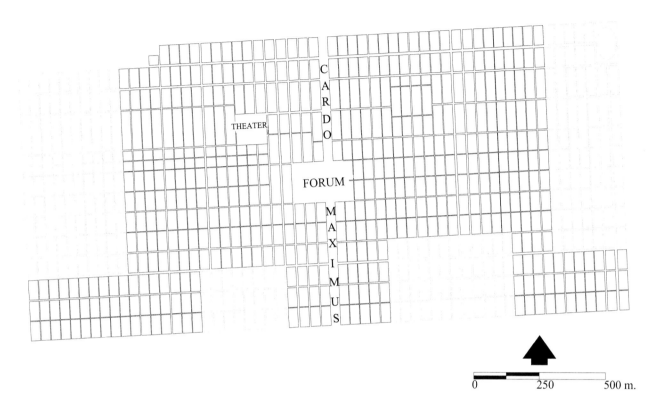

Fig. 16. Drawing-board plan of 44 B.C. Areas in grey show where Flavian centuriation is predominant.

The colonists

Who were the colonists that settled Corinth in and after 44 B.C? And what, if anything, do we know about the colonists who settled Corinth in the early 70s? We know something about the colonists of the *Colonia Laus Iulia Corinthiensis* from literary and epigraphical evidence. Strabo reports that most of the colonists were freedmen.[59] Appian says that 3000 colonists were sent to Carthage in the same year, 44 B.C., and some scholars have suggested that the same number would have been sent to Corinth.[60] Plutarch implies[61] that veterans were among those settled at Corinth and Carthage.

A. Spawforth has recently suggested that there is epigraphical evidence for a class of businessmen (*negotiatores*) as early settlers in Corinth.[62] His discussion concentrates on four principal groups of individuals in early Roman Corinth: freedmen, veterans, *negotiatores*, and outside Greek notables. He sees a colony

> which in its early years was dominated socially and politically by wealthy men of freedmen stock and by Roman families with business interests in the east, some no doubt of freedman stock themselves, and many probably already resident in the east — and in some cases partly Hellenized — when Corinth was refounded.[63]

in a landscape that was largely uninhabited. Depending on the method utilized, Alcock's theory of "rural abandonment" may mean in certain cases only that the land was being heavily used for agricultural purposes. Since no surface survey has been completed for the entire Corinthia, it is not possible to compare the results of a partial surface survey with the present results of the study of centuriation.

59 Strabo 8.6.23.
60 App., *Pun.* 136.
61 Plut., Vit. Caes. 57.
62 A. J. S. Spawforth, "Roman Corinth: The formation of a colonial elite," in A. D. Rizakis (ed.), *Roman onomastics in the Greek East: Social and political aspects* (= *Meletemata* 21, 1996) 167-82.
63 See C. K. Williams II, "Roman Corinth as a commercial center," in Gregory (supra n.4) 31-46. See also

With respect to the Vespasianic colony of the early 70s, one must ask whether new settlers came to Corinth to inhabit the land. Previously the Flavian colony was thought to be of only titular significance, so few new settlers would have been expected. The present evidence of new and widespread centuriation of the Corinthia suggests that there would have been new colonists coming into the area in order to farm under-utilized portions of the agricultural land.[64] Since the vestiges of the land-division to be associated with the Flavian period are more substantial than those of the Caesarian colony, one should ask where these new colonists would have been coming from and how many there would have been.

There are several possible explanations for this new intensive agricultural activity. As with other Roman cities in Greece, it is feasible that there was some re-arrangement of populations and cities. For instance Patrai, *Colonia Aroe Augusta Patrensis*, an Augustan colony in the NW Peloponnesos, was a foundation composed of a combination of veterans and elements of the native population.[65] The new colony was given large areas of land on both sides of the Corinthian Gulf. The new city of Nikopolis, founded by Octavian following the battle of Actium, was given the land of Ambracia, Akarnania and parts of Aetolia. It also received transplanted populations from neighboring areas.[66]

It may be that some of the new Corinthian colonists were Sikyonians or relocated citizens of other neighboring cities. There is also the possibility that some of the labor could have come from the ranks of the slaves who had worked on Nero's canal project, a project continued by Vespasian.[67] The strong Jewish male slaves are not heard of following the canal project, and it

Walbank (supra n.5) 107.

64 There are parallels from Gaul and Italy for Flavian colonies being superimposed on earlier land-divisions. For instance, the famous Orange marble plans that are on display in the Musée Municipal d'Orange illustrate fragments of three ancient marble maps, A, B and C, representing elements of successive centuriations of the area. It is known that there was founded at Arausio in *c*.35 B.C. a colony *Colonia Iulia Firma Secundanorum Arausio*, and that later under the Flavian emperors a second colony was founded, *Colonia Flavia Tricastinorum*, as a capital of the local Tricastini tribe. The Flavian centuriation is to be associated with land system B. An inscription of A.D. 77 accompanies the map and states that in 77, in order to restore state lands that had been assigned by Augustus to the veterans of the Second Gallic legion but which had been occupied for some years by private individuals, Vespasian ordered a map to be set up with a record of the annual rental of each century. This was to be carried out by Ummidius Bassus, proconsul of Gallia Narbonensis. See A. Piganiol, *Les documents cadastraux de la colonie romaine d'Orange* (Gallia Suppl. 16, 1962); F. Salviat, "Orientation, extension et chronologie des plans cadastraux d'Orange," *RANarb* 10 (1977) 107-18. Another example is Nola, where there is known to be a colony of Sulla's veterans, *Colonia Felix Augusta*, followed by an Augustan colony and then a Vespasianic settlement of veterans (*Lib. Col.* 236). Three distinct systems of centuriation have been identified at Nola (I, II, III); Nola III is identified as Vespasianic. See G. Chouquer, M. Clavel-Lévêque, F. Favory and J. P. Vallat, *Structures agraires en Italie centro-méridionale. Cadastres et espace ruraux* (Paris-Rome 1987) 209-12. See also G. Chouquer and F. Favory, *Les paysages de l'antiquité, terres et cadastres de l'Occident romain* (Paris 1991) 167-68. A third example is at Béziers where there are three systems of land division (A, B and C); system A is datable to the Flavian period: see M. Clavel-Lévêque, *Puzzle gaulois: les Gaules en mémoire* (Paris 1989) 255-82.

65 Paus. 7.18.6-22.1. See the discussion in Alcock (supra n.56) 132-45.

66 Paus. 5.23.3, 7.18.8, 8.24.11, 10.38.4; Strabo 7.7.5, 10.2.2.

67 It is known from literary evidence that the emperor Nero undertook the construction of the Corinth canal in A.D. 66/67, and that he presided at the initiation of the construction following the Isthmian Games of 67 (J. Wiseman, *The land of the ancient Corinthians* (SIMA, Goteborg 1978) 75 n.26; Suet., *Nero* 19; Pliny, *NH* 4.10; Lucian, *Nero* 1-5; Philost., *Vit. Apoll.* 4.24, 5.19; Paus. 2.1.5; Dio Cassius 62.16). The work was undertaken by soldiers and convicts and it is known that it continued for some time after Nero's visit to Greece. Josephus (*BJ* 3.540) tells us that Vespasian brought together Jewish captives in the stadium at Tiberias in September of 67. He had 1200 of the elderly put to death and sent 6000 of the strongest young men to the isthmus, presumably for the canal project. This project may have a relationship with the later *limitatio*. For preliminary discussions on this subject I thank B. D. Shaw, who has suggested a number of bibliographic references, and C. K. Williams, II.

is possible that they were sold on the open market. But perhaps, after the work of the canal had stopped (unfinished), the slaves may have been given their freedom together with plots of land in the neighborhood of Corinth. Alternatively, they might have become tenant farmers for the new colony.[68] There is in the vicinity of the isthmus of Corinth a large series of limestone quarries, some of which were being worked in the Roman period.[69] It remains a possibility that some of the slaves could have been put to work in the quarries, and later set free.[70]

Although we do not know the population of Corinth during this period, the current evidence suggests that the size of the urban city before the 70s had not grown to fill the drawing-board grid of 44 B.C.[71] The dense Flavian centuriation of the Corinthia suggests that the new colonists may have been farmers, possibly living outside the city of Corinth, as the urban center seems not to have grown to its expected size.[72]

Literary and epigraphic sources show that Vespasian was interested in rehabilitating the finances of the empire following the extravagances of the Julio-Claudian emperors.[73] This new allocation of land would be in keeping with his aims, to stabilize the empire's financial basis by means of re-allocation of *subseciva*, land that had not been allocated or land that had been allocated but unsettled, or land occupied by squatters. The result would give a new tax-base to the region.

Furthermore, it is known that Vespasian cancelled the freedom that Nero had given Greece in 66/7 A.D. and made Greece once again a senatorial province. Two ancient authors have suggested that this occurred in A.D. 70.[74] Pausanias suggests that this happened because the Greeks had forgotten how to be free, but Suetonius suggests that the reason for the revocation may have been economic.[75] It is possible that Vespasian withdrew the right of coinage from Corinth,[76] and this may be the most likely date for the new *limitatio* of the Corinthia and the Sikyonia.

I suggest that the timing of this *limitatio*, (units A1–A10 and A11), followed the earthquake that damaged Corinth and the Corinthia in the early 70s but preceded the foundation of the new colony. Thus the agricultural tax base of the new colony would have been in place when it was founded. It is likely that Vespasian or Domitian was responsible for several rebuilding projects in the city as well as for paving some of the Roman roads of Corinth.[77] The right of coinage probably returned to Corinth under Domitian.[78]

68 A parallel case would be the settlement of barbarians in the Roman world as tenants on imperial land: see G. E. M. de Ste. Croix, *The class struggle in the ancient Greek world* (Ithaca 1981) Appendix III, "The settlement of barbarians within the Roman empire," 509-18.

69 See Wiseman (supra n.67) 68 fig. 76.

70 See F. Millar, "Condemnation to hard labour in the Roman empire, from the Julio-Claudians to Constantine," *PBSR* 52 (1984) 124-47.

71 Engels (supra n.35) 82, suggests that the population of Roman Corinth was between 72,500 and 116,000. I would propose a much smaller number.

72 It is not possible at this writing to estimate the land allocation per colonist, although this issue will be considered in the final publication.

73 See the discussion by M. P. Charlesworth, "The Flavian dynasty," *CAH* XI.1 (1936) 1-45.

74 Philost., *VA* 5.41; Syncellus, *Chron.* p. 271.

75 Paus. 7.17.4; Suet., *Vesp.* 16.

76 Amandry (supra n.5) 102 suggests that this occurred in A.D. 70, 73 or 74.

77 O. Broneer, *Corinth X, The Odeum* (Cambridge 1932) 143-44, writes that the odeum was built "toward the end of the 1st century A.D." See also Kent, *Corinth* VIII, iii, 21, 134, fig. no. 334, a Doric epistyle frieze block of poros from the dedication of the *scaenae frons* of the odeum, suggested by Kent to date to the time of Domitian. For the theater, see C. K. Williams, II and O. H. Zervos, "Corinth 1987: South of Temple E and east of the Theater," *Hesperia* 57 (1988) 113, 115, who give the date as "late 1st or in the very beginning of the 2nd century for the laying of the construction fill". The date of the reconstruction of the theater is not absolutely certain but possibly occurred in the time of Domitian.

78 *Corinth* VI, 91 ff.

Proposed historical timeline

A summary of the sequence of events as here envisioned is as follows:

66-67 Nero authorizes construction of the canal and work begins. Along the narrowest part of the isthmus, his surveyors lay out an oblique line determined by the existing centuriation of 16 x 24 *actus* units. This centuriation is the *limitatio* probably begun in the 2nd c. B.C. (*lex agraria*) and later incorporated into the Caesarian colony, *Colonia Laus Iulia Corinthiensis*.

68-? Vespasian continues the project after Nero leaves Greece.

70-77 Vespasian as emperor initiates a new centuriation. A grid is established that probably originates in the city of Corinth, at its southern *limes*. This new centuriation is part of the re-organization of the colony.

70-77 A new colonial foundation, *Colonia Iulia Flavia Augusta Corinthiensis*, is established under Vespasian.[79] A new division of the land (units A1-A10) is completed at this time, probably after the earthquake of the 70s.

Conclusions

Corinth's long history, economic potential and strategic location on the isthmus made it attractive to the Romans for numerous reasons. Following the sack of Corinth in 146 B.C. by Lucius Mummius, it is quite possible that the Romans had the site in mind for a future colony. A generation later, in 111 B.C., the *lex agraria* probably provided for the centuriation and sale of at least some of the land of the Corinthia, including the land north of the city between the Greek long walls. When this land was laid out, the Romans probably already had in mind a detailed design of the colony, as is clear from the spacing of the division and the reservation one *actus* wide for the *cardo maximus*.

By the time of the Caesarian foundation in 44 B.C., many parts of the Corinthia had probably been centuriated. From 44 B.C. the urban grid of the Roman city was imposed on the remains of the former Greek city and new Roman spaces and buildings began to take shape. It has been suggested that the early colonists who came were a combination of freedmen, veterans and *negotiatores*, as well as outside Greek notables.

Over a century later, following the excesses of the Julio-Claudian emperors, Vespasian tightened the administration of the Roman empire. Following a devastating earthquake probably in the early 70s, a new *limitatio* of the Corinthia and the Sikyonia was carried out, preceding the foundation of the new colony.

The evidence from Corinth suggests that in both the case of the Caesarian colony and in that of the probable Flavian colony there was advance planning in the organization and division of land. In both cases it would seem that the division of land as a *limitatio* was conducted, or at least begun, before the actual dates of the foundations. This implies a long-term plan for the land that would have had both practical and philosophical implications. It was paralleled by the equally long-term political, social and economic Romanization of the Corinthia.

The University of Pennsylvania Museum of Archaeology and Anthropology
dromano@sas.upenn.edu

79 Following the death of Domitian, the city apparently reverted to its former name, *Colonia Laus Iulia Corinthiensis*. See *Corinth* VIII, iii, nos. 82, 96; *Corinth* VI, pp. 28-29. There may have been elements of the Flavian colony that were planned but unfinished.

The fortress *coloniae* of Roman Britain: Colchester, Lincoln and Gloucester

Henry Hurst

This paper explores the approach to urbanism expressed in the three British *coloniae* which were created from ex-legionary fortresses, and attempts to consider some of the issues involved.

The title may first need some explanation. "Fortress *coloniae*" refers to the city-creation phase at these three sites: Colchester had been a fortress of *legio XX* established soon after the invasion of A.D. 43, and according to Tacitus (*Ann.* 12.32) it became a *colonia* in A.D. 49. Lincoln was a fortress of *legio IX*, followed by *II Adiutrix*, from the early 60s and it became a *colonia* probably in the 80s. Gloucester was a fortress probably of *legio XX* in direct succession to Colchester, moving in the early Flavian period about 1 km from the site of Kingsholm to what became the city centre, and it probably became a *colonia* under Nerva. York became the fourth known British *colonia* at a later date and in different circumstances, with the status being conferred probably in the early 3rd c. on the civilian community attached to the fortress of *legio VI*. What all three earlier British *coloniae* have in common, and in contrast with *coloniae* in the Rhineland where there had been periods of legionary occupation, such as Cologne, Xanten and Nijmegen, is that the disused fortress buildings became the core of the new cities. Consequently, not only the shape but also the internal arrangements of the fortress influenced the shape and arrangements of the cities, albeit to a varying extent, as we shall see.

In Romano-British studies,[1] both a general and a particular issue might be seen to arise from this. The general issue, which has been much debated, is the impact of the military occupation of southern Britain on the Roman urbanization of the province. This has been well discussed by M. Millett,[2] and it is sufficient here to express agreement with his view that, while the military occupation assisted infrastructural development, the crucial factor in urbanization was the level of pre-Roman socio-economic organisation. The particular issue is how far the category of 'fortress cities' in the sense just defined is meaningful. It emerged in what might be called the pre-Millett phase of seeing the military occupation as the dominating influence on Romano-British urbanism: a book edited by G. Webster, entitled *Fortress into city. The consolidation of Roman Britain, first century AD* (1988), might seem to encapsulate this viewpoint; and Webster said or implied as much in his Introduction and account of Wroxeter, although not all the contributors took the same view (this volume provided accounts of the three *coloniae* discussed here together with the *civitas* capitals of Exeter and Wroxeter, which accompanied the sites of former legionary fortresses, and Cirencester, which followed an auxiliary fort). P. Crummy's recent study on Colchester[3] confirms the continuing use of this approach in thinking about Roman Britain.

A traditional way of understanding 'fortress city' is as a functional and symbolic expression of Roman thought about *coloniae*. Tacitus' well-known phrase about *Camulodunum* (Colchester) being a '*subsidium adversus rebellis*' (*Ann.* 12.32) and his description of *Lugdunum* as '*coloniam Romanam et partem exercitus*' (*Hist.* 1.65) express this, but such an association in the planning and design of colonial sites can be traced back to the maritime colonies of the early Roman Republic.[4]

1 Though not, perhaps, in Roman provincial archaeology seen from a non-British perspective; see further below.

2 M. Millett, *The Romanization of Britain* (Cambridge 1990).

3 P. Crummy, "Colchester: making towns out of fortresses and the first urban fortifications in Britain," in H. Hurst (ed.), *The coloniae of Roman Britain: new studies and a review* (JRA Suppl. Ser. 36, 1999) 88-100.

4 Compare Zanker in this volume. As Torelli points out (in P. Gros and M. Torelli, *Storia dell'urbanistica. Il mondo romano* [Roma-Bari 1988]130-31), it appears that the regular rectilinear fortress design was

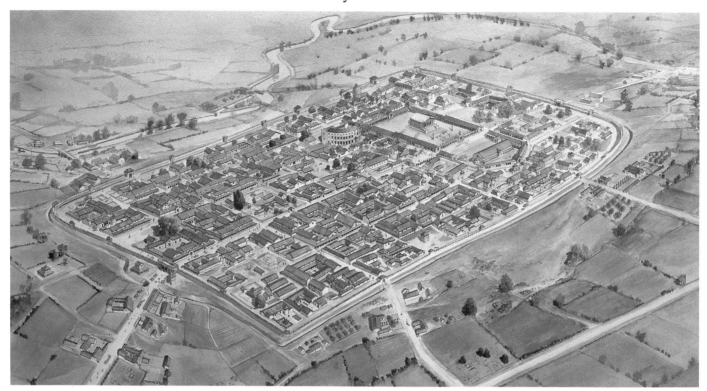

Fig. 1. Conjectural reconstruction of the walled area of Roman Colchester in the 3rd c. A.D., looking NE
(Peter Froste). The former legionary fortress occupied most of the western (near) half of the walled city,
with its NE corner lying close to the west end of the theatre. The Temple of Claudius, which dominates the
walled area, thus lay to one side of the presumed initial *colonia* settlement.

With these meanings in mind, we might ask whether the three British *coloniae* were a
special case — cities made out of disused military establishments because of a stronger-than-
usual military setting combined with an absence of will and the resources to build from scratch
— or was this the application of traditional ideology: cities made from fortresses because their
makers wanted them to look like fortresses. However, as was well shown by M. Schimmenti's
remarks on modern city design, made at this conference, strict 'either/or' questions are not
really appropriate: the result of an actual city plan may not be quite what was designed, and
within the design process there may be active and passive elements — the positive following
of models mixed with a more empirical approach. My question is not, then, posed absolutely but
rather to provide indications.

In terms of its political significance Colchester (*Camulodunum*) stands out, since it was the
political capital of pre-Roman and earliest Roman Britain. Its virtually instant elevation to
colonial status, combined with the establishment there of a temple of the imperial cult, is
reminiscent of the rôle of *Lugdunum* within Gaul. Another parallel, discussed below, would be
Cologne, designated a leading centre for an Augustan province of Germany and eventually be-
coming the capital of Lower Germany under Domitian. The archaeology of Colchester suggests
that the colonial settlers were housed in the former barracks of the legionary fortress, which
they continued to occupy until the destruction of the city by fire, arguably in the rebellion of
Boudica of A.D. 60/1 (fig. 1).[5] In Tacitus' description of *Camulodunum* when attacked (*Ann.*
12.32), mention was made of the construction of a theatre and temples, including that of the
deified Claudius, and the fact that the Roman settlement was unwalled. It is difficult to judge

borrowed from city planning, and not vice-versa; he cites Polybius' account of a military camp (6.26-42),
which mentions how its shape was similar to that of a city, and Frontinus (*Strat.* 4.1.14), saying that the
practice of constructing *castra* for entire legions dates only from the time of the battle of Maleventum
against Pyrrhus (275 B.C.).

5 For summaries with further bibliography, cf. P. Crummy, *City of victory. The story of Colchester —
Britain's first Roman town* (Colchester 1997) and id. (supra n.3).

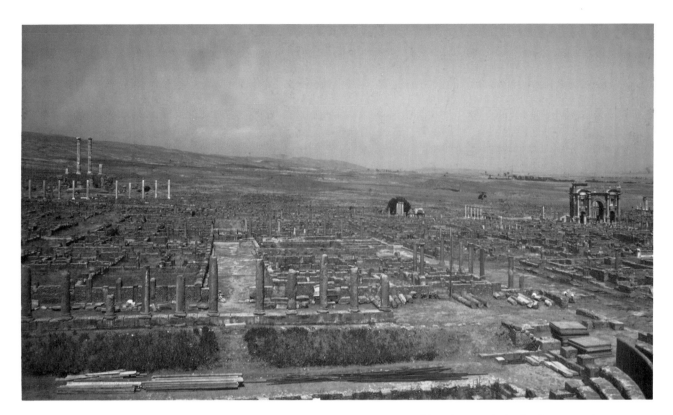

Fig. 2. Timgad, looking E from the theatre, whose stage building (with columns) is in the foreground. In the distance, left, can be seen two standing columns of the *capitolium*, lying just outside the initial walled nucleus of the *colonia*.

how literally to take such phraseology in Tacitus, as to whether he is offering information about specific buildings or a generic statement of what he might expect, and we still do not have enough detailed archaeological information to know when these major buildings were begun. However, it seems clear that the Temple of Claudius was envisaged from an early stage[6] and this gives us a feel for the urbanism of the Roman settlement.

The domination of the Roman settlement area at Colchester by a grand temple in the classical style — no forum-basilica has yet been found, and wherever it is, it must be smaller than the temple precinct — is reminiscent of the domination of African towns by their *capitolia* (fig. 2).[7] That can be read as a mark of 'Romanness' with nothing military or fortress-like about it. If we accept Tacitus' statement that the settlement was unwalled in 60/61, which perhaps can be believed since he makes play about how this was partly due to the misjudgement of a faction in the community, then Roman Colchester was, conceptually, even less like a fortress. After the barracks housing the first settlers were burnt down and disappeared, the buildings which replaced them were of a different, non-military plan, thereby further diminishing the military aspect of the city.

But the urban area of Roman Colchester consisted of much more than just the former legionary fortress and temple precinct. An important pre-Roman cult-centre at Gosbecks, 4 km from the fortress site, eventually included a stone Roman theatre and Romano-Celtic temple building. Gosbecks lay within the sweep of pre-Roman earthworks which also surrounded the fortress; and nearer to the fortress, there were pre-Roman and Roman habitation and craft areas, of which the best known is Sheepen, a short distance west of the fortress. Grand burial enclosures which possibly span the invasion period have recently been excavated at Stanway, just west of Gosbecks. A notable feature among these is the way in which an elaborate ritual reminiscent of other rich pre-Roman burials from SE Britain was followed in a burial which seems to date

6 P. J. Drury, "The temple of Claudius at Colchester reconsidered," *Britannia* 15 (1984) 7-50.
7 Cf. P. Gros, *L'architecture romaine, I. Les monuments publics* (Paris 1996) 227-28.

from around A.D. 60.[8] Within the context of early Roman Britain this is to be expected; in the context of early Roman *Camulodunum*, this is another sign, along with the settlement pattern just described and a well-known inscription to Munatius Bassus, censor of the Roman citizens at Camulodunum (*CIL* XIV 3955, implying that there was also a non-citizen community), that this site had a dual rôle, as both a native cantonal capital of the Trinovantes and a colonial settlement. Its sprawling overall pattern reflects the essentially native polyfocal (some would say pre-urban) basis of its urbanism, within a small part of which was the *colonia* and the Temple of Claudius. Shortly after the Boudican rebellion it seems that a curtain wall was built around the *colonia*.[9] This may have emphasized the *colonia*-like nature of that area and given physical expression to the distinction between two classes of citizen, but it owed nothing to military associations.

At this point comparisons may be made with Cologne and Lyon. Cologne[10] also achieved colonial status under Claudius, having previously seen occupation by legions I and XX. Like Colchester, it was made an important Romanised cult centre, having both the *ara Ubiorum*, which we may take to be a Romanised version of a pre-Roman cult and community focus, and a major temple of the imperial cult. However, there are crucial and revealing differences. Cologne seems to have been established as an urban centre from the Augustan period for the native community of the Ubii, with the *ara Ubiorum* at its centre, and that urban centre was promoted to colonial status. At Colchester, the colonial site consisted of just the former legionary fortress and temple of deified Claudius (located within what might have been an annexe to the legionary fortress), with the pre-colonial native settlement of the Trinovantes left to continue its less-spatially-focused existence outside the *colonia* walls. The contrast between the two sites is underlined by a comparison of their walled areas, which can be taken as defining the colonial settlements — Cologne's covered 97 ha, whereas Colchester's was less than half that — and by the reversal of position for the principal cult centres. What is interpreted as the *ara Ubiorum* at Cologne was centrally placed, just west of the forum, while the temple of the imperial cult occupied, as it were, a secondary position in the SE quarter of the walled city; at Colchester, the temple of deified Claudius dominated the walled *colonia* as described, whereas the major Romanised native cult centre at Gosbecks was 3 km away. And, by contrast with Colchester, we do not even know whether the legions at Cologne were housed on the *colonia* site or nearby, as was the case with the other Rhineland *coloniae* of Xanten (3 km from the fortress) and Nijmegen.

The logic of this contrast would seem to be that at Cologne, a half-century-old Romanised urban centre in an area which had seen a Roman presence for a century, the native community was seen as ready for promotion to colonial status and the legionary occupation of relatively little significance. At Colchester, just 6 years after the Roman invasion the native community was unreliable or perhaps still the enemy; so the *colonia* was made out of the former fortress, presumably settled more or less exclusively with veterans, with the Temple of Claudius added to offer a cult focus for the new province as well as for this community. *Camulodunum* — the native centre — was left to continue a separate identity outside the bounds of the *colonia*. In the event, this was not the most skillful application of Roman provincial policy, as was soon shown in the uprising of Boudica. But perhaps Lyon was seen as a precedent for doing things in this way since the colonial settlement under Caesar's associate, Munatius Plancus, happened within just a few years of conquest and seems to have consisted at least partly of army veterans,[11] established on a site adjacent to, but separate from, a pre-existing native community. The Altar of the Three Gauls at Lyon which signified its cultural dominance within Roman Gaul, as perhaps the Temple of Claudius was intended to within Britain, was located outside the bounds of

8 Crummy, *City of victory* (supra n.5) for a summary of this evidence.
9 Crummy in Hurst (supra n.3).
10 Conveniently summarised by Gros in Gros and Torelli (supra n.2) 325-31, with bibliography.
11 Cf. Goudineau in G. Duby, *Histoire de la France urbaine, vol. I. La ville antique* (Paris 1980) 90.

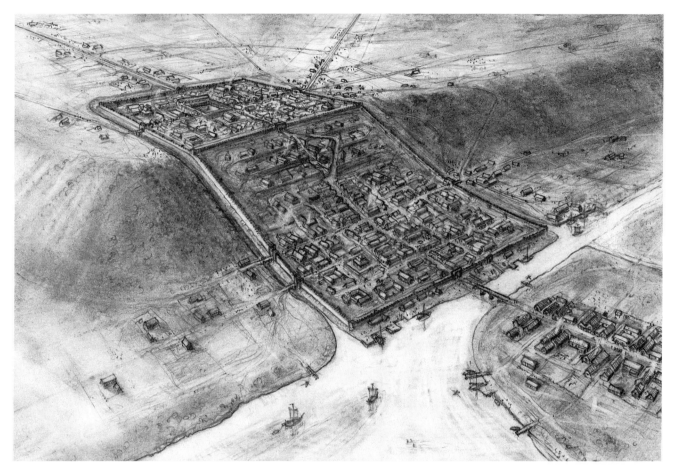

Fig. 3. Conjectural reconstruction of Roman Lincoln in the 3rd c. A.D., looking NE (D. Vale). The defended area of the former fortress and presumed initial *colonia* is on the summit of the hill, with the walled 'Lower Colonia' extending down the slope to the river and extramural settlement on the S side of the river.

the *colonia*, and it was developed under Augustus a generation after the colonial foundation,[12] so it can be seen as less of an imposition than the Temple of Claudius at Colchester.

Lincoln became a *colonia* more than a generation later.[13] For the first century or so of its existence the physical impact of the former military site was more immediately visible than at Colchester because the defended area of the former fortress became a walled area of the city, probably from a time soon after the colonial foundation, and it occupied a spectacular setting at the top of a limestone bluff overlooking the river Witham. Later, a walled annexe, the so-called 'Lower Colonia', was added, extending down the steep hill to the river (fig. 3).[14] In addition to these two walled enclosures, there was substantial extramural settlement originating in pre-Roman settlement to the east of the city and also to its south, on an apparent sand island in the marshy valley of the Witham. Significant reclamation of former marshland took place, at least partly in the late 2nd c., with the result that the riverfront and southern suburb became a substantial commercial area, extending as much as 1 km outside the walled area. Extramural settlement was also present on the other sides of the walled area, though on a smaller scale. Again, then, the *colonia* on the site of the former fortress seems to have been only a small part of a wider cityscape, part of which had pre-Roman origins.[15]

12 Ibid. 100.

13 The date is not known, though it is assumed to have been Domitianic: cf. M. Jones, "Roman Lincoln: changing perspectives," in Hurst (supra n.3) 101-12.

14 The walling of this enclosure probably dates from the 3rd c., though it may have been enclosed by an earthwork like other major native cities in Britain from about the 160s-180s.

15 Jones (supra n.13) for a summary with bibliography.

It is not clear how to read the extension of the walled area to the 'Lower Colonia': did this mark an extension of the colonial settlement, and thus perhaps the promotion of at least part of the native community; or, perhaps more plausibly, does it in fact reinforce the separation of that community on the Colchester model? If first enclosed by an earthwork, this area would be distinct from the walled former fortress at the top of the hill, and the wall dividing the two areas seems initially at least to have been retained.[16]

Generally with regard to the walled areas of Roman Lincoln, while we know a great deal about the defences themselves (making allowance for the observations just made), there has been much less opportunity to study the remains within them; and consequently, our feel for the nature of the *colonia* at Lincoln is restricted. An exception is the *principia* and forum.[17] Here there seems to have been a clear desire to follow civilian urban models, with several changes over a long period, culminating in a monumental phase of late 2nd- or even early 3rd-c. date. M. Jones' reconstruction from an inevitably fragmentary plan suggests a civil forum on what Romano-British archaeologists used to call the 'continental' plan, and many continental archaeologists the tripartite plan,[18] with a colonnaded space flanked on one side by a basilica or civic buildings and on the other by a major temple. Neither has yet been found at Lincoln, though the temple may be indicated by an inscription referring to the rebuilding of a temple of the imperial cult, fragments of which were found in the foundations of a Saxon church on the site. An elegant large colonnade, the Bailgate colonnade, belonging to this civil forum is known, together with other architectural details. The only other possible Romano-British candidate for a tripartite forum known so far is the *municipium* of *Verulamium*; all other known examples (more than a dozen) are of the so-called '*principia* type', consisting just of a colonnaded court (usually flanked by ranges of rooms) and basilica. To achieve its grander forum, Lincoln effaced a characteristic element of its military street layout, by which the *via praetoria* led from the principal gate to the entrance of the *principia* enclosure and then split into two, running on either side of the *principia*. This contrasts with Gloucester, where the civil forum occupied precisely the same spot as the *principia*.

Gloucester was probably a *colonia Nervia(na)* and if, as seems likely, it was founded in 96-98, this would make it perhaps a decade or so later than Lincoln.[19] As at Lincoln, the former fortress became the walled area of the *colonia* and, unlike Lincoln, that is how it remained, with no secondary extension of the walled area, which consequently enclosed a mere 17 ha (fig. 4). Like Lincoln and Colchester, the walled area at Gloucester made up only a small part of the urban area — about one-eighth if one judges by the nearest cemetery sites. Our understanding of the site of Gloucester is in transition, since it was once supposed that occupation originated with an earlier military site at Kingsholm, 1 km north of the fortress-*colonia* but still within the area circumscribed by cemeteries, and that there was no pre-Roman settlement on any scale. Now, however, it would appear that there was extensive occupation of immediately pre-Roman date in a Roman cemetery area to the north of Kingsholm[20] and to its north and for up to 1 km east from this. So what we can conceive as broadly the Colchester model of using the former fortress and keeping the natives outside seems again to have been followed. But at Gloucester, with a Roman military and pre-colonial civilian occupation perhaps lasting for as long as 50 years, the situation was different from Colchester. The making of a crossing of the Severn 1 km south of Kingsholm at the fortress-*colonia* site shifted the focus of settlement from

16 By the time it was walled in the 3rd c., the distinction between the Roman-citizen colonists and pere-
 grine others would have been removed by the *constitutio antoniniana* of 212.
17 Summary account with references in M. Jones, "Lincoln and the British fora in context," in Hurst (supra
 n.3) 167-74.
18 E.g., Gros (supra n.7), chapter on fora.
19 Summary accounts with references in H. Hurst, "Gloucester (*Glevum*)," in G. Webster (ed.), *Fortress into
 city. The consolidation of Roman Britain, first century AD* (London 1988) 48-73 and in Hurst,
 "Topography and identity in *Glevum colonia*" in Hurst (ed.) (supra n.3) 112-35.
20 Generally known as the Coppice Corner site.

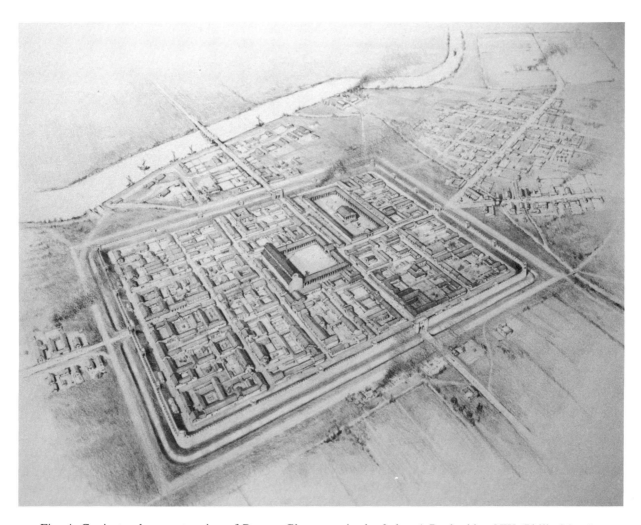

Fig. 4. Conjectural reconstruction of Roman Gloucester in the 3rd c. A.D., looking NW (Philip Moss). The walled area corresponds exactly to the former fortress limits, with the forum occupying the site of (though slightly larger than) the fortress *principia*. The temple enclosure is conjectured from the evidence discussed. The main extramural part of the urban settlement extends north to the early fortress site of Kingsholm (shown in outline, top right).

the Kingsholm area to that site a generation before the colonial foundation. By the time of the foundation, the memory of the community having an existence other than as service-providers to the Roman military must have been faint. In other words there was not such risk in keeping this community outside the walls of the *colonia* as there had been at Colchester. Yet this still happened.

There has been more opportunity for excavation within the walls of Gloucester than at Lincoln, and this has given us a nuanced view of its developed character but also a disputed understanding of the initial colonial foundation. Taking the second point, my own reading as a former excavator of the site is that, as at Colchester 50 years previously, the initial colonial settlement used the barrack buildings of a former legionary fortress. Gloucester city centre appeared to have had two major constructional periods as a legionary fortress, the first in the early Flavian period (when the move from Kingsholm occurred), the second not earlier than 86.[21] The second set of buildings would have been built and used for a purely military purpose for a few years before the Nervan colonists moved into them. Some think that this runs against accepted views of military dispositions in Britain, and argue that the post-86 rebuilding was to produce purpose-built barrack-like housing for the colonists; a few even redate the colonial

21 The date of two coins found in construction levels.

foundation, arguing that Gloucester was initially a Domitianic *colonia* which received a Nervan title after the *damnatio memoriae*.[22] How we interpret these buildings is an interesting problem, since it touches on the wider perception of how Roman veteran colonies began. Literally who built the buildings? Was it the settlers or might the army do it for them? From Gloucester there are also two cohort building stones, one identifying the cohort as part of *legio XX*, the other fragmentary. Although not directly associated with buildings, it seems reasonable to associate them with the post-86 phase when there were stone buildings, as opposed to the earlier phase of timber buildings. This for me tilts the argument towards the legion building for its own purposes in the first instance, although from the 2nd c. onward there is evidence for legionary activity in a colonial context, for example the roof-tiles of *leg. XXX* at Xanten[23] and evidence assembled by R. MacMullen for the military being involved in civilian projects.[24]

In any event, the fortress layout at Gloucester came to be fossilized in the city plan as later piecemeal rebuildings occurred within the same frame. The forum was built within exactly the same bounds as the fortress *principia*, and it is of what is called 'the *principia* type', with just a colonnaded space and a basilica, although such architectural detailing as we have (for its second phase, possibly Hadrianic) — a Tuscan order for the side colonnades, an open front for the basilica, a handsome well-built probable equestrian statue in bronze, multicolouring in grey-green paving slabs, red side gutters and cream limestone colonnades — separates this from the military architecture of Roman Britain. It was accompanied by other public architecture, of which we only have fragments, including a huge colonnade — huge in both the size of its columns (1 m in diameter) and in its overall length, traced for over 100 m (on the N side of Westgate Street). The columns are basilica-sized, being the same size as those within the Gloucester forum-basilica, but the extent of the colonnade — at least half as much again longer than the forum basilica — seems to rule out a basilica interpretation. Instead, one wonders if this was not the internal division of a cryptoporticus or colonnade belonging to a major temple enclosure, making Gloucester dominated by a principal temple in a similar manner to Colchester.[25] If so, again this can be read as a mainstream Roman colonial message, and such a precinct must mark a departure from the earlier military planning in this area.

Elsewhere in the walled area of Gloucester we find the site of a former centurion's house in the fortress rebuilt in the 2nd c. to look like a centurion's house. Next to it is a 2nd-c. courtyard house, which could be described, along with one or two houses from Colchester and Caerwent, as the nearest thing in the towns of Roman Britain to the classic Mediterranean peristyle house, but a more immediate, and more convincing, parallel must be with the *praetoria* or commander's houses of forts and fortresses — that at Housesteads on Hadrian's Wall, for example, is similar in plan, although adapted to a steeply sloping site.[26] Add to this the city walls, which never departed from the fortress circuit, and the walled area of Gloucester must have had a fortress-like aspect. But, as noted, the walled area was only a small part of the urban area. In the area just north of the walls there are public buildings, shops with colonnaded façades and a dedication to Mercury and Rosmerta, so this is highly urbanised; indeed we can plot the urban density as it moves from that through fringe areas of lime-kilns and tile-making, to open fields.

22 E.g., M. Hassall in id. and H. Hurst, "Soldier and civilian: a debate on the bank of the Severn," in Hurst (supra n.3) 181-89.

23 The presence of the legion in that area in A.D. 119 was, however, secondary to the colonial foundation: Gros and Torelli (supra n.2) 330.

24 R. MacMullen, *Soldier and civilian in the Later Roman Empire* (Cambridge, MA 1963) 32-38; see further discussion below.

25 See H. Hurst, "Civic space at *Glevum*" in id. (supra n.3) 152-60 for a summary of the forum and Westgate structure.

26 A. Johnson, *Roman forts of the 1st and 2nd centuries AD in Britain and the German provinces* (London 1983) figs. 102-3.

These three *coloniae* which follow what we have called 'the Colchester model', of using purely former military areas for the urban nucleus, therefore differ from the Rhineland, where the urban nucleus of *coloniae* on sites where there had been legionary occupation encompassed and merged with pre-existing civilian settlements. Settlement in these three British *coloniae* thus appears (initially, at least) to have been exclusive of the local native communities, whereas it was inclusive at the Rhineland sites and, for example, in the Flavian *colonia* at Avenches, which received a veteran settlement into a pre-existing civilian community, the whole of which seems to have been elevated to colonial status. Where former fortress sites in Britain were converted into *civitas* capitals, at Exeter and Wroxeter, the shape of these two cities does not reveal the underlying fortress, although at Exeter the fabric of the legionary baths seems to have been retained for use initially within the new city.[27] In their outline plans these cities paradoxically come to look more like the continental *coloniae* such as, for example, Cologne.

How should we read this? Was it simply a very cautious policy as regards Roman citizenship in Britain, that promotions of native groups did not occur in the 1st/2nd c. A.D.? Hence the different treatment of former fortress sites which became *coloniae* and *civitas* capitals — in the latter case the fortresses were effaced to make way for what was designed to be a larger urban community. Only with the promotion of the civilian settlement attached to the legionary fortress at York, probably in the early 3rd c.,[28] do we see an absolutely clear elevation of a British urban community, and that could be linked to the specific historical context of the use of York as a base for the Severan campaigns into Scotland. York as a site, with its legionary fortress on one side of the river Ouse and on the other the *colonia*, a promoted civilian settlement dependent on the fortress, parallels sites such as Nijmegen in the 1st c. A.D. or Lambaesis in the later 2nd c. Even Roman London cannot be shown to have achieved colonial status under the High Empire; it evidently had some titular distinction later on.[29]

Or were the British fortress-*coloniae* an archaism, harking back to the maritime colonies of the Tyrrhenian sea of Italy in the 4th and 3rd c. B.C.: rectilinear in plan, small and exclusive in their number of inhabitants, and having an overtly defensive rôle? Some of these colonies were on sites where much larger urban agglomerations arose, as for example Ostia, Anzio and Minturno.[30]

What might be called the cognitive issue, of how military the authorities and their inhabitants wished these three cities to look, is indeed central to this discussion. Let us at once distinguish between the question of the army building cities, or building within them, and that of a military 'look'. The classic case for such a discussion is Timgad.[31] From the outside, or viewed from the air, Timgad looks military: the initial colonial nucleus was surrounded by a curtain wall of exactly rectangular plan with rounded corners in the manner of a fort, the *insulae* are constructed according to a regular module and the buildings fill the spaces within the walls. The configuration of the streets and location of the forum are also reminiscent of a fort, in that the *cardo* leads from the N gate directly to the forum, as if it is a *via praetoria*; it stops there (so there is no continuation as the *via decumana*), while the main *decumanus* runs E-W along the N side of the forum, in the manner of a *via principalis*. The inscription on the 'Arch of Trajan' recording that Trajan 'made' (*fecit*, restored) Timgad *per legionem III* (by means of the third legion) can be taken to mean that the army built the colony.[32] But it is ambiguous: another possibility is 'founded through the agency of ...', meaning that the third

27 P. Bidwell, *The legionary bath-house and basilica and forum* (Exeter Archaeological Report 1, 1979).

28 P. Ottaway, "York: the study of a Late Roman *colonia*," in Hurst (supra n.3) 136-50. for a convenient summary of York with references.

29 J. J. Wilkes, "The status of Roman London," in J. Bird, M. Hassall and H. Sheldon (edd.), *Interpreting Roman London: papers in memory of Hugh Chapman* (Oxford 1996) 27-32.

30 See the discussion by Torelli in Gros and Torelli (supra n.2), esp. 127-29 and 150-51, with figs. 56-57.

31 Here I make use of the valuable discussion of Gros, ibid. 331-38.

32 As by Gros, ibid. 331. *ILS* 6841 or *CIL* VIII 17842-3 for the text of the inscription.

legion supplied veteran settlers, or that its authority was used to bring about the colonial foundation without, necessarily, the direct sense of building. An absence — so far as I am aware — of small military building inscriptions from Timgad, such as the cohortal building stones from Gloucester or the bricks from Xanten stamped *leg. XXX*, seems to weaken the case for formal military involvement in its building. Insofar as Timgad looks military — and, as P. Gros[33] and Y. Le Bohec[34] suggest, this was not its strongest message — this seems best explained in the manner of Gros (p. 334), who cites Hyginus discussing *Ammaedara* (Haïdra), a Flavian colony founded on a former fortress site of the third legion: space was divided into four quarters by very wide streets *in morem castrorum* (in the manner of military camps).[35] Timgad, then, was an urban creation *in morem castrorum* in certain respects. Its near neighbour and contemporary colonial foundation, Djemila, in a spectacular promontory setting, was less so, indeed hardly so at all. Yet, from the location and date, the third legion was as likely to have been involved in building Djemila as Timgad, and both sites were equally accessible to veterans from that legion. The fortress look of Timgad, then, is a matter of design, not the accidental consequence of it being in a partly military region.

This also seems to be borne out by the three British fortress-*coloniae*, because they vary as described in their treatment of their military heritage. It is the third of these, Gloucester, which looks most military. Yet, as suggested above, even it was not a passive conversion to civilian use of a military installation, indeed the picture is very nuanced: its forum was of *principia* type and in the position of the fortress *principia*, but its architectural ornament referred to civilian, not military, traditions;[36] the public building incorporating the Westgate colonnade marked a clear departure from military planning; the courtyard house in the style of a *praetorium* probably evoked this military model rather than the more remote one of the peristyle house of the Mediterranean (on which both were based), but it did so by obliterating the underlying fortress plan of barrack buildings; the walled area seems eventually to have moved towards a low-density rather than military look in the general disposition of buildings; and finally, one must not lose sight of the fact that this walled area formed part of a much larger urban landscape, and its character must have been submerged to some extent within what looks like a sprawling, low-density Romano-British urban agglomeration.

The three early British fortress-*coloniae*, then, seem to have a special identity in the initial use of former military installations. Rather than the formulation made above, that somehow the military setting might have been stronger or the impetus towards urbanisation weaker than usual, they seem best understood as expressions of an active ideational approach[37] which drew upon Roman urban and military associations. Their actual appearance as cities varied, and here what seems significant is the way the authorities and the inhabitants of these cities used the conceptual play between military and civilian that had existed in Roman architecture and planning from far back in the Republic. The appearance of Gloucester and Timgad, which may have been almost exactly contemporary foundations, hints that a canonical military look — as exemplified in late Flavian military sites, notably Inchtuthil — may have been in vogue at the very end of the 1st c. It was only one alternative, however, among a variety of colonial styles and, even in these two cases, there seems no reason to suppose that it was used other than metaphorically.

Faculty of Classics, University of Cambridge

33 Ibid. 331-38.

34 Y. Le Bohec, "Timgad, la Numidie et l'armée romaine. A propos du livre d'E. Fentress," *Bull. Arch.* NS 15-16, *Années 1979-1980. Fasc. B, Afrique du Nord* (1984) 105-20.

35 See the reconstruction drawing in this volume (fig. 3 on p. 17).

36 Cf. Hurst, "Civic space" (supra n.25), using the study of T. F. C. Blagg, "Roman civil and military architecture in the province of Britain," *World Archaeology* 12.1 (1980) 27-42.

37 Cf. J. Metzler, M. Millett, N. Roymans and J. Slofstra, *Integration in the Early Roman West* (Luxembourg 1995), especially the introduction by Millett, Roymans and Slofstra (ibid. 1-6).

Urbanization and its discontents in early Roman Gaul

Greg Woolf

'I had no idea there *were* any bookshops in Lyon', Pliny exclaims in one of his letters,[1] 'so I am even more glad to learn from you that they sell my little works, and that they remain as popular there as when they were published in Rome' (*in urbe*). The Gallic provinces stand here, in a way wholly familiar in Latin literature, as the polar opposite of the city of Rome, its cultural antipodes. Pliny's success there — as he points out — demonstrates the power of his writing and its worth. The function of the Gallic provinces (fig. 1) in this volume might seem to be to make a similar point about the success of the Romans' civilizing mission and of their urbanizing project. If Roman ideals were established and propagated by city building *even in Gaul*, then the cultural power and centrality of the Roman city seems as safely assured as Pliny's reputation.

It is easy to see how such a demonstration might begin. Consider the city of Autun in Burgundy.[2] The city was a new foundation, the Aeduans' own 'Augustusville' replacing the Roman city

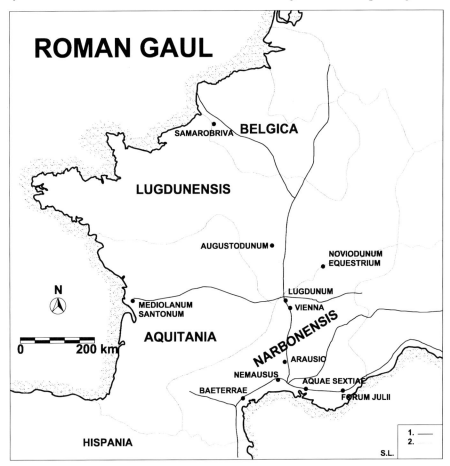

Fig. 1. Roman Gaul, 1 = roads. 2 = provincial boundaries. After J. Drinkwater in R. J. A. Talbert, *Atlas of Classical History* (London 1985) 136 (*del.* S. Leigh).

1 Plin., *Ep.* 9.11.2.

2 A. Rebourg, "Les origines d'Autun: l'archéologie et les textes," in C. Goudineau and A. Rebourg, *Les villes augustéennes de Gaule (Actes du Colloque international d'Autun 6-8 juin 1985)* (Autun 1991) 99-

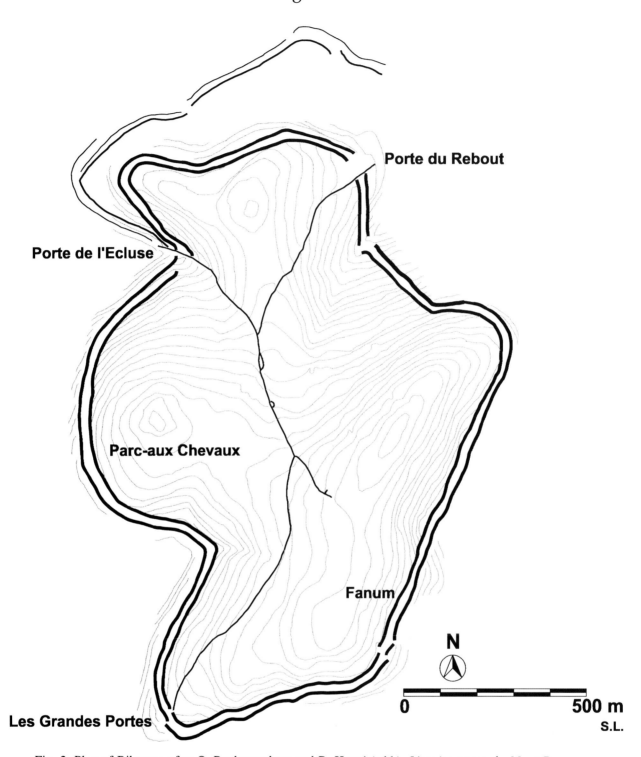

Fig. 2. Plan of Bibracte, after O. Buchsenschutz and R. Hervé (edd.), *L'environment du Mont Beuvray, Bibracte 1* (Glux-en-Glenne 1996) 181 (del. S. Leigh).

they had already built on the wet and windy slopes of Mont Beuvray on top of the late La Tène *oppidum* of *Bibracte* (fig. 2).[3] *Bibracte* had not been forgotten. Marble altars dedicated to Dea

106, for a summary of the state of our knowledge of early Autun, now fully described in M. Provost, *Autun: atlas des vestiges gallo-romains = Carte archéologique de la Gaule* vol. 71 *(Saône-et-Loire)* fascicules 1-2 (Paris 1993).

3 For a recent account of *Bibracte*, incorporating material from the recent excavations, see C. Goudineau and C. Peyre, *Bibracte et les Éduens. À la découverte d'un peuple gaulois* (Paris 1993).

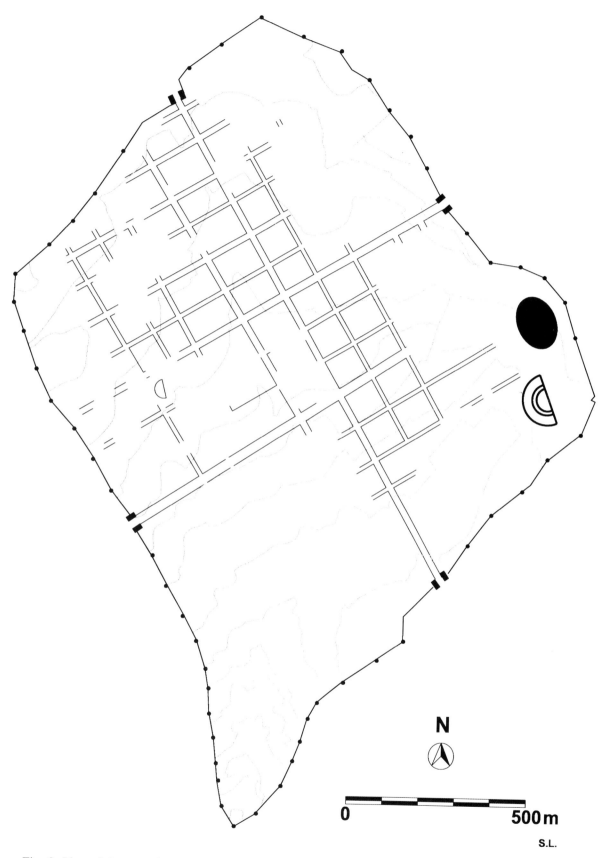

N

500 m
0

S.L.

Fig. 3. Plan of *Augustodunum* (Autun), after M. Pinette and A. Rebourg, *Autun. Ville gallo-romaine* (Guides Archéologiques de la France 12) 11; and G. Duby (ed.), *Histoire de la France urbaine* 1 (Paris 1980) 255 (*del.* S. Leigh).

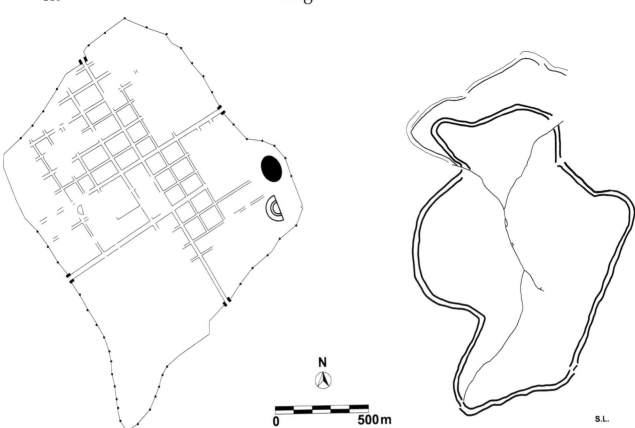

Fig. 4. Comparative plans of Autun and Bibracte at the same scale, after M. Pinette and A. Rebourg, *Autun. Ville gallo-romaine* 11; G. Duby (ed.), *Histoire de la France urbaine* 1, 255; O. Buchsenschutz and R. Hervé (edd.), *L'environnement du Mont Beuvray, Bibracte* 1, 181; and A. Colin, S. Fichtl and O. Buchsenschutz, "Die ideologische Bedeutung der Architektur der Oppida nach der Eroberung Galliens," in J. Metzler *et al.* (edd.), *Integration in the Early Roman West* 159-67 (*del.* S. Leigh).

Bibracte have been found in Autun[4] and a *fanum* stood on the summit of the hillfort. But the ancestral mountain had been otherwise abandoned, including the Italianate houses constructed in the Parc des Chevaux during the first generations after Caesar's conquest. Despite the time, energy and money invested in that first Romano-Aeduan city, the next generation had begun again, building an even bigger city down in the valley of the Arroux (fig. 3). By the A.D. 20s, a Roman grid had been laid out and work had begun on the walls, their 6-km circuit enclosing an area of 200 ha, and pierced by gates that recall those of Turin and other N Italian cities.[5] Recent research suggests that, alongside this overt Italian style, the precise dimensions of the enclosed area, the walls, and the gates themselves seem to have been designed to rival the very *un-Roman* monumentality of *Bibracte* (fig. 4) on its own terms.[6] Certainly the energy put into levelling a series of terraces on which the town was built, and which the walls partly revet, is comparable to the raising of the two great ramparts of the *oppidum*. But Roman monumentality was not neglected. At the centre of Autun spaces were reserved from the first for the forum and its surrounding temples, and probably also for the eventual theatre and amphitheatre.

4 *CIL* XIII 2651, 2652, 2653.

5 On Gallo-Roman use of N. Italian models of urban design and monumental architecture, see J. B. Ward-Perkins, "From Republic to Empire: Reflections on the early imperial provincial architecture of the Roman West," *JRS* 60 (1970) 1-19.

6 A. Colin, S. Fichtl and O. Buchsenschutz, "Die ideologische Bedeutung der Architektur der Oppida nach der Eroberung Galliens," in J. Metzler *et al.* (edd.), *Integration in the early Roman West: The role of culture and ideology* (Dossiers d'Archéologie du Musée National d'Histoire et d'Art 4, Luxembourg 1995) 159-67, for discussion of these parallels.

Augustodunum — like Rome and all Roman cities — was not built in a day. In common with most of the great tribal capitals of early Imperial Gaul, the completion of the monumental kit took about two generations.[7] While the monuments rose in the new cities of Gaul, most private housing remained small-scale and built of earth and wood, even if the designs and some of the carpentry already showed the influence of Rome.[8] In some of the cities of the north and west — sites like Carhaix in Brittany — the huge monumental grids laid out in the 1st c. were *never* filled in, but framed vacant lots, empty *insulae* perhaps turned over to agriculture. That was not true of all northern cities. Amiens, for example, rapidly outgrew its similarly extensive planned area.[9] Yet even in Autun we cannot be sure that the houses stretched to the walls before the Severan period. Autun at the beginning of the 1st c. A.D. was a vast building site, the scale of Aeduan aspirations evident only dimly above the smoke and squalour of a shanty town squatting at the feet of half-finished monuments.

What did the Aeduans think they were doing? It is evident — by the way — that the impetus came from the aristocracy of the Aedui. Imperial encouragement is likely enough; indeed, the walls may have been an emperor's gift, as those of contemporary Nîmes seem to have been. We know, too, of instances where Roman governors encouraged investment in monumentality. A likely Gallic case is that of the Arverni whose Senate was probably encouraged by Dubius Avitus to commission (at great expense) a new cult statue of Mercury from Zenodorus, one of the leading Greek sculptors of his day.[10] But there can be no question of compulsion. The Aedui had their Roman city already on *Bibracte*, and the relocation cannot have been required for considerations of security. The Aedui were model subjects, and their new city bore the emperor's name.

By the late 3rd c., speeches made by Eumenius and other Aeduan orators asserted their adherence to conventional Roman ideas about urbanism. Indeed, most of these speeches were designed to restore and improve on the urban monumentality of Autun. The same speeches also show those Aeduans ready to present their own urbanization in the familiar context of Roman culture-myths of the civilizing process, the promulgation of *humanitas* at the expense of barbarism, and so forth.[11] But things may have been different by the 3rd c. Myths of this kind often operate as *post facto* rationalizations, devices for making retrospective sense of sequences of events the causation and interrelationship of which were less clear-cut or palatable. The civilizing myth provided an explanation of the Roman conquest of a barbarous Gaul, coupled with a promise of success in the future for civilized Gauls (a promise all the more valuable after the barbarian invasions of the Gallic provinces in the late 3rd c.). It also offered the Aeduans a justification of their own prolonged collaboration with Caesar in the reduction of other Gallic tribes, the assurance that they had sided with 'Civilization and History', and out of necessity.

Did the same ideas inspire the building of Autun in the first place? It is difficult to establish for certain how early a familiarity with the Roman concepts of civilization became widespread in Gaul, but there is some reason to think that the Gallo-Roman aristocracy of the early 1st c. were not ignorant of them, nor unaware of how they related to urbanization. Tacitus describes the children of Gallic aristocrats being educated in Autun in the A.D. 20s.[12] Presum-

7 Goudineau and Rebourg (supra n.2) survey the evidence from the best-studied *civitas* capitals.

8 Cf. J. Lasfargues (ed.), *Architectures de terre et de bois. L'habitat privé des provinces occidentales du monde romain* (DAF 2, Paris 1985) on early domestic architecture.

9 Cf. D. Bayard and J. L. Massy, *Amiens romain. Samarobriva Ambianorum* (RAPicardie num. spéc., 1983). for discussion of the development of the city. More recent excavations have already shown the ultimate extension was even greater than supposed in this survey.

10 Plin., *NH* 34.45 with discussion in G. D. Woolf, *Becoming Roman. The origins of provincial civilization in Gaul* (Cambridge 1998) 215-16.

11 G. D. Woolf, "The uses of forgetfulness in Roman Gaul," in H.-J. Gehrke and A. Möller (edd.), *Vergangenheit und Lebenswelt. Soziale Kommunikation, Traditionsbildung und historisches Bewußtsein,* (ScriptOralia 90, Tübingen 1996) 361-81, on the basis of the *Pan.Lat.*

12 Tac., *Ann.* 3.43.

ably they followed the syllabus that rapidly became standard throughout the Latin-speaking empire, with its emphasis on a literary canon in which texts like the *Aeneid* had a central place.

The association of city founding with civilization and divine favour is central to those works. Virgil's description of the foundation of Carthage is one of the few Augustan-period accounts of how the cities were laid out, with their grid plans, temples and other monuments.[13] Vitruvius' *De architectura*, published earlier in Augustus' reign, provides another rich source. Vitruvius pays particular attention to the foundation of cities in 1.3-7, but the ordering of urban space recurs throughout the work. The preface to Book 2, after an anecdote on the foundation of Alexandria, adds architecture to an evolutionary vision of the spread of civilization; in 2.1.4 the building techniques of Iberia and Gaul in his own day (i.e., Augustan) are cited as evidence for the nature of primitive architecture. After further examples of hut building, Vitruvius works his way back, *via* Athens, to the Hut of Romulus and ancient Rome. Virgil too described ancient Rome — in fact, an even more ancient and pre-Romulean Rome — in the eighth book of the *Aeneid*. The account of the site of Rome, like the description of the foundation of Carthage in Book 1, is brought into focus through Aeneas, and acts as a contrasting pendant to that earlier description. Virgilian Carthage looked back to the heroic (or tragic?) and Homeric past, capped by the *ecphrasis* of the decorated doors of the temple of Juno on which are depicted the slaughter of various Trojans by the Greeks, led by Achilles (1.456-493). Aeneas' visit to Evander's settlement on the future site of Rome, on the other hand, points forward to a glorious future, culminating in the *ecphrasis* of the shield of Aeneas (8.626-728) on which Vulcan has put scenes from Roman history culminating in Augustus' victory at Actium, his triple triumph and the Temple of Apollo on the Palatine. The civilizing of Rome is to begin again not from post-Homeric luxury, but from the rural simplicity of Evander's *Pallanteum* and the Hut of Romulus.[14]

The convergence of Vitruvian and Virgilian accounts of the civilizing process, and of the place of urbanism within it, is not accidental. Both not only reflected commonplace views, but also drew heavily on Lucretius' account (Book 5) of the civilizing process.[15] Lucretius described a state of nature in which primitive men lived like animals, and how the invention of marriage and friendship, and the discovery of fire and language, led inexorably to civilization and its attendant vices. Eventually society, cities and property appeared:

> And in that time those public-spirited individuals (*benigni*) who stood out for their intelligence or their will began progressively to show men how to exchange the previous basis and manner of their lives for new ways. Kings began to found cities, and to build citadels to strengthen their position and protect themselves. And they divided up the flocks and the land, distributing them according to the beauty and intellect and strength of each, since appearance was greatly valued in those days and strength was held in high esteem. *De Rer. Nat.* 5.1105-12

Educated Roman readers might have been expected to hear Lucretius behind these passages of Vitruvius and Virgil. The most educated might even have heard another Virgilian passage behind the part of Virgil's account of the founding of Carthage (*Aen.* 1.430-36) where Virgil compares the division of labour among the Phoenicians building the city to that among bees

13 Verg., *Aen.* 1.421-49, briefly discussed in Woolf (supra n.10) 125-26. See also Rakob, above p. 75.

14 On the symbolic weight of this imagery and on ancient Rome as a privileged *locus* for discussion of civilization, and as a vantage-point from which to view Augustan and post-Augustan Rome, see C. Edwards, *Writing Rome: Textual approaches to the city* (Cambridge 1996) 30-43.

15 Virgil's debt to Lucretius is well known. For Vitruvius' use of Lucretius see, for example, Vitr. 2 *praef.* 5: *insequar ingressus antiquitatis rerum naturae et eorum qui initia humanitatis et inventiones perquisitas scriptorum praeceptis dedicaverunt*. He also refers explicitly to Lucretius in 9 *praef.* 17, where he ranks his work alongside those of Cicero on rhetoric and Varro on language. This chapter, with the preceding one praising Accius and Ennius, offers a rare description of a pre-Virgilian (i.e., Triumviral or early Augustan) Latin canon.

making honey, in words quoted from a similar passage in the *Georgics*.[16] Central to all these accounts is the animating personality of the founder and leader: the king bee of the hive, Lucretius' *benigni*, Evander, Dido, Aeneas, and of course Augustus.

But the significance of the Virgilian version for most Gauls will have been different. Vitruvius' work may have been known to some of the architects hired by Gallic grandees, but few Gauls would have read either him or Lucretius. It was through Virgil that Roman visions of the civilizing process were made accessible to Gauls. Even if they missed the *Aeneid*'s complex allusiveness, future euergetists at their lessons in the classrooms of Autun and elsewhere might have made the connection between Aeneas' mission and the noise from the building sites outside.

It is important not to exaggerate the rôle of education. Gauls had been made aware of the importance Romans attached to urbanism in a number of ways. Visual representations on various media — coins, triumphal arches, wall-paintings — may have played a part. We might also imagine that quite an impression had been made on many Gaulish nobles when they visited Rome and other Italian and Mediterranean cities as envoys, and especially as mercenaries and allies in the late Republic and Triumviral periods.[17] Perhaps some were as impressed by Rome as returning Varangians seem to have been by Micklegard. Besides, the *coloniae* of southern Gaul and the Rhône valley, being monumentalised for the first time in the late Augustan period, will have impressed many Comatan nobles. Lyon, in particular, served as the "the mirror of Rome in Gaul"[18] once Agrippa's road-system, and Drusus' creation of the provincial cult centre, had made it the point through which anyone who was anyone in the Gauls passed again and again. Those repeated journeys will have given the leaders of the Gallic communities the impression of urbanism in action, of the slow but incremental processes of monumentalization.

What Roman education offered those first generations of Gallo-Roman aristocrats was a way of understanding the urbanization they were witnessing. By offering them a convenient and compelling narrative of the civilizing process in history, it helped them to recognise, like Aeneas, the cultural import of the city building they encountered on their real and metaphorical explorations of the Roman empire. Accepting this explanation, of course, entailed accepting much more, and had striking consequences for the physical environment of cities. P. Zanker put it well when he wrote that

> The impact of the new imagery in the West thus presupposed the acceptance of a complete ideological package. Temples, theatres, water systems, and city gates, all of specifically Roman type, gave each city in the West a uniform look, one which remained essentially unchanged.[19]

That notion of urbanization, as both a manifestation of and a medium for the spread of an imperial ideology in the provinces, has been developed by others.[20] In the Gallic provinces, as

16 *G.* 4.162-69 within the longer section of Book 4 in which the analogy of the bees with human society and of their hive with a city is developed at length. Aeneas' immediate response in the *Aeneid* passage is to recognise in this co-ordinated activity the birth of a new society/city with the words, 'O happy people whose city walls rise already' (1.436). But, as in much of Carthage, the impression of civilization is misleading. The Phoenician bees follow a woman rather than a man.

17 On embassies, see Woolf (supra n.10) 36-37, with full documentation. For the travels of Gallic nobles with triumviral armies, J. F. Drinkwater, "The rise and fall of the Gallic Julii," *Latomus* 37 (1978) 817-50, is fundamental. The cultural importance of contacts of this kind in an earlier period is argued by P. S. Wells, *Culture contact and culture change: Early Iron Age central Europe and the Mediterranean world* (Cambridge 1980) 136-38.

18 A. Audin, *Lyon, miroir de Rome dans les Gaules* (Paris 1965). For the time-lag between the foundation of Lyon and its emergence as the centre stage of Gallo-Roman politics, see J. F. Drinkwater, "Lugdunum — 'natural capital' of Gaul?" *Britannia* 6 (1976) 133-40.

19 P. Zanker, *The power of images in the age of Augustus* (Ann Arbor 1988) 332.

20 Most recently by C. R. Whittaker, "Imperialism and culture: The Roman initiative," in D. Mattingly (ed.), *Dialogues in Roman imperialism* (JRA Suppl. 23, 1997) 143-63, esp. 144-48.

everywhere in the empire, it has proved possible to trace the spread of a cluster of architectural forms and iconographic motifs, and to note common emphases, for example on planning monumental ensembles in ways that drew on Hellenistic models, on the use of marble and other expensive decorative stone, on the monumental display of writing and on the imperial cult.[21] Thus monumental urbanism, like Pliny's success among the *literati* of Lyon, seems to bear witness to the power of Roman civilization to touch even distant Gaul, and it seems plausible to suppose that Gallo-Roman aristocrats promoted urbanism at least in part because they had become convinced that cities were essential to civilization, and that civilization was essential to human happiness.

Thus far, the argument has been conventional. This understanding of the urbanization of the Gallic provinces as the dissemination of new values, of an ideology, or even as the spreading of a cultural movement from the centre into the provinces, has many strengths. It offers an explanation for the relative uniformity of early Roman urban design in Gaul and the West.[22] It suggests some connections between 'Romanization' in the provinces and what has recently been termed the "Roman Cultural Revolution" in the capital.[23] Not least it accounts for these changes in terms of values which at least some of the participants are likely to have shared.

But it is important not to end the analysis here. However attractive any total account of Gallo-Roman urbanism might be — whether to us or to the Romans of Gaul — no such account could be definitive, if only because there is no reason to think there was a contemporary consensus about the cultural significance of city building in Gaul. Indeed, it is possible to suggest some rather different motivations for, and understandings of, the urbanization of the Gallic provinces that complement this eirenic vision of the civilizing power of Rome.

A starting point is provided by a recent re-interpretation of the grid plans that — in Gaul as in Britain — distinguished *civitas* capitals and *coloniae* from other urban settlements. Rather

21 For general accounts of Gallo-Roman urban monumentality, see C. Goudineau in P. A. Février *et al.*, (edd.), *L'histoire de la France urbaine. I. La ville antique* (Paris 1980) 271-96, and R. Bedon, R. Chevallier and P. Pinon, *Architecture et urbanisme en Gaule romaine* (2 vols., Paris 1988). On empire-wide trends, see most recently S. Walker, "Athens under Augustus," in M. C. Hoff and S. I. Rotroff (edd.), *The Romanization of Athens* (Oxford 1997) 67-80, on monumental ensembles; G. Alföldy, "Augustus und die Inschriften: Tradition und Innovation," *Gymnasium* 98 (1991) 289-324, on monumental writing; and P. Gros, "Nouveau paysage urbain et cultes dynastiques: remarques sur l'idéologie de la ville augustéene à partir des centres monumentaux d'Athènes, Thasos, Arles et Nîmes," in Goudineau and Rebourg (supra n.2) 127-40, for the imperial cult (with references to the same author's earlier studies).

22 Only 'relative' because of the risk that the similarities between cities may be overstressed in analyses of this sort. Regional styles emerged both from different selections from the repertoire offered by Mediterranean building technology and design — not all areas adopted *capitolia* — and also from the development of regional variants, like the forum–basilica complex, which never became generalised. Recent attempts to trace the spread of key features of 'Augustan' style in the provinces may have something to learn, in this respect, from Romanization studies such as those collected in R. Brandt and J. Slofstra (edd.), *Roman and native in the Low Countries: Spheres of interaction* (BAR Int. Ser. 184, Oxford 1983), T. Blagg and M. Millett (edd.), *The Early Roman Empire in the West* (Oxford 1990), and Metzler *et al.* (supra n.6), in which the emergence of diversity and the active rôle of provincials in creating their own Roman cultures has been stressed.

23 T. Habinek and A. Schiesaro, *The Roman cultural revolution* (Cambridge 1997), borrowing the title from that of A. Wallace-Hadrill's review article of Zanker, "Rome's cultural revolution," *JRS* 79 (1989) 157-64. But there have been a number of recent cultural approaches to the Augustan principate, e.g., C. Nicolet, *L'inventaire du monde. Géographie et politique aux origines de l'empire romain* (Paris 1988), and K. Galinsky, *Augustan culture. An interpretative introduction* (Princeton 1996). Yet most have focused on the city of Rome and central Italy. For the importance of the same period in the provinces, see Ward-Perkins (supra n.5); M. Millett, "Romanization: Historical issues and archaeological interpretation" in Blagg and Millett (supra n.22) 35-41; G. D. Woolf, "The formation of Roman provincial cultures," in Metzler *et al.* (supra n.6) 9-18;.and id., "Beyond Romans and natives," *World Archaeology* 28 (1997) 339-50.

than seeing the roads and spaces of the planned city either as neutral systems of organizing space or as "premeditated design for what a functioning Roman environment ought to be",[24] R. Hingley presents them as disciplinary in a Foucauldian sense, as a means of controlling movement and free association, and of asserting the control of imperial and local élites over subject populations.[25] Hingley's disagreement with conventional views of urbanism needs to be contextualised within broader debates over whether the ancient city ought to be seen as an oppressive institution or as a manifestation of a prosperity that was widely shared, debates which may have more to do with modern attitudes to urbanism, and which have obscured the complexity and diversity of ancient urban societies. But Hingley's reading of Romano-British town-plans demands to be taken just as seriously as readings that see Roman and Hellenistic city-planning in terms of the creation of pleasant environments within which civilized life was possible.

Both views in fact work better as analyses of urban design — of the aspirations of architects and their patrons — than of the actual dynamics of social power in provincial societies. The street-grids of Gallo-Roman and Romano-British cities underwent continual modifications in response to changing demands and needs. The Roman planners of *Verulamium* had to take account of pre-existing roads, just as the planners of Manhattan could not ignore Broadway, and euergetists everywhere seem to have been able to derail existing plans to accommodate new schemes. The abandoned lots of Carhaix and the rapid expansion of Amiens illustrate other limitations on the power of the original designer to 'fix' the image of a city or town centre. But the fact that the power of city builders was limited does not mean it is not worth asking what motivated them.

In fact, the idea that the Romanized town was intended as "a design for Roman living" is not incompatible with the idea of the planned city as a disciplinary environment. If one wishes to live a civilized life, *Romano more*, or to imagine oneself doing so, the physical constructs of the city are invaluable. The *curia* and the forum offer frameworks for political life, the temples and altars guide one's steps to the gods, the vistas and façades fix the eye on a civilized horizon, the schools and baths train Roman minds in Roman bodies. If, on the other hand, a Roman life is not what you desire, the grid plan obstructs you at every turn, unwelcome monuments loom up at you, and everywhere you look the alien city triumphantly imposes itself on your gaze. It all depends on the inhabitant's point of view.

This is exactly the point. Privileging the Roman view of what was going on — even if it was a view to which some Gauls came to subscribe, as they became Romans — captures only one aspect of the cultural significance of urbanization. Worse, that view is indeed ideological in the very precise sense that it served the interests of only a part of society.[26] This is not the same as claiming that no one sincerely believed that city building was a sign and means of civilizing the Gauls. It is difficult to explain why Gallo-Roman nobles spent quite so much on building the cities of Gaul if urbanization was merely some kind of elaborate ruse, a pretence

24 F. E. Brown, *Cosa, the making of a Roman town* (Ann Arbor 1980) 12.

25 R. Hingley, "Resistance and domination: social change in Roman Britain," in Mattingly (supra n.20) 81-100, with a perspective shared in places by W. S. Hanson, "Forces of change and methods of control," ibid. 67-80. For more conventional accounts of grid-plans, see S. S. Frere, "Town planning in the western provinces," *Beiheft zum Bericht der Römisch-Germanisch Kommission* 58 (1977) 87-104, and H. von Hesberg, "Die Monumentalisierung der Städte in den nordwestlichen Provinzen zu Beginn der Kaiserzeit," in W. Eck and H. Galsterer (edd.), *Die Stadt in Oberitalien und in dem nordwestlichen Provinzen der römischen Reiches* (Mainz 1991) 179-99, with discussion of their significance in Gaul in J. F. Drinkwater, "Urbanization in the three Gauls: Some observations," in F. Grew and B. Hobley (edd.), *Roman urban topography in Britain and the western Empire* (CBA Res. Rep. 59, London 1985) 53.

26 See T. F. Eagleton, *Ideology: An introduction* (London 1991), for an introduction to debates over the term ideology, although classicists often employ the term more loosely than do social scientists, simply to mean something like a shared understanding, with no particular sense that that understanding serves sectional interests.

directed at conquerors and/or subjects. Ideology is sometimes held to be most convincing to those whose interests it serves. If civilization is always a 'confidence' trick played on the barbarian, sometimes it is also a confidence trick played on the civilized.

Even those who were (literally) best-versed in this Roman ideology were free to understand what was happening in Gaul in different ways. Perhaps there were subtle and resistant readers among the brightest boys in the schools of Autun who learned from the story of Aeneas at Carthage that appearances can be deceptive, that not all city-founding leads to civilization, that temples to the gods do not necessarily ensure divine favour. Perhaps some wondered if the shabby thatched huts of Iron Age *Bibracte* — so like those of Romulean Rome — might not have been a better foundation for Aeduan posterity than the perilously Punic strategy of building civilization out of grand monuments erected on the greenfield site of Autun. More certainly there will have been Roman sophisticates who had to conceal their contempt of the shabby efforts of the Aedui to counterfeit culture. Besides, Roman culture was far from monolithic. The fear that the civilizing process was accompanied, for all or part of its way, by moral decline is present already in Lucretius and followed by Caesar, Livy and Virgil, while Tacitus famously represented barbarians as enslaved by civilization, and Juvenal juxtaposed the civilizing process with the spread of inhuman behaviour.[27] Other aspects of the myth were also vulnerable to attack. Augustan writers had been proclaiming the incomparability of Rome for as long as they had been holding it up as a model for imitation. And Lucan problematized the identification in Roman myth and epic of the founding leader's interests and destiny with those of his (or her) people, by depicting Pompey and Caesar *unfounding* the Republic in a bloody civil war.

But there is no sign that many Aeduans were converted into such sensitive readers of their school texts in the 1st c. A.D., Pliny's later popularity in Lyon notwithstanding. More significant in this formative period of Gallo-Roman urbanism may have been a population of silent, yet passively resistant, commoners of the kind that Hingley implicitly conjures up, coerced into leaving their mountain homes, compelled to level the terraces and cut the stone for the buildings at the direction of foreign architects, offering no reading at all of the new city, either because they did not wish to see it or because they had been culturally disempowered by the exclusive schools of Autun. It is the silence of these groups, with their very different experiences of Gallo-Roman urbanism,[28] that make it worth asking how else Gallo-Roman cities might have been understood by contemporaries, if not through Roman understandings of civilization.

The experience of those masses was not represented by them in any literary and epigraphic form, but less direct means of analysis are available. Gallo-Roman cities were, above all, huge and complicated monumental complexes that devoured the wealth of generations of aristocrats and the labour of generations of their subordinates. But impressive as that urbanistic project is, it was hardly unique in historical or archaeological terms, and a comparison with similar projects is suggestive of the circumstances in which they arise.

Consider, for example, the building of Gothic cathedrals across 12th- and 13th-c. Europe. The parallels with early Roman urbanism are numerous. The new architecture in both cases represented a conscious and deliberate break with tradition, and at the same time appealed to a recognisable style. Gothic cathedrals referred explicitly to alien models, just as the monumental equipment of Gallo-Roman *civitas* capitals referred to the Narbonensian *coloniae*, the

27 Civilization and moral decline: Lucr. 5.998-1010; Caes., *BG* 1.1, 6.24; Livy, *Pref.* passim; Verg., *Ecl.* 4 *in toto* may be read as a utopian vision of the rolling back of civilization; Tac., *Agr.* 21; Juv. 15.147-71. Many other instances (and variants) of this trope could be adduced from these and other Latin writers.

28 Or, in post-colonial parlance, "discrepant experiences". See Mattingly (supra n.20) as well as J. Webster and N. Cooper (edd.), *Roman imperialism: Post-colonial perspectives* (Leicester Archaeology monograph 3, 1996) for this approach.

cities of *Cisalpina* and Rome itself. Nor did the new cathedrals dominate entire communities simply by being visually prominent: they were also expensive in materials and required the labour of skilled master-craftsmen. Again like gridded cities, although Gothic cathedrals were planned as wholes, they took decades to complete, and their designs were subject to constant modification.

Historians of this much-better-documented cultural phenomenon have offered complex explanations for the spread of the Gothic style. As with Roman cities, the influence of an archetype is evident, in this case the Capetian centre of St. Denis. But, while some scholars emphasise the connection with the growth of royal power in northern France, others lay more stress on competition between neighbouring bishops or cities as the impulse behind building cathedrals in the new style; in some cases a new cathedral seems to be an episcopal response to the rise of mercantile classes in the cities, a re-assertion of the dominance of the bishop in the community. Technological developments and a general growth in prosperity in these regions made these political contests possible. The demographic component of that growth also played a part, insofar as the need to provide larger spaces for bigger urban populations provided opportunities and excuses for cathedral-building. But rebuilding might have taken a different form if new styles of architecture were not already available to be borrowed from monastic and even secular contexts. Wider cognitive, aesthetic and liturgical contexts have also been suggested, with varying degrees of plausibility.[29]

Our knowledge of the spread of Gothic cathedrals is far superior to that of the beginnings of Gallo-Roman urbanism. The physical structures survive in a better state, the chronology of change is better understood, archives allow costs and labour régimes to be reconstructed in detail, while chronicles record every stage of the politics of cathedral-building from high diplomacy to riots on building sites. There are even a few accounts of debates over how to build new churches, such as Gervase of Canterbury's late 12th-c. account of the rebuilding of Canterbury Cathedral following a devastating fire. Romanists can never hope to produce such well-documented studies of urbanization in the west, but should certainly envisage equally-complex cultural and political contexts for the creation of these monuments.[30] Explaining Gallo-Roman urbanism in terms of the civilizing process alone would be like accounting for Gothic cathedrals as solely a product of Christian piety.

As proof that analyses of this sort can be produced even in the absence of detailed documentary sources, let us consider a second and very different category of monuments, the megalithic tombs constructed in much of western Europe at the very beginning of the Neolithic period. Despite their generally small scale — at least by comparison with Köln Cathedral or Gallo-Roman Vienne — these monuments also absorbed the energies of entire communities over long periods, dominated landscapes and were centres of enormous cultic and social significance. Some were enlarged, elaborated, redesigned and repaired over centuries. A wide variety of interpretations has been suggested in recent years.[31] Megaliths, which first appeared around the same

29 J. Le Goff, "L'apogée de la France urbaine médiévale 1150-1330," in P. A. Fevrier *et al.* (edd.), *L'histoire de la France urbaine. II. La ville médiévale* (Paris 1980) 384-87.

30 One relevant area of classical studies in which this has been undertaken is in the increasing sophistication of recent studies of euergetism, beginning from P. Veyne, *Le pain et le cirque: sociologie historique d'un pluralisme politique* (Paris 1976), now with P. Garnsey, "The generosity of Veyne," *JRS* 81 (1991) 164-68, and G. M. Rogers, "Demosthenes of Oenoanda and models of euergetism," *JRS* 81 (1991) 91-100, but most work has naturally focused on eastern provincial societies where a rich epigraphic record may be juxtaposed with the writings of the Second Sophistic and Roman sources such as Pliny's *Letters* Book 10.

31 For documentation, see G. D. Woolf, "Monumental writing and the expansion of Roman society in the early empire," *JRS* 86 (1996) 30-31, with the works cited there in nn. 37-41. The best introductory accounts are R. J. Bradley, *Altering the earth: The origins of monuments in Britain and continental Europe: The Rhind Lectures 1991-92* (Society of Antiquaries of Scotland monograph 8, Edinburgh 1993), and J. Thomas, *Rethinking the Neolithic* (Cambridge 1991).

time as agriculture, have been seen as asserting claims to territory, as stakes in the land. Some prehistorians have pointed out that their construction must have bound communities together, whether that process is seen primarily as the creation of social ties not based on kinship, or as one that generated social ranking. Monuments may well have entrenched the power of élite individuals, lineages or classes over the masses, and may have been constructed competitively, against the monuments of rival groups. The parallels with the politics of cathedral building are obvious. Again, as with cathedral building, demographic growth probably lies behind the movement, and again wider cognitive and aesthetic contexts have been invoked. For some prehistorians, monuments are in general to be seen as responses to anxiety of various kinds, as attempts to solidify the contingent social world by anchoring it to the transcendent physical, while others see monuments as means of domesticating the wilderness, as naturalizing particular views of space, time and the cosmos.

Gallo-Roman cities, Gothic cathedrals and megalithic tombs all had their own peculiarities, but they were also massive and complex communal monuments that served as important foci for political and cultural action. What is to be gained from thinking of Gallo-Roman cities in this light? First, the emergence of this kind of monument seems often to draw on major changes in society — demographic, economic, technologpical and cognitive — and in some sense provides an answer to them. We might consider Gallo-Roman cities, in other words, as responses to crisis. Second, the construction of such monuments is so costly, in every sense, that it draws to itself powerful political forces. Monumentalization offers a chance to confirm or redefine the political order, and so much symbolic, as well as financial, capital is invested in such schemes that no powerful group or individual dare ignore them. Third, programmes of this kind are consciously innovative and make declarations of faith in a posterity that the builders hope will enjoy and understand monuments, some of which will not be completed in the lifetimes of those who began them. This last point — the novelty of monuments — requires an empathetic leap on our part, since monuments appear to us first of all as relics of antiquity, as 'sites of memory',[32] rather than messages despatched into the unknown. Gallo-Roman city building, then, dealt with the future as well as the past.

Perhaps the best way of illustrating the value of this approach is to show how it may be applied it to a concrete example. The Arch of Saintes is among the earliest urban monuments of Roman Gaul (fig. 5).[33] Constructed in A.D. 18 or 19, the Arch originally stood at the eastern end of the bridge over which the road from Lyon crossed the Charente to *Mediolanum*, the capital of the Santones, on the opposite bank of the river. That road, the 'great western trunk road' of the Agrippan system, was one of the major arteries of the early Roman communications system in the Gallic provinces, the route along which nobles from most of western Gaul would travel to Lyon, to the cities of the Rhône valley or on to Italy and Rome. According to Strabo, writing under Tiberius, Saintes was at its western terminus.[34] The bridge also connected the Santones' capital with half of their territory. On the top of the Arch stood three statues, Tiberius in the middle with his sons, Drusus and Germanicus, on either side. The statues are gone but inscriptions that were written beneath them on the side facing the town record their titles and make it likely that the statues, too, faced the town and those leaving it on the long road to Lyon.[35] Beneath the imperial statues on that western face, and also on the other side, is the name of the donor, Caius Iulius Rufus, who announced himself as son of Caius Iulius Catuaneunius, grand-

32 As "lieux de mémoire" in the phrase of P. Nora (ed.), *Les lieux de mémoire* (3 vols., Paris 1984-92).

33 L. Maurin, *Saintes antique* (Saintes 1978) 71-81, is still the fullest discussion. For some excellent illustrations, see L. Maurin and M. Thauré, *Saintes antique* (Guides Archéologiques de la France 29, Paris 1994).

34 Strab. 4.6.7, although the road was continued later to Bordeaux.

35 For the inscriptions on the Arch, *CIL* XIII 1036, now republished in L. Maurin, M. Thauré and F. Tassaux, *Inscriptions latines d'Aquitaine (ILA), Santons* (Bordeaux 1994) as *ILA (Santons)* 7, with corrected readings of the names of Rufus' family.

Fig. 5. The Arch of Saintes.

son of Caius Iulius Agedomopas and great grandson of Epotsorovidius, and also declared he had served as priest at the Altar of Lyon.

Rufus' arch announced him as one of those great benefactors whose euergetism funded the construction of the cities of Roman Gaul.[36] As it happens, the early history of Saintes is unusually well-known for a Gallo-Roman city (fig. 6).[37] Like Autun, Saintes seems to have been founded on a greenfield site, probably in Saintes' case to take advantage of the Agrippan highway. By the early Augustan period, architectural fragments make it clear that Saintes already possessed some impressive public monuments,[38] but to the north and west of the earliest Forum the private housing was largely built of wood and daub. The first comprehensive street grid was not laid out until the reigns of Tiberius and Claudius. Rufus' arch, in other words, ushered visitors into a city of Iron Age houses squatting untidily around a classical monumental centre.

Many features of Rufus's arch show him closely following the lead given by the centre. To begin with, the use of the arch as an honorific monument was itself new in Rome, and closely associated with the principate.[39] The prominence of imperial images and the prominent mention of Rufus' priesthood of the imperial cult are conventional for monuments and epigraphy of

36 For the importance of individual benefactors in funding Gallo-Roman monuments, see E. Frézouls, "Evergétisme et construction urbaine dans les Trois Gaules et les Germanies," *Révue du Nord* 66 (1984) 27-54 and J. F. Drinkwater, "Gallic personal wealth," *Chiron* 9 (1979) 238-39.

37 L. Maurin, *Les fouilles de "Ma Maison". Etudes sur Saintes antique* (Aquitania suppl. 3, 1988), building on his magisterial synthesis (supra n.33).

38 D. Tardy, *Le décor architectonique de Saintes antique. Les chapiteaux et bases* (Aquitania suppl. 5, 1989).

39 Augustus' Parthian Arch is the most famous example, but note also the arches voted for Germanicus only a few years after Rufus', in *Tabula Siarensis* frag. 1, 9-29. On the cultural affiliations of Roman honorific arches, see A. Wallace-Hadrill, "Roman arches and Greek honours: The language of power at Rome," *ProcCambPhilSoc* n.s. 36 (1990) 143-81. On arches (of various kinds) in early Gallo-Roman cities, see S. Silberberg-Pierce, "The many faces of the Pax Augusta: Images of war and peace in Rome

Fig. 6. Plan of Saintes. **1** = Known ancient roads. **2** = Probable ancient roads. **3** = Hypothetical ancient roads. **4** = Probable maximum extent of the city in the High Empire. **5** = Early 1st c. A.D. potter's shops. **6** = Late 1st c. A.D. potter's shops. After H. Delhumeau, after L. Maurin in L. Maurin, M. Thauré and F. Tassaux, *Inscriptions latines d'Aquitaine (ILA) Santons* 40; and L. Maurin and M. Thauré, *Saintes antique* (Guides Archéologiques de la France) 36-37 (*del.* Shawna Leigh).

this period. The grouping of the *princeps* with his two sons seems to reflect official representations of the early years of Tiberius' principate.[40] Even Rufus' nomenclature and that of his ancestors might be read as an illustration (or exposition) of the civilizing process, marking the stage-by-stage Romanization of a noble family. Should we read Rufus' arch, then, as a typical example of the civilizing of the Gallo-Roman élite, as an assertion of their commitment to urban values and of their "acceptance ... of an ideological package"?

and Gallia Narbonensis," *Art History* 9 (1986) 306-24. On specific parallels to Rufus' Arch, see Maurin (*supra* n.33) 74-76.

40 Compare Strab. 6.4.2, the praise of the achievements of Tiberius and his sons with which book 6 ends; Vell. Pat. 2.129, concluding his history in similar terms; *SC de Cn. Pisone patre* ll. 130-35, representing Tiberius, Livia and Drusus as Germanicus' nearest and dearest.

Yes, of course we should read it this way — as it has often been read before[41] — but we should also go on reading, sensitive to other understandings of the Arch, trying to imagine what crises, real or imagined, might have provoked its construction, what the politics of its building might have been, and what claims Rufus was making on the future through its creation.

It is easy to guess some kinds of instability that may have provided a background for the construction of the Arch. Early Tiberian Saintes resembled a modern-day Third World metropolis with its skyscrapers and monumental avenues juxtaposed with shanty towns. The social tensions created by the close proximity of extremes of wealth and poverty are easy to imagine. So, too, are the stresses caused by the rapidity of the civilizing process.[42] If many Santones felt their houses were simply traditional, some at least had come to realise they were barbarous. The response made by Rufus and his peers — at much the same time as the Arch was set up — was to extend the Agrippan way across the river to form the *decumanus maximus* of a new planned town. But laying out a street grid over an inhabited area is a brutal process. Whether or not the population of Augustan Saintes had been assembled by coercion, force must have been employed to remake the city in a civilized form under Tiberius and Claudius. The force of Hingley's emphasis on the disciplinary aspects of urbanizing the west is apparent.

There may also have been other uncertainties. Rufus may well have felt that an assertion of support for the new *princeps*, only 4 or 5 years after his troubled accession, seemed prudent. Rufus was certainly prominent enough within provincial politics to make it worthwhile to display his loyalty. From Lyon, another inscription records his construction of an amphitheatre at the Sanctuary of the Three Gauls.[43] An amphitheatre was one of the most expensive gifts a benefactor might make. Despite the importance of the sanctuary at Lyon, it had been without one for more than 30 years before Rufus made his grand gesture.

But we are best informed about Rufus' local connections, thanks to a series of inscriptions, most known for some time but recently re-read by L. Maurin and his colleagues.[44] The new readings make clear that Rufus was not just any Santon noble, and that the Santones were dominated, throughout the Julio-Claudian period and probably earlier, by his family, the descendants of Epotsoviridius.

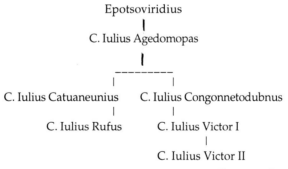

Stemma after Maurin *et al.* (1994, 132)

41 E.g., by Maurin (supra n.33) 76, suggesting that the building of the Arch gave Rufus an opportunity "d'exercer... son évergétisme envers sa patrie, d'afficher sa richesse, de manifester son loyalisme à l'égard de la dynastie".

42 S. L. Dyson, "Native revolts in the Roman empire," *Historia* 20 (1971) 239-74, also employing comparative analysis.

43 *ILTG* 217. Rufus' political priorities are made clear by the fact that it was not until the reign of Claudius that Saintes itself gained an amphitheatre, on which see J. Doreau, J.-C. Golvin and L. Maurin, *L'amphithéâtre gallo-romain de Saintes* (Bordeaux 1982).

44 The principal inscriptions are *CIL* XIII 1036-38, 1040, 1042-45 re-read as *ILA (Santons)* 7, 8, 9, 10 and 18. The following discussion draws on Maurin (supra n.35) 131-35, which supercedes the analysis in Maurin (supra n.33) 181-85.

This stemma brings together virtually all the major figures known in the epigraphy of Saintes of the 1st-c. A.D. C. Iulius Rufus and his cousin, C. Iulius Victor, both served as priests at the Altar of Lyon and were both *praefecti fabrum*, a post which marks their entry into the equestrian order. A series of monuments and dedications to the imperial house can be connected with various members of the family, and it seems clear that they had no rivals in Saintes. The Arch is revealed not as the gift of one of Saintes' benefactors but as a monument to *the* benefactor of the Santones, and Saintes was Rufus' town in more than one sense. Like Tiberius, Rufus had to play at being *princeps* in a republic, simply the first among equals, but he was in reality a Santon Aeneas or a Santon Augustus. To those who understood this — and who could have missed it? — the Arch might appear rather differently. Saintes was, in all likelihood, the creation of that family, and they were certainly the most prominent backers of the brutal civilizing of the Tiberian city. Those entering Saintes from the east would have had no doubt who ruled the city: to those heading eastwards to Lyon or beyond, the Arch proclaimed 'no one comes to Rome except through me'. Rufus's inscription, supporting that of the imperial house, also showed at least one basis of his power. Local rivals knew they could not demolish Rufus without also attacking Tiberius. The Arch is a graphic representation of the collusion of interests between the greatest Gallo-Roman nobles and the imperial house.[45]

What message did Rufus send to Santon and Gallic prosperity with his Arch? That the new order was firmly established, certainly. But perhaps there is more to that supererogatory genealogy back to the pre-citizen past. The near-contemporary Lyon inscription omits the Gaulish *praenomen* of Rufus' father and his ancestors. Various reasons may be suggested for including a longer genealogy on the Arch. Perhaps a desire to display the civilizing of the clan, or to boast of being a third generation citizen? Perhaps it was important to advertise descent from the common ancestors of Rufus' family and his cousin's. Relations between the two branches may have been no more cosy than between Germanicus, Drusus and Tiberius. But maybe, too, Rufus was declaring the antiquity (even the pre-Roman antiquity) of his family's eminence. Coupled with the imperial triad above, the Arch might even be read not just as a celebration of the power of two dynasties but as a celebration of dynastic power itself. The claim on the future is unmistakable. Saintes belonged to Rufus and to his family and it always would. Roman rule had only strengthened their power. Civilization, destiny and the emperors were all on their side.

Rufus and Victor were not alone. The cities of Gaul were built to lay claim to the land and to entrench the power of those who had emerged with success from Caesar's conquest of Gaul and the triumviral chaos that followed. Just as the myth of a civilizing process offered the Romans of Rome a way to deal with a chaotic past, it served related ends in Gaul; but just as the crisis there had had distinctly local features, so too the urban response to it had a local flavour. What then of the civilizing ideology? The view of the provincial city as seen from the imperial centre is no less real for these alternative readings. But its ideological nature becomes clearer. The imperial gaze offers a beguiling view of urbanism, and offers it a place in the grand narrative of the civilizing of the West and the moral regeneration of Rome. Viewing the urbanization of the West as a rather less harmonious process is hardly original, as these words, written twenty years ago by the urban sociologist Philip Abrams, make clear:

> The history of towns commands attention as a history of appropriation and resistance, internal and external war, defiance and monopoly, a history in which resources are concentrated for the pursuit of some struggle, for the enhancement of power.[46]

45 On different aspects of that relationship, see P. A. Brunt, "The Romanization of the local ruling classes in the Roman empire," in D. M. Pippidi (ed.), *Assimilation et résistance à la culture gréco-romaine dans le monde ancien* (Paris 1976) 161-73; Drinkwater (supra n.17); Drinkwater (supra n.36).

46 P. Abrams, "Towns and economic growth: some theories and problems," in P. Abrams and E. A. Wrigley (edd.), *Towns in societies: Essays in economic history and historical sociology* (Cambridge 1978) 32.

The founders of Autun and Saintes, the schoolboys reading "how great a toil it was to found the Roman race",[47] the silent commoners labouring on the building of these huge monuments, and the Roman governors watching in approval as the vast energies and resources of the Gauls were expended on the urbanistic project, all, in their different ways, would have understood what Abrams meant.

School of Greek, Latin and Ancient History, University of St. Andrews

Acknowledgements

I am grateful to the participants in the Rome conference and also to Llewelyn Morgan, John Nightingale and Alex Woolf for advice and help with this paper.

47 Verg., *Aen.* 1.33: *tantae molis erat Romanam condere gentem*, conventionally read as a one-line summary of the subject of the epic.

Memory, metaphor, and meaning in the cities of Asia Minor

Fikret K. Yegül

In attempting to place the "fortified and manned" Cosa in the larger framework of Rome's policy in the founding of new Latin colonies, F. E. Brown remarked that "their initial role in Roman strategy was ... military, but as fixed and lasting city-states in pacified surroundings they were inevitably destined to become vital centers for the dissemination of Roman attitudes, institutions, law and language."[1] Brown's sensible observation cuts through a lot of learned debate concerning intent in forming colonies and it is, in principle, as equally true for the colonies in Asia Minor and the eastern provinces as it is for Italy. Controversy over the original intentions of the state — whether it was planning to use colonization as a deliberate vehicle of Romanization — must be viewed in relation to the 'inevitability' of the final product. What mattered in the end was not so much the intention but the reality of the colony, the creation of a context where one culture was imposed upon another.[2]

The *colonia civium Romanorum* in Asia Minor, as an agent of Romanization, is a special concern mainly because there were very few of them. If discussed at all, the Romanization of Asia Minor is discussed in relation to the great cities in the province of Asia. Yet these colonies, especially the six established in Pisidia under Augustus, were properly formed under the *lex Coloniae Iuliae* with well-developed constitutions, magistrates and *ordo*, and created a reasonably effective context and exemplar for Rome's and the Roman emperor's presence in the pathless wilds of Anatolia where no bird flew and which no caravan crossed. Unlike Italy's new Latin colonies, or the Greek colonies of the pre-Classical era, almost all colonies in Anatolia, including Antioch-in-Pisidia, were additions of a formally-constituted group of veteran soldiers from Italy to a pre-existing, and fully developed, Greek city. The impact of Roman culture and Latin language on these communities was understandably limited, and in the course of time the Italian element, proud and precious as it might have been, was absorbed into the local fabric.[3] But this aspect of the story, the essential and tenacious 'Greekness' of Asia Minor under Roman rule, is well published and publicized: the efforts of several generations of scholars whose works on the subject have become standard reading — W. Ramsay, R. Syme, A. H. M. Jones, D. Magie, G. Bean, and L. and J. Robert — stand in stolid and sturdy testimony.[4]

It is with considerable pleasure that one welcomes a fresh point of view which sifts through the evidence with pro-Roman eyes, as in B. Levick's 1967 study of Roman colonies in SW Asia

1 F. Brown, *Cosa, the making of a Roman town* (Ann Arbor 1980) 5.

2 Discussion and divergent views on the nature and intent of Roman colonization: D. Magie, *Roman rule in Asia Minor* (Princeton 1950) 459-67; E. Kornemann, *RE* IV (1901) cols. 511-88, s.v. "coloniae"; C. B. Welles *et al.*, "The Romanization of the Greek East," *BASP* 2 (1964) 42-77; P. W. M. Freeman, "Romanization and Roman material culture," *JRA* 6 (1993) 438-45; R. MacMullen, "Notes on Romanization," *BASP* 21 (1984) 161-77; P. MacKendrick, "Cicero, Livy, and Roman colonization," *Athenaeum* 32 (1954) 201-49, esp. 244-49; F. Vittinghoff, "Römische Stadtrechtsformen der Kaiserzeit," *SavZ* 68 (1951) 435 ff.; id., *Römische Kolonisation und Bürgerrechtspolitik unter Caesar und Augustus* (Mainz 1951); cf. also B. Levick, *Roman colonies in southwest Asia Minor* (Oxford 1967) 184-92.

3 S. Price, *Rituals and power. The Roman imperial cult in Asia Minor* (Cambridge 1984) 88-89.

4 W. M. Ramsay, *The historical geography of Asia Minor* (Royal Geog. Soc. Suppl. Papers IV, 1890); id., "Studies in the Roman province of Galatia," *JRS* 16 (1926) 102-19; id., "The Graeco-Roman civilization in Pisidia," *JHS* 4 (1883) 23 f.; R. Syme, "Galatia and Pamphilia under Augustus," *Klio* 27 (1934) 122 ff.; A. H. M. Jones, *The cities of the eastern Roman provinces* (Oxford 1937); id., *The Greek city from Alexander to Justinian* (Oxford 1940); Magie (supra n.2); L. and J. Robert, "Notes sur le voyage archéologique de M. et Mme. L. Robert en Pisidie," *CRAI* 1948, 401 f.; iid., *Noms indigènes dans l'Asie-Mineure gréco-romaine* 1 (Paris 1963). See also G. W. Bowersock, *Augustus and the Greek world* (Oxford 1965).

Minor and more recent studies by S. Mitchell and G. Woolf.[5] As one historian put it, it is understandable that occasionally "the evidence might have been forced to yield more fruit."[6] In such deliberately corrective attempts the pendulum may need to swing far to the other side. Levick's suggestion that, as late as the 3rd c., "public dedications set up [in Antioch] were in Latin not only because they were official documents, but because they were the work of a small, compact, upper class Italian settlers, who debated in Latin ..." is hard to accept.[7] An overwhelming majority of private inscriptions from the colonies is in Greek, and there is no factual or logical basis to assume that the original Italian settlers constituted and maintained a sharply divided aristocratic, upper class over the native population of the Greek *polis*, which had at least a 200-year history before the arrival of the colonists. It is more likely that the newly-arriving groups of veterans, almost all from modest, rural Italian origins, found themselves in the middle of a well-developed urban world with a well-established social order. If their Italian background, citizenship, and military connections were valued as social and political assets, many might have been induced to marry the eligible daughters of the town's upper crust and thus be enfolded into the local aristocracy. Acceptance into the majority culture, too, would have been much to their advantage. Prominent local families might in turn have benefited from such connections, which would have increased their chances to gain Roman citizenship. At any rate, it is logical to expect that within the next generation or two a reasonable level of integration with a strong local color would have been achieved. This does not mean that the colony, especially during its early history, did not strive to maintain certain formal, symbolic and emotional ties with Rome. Administrative, legal, and electoral systems followed Roman models and used the Latin language, names and formulas. Although local cults were ever-popular, colonies were the accepted standard-bearers for the introduction and dissemination of the imperial cult.[8] But in the civic life of the free cities of Asia, even that cult assumed a new and uncharacteristically emotional nature. Apart from the neokorate honors associated with the imperial cult temples, for which cities keenly competed, the cult was incorporated into the daily life of citizens through a great variety of new institutions and new architectural modes, some of them thoroughly secular in nature. Thus it is that the impressive two-storey sculptural 'gallery' honoring the Julio-Claudian family in the so-called Sebasteion of Aphrodisias, or the baroque façades of the imperial bath hall in Sardis (dubbed the "Marble Court") created in honor of the Severan family, the goddess Roma, the Senate and the People of Rome, represent a manifestation of the imperial cult in showy but secular everyday settings unique for the cities of Asia Minor.[9] In Antioch, the leading Pisidian colony, the city was divided into *vici* reminiscent of Rome's seven hills, and it took some of her topographical and neighborhood names such as the Velabrum or Germalus — a nostalgic link to the distant capital which probably few of the settlers had ever seen. Yet, it appears that the Roman *vici* and the Greek *tribus* (representing the tribes constituting traditional neighborhood districts of a Greek city) soon began to exist side-by-side.[10]

5 Levick (supra n.2); S. Mitchell, *Anatolia: Land, men and gods in Asia Minor* 1 (Oxford 1993); id., "The Balkans, Anatolia, and Roman armies across Asia Minor," in id. (ed.), *Armies and frontiers in Roman and Byzantine Anatolia* (BAR Int. Ser. 156, Oxford 1983) 7-34; id., "Imperial buildings in the eastern provinces," in S. Macready and F. H. Thompson (edd.), *Roman architecture in the Greek world* (London 1987) 18-25; G. Woolf, "Becoming Roman, staying Greek: cultural identity and the civilizing process in the Roman East," *ProcCambPhilSoc* 40 (1995) 116-43. For an early pro-Roman view, see L. Hahn, *Rom und Romanismus im griechisch-römischen Osten* (Leipzig 1906).

6 E. L. Bowie, review of Levick (op. cit. supra n.2), *JRS* 60 (1970) 202-7, esp. 206-7.

7 Levick supra n.2) 136.

8 Levick (supra n.2) 88, 187. For divergent views on the nature of imperial cult in Roman colonies see Price (supra n.3) 87-100, esp. 88-89.

9 R. R. R. Smith, "The imperial reliefs from the Sebasteion at Aphrodisias," *JRS* 77 (1987) 98; id. and C. Ratte, "Archaeological research at Aphrodisias in Caria, 1995," *AJA* 101 (1997) 18-19, fig. 15; F. K. Yegül, "A study in architectural iconography: Kaisersaal and the imperial cult," *ArtB* 64 (1982) 3-31.

10 Magie (supra n.2) 460; Vittinghoff, *Römische Kolonisation* (supra n.2) 76-79. For the division of the city

Taking the broader view and seeing in the dual heritage of the Greek city under Roman rule the terms of a cultural fusion may be a constructive starting point, and justifies the logic behind the customary designation 'Graeco-Roman', but to reverse this designation to 'Romano-Greek' reveals a pointed, and perhaps artificial, attempt to minimize the Greek component of the mix. It helps to remember that the Greek-speaking citizens of western Asia Minor specifically called themselves *rhomaioi*, not *Romani*.[11]

The main concern of this paper, however, is not the *bona fide* Roman colonies of Asia Minor, but the great, quasi-independent cities of the province of Asia and beyond: the urbanized, romanized world created by the likes of Ephesus, Pergamon, Sardis, Aezani, or Perge, Phaselis, Oenoanda, and Termessus.

Already in the turbulent decades and centuries following Alexander's death, Rome had established a tradition of non-interference in the free city-states of Asia Minor. When she could, she preferred to let the cities resolve their differences among themselves. This tradition, in principle and spirit, continued into the late Republic and the Principate. It was good that the cities were 'independent' but dependent on her favors; that they were reliable, tax-paying allies of the rising power in the West; and that they were valued performers in the last act of an historical play in which the Romans appeared as predestined saviors and benefactors.[12] For all its ups and downs, it was a symbiotic relationship. Rome's liberal policies toward the Greek cities may have been affected by the presence of large numbers of Italian merchants, the *negotiatores*, who began to settle in the business centers of the Aegean and coastal Asia Minor from the 2nd c. B.C. onward. This special class of privileged immigrants was able to retain its Italian customs and character for a while, and performed as agents of cultural diffusion across a far broader geographical base and far more effectively than the colonists were able to do.[13] Although many merchant groups may have settled in their own separate neighborhoods in cities, as in Delos, mixture and dissemination over time, as F. E. Brown saw it, was inevitable. Equally remarkable is Rome's early interest in and ability to project itself into the historic and mythical basis of Greek identity.[14] The entangled motives for integration, some purely practical, some ideological and fictional, made the emergence of sharply defined rôles as Greek *versus* Roman difficult to discern.

The administrative structure of Asia Minor under the Empire was organized into various provinces such as Asia, Galatia, Bithynia, and Pontus. These were ruled by proconsuls or governors who served for only two years and were answerable to the Senate in Rome. The management-style of the proconsul was unobtrusive, his staff uncommonly small relative to the size of the province, and his presence somewhat elusive, since he spent much time on the road

into *vici* (as in Rome) also in the colonies of Alexandria Troas and Sinope, see Magie (supra n.2) 11, chapt. 17 n.33, chapt. 20 n.15.

11 Woolf (supra n.5) 127.

12 D. Magie, "Rome and the city-states of western Asia Minor from 200 to 133 B.C.," in W. M. Calder (ed.), *Anatolian studies presented to William H. Buckler* (Manchester 1939) 161-85.

13 Magie (supra n.12) 184-85; Vittinghoff, *Römische Kolonisation* (supra n.2) 56-58; A. N. Sherwin-White, *The Roman citizenship* (Oxford 1939) 170 ff.; A. J. N. Wilson, *Emigration from Italy in the Republican age of Rome* (Manchester 1966) 9 ff. For the early history of the privileged groups of 'resident Romans', *conventus civium Romanorum*, engaged in business in many cities which had formed politically powerful associations, see Magie (supra n.2) 162-63.

14 Questions of Rome's own identity and its attempts to rewrite its history in terms of a Greek view of the cosmos go back to Archaic times, particularly to its contacts with the Greek colonies in S Italy and Campania. The carefully-scripted ambiguities in Rome's identity *vis à vis* the Greek East, as enemy/conqueror, liberator, restorer, and benefactor, necessitated the creation of a fiction in shared origins and common destiny; cf. F. Millar, "The Greek city in the Roman period," in M. H. Hansen (ed.), *The ancient Greek city-state* (Copenhagen 1993) 232-33. For questions of Rome's identity and myth-making in the context of the Italian peninsula, especially the peoples of the central highlands, see E. Dench, *From barbarians to new men* (Oxford 1995) 67-108.

holding court and administering justice in the various assize-centers of the province. Ankyra was the capital of Galatia, but for the more important province of Asia we are not so sure: Ephesus is a possibility.[15] After decades of excavations and site surveys in a large number of ancient cities in Asia Minor, including leading cities such as Pergamon, Ephesus, Miletus, and Sardis, there are no buildings which could be clearly identified as the headquarters for a Roman legate and his staff, or as the official residence of a governor.[16] Except for certain roads and bridges in western Anatolia, there are no military constructions such as camps, forts, security check-points, and stations. Even the presence of troops and auxiliary forces appears to have been restricted to the countryside.[17] The military zone lay to the east and southeast of Asia Minor, and on the Euphrates front where the remains of a long line of forts and signal-stations connected by roads have been recorded.[18]

F. G. B. Millar's thought-provoking, even provocative, observation that "archaeologically speaking the Roman state remains almost invisible" has a lot of truth in the context of Rome's physical presence in Asia Minor.[19] Yet, judging by the enthusiasm with which the cities honored the emperor and his image as a part of their daily life and order and tried to appease and please proconsuls and governors, the Roman state and its representatives did have power.[20] Occasionally, Rome stepped in to advise, approve, intervene and (rarely) reprimand.[21] If the situation was important enough, or grave enough, a direct representative of the emperor with special investigative powers was sent to the province — as in the case of Pliny the Younger, who took charge of Bithynia as Trajan's legate in 110. For the fair cities of Asia, self-rule in the everyday sense was real, not fictional, but it was exercised at the end of a long leash.

The cities had their *boule* and *demos*, and a constitution based on the meeting of these august, representative bodies. The names and duties of the magistrates and the public offices they held had their origins in the historical, even mythical past. The complete list of magistrates preserved in a Hadrianic inscription from Oenoanda, a small city in N Lycia, is representative: there were 3 panegyriarchs, who supervised festivals; 5 prytaneis, who were officers of the city council; 2 gymnasiarchs and 1 ephebarch, to manage the gymnasia in the city and oversee gymnastic education; 2 market-controllers (usually known as *agoranomoi*); a supervisor of public buildings, and 2 *paraphylakes*, who maintained law and order in the country. Leading the list were the priests and priestesses of Zeus and the cult of the emperors, sometimes referred to as *stephanephoroi*.[22] Many cities were divided, not into *vici* as in the West, but into tribal neighborhoods with their own assemblies and overseen by their

15 Mitchell, *Anatolia* (supra n.5) vol. 1, 64-69.

16 F. Millar, "Introduction," in Macready and Thompson (supra n.5) x-xii.

17 Mitchell, *Anatolia* (supra n.5) vol. 1, 118-36. See also Aelius Aristides: 'cities of the Empire are free of garrisons: cohorts and cavalry units are sufficient to guard whole provinces and not even many of these are quartered in the cities of each province, but they are few taking account of the size of the population, and settled throughout the countryside, so that many provinces do not even know where their garrison is' (*To Rome* 69, transl. C. A. Behr, *P. Aelius Aristides: the complete works* [London 1981] 87).

18 For greater Roman military presence in Phrygia, the central highlands, and the Euphrates *limes*, see various essays in Mitchell (ed.), *Armies and frontiers* (supra n.5), esp. M. P. Speidel, "The Roman army in Asia Minor. Recent epigraphical discoveries and researches," 7-37, and Mitchell ibid. 131-51; for the Roman fort at Eskihisar east of the Euphrates near Zeugma, see J. Wagner, "Provincia Osrhoenae: new archaeological finds illustrating the military organization under the Severan dynasty," in Mitchell ibid. 103-26.

19 Millar (supra n.16) xi.

20 Millar (supra n.14) 245-46.

21 For Rome's interventions in the civic and religious institutional structure of the Greek city, stemming from notions of legal and moral superiority over the Greeks ("saving imperial Greeks from their characteristic vices"), see Woolf (supra n.5) 118-25.

22 Mitchell, *Anatolia* (supra n.5) vol. 1, 199; M. Wörrle, *Stadt und Fest im kaiserzeitlichen Kleinasien: Studien zu einer agonistischen Stiftung aus Oinoanda II* (Munich 1988) 70-72.

phylarchs. In Ankyra, the office of *astynomos*, not the aediles, was charged with maintaining streets, squares, the water system and drainage. Professional clubs and athletic colleges, synods, occupied prestigious positions in the social structure of the communities and some were even represented abroad.[23] Trade associations and guilds, typically Greek and variously known as *homotechniai*, or *syntechniai*, existed in even the smallest cities and were often geographi- ally conceived and described as *plateia*, like the colonnade in which a row of shops was grouped. As potential agents for political disturbance, some of these associations came under the jurisdictions and scrutiny of local and imperial authorities. On the whole, however, they were responsible civic organizations. Encouraging professionalism and trade, honoring their own members as well as leading citizens, Roman magistrates and governors, by setting up inscriptions and statues they "helped to cement a good relationship between the leading men of the city and common people."[24]

The men who held the municipal offices and possessed the power to rule at the local level were Greeks and native Anatolians who had been granted the much-coveted Roman citizenship. The creation of a local élite, an ambitious, upwardly-mobile, new aristocracy, with strong ties to Rome and the imperial system, was an event of near-revolutionary dimensions in the social restructuring of Asia Minor under Roman rule. Indeed, to involve this new class of privileged families in the culture of civic munificence, and to undertake massive public building projects as a responsibility of their office, is an aspect of Romanization which can be applied to rural Italy as well as Asia Minor. What is remarkable is the opening of the boundaries between West and East due to the mobility available to the new élite. Holding equestrian or even consular rank, the 'new men' avidly pursued a service career, and many occupied the highest military and administrative positions far and wide in the empire before returning home to retire.[25] According to a study published by M. Hammond in 1957, by the second half of the 1st c. 17% of the identifiable senators originated from Greece and Asia Minor; a century later the number had risen to 58%.[26]

In a close survey of the rich material emerging from Sagalassos in Pisidia, H. Devijver outlined three preconditions for membership in the new aristocracy: wealth (*facultates*); education in the Greek liberal arts (*paideia*); and munificence within the framework of the *polis* (*euergesia*). Of these, possession of wealth is not surprising; the minimum requirement was 400,000 sesterces for the equestrian order and 1.2 million for senators — with all applica- tions to be registered in Rome and subject at all times to review by the emperor. The second condition, that one had to be Hellenized before becoming Romanized, is more remarkable because it implies a far deeper cultural significance than the possession of mere wealth. Of course, it was wealth that best assured the privilege of a good education, and created the conditions for participation in the literary-rhetorical-judicial culture of Asia which gave us

23 A set of Greek and Latin inscriptions from Rome attests to a very successful college of athletes from Asia Minor belonging to the cult of Hercules. They established their headquarters in the Baths of Trajan in his reign, and had their privileges extended under Hadrian and Antoninus Pius: *CIL* VI 10153-54; *CIG* III 5906-13; O. Falconieri, *Inscriptiones athleticae* (Rome 1669); F. Yegül, *Baths and bathing in classical antiquity* (New York 1992) 175-76.

24 Mitchell, *Anatolia* (supra n.5) vol. 1, 199-204, esp. 202. See also Jones 1937 and Jones 1940 (both supra n.4); W. Liebenam, *Städteverwaltung im römische Kaiserreiche* (Leipzig 1900); Magie, *Roman rule* (supra n.2) vol. 2, 1501-4.

25 Mitchell, *Anatolia* (supra n.5) vol. 1, 210-11; Millar (supra n.14) 247-49; J. R. Patterson, "Settlement, city, and elite in Samnium and Lycia," in J. Rich and A. Wallace-Hadrill (edd.), *City and country in the ancient world* (London 1991) 148-68, esp. 159-62; T. P. Wiseman, *New men in the Roman senate 139 B.C.- A.D. 14* (Oxford 1971).

26 M. Hammond, "Composition of the senate A.D. 68-238," *JRS* 47 (1957) 73-81; H. Halfmann, "Die Senatoren den Kleinasiatischen Provinzen," in *Epigrafia e ordine senatorio* 2 (Rome 1982) 603-50. For a more cautious interpretation of the Senate's composition, see R. J. A. Talbert, *The senate of imperial Rome* (Princeton 1984) 29-38, esp. 32 n.14.

the likes of Dionysus of Halicarnassos, Dion of Prusa, and Aelius Aristides of Smyrna. But it was *paideia*, anchoring one in the literary culture of one's *patria*, with the sense of identity that this knowledge and love provided, that made possible (at least as far as the upper crust of the society was concerned) belief in and loyalty to the empire.[27] If this is Romanization, the secret of the system lies in Rome's ability to co-opt local heritages and local values and to create a cultural climate in which it was difficult to feel like an alien.

Aelius Aristides, who lived under Antoninus Pius, underlined the same values in his famous, if florid, encomium *To Rome*.[28] Commenting upon Rome's gifts for ruling peacefully though inclusion and assimilation, Aristides says that:

> the most praiseworthy of it all is your conception of citizenship. There is nothing on earth like it ... Neither the sea nor any distance from land shuts a man out from citizenship ... Everything lies open to everybody: and no one fit for office or responsibility is an alien. The constitution is an universal democracy under the one man who can rule and govern best. (*To Rome*, 59-60)

In the government represented by Rome, democracy as we understand it or independence of the Greek city states is a fiction. But, as an educated Greek from a leading Greek city, Aristides assures his Roman audience that the cities' voluntary and joyful acquiescence in Rome's expert and benign rule, in his view, is a fair price to pay for the *pax romana* and the good life it provides. Full independence, or for that matter even democracy, was always a fiction in the turbulent, warring history of Greek cities, even during the Classical period. It was also a questionable concept in political thought.

Pausanius had difficulty accepting *Panopeus* in Phokis as a *polis*.[29] Although this small mountain hamlet in N Greece had a marked territory and probably a constitution on which to stake its political independence, it had no government offices, no market-place, no gymnasium, no theater, and no water supply — none of the tangible realities that make life meaningful and pleasurable. Plato had underlined the importance of the physicality and practicality of urban culture thus: a *polis* 'arises out of the needs of mankind: no one is self-sufficient, but all of us have many wants' (*Resp.* 2.369b). These needs and desires give rise to institutions which develop their physical and architectural expression in public and private buildings — temples, government offices, courts of law, gymnasia for the young and warm baths for the old (*Leg.* 6.761c). For Plato, the *polis* is fundamentally a physical reality, not a theoretical concept.[30] The ideas of civic autonomy and freedom are relative, because they are compromised constantly by the community's desire for the good life and its willingness to accept an authority which will impose the "orderliness" necessary to maintain it. In Plato's imaginary Magnesia, "city of the Magnetes," the citizens pursue happiness in a kind of political vacuum, in international isolation from foreign-policy matters. The power to rule is turned over to an outside authority which knows it best. Thus, as long as the ruler is benevolent and does not abridge individual freedoms, the community is content. Plato's preference for a 'limited government' over the dubious advantages of full freedom is echoed by Aristotle, who believes in compromise: 'A citizen is one who shares governing and being governed ... [In the best form of constitution he] is one who has capacity and the will to be governed ... with a view for the good life in accordance

27 H. Devijver, "Local elite, equestrians, and senators: a social history of Roman Sagalassos," *AncSoc* 27 (1996) 105-62, esp. 105-7.

28 Aelius Aristides, *ΕΙΣ ΡΩΜΗΝ. To Rome* (transl. S. Levin; Chicago 1950). It is too easy to dismiss the writings of Aristides, especially his Roman oration, as a lavish and conceited encomium to the ruling power in Rome. No doubt some parts of it are, but if one is willing to strip the text of its literary embellishments, there is also a hard core of sincere feeling, which is not insubstantial 'rhetoric', but based on hard observation and contemporary knowledge of specific conditions. See also the useful 'Introduction' by Levin.

29 Paus. 10.34.

30 For a fuller development of the philosophical and theoretical basis of the Greek city, see the excellent article by C. B. Welles, "The Greek city," in *Studi in onore di Aristide Calderini e Roberto Paribeni* (Milan 1956) 81-99.

with virtue' (*Plt.* 1284b, transl. H. Rackham). If, however, there are men of exceptional virtue and ability, they should be allowed to rise over the state (*polis*) as absolute rulers 'since such a man will naturally be as a god among men' (*Plt.* 1284a, transl. Rackham). In his perceptive essay, C. B. Welles observed that we have here "the theoretical basis of the Hellenistic monarchy, complete with the ruler cult."[31] We also have the theoretical basis for Aristides' view of the Greek city thriving under Roman imperial rule, and validation for that strange concept of a democracy under one man who can rule and govern best.

What of the physical basis of the city under Roman rule, that aspect of Romanization or urbanization which made the city an 'argument in stone' and shaped the good life that was so dear to Aristides and his fellow citizens? Aristides continues to be our guide in assessing the nature of Romanization and linking it with the built environment. Whereas previously kings ruled tribes, Rome rules cities, he observes. Rome made 'cities' out of tribes, city-dwellers out of tribal people. It was not only the new cities, but even the old Greek cities that realized the full potential of their native culture and art under Roman rule: "Now, under your tutelage, all the Greek cities emerge. All the monuments, works of art, and showplaces in them mean glory to you" (*To Rome* 94-95). Thus Rome co-opts and assimilates Greek culture, this time the physical culture of art, architecture and city-making. Elsewhere, Aristides confirms what we generally know from other sources, such as Dion Chrysostomos of Prusa, but most effectively through archaeology, that the cities of Asia Minor blossomed under the Empire rivaling each other

> ... to show off a maximum of elegance and luxury. Every place is full of gymnasia, fountains, gateways, temples, shops, schools ... Gifts never stop flowing from you to the cities and because you are impartially generous to all, the leading beneficiaries cannot be determined. Cities shine in radiance and beauty, and the entire countryside is decked out like a pleasure ground. (*To Rome* 97-99)

There is no doubt that building activity was brisk, and we can easily expand on Aristides' list of urban amenities, but there is also exaggeration. Rome was never so generous with direct 'gifts' to the cities: with the significant exception of major civil engineering projects such as roads, bridges and aqueducts, cities built themselves mainly through the generosity of their local benefactors.[32] And although the cities may have shone, the situation in the country was dismal, hardly a pleasure ground. These are generalities. The brisk pace of urbanization which affected even the remote highlands of Anatolia under Roman rule — the marble-paved streets, colonnades bedecked with statues, lavish fountains at urban intersections, decorative gateways, and monumental baths — may be explained by two centuries of peace and prosperity made possible by a well-administered empire, an economic tide which raised all boats. But does this count as Romanization? As F. G. B. Millar framed the question with refreshing directness, "When a senator like Cassius Dio Cocceianus finally went home to Nicaea in Bithynia, in A.D. 229, after an adult lifetime spent largely in Rome or at his villa in Capua, did he bring any ideas about architecture with him?"[33] Or, to recall a simpler query posed by G. M. A. Hanfmann nearly three decades ago, "What is Anatolian, what is Greek, and what is Roman in this urban renewal and grandiose architecture?"[34]

Although the dangers of reducing the complex Mediterranean heritage of classical architecture to simple polarities between East and West, Hellenism and Romanism, have been recognized, the temptation to identify a set of more-or-less formally paired stylistic and structural characteristics traceable to their respective origins remains.[35] Perhaps the sheer logic and

31 Welles ibid. 93-94.

32 On the nature of imperial 'gifts' see Mitchell, *Anatolia* (supra n.5) vol. 1, 18-25; also see R. MacMullen, "Roman imperial building in the provinces," *HSCP* 64 (1959) 207-35.

33 Millar (supra n.16) xiii.

34 G. M. A. Hanfmann, *From Croesus to Constantine* (Ann Arbor 1975) 55. For a perceptive view of Roman urbanization in Asia Minor, combining historical, literary, and archaeological evidence, see chapt. 3: "Ad claras Asiae volemus urbes: Roman governors and urban renewal," 41-56.

35 Some of the ideas presented in the next pages amplify what I said in"'Roman' architecture in the Greek

Fig. 1. Mixed Roman construction in Asia Minor: mortared rubble, brick bands and arches supported by ashlar piers, from the bath-gymnasium complex at Sardis (author).

quantifiable nature of architecture makes it inevitable to respond to such questions by comparing cultural and aesthetic identities. Some of the more common identifying characteristics (or 'contrasting elements') which are paired as East *versus* West include: a continuing tradition of

world," *JRA* 4 (1991) 344-55, esp. 344-45 and 355. The historic controversy concerns the recognition of what is western and what is eastern in Roman imperial architecture by identifying a set of 'contrasting structural elements and design characteristics'. The issue was brought up by J. B. Ward Perkins in his famous response to the controversy which had been ignited by J. Strzygowski's *Orient oder Rom* (London 1901). Ward Perkins emphasized the difficulty of treating the architecture of the Roman East as a block, and pointed to the diversity of traditions within the East itself and to reciprocating currents which bypassed the capital altogether. Yet all told, he was one of the many scholars who used formal methods to analyze Roman architecture: see his "The Italian element in late Roman and early Medieval architecture," *ProcBritAc* 33 (1947) 1-31. For recent studies of building technology in Asia Minor identifying polarized characteristics, see n.36.

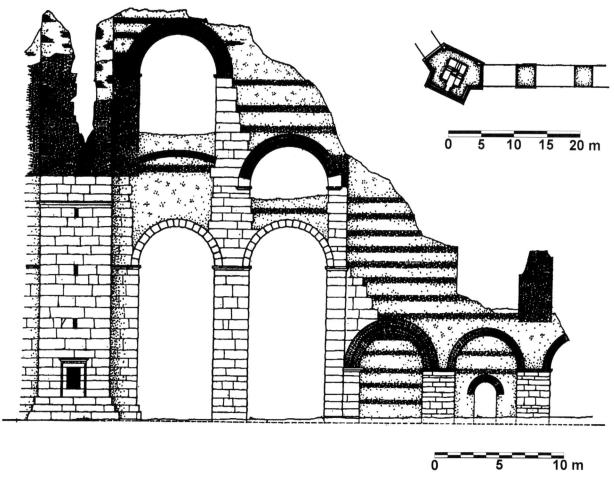

Fig. 2. The aqueduct of Aspendos, south pressure tower (British School at Rome).

solid ashlar construction (East), concrete walls faced in tufa or brick (West); columns, colon-
nades, and flat roofs (East), vaults and domes used singly or in groups, made possible by concrete
(West); orthogonal simplicity (East), geometric elaborations of space (West); linearity in
plans (East), dynamic use of curves and inventive shapes (West); a limited use of axiality with
irregular compositions (East), strong axiality and bilateral symmetry of compositions (West);
horizontal massing (East), an emphasis on height and the vertical (West). Such distinctions
are valid as a loose working hypothesis, but in reality much of Roman architecture, eastern or
western, cannot be described in such diametric terms, nor broken down into binary sources. The
High Empire produced complex and sophisticated combinations of building types and
techniques which are neither eastern nor western. Roman wall construction is often a hetero-
geneous mixture of materials and techniques; mortared rubble (and its many local variants) is
not simply a "substitute" for Roman concrete but an indigenous technique at home in Asia Minor
(fig. 1). The aqueduct serving Aspendos in Pamphylia is a mélange of construction styles and
materials, East and West (fig. 2). Ashlar masonry is patently a Greek–Hellenistic technique,
but it is found widely in the West, most famously in Rome's Colosseum. Arches and vaults,
though informed and inspired by western usage, are used in the East more often than we tend to
think, while trabeated architecture and flat wooden roofs continued in Rome and the West.
Some eastern architectural schemes, such as bath buildings, have remarkable spatial variety
and elaboration, while a civic structure such as Vespasian's much-admired *Templum Pacis* in
Rome displays the orthogonal simplicity and purity ascribed to Greek classicism.

Even specialists of Asia Minor tend to perceive this architecture from an Italian perspective
and see it as a passive position — a provincial phenomenon 'impacted' by Rome. Thus, H.
Dodge's valuable essay on the architectural influence of Rome in the East offers a good review
of the building technologies and materials recognized to be inherently Roman or western, adap-
ted to local materials and taste in the eastern provinces. She concludes that "the architectural

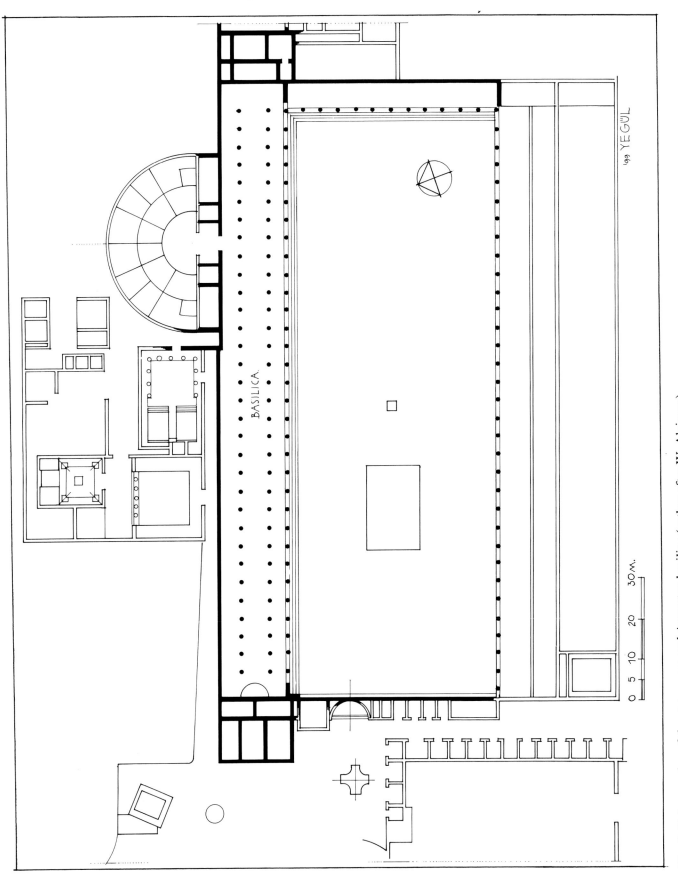

BASILICA.

YEGÜL '99

0 5 10 20 30 M.

Fig. 3. Ephesus, plan of the state agora and Augustan basilica (author after W. Alzinger).

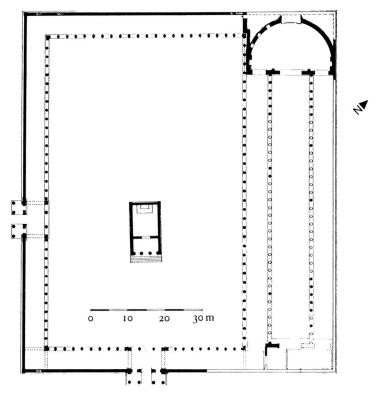

evidence clearly shows that the architecture [of the] Eastern provinces was not in any way second-rate ... Provincial architecture was not a pale imitation of metropolitan form."[36] This 'positive approach' is well and good, but in fact it damns with faint praise. Architecture in Asia Minor, especially, was not an imitation of metropolitan forms, pale or not. There was no conscious attempt to 'adopt' a western standard of building form or to substitute a building method explicitly set by the capital. There was, of course, some interchange and reciprocity, natural development, and much experimentation among the many centers, but Rome and the West had ceased to be the overarching architectural reference for the cities of Asia.

Fig. 4. Plan of Caesareum at Cyrene (British School at Rome).

Let us consider a few building types, and institutions represented by them. The basilica in characteristic form and function is a well-recognized western institution. Yet, inspired by the Greek stoa, it existed early on in the East as a porticoed type. Sometimes articulated with a 'Roman' apse, it was commonly incorporated as a 'basilica-stoa' into one of the wings of a colonnaded enclosure, such as an agora. Good examples of this altered type come from a Hadrianic *quadriporticus* in Cyrene (*Caesareum*),[37] the Augustan basilica in the Upper Agora of Ephesus,[38] and the Antonine basilica in the Agora of Smyrna (figs. 3-5).[39] The amphitheater, a *bona fide* Roman creation with native roots in central Italy, and most popular in N Africa and Rome's western provinces, hardly makes an appearance in Asia Minor. This is not because gladiators and beasts were not appreciated in the East: they were, but eastern audi-

36 H. Dodge, "The architectural impact of Rome in the East," in M. Henig (ed.), *Architecture and architectural sculpture in the Roman empire* (Oxford 1990) 108-21, esp. 118; ead., "Brick construction in Roman Greece and Asia Minor," in Macready and Thompson (supra n.5) 106-16. M. Waelkens' meticulous study of building techniques in Asia Minor also tends to pair formally-defined characteristics and to view the architecture, at best, as an innovative "adaptation" of western forms: see his "The adaptation of Roman building techniques in Asia Minor," ibid. 94-105. See also R. L. Vann, *A study of Roman construction in Asia Minor. The lingering role of a Hellenistic tradition of ashlar masonry* (Ph.D. diss., Cornell University 1976); F. Fasolo, "L'architettura romana di Efeso," *Boll. Centro Studio Storia dell'Architettura* 18 (1962) 7-91.

37 J. B. Ward Perkins and M. Ballance, "The Caesareum at Cyrene and the Basilica at Cremna," *PBSR* 26 (1958) 137-94, esp. 175-86; E. Sjöqvist, "Kaisareion, a study in architectural iconography," *OpRom* 18 (1954) 98-104; S. Mitchell, "The Hadrianic Forum and Basilica at Cremna," in *Festschrift für Jale Inan* I (Istanbul 1989) 229-45, pls. 103-6.

38 W. Alzinger, "Grabungen in Ephesos von 1960-70: Daß Regierungsviertel," *JÖAI* 50 (1972-75) 258-82; id., *Augusteische Architektur in Ephesos* (Sonderschriften ÖAI 16, 1974) 24-37.

39 R. Naumann and S. Kantar, *Kleinasien und Byzanz* (IstForsch 17, 1950) 69-114; J. B. Ward-Perkins, *Roman imperial architecture* (New York 1981) 287-88. For the forum-basilica type see id., "From Republic to Empire: reflections on the early provincial architecture of the Roman West," *JRS* 60 (1970) 7-11.

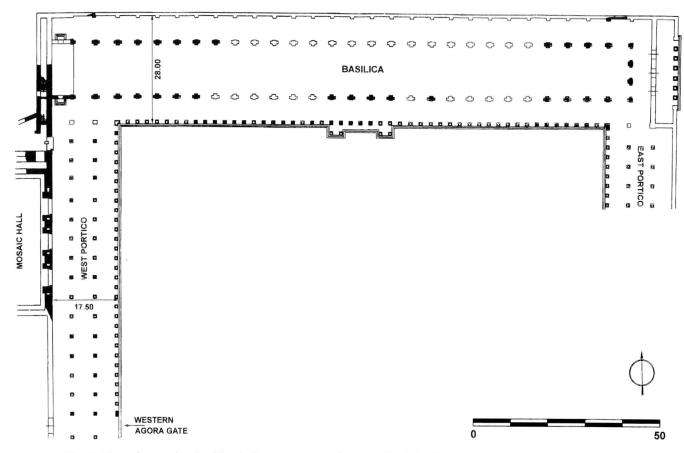

Fig. 5. Plan of Antonine Basilica in Roman agora at Smyrna (DAI, Berlin).

ences found alternative venues for these forms of entertainment — the theater, a walled-off section of the stadium, even the agora. More intriguing is the bath-gymnasium complex, a new architectural type created in Asia Minor by combining the vaulted Roman bath and the colonnaded Greek palaestra. Almost from their inception in the 5th and 4th c. B.C., there was a relationship between the gymnasium and heated baths. The development of this new, composite institution demonstrates with remarkable clarity the processes of co-existence, imitation, adaptation, and re-creation in hybrid cultures.[40]

Finally, let us consider the planning of cities. It is ironic that the land that gave the Classical world the textbook model of the orthogonal grid planning of Miletus, or its absurdly persistent application in steeply sloping sites such as as Priene and Knidos, maintained under Roman rule a pragmatic approach to planning. In the great majority of small cities in mountain regions, such as Oenoanda, Balbura, Selge, Alinda, and Assos, the natural potential of the terrain is exploited, resulting in an irregular, organic, and to a large extent functional planning. These are, of course, cities with long histories whose urban structures developed in an additive fashion over many years. Even in the few newly-founded Roman colonies in Asia Minor, how- ever, there was, as F. E. Brown would have observed, no "premeditated design for what a functioning Roman environment ought to be."[41] Nothing that can be compared to Cosa, Norba, or Alba Fucens, much less the tight, *castrum*-inspired, four-square grid of Trier or Timgad. Cremna (*Colonia Julia Augusta Felix*), the mountain-top Augustan colony in Pisidia, looked like no military colony in the West ever did: a loosely-applied grid with blocks of different size, shape and orientation occupies the west end of the city (fig. 6). Elsewhere, the town's major monuments, the Doric agora, Roman forum and basilica, temples, theaters, baths, and housing

40 Yegül (supra n.23) 6-29, 250-313; id., *The bath-gymnasium complex in Asia Minor during the Roman era* (Ph.D. diss., Harvard Univ. 1975).

41 Brown (supra n.1) 12.

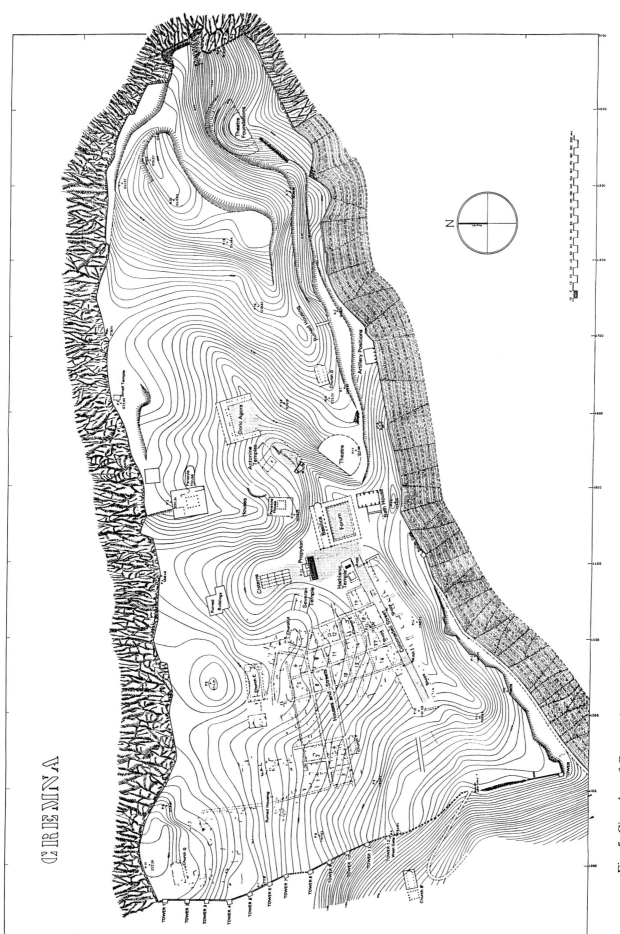

Fig. 5. City plan of Cremna (courtesy S. Mitchell).

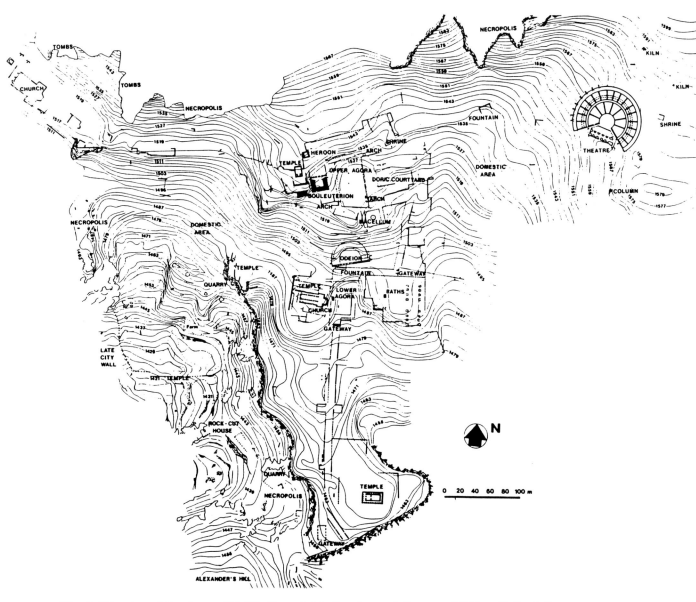

Fig. 7. City plan of Sagalassos (M. Waelkens [ed.], *Sagalassos I* [Leuven 1993] p. 52 fig. 14).

quarters, are raised on terraces or carved into hollows, linked by stairs, streets, gates and plazas — that is, draped over the uneven terrain in visually interactive relationships.[42] Introduced sometime in the 2nd c. A.D., the broad colonnaded street functioned as a strong urban organizer, and linked the residential quarters with the civic center. The loose grid arrangement north and northwest of the colonnaded street, characterized by "approximately perpendicular" crossings and irregular blocks with slightly changing orientations, might have been an early colonial attempt to regularize an already-existing Hellenistic neighborhood. No doubt there is an element of piecemeal growth and historic layering here; other factors would have been site conditions, desirable views, property lines, legal disputes, traditional tastes, and plain, rational choices.

Cremna was a military colony, but in many of the larger, more important cities of Asia Minor we see a similar, non-theoretical approach to planning. I would like to describe it as a

42 Vittinghoff, *Römische Kolonisation* (supra n.2) 46-47, 148-53; S. Mitchell and M. Waelkens, "Cremna and Sagalassus," *AnatSt* 38 (1988) 53-59; S. Mitchell *et al.*, *Cremna in Pisidia* (London 1995).

Fig. 8. Sagalassos, view to south, showing baths, lower agora, colonnaded street, Antonine temple (author).

distinct urban type, although I hesitate to privilege it with a designation such as the "Anatolian choice".[43] This is a pattern characterized by a partially-ordered, structured, and 'premeditated' design lightened by an environmentally-conscious, flexible, and even picturesque approach. The differently-ordered monuments of hilly Sagalassos are subordinated to a strong urban backbone: a wide and straight colonnaded avenue (crossed by straight but not necessarily parallel streets) is stretched across the prominent natural saddle, connecting the Lower Agora with the temple precinct of Antoninus Pius (figs. 7-8).[44] At coastal Phaselis straight sections of avenues link its several harbors and create a network articulated by plazas, buildings and arches (fig. 9).[45] Likewise, Ephesus and Sardis both harness the urban energies of their dramatic settings into armatures shaped by their thoroughfares, public plazas, loosely-applied grids, and powerful building alignments (figs. 10-13). Order is often imposed by the conformity of major buildings to one or more dominant alignments, not strict reticulation.[46] If there is a sense of Roman 'ordering', an 'authority' (as Aristides would have it) in these structured cities of Asia, it is tempered by a desire for improvisation and regulated by the historic and natural features of the sites. In Sardis, a succession of natural and artificial terraces on the N/NE slopes of the acropolis support and display many of the civic structures and housing neighborhoods of the Roman city (fig. 14). These are urban situations, real in time and place, which ultimately inspire and inform the physical shape of the city and control its

43 F. Yegül, "Efes ve Sardis," *Anadolu Medeniyetleri Müzesi 1994 Yılı Konferansları* (Ankara 1994) 77-96. In the Cremna survey, Mitchell demonstrates that the city plan, especially the western residential quarter, was nowhere as orderly as Lanckoronski had assumed: "Whilst the overall regularity of the area was maintained, the district was not laid out to any rigid, theoretical system of planning, but developed in practical response to the nature of the ground, existing features, and the needs of the inhabitants" (*Cremna* ibid. 160).

44 M. Waelkens, S. Mitchell, and E. Owen, "Sagalassos, 1989," *AnatSt* 40 (1990) 185-204; M. Waelkens (ed.), *Sagalassos* I-II-III (*ActaArchLov* Monog. 5, 6, 7, 1993-95).

45 H. Schläger, D. J. Blackman, H. Bremer *et al.*, *Phaselis* (IstMitt Beiheft 24, 1980) esp. 19-23.

46 F. Yegül, "The street experience of ancient Ephesus," in Z. Çelik, D. Favro and R. Ingersoll (edd.), *Streets: Critical perspectives on public space* (Berkeley 1994) 95-110, esp. 97-98; id., "Ephesus and Sardis: a tale of two cities," *La ciudad en el mundo romano. Pre-Actas (XIV Int. Congr. Class. Arch.)* I (Taragona 1993) 231-35; id., "Roman architecture at Sardis," in E. Guralnick (ed.), *Sardis: Twenty-seven years of discovery* (Chicago 1987) 46-61, esp. 48-49.

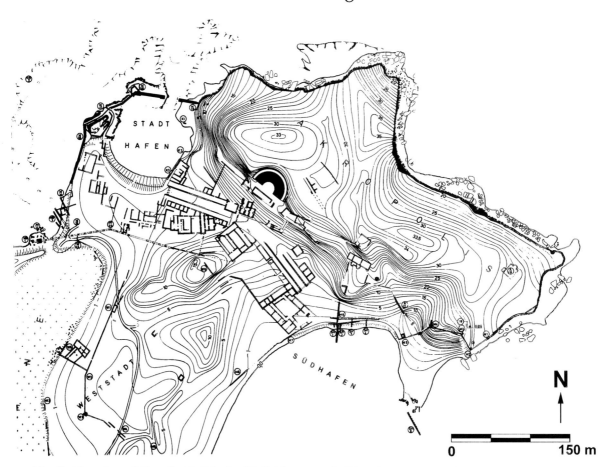

Fig. 9. City plan of Phaselis (J. Schafer, H. Schlager *et al.*, *Phaselis (IstMitt Beiheft* 24 [1981] fig. 9).
future growth.[47]

By the 2nd and 3rd c., the so-called Greek, Roman, and Anatolian elements of architecture and urbanism in Asia Minor could not be measured. They had become a part of the new repertoire of forms and techniques serving new needs and institutions. Thus, in assessing the city as an agent of Romanization, we need to move beyond searching for quantifiable and visible presences. At least as far as architecture is concerned, we need to view it as a synthetic construct meaningful within historically-defined, changing conditions of time and place. The Roman city in Asia Minor is a synthesis of ultimate and immediate sources, cosmopolitan practices, local needs, and Anatolian traditions. Its buildings thus represent, not a mixture of polarized and imported physical entities with clear origins, but an historic inevitability, a moment in time, alive with paradox and invention, reality and myth. It is in this sense that the future of the Greek city lay in its past. And it is to the rôle of memory and myth in the life of the city that I now turn.

To the citizens and the rulers of the Greek city who sought protection and patronage from Rome, the memory of a long tradition of freedom was as important as an up-to-date city center with splendid buildings. Foundation legends have always been essential elements in establishing the national identities of the Greek city: 'non-Greek cities might just grow, but a Greek city must have parents who were Greek in order for it to be admitted to the community of Hellas, just as its citizens must have parents who were citizens to be admitted into its community,' wrote Plato (*Leg.* 6.754a). In fact, as urbanization spread, and as the cities of Asia, large or small, competed with fervor and similar methods to win favor in the eyes of the Senate and the emperor, the question of identity and the need for 'parents' became more acute. Much as civ-

47 On a city's physical setting and history as "privileged situations" capable of being transferred into perfect urban form and experience, see Yegül in *Streets* (supra n.46) 107.

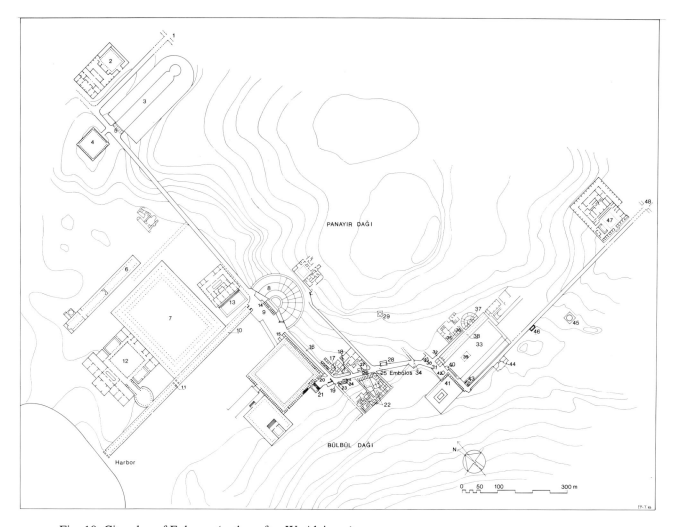

Fig. 10. City plan of Ephesus (author after W. Alzinger).

ic, physical splendor was appreciated, what made a city unique could not be sought solely in its buildings, nor in the number of times it won imperial favors through neokorates, but in the intangible idea of the city in the minds of its citizens.[48] Inventing the past gave value to the present and prepared for the future. Under the Empire, even the remote mountain towns of Pisidia and Lycia claimed glorious bonds with glorious founders and old Greece.[49] Some, like Aphrodisias, city of Venus–Aphrodite, snared their Roman masters in the craftily-woven and irresistible webs of myth of common origin – much to the gratification of both.[50] For generations

48 G. Woolf observes that, unlike the Roman sense of identify defined by the material constituents of urban culture, "material culture does not ... seem to appear prominently in Greek definitions of Hellenism." Instead, Greek self-definition centers mainly on language and descent. This does not mean that they (especially the Imperial Greeks of Asia Minor) did not create, articulate, and enjoy a highly original material culture and urban presence: Woolf (supra n.5) 125-30. For a similar assessment, see Yegül in *Sardis* 59.

49 The venerable oral traditions of legends, stories, and names of places must have disappeared without a trace. More lasting symbols of historic and mythological identity, and sense of autonomy, were expressed through the public display of writing and coins: Millar (supra n.14) 236, 249-51; Mitchell, *Anatolia* (supra n.5) vol. 1, 206-8. For useful summaries of city histories and founding legends, see discussions at the beginning of each chapter in G. Bean's books covering W and S Asia Minor: *Aegean Turkey* (London 1966); *Turkey's southern shore* (London 1968); *Turkey beyond the Meander* (London 1971); *Lycian Turkey* (London 1978).

50 K. T. Erim, *Aphrodisias, city of Venus Aphrodite* (London 1986) 25-30; R. Pierobon, "Il nome di Aphrodisias," in J. De La Genière and K. Erim (edd.), *Aphrodisias de Carie* (Paris 1987) 39-51; Bean, *Turkey beyond the Meander* (supra n.49) 221-23.

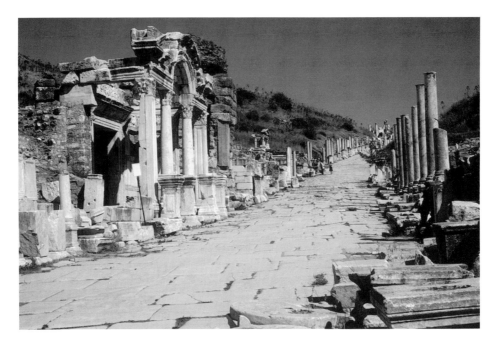

Fig. 11. Ephesus, view of the Embolos (Kuretes street) to the E (author).

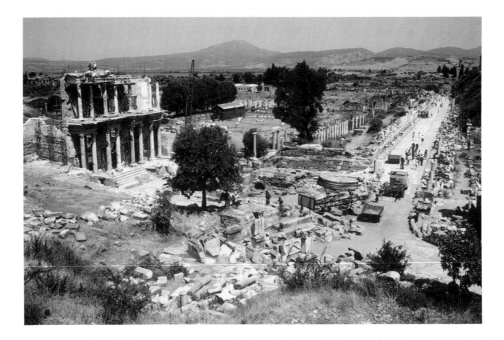

Fig. 12. Ephesus, view of the marble avenue and plaza in front of Library of Celsus, to N (author).

of its inhabitants, "golden Sardis" never lost its historical and mythological allure as the royal capital of the mighty Lydian empire and the beloved city of Croesus. Time and again its romantic Anatolian past was evoked in literature and poetry, resurrecting feelings of, not pan-Hellenism, but pan-Lydianism and rekindling the city's pride: '... under the flowering Tmolos, beside the stream of Maeonian Hermes' Sardis was the first witness of Zeus and the first nurse of Dionysus (*Anth. Graec.* 9.645).[51]

Memory of the mythical past, and the use of this memory as a metaphor for the present, took forms in which the literary and physical personas of the city became interwoven. Civic

51 Yegül in *Sardis* (supra n.46) 59-60.

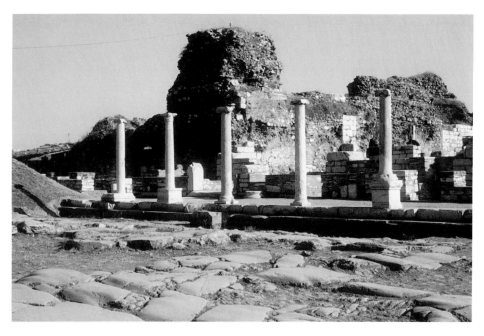

Fig. 13. Sardis, marble avenue in front of bath-gymnasium complex (author).

and religious ritual commemorating a city's legendary past gave life to the very stones with which the city was built, while the stones enhanced the meaning of its identity and shaped its future. The enthusiasm to endow one's homeland with marble monuments and beautiful buildings was matched only by the desire to found and subsidize agonistic festivals, athletic and musical competitions, and religious processions evoking pride in the city's past and honoring its heroes.[52] These occasions linked ritual to reality: they linked human action to physical urban presence, and in doing so magnified the personal, every-day experience of the city and elevated the event to the level of a community celebration. Some were particularly aimed at a certain group or age, such as those that initiated the young men, the *ephebes*, into the duties and responsibilities of adult life. Many ended in parades and banquets, fostering feelings of good citizenship. An important characteristic was the superbly-choreographed mixing of cults of local deities with the cult and sacred presence of the Roman emperor. While the celebrants looked back to the memory of old Greece, by proclaiming loyalty to the system and to the emperor they invested in their future.

An inscription from Oenoanda honors C. Iulius Demosthenes, an equestrian official who returned home after years of public service abroad, and endowed a musical and theatrical festival with various prizes (the categories and prizes are listed in detail) modeled after the great games in Delphi, Olympia, etc. The program and financial arrangements of the festival and the responsibilities of various civic bodies were worked out in detail by a committee of three and approved by the city council and the people, as well as by the governor of Lycia and the emperor Hadrian.[53] All this shows a model of co-operation between local donor, community, civic authorities, and the Roman administration. More dramatic in illustrating the values of a Graeco-Roman town under the High Empire, and the subtle mixing of Greek and Roman heritages, is the description of the golden crown worn by the *agonothetes*. Decorating the crown was a relief portrait of Hadrian 'and our leader, the ancestral god Apollo'. A similar crown is worn by the famous sophist Flavius Damianus of Ephesus, decorated with the busts of 12 gods and the emperor whose symbolic presence 'is the one Roman element in this Greek-centered rendering of a Zeus-like citizen philosopher.'[54]

52 Mitchell, *Anatolia* (supra n.5) vol. 1, 217-25; Jones, *Cities* (supra n.4) 230-35, 279-80; S. Mitchell, "Festivals, games, and civic life in Roman Asia Minor," *JRS* 80 (1990) 189-93; L. Robert, in *Eighth International Congress of Greek and Latin Epigraphy, 1982* (Athens 1984) 34-45.
53 Wörrle (supra n.22); Mitchell, *Anatolia* (supra n.5) vol. 1, 210; id., "Festivals" (supra n.52) 183-87.
54 Hanfmann (supra n.34) 71.

Fig. 14. Sardis, panoramic view of N/NE slopes of acropolis; the slopes at lower right and center support terraced housing (author).

In Ephesus, C. Vibius Salutarius, a local notable and a Roman citizen of the equestrian order under Trajan, provided for an annual procession celebrating the mythical past and sacred identity of his city.[55] The procession started in the venerable sanctuary of Artemis — the ancestral goddess of Ephesus and the main honorand — and entered the city through the Magnesian Gate. It proceeded down the 2-km thoroughfare, winding its way through the city and stopping at its monuments, the Augustan basilica, the temple of the imperial cult, the bouleuterion and prytenaion, numerous fountains, passed along the marble-paved colonnaded streets to the theater, and finally exited by way of the sacred Koressian Gate back to the Artemesion (fig. 10). Statuettes of Artemis, along with heroes and legendary founders from the distant past, such as Oranos, Ge, Pion, Androklos and Lysimachos, were displayed alongside those of Augustus, Trajan, Plotina, and personifications of the Roman Senate and People. In this dramatic and entertaining display, in the words of F. Millar, "the rituals celebrated the present as the fulfilment of a long history, not an opposition between the Greek past and Roman present."[56] Through many similar events, pageants, festivals, and communal celebrations, the cities of Asia created an urban narrative which stitched the hard reality of the present to the soft fiction of myth and memory.

Nowhere is the connection between a city's physicality and its communal memory recalled with greater insight than in Freud's famous analogy between the human mind and the physical layering of history at Rome.[57] For Freud, the greatest trauma in mental life was forgetting, the complete loss of memory, since it might mean the annihilation of the past. But, unlike the physical world of the city where the same space cannot have different contents, nothing is allowed to perish in the transparencies of the mind, and everything may be preserved simultaneously

55 G. M. Rogers, *The sacred identity of Ephesos* (London 1991).
56 Millar (supra n.14) 251.
57 S. Freud, *Civilization and its discontents* (transl. and ed. J. Strachey; New York 1989) 16-20.

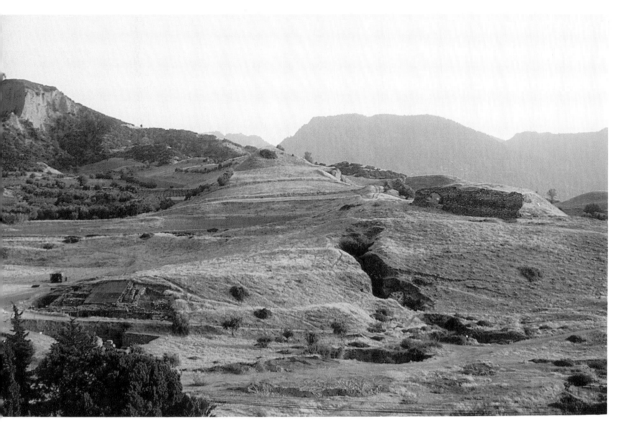

and brought back under the right conditions. Let us imagine what it might be like if we could represent a historical sequence and layering in spatial and temporal terms in the city, too. Imagine the creation of a venerable urban geography that wove together a network of public and private spaces — streets, colonnades, arcades, plazas, fountains, and civic buildings. Structures sacred and profane from different periods would line up, overlap, roll and jostle against each other. A temple front of the early Empire would be enriched by the additions of later decades; a library façade would find its double reflected in the pool of a later period; a simple tomb would be built next to a multicolumnar *exedra*; a phalanx of togate marble dignitaries would assemble inside the long portico, all overlooked from a distant hill by a tower-like monument to a local hero, perhaps a founder, from the legendary past — the whole a rich visual and textural assembly, layered in time, blended in purpose, and coalesced into one moment of urban experience. In order to do this, we would have to grant the city with a memory, suffuse its streets and buildings with myth and meaning, and relate them to each other by way of powerful kinetic and visual vectors. Ceremony, ritual, and of course ordinary daily life, would do the rest, and bind them in a grand urban narrative. That narrative could be Greek and Roman, Lydian and Anatolian. In the classical city of layered, transparent experiences — as in Freud's world of the unforgetting mind — the memory of the past could continuously remake the present.

University of California at Santa Barbara

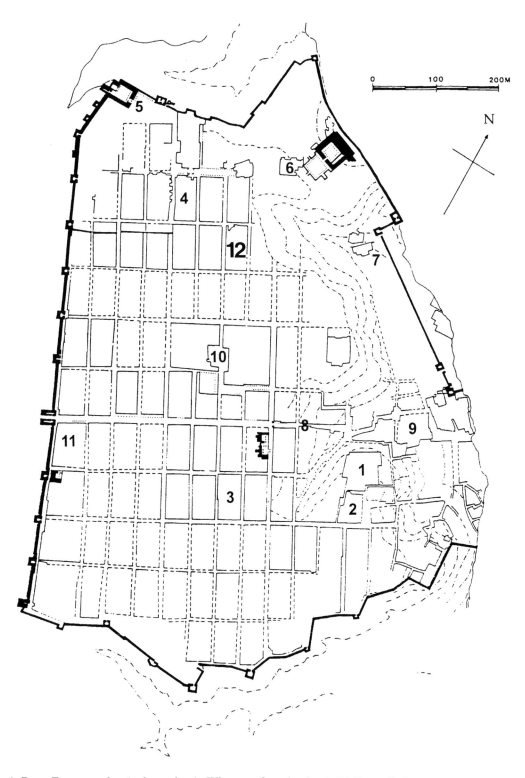

Fig. 1. Dura-Europos, plan (redrawn by A. Wharton after plan by A. H. Detweiler).
Key: 1 Strategion; 2 Temple of Zeus Megistos; 3 Temple of Artemis; 4 Barracks; 5 Temple of Bel;
6 Dolicheneum and barracks; 7 Military temple; 8 Roman arch; 9 Bath; 10 Agora; 11 Baths; 12 Bath and
amphitheatre.

The transformation of Seleucid Dura-Europos

Susan B. Downey

The first questions to be asked about the transformation of Seleucid Dura-Europos are What did the Seleucid city look like? and, When was the city as such, with its grid of streets and public buildings (fig. 1) created? The Yale excavators assumed that the Hippodamian grid was laid out at the founding of the colony in the late 4th or 3rd c. B.C., creating blocks of equal size, an agora intended to occupy a set number of blocks, a temple to Artemis and, later in the Seleucid period, one to Zeus Olympios, and an administrative building (the *Strategeion*, also known as the Redoubt Palace[1]) (fig. 2). Recent excavations by the Mission franco-syrienne de Doura-Europos challenge this assumption, suggesting instead that the initial settlement was a small military garrison on the citadel hill and in adjacent areas, unlike the fully-laid-out colonies of Sicily and S Italy, and that the fortifications, the Hippodamian grid, and the associated buildings were constructed only in the second half of the 2nd c. B.C.[2] The evidence for this interpretation will be discussed in more detail below.

It is clear, in any case, that after the Parthian conquest of *c.*113 B.C.[3] the area of the agora ceased to exist as a public space, being covered with private houses whose plans are related to Babylonian rather than to Greek house types[4] (fig. 3). The street grid remained the organizing factor of the Parthian city, though some blocks became rather irregular.[5] A major burst of temple building occurred between *c.*50 B.C. and A.D. 50; not only are the divinities mostly Semitic, the temple plans are based on Babylonian forms.[6]

The abbreviations in the notes follow the system of *AJA* 95 (1991) 4-16. In addition, the following short titles are used:

Downey, *Religious architecture*	S. B. Downey, *Mesopotamian religious architecture: Alexander through the Parthians* (Princeton 1988)
Dura report 1 [etc.]	*The excavations at Dura-Europos, preliminary report on the first* [etc.] *season of work* (New Haven 1929-52)
Leriche, "*Chreophylakeion*"	P. Leriche, "Le *Chreophylakeion* de Doura-Europos et la mise en place du plan hippodamien de la ville," in M. F. Boussac and A. Invernizzi (edd.), *Archives et sceaux du monde hellénistique* (BCH suppl. 29, 1997) 157-69
Perkins, *Art*	A. Perkins, *The art of Dura-Europos* (Oxford 1973)
Pollard, "Roman army"	N. Pollard, "The Roman army as 'Total Institution' in the Near East? Dura-Europos as a case study," in D. L. Kennedy (ed.), *The Roman army in the East* (JRA Suppl. 18, 1996) 211-27
Welles, "Population"	C. B. Welles, "The population of Roman Dura," in P. R. Coleman-Norton (ed.), *Studies in Roman economic and social history in honor of Alan Chester Johnson* (Princeton 1951) 251-74.

1 E.g., F. E. Brown, *Dura report* 9.1, 19-20; M. I. Rostovtzeff, *Dura-Europos and its art* (Oxford 1938) 11-13, 34-35; Perkins, *Art* 3-13. The *Strategeion* and the Temple to Zeus Olympios are located on the isolated spur in the lower left-hand corner of fig. 2.

2 Leriche, "*Chreophylakeion*" 157-69; id., "Pourquoi et comment Europos a été fondé à Doura?," in P. Brule and J. Oulhen (edd.), *Esclavage, guerre, économie en Grèce ancienne: Hommages à Yvon Garlan* (Rennes 1997) 191-210. For the suggested limits of the original military colony, see the plan in P. Leriche, "Matériaux pour une réflexion rénouvelée sur les sanctuaires de Doura-Europos," *Topoi* 7 (1997) 890-91, fig. 1. The work of the Mission franco-syrienne de Doura-Europos from 1986 to 1994 is summarized in P. Leriche and A. Mahmoud, "Doura-Europos. Bilan des recherches récentes," *CRAI* 1994, 395-420.

3 A. R. Bellinger, *Berytus* 9 (1948) 66.

4 For this transformation, see F. E. Brown, *Dura report* 9.1, 28-68.

5 Leriche, "*Chreophylakeion*" 169.

6 Downey, *Religious architecture* 88-129, with references to earlier literature.

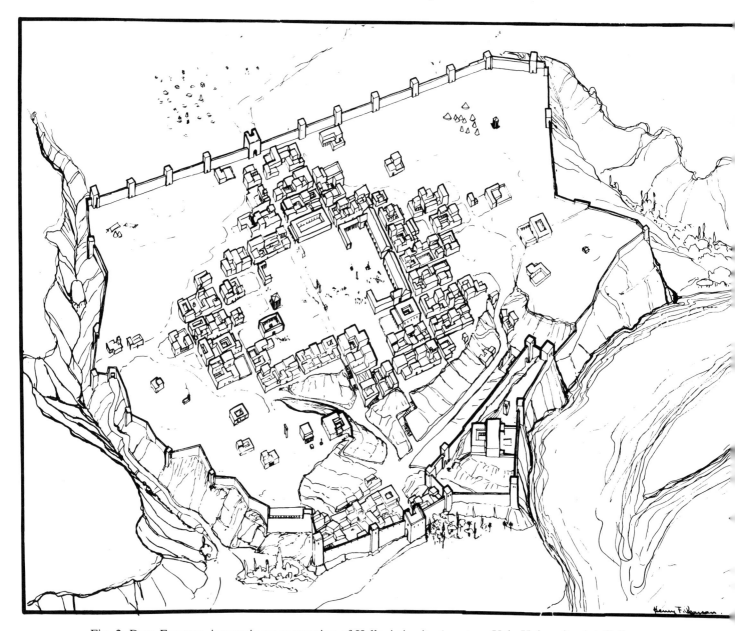

Fig. 2. Dura-Europos, isometric reconstruction of Hellenistic city (courtesy Yale University Art Gallery, Dura-Europos Collection).

The next major transformation came with the arrival of the Roman army in the late 2nd and early 3rd c. A.D.[7] Much of the northern part of the city was occupied by army headquarters, barracks, and other buildings constructed by the army for its use, such as a small amphitheater and, almost certainly, baths. Some temples may have gone out of use for the population as a whole, while others, with cults previously unknown at Dura, were probably built to serve members of the garrison. The southern part of the city was affected indirectly, as overcrowding created a need for housing. By the end of the life of the city, the fortification walls were practically the only remnant of its Greek heritage.

It is my contention that, in contrast to their projects in such cities as Corinth and Carthage (see D. Romano and F. Rakob in this volume), the Romans never intended to remake Dura into a 'Roman' city; rather, they remade a small part of it, building some facilities considered necessary for the public life and leisure of the Roman garrison, but otherwise leaving the city as it

7 This process will be discussed in the second section of the paper, where references will be given.

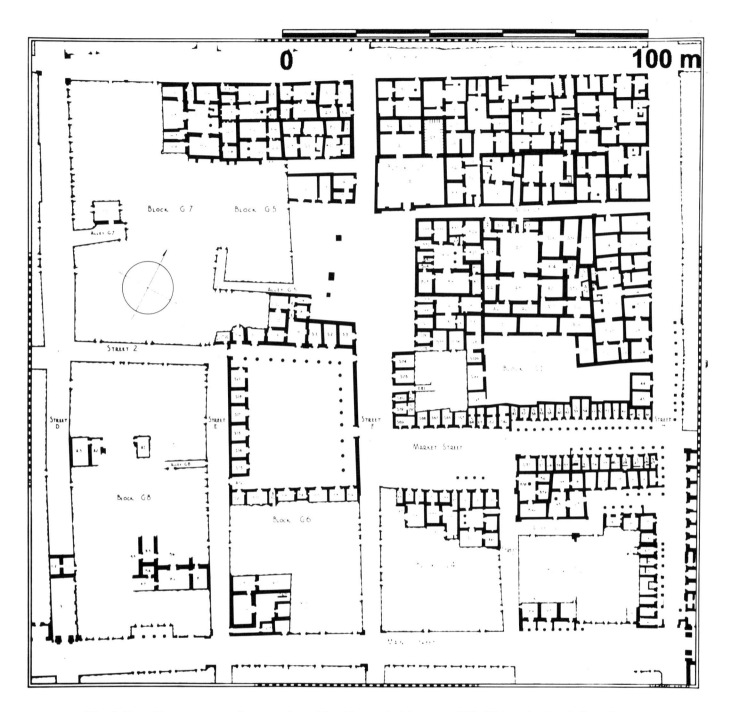

Fig. 3. Dura-Europos, area of agora, plan of Parthian period (courtesy Yale University Art Gallery, Dura-Europos Collection).

was, an amalgam of Greek and Near Eastern forms. This paper will be divided into two parts: current understanding of the Seleucid city, and the Roman transformation.

1. Current understanding of the Seleucid city

As stated above, the assumption of the Yale excavators was that Dura had been laid out at its founding in *c*.300 B.C. as a city with fortifications and a Hippodamian grid plan. Ideas about the date of the fortifications differed, but von Gerkan's suggestion, that the western defensive wall was constructed in the Hellenistic period with a stone socle and mudbrick above, intended to be replaced gradually by stone, and the other walls without a masonry socle or towers, was

158Susan B. Downey

generally accepted.[8] The date of the walls remains difficult to determine, but according to Leriche the preponderance of evidence points to a date in the 2nd c. B.C. He agrees with the Yale excavators about the contemporaneity of the fortifications, the grid plan, and the associated buildings; thus, his dating of the city walls depends in part on other evidence that will be discussed below. Independent of this evidence, however, he suggests that the West wall, originally constructed as a "rampart de prestige", was turned into a defensive wall, as indicated by the closing of postern gates in the course of construction, increasingly summary methods of construction, and the abandonment of stone in favor of mudbrick in the northern part of the wall. Leriche argues that the most logical explanation of these phenomena is the threat of a Parthian invasion when the walls were under construction.[9] The Yale excavators had already noted that the fortification of the citadel walls was never completed, and this lack of completion may suggest the end of an external threat.

Frank Brown suggested that the original plan for the Agora was over-ambitious, and that the project was carried out in a truncated form not later than the middle of the 3rd c. B.C. This date was derived partly by calculating back from the approximate date of the succeeding period, and by scanty ceramic finds, none of which came from the original floors of the buildings.[10] Indeed, the epigraphic evidence is somewhat contradictory. Part of the Agora (Block G3) housed a *chreophylakeion* (archives building). Since the cubicles are dated, and the approximate number of documents housed in each can be calculated, the earliest year represented can be shown to have been 184 of the Seleucid era, or 129-28 B.C. Brown deduced from this that the structure that housed the compartments was built towards the end of the 2nd c. over the remains of earlier shops and that earlier documents must have been housed elsewhere,[11] but another interpretation seems not only possible but more plausible. Leriche has argued on the basis of both archaeological and epigraphical evidence that the rooms housing the *chreophylakeion* belong to the first phase of construction in the agora area. From this and other evidence he deduces that only in the last quarter of the 2nd c. B.C. did Dura-Europos become a city divided into lots that needed to be registered. This late date is supported by an analysis of the ceramics found in the lowest levels of a sounding in the main street running east from the Palmyrene Gate. This sounding revealed, under the earliest roadbed, a mass of organic material mixed with pottery that is still difficult to explain, but the pottery is comparable to that described by the Yale excavators as found in the early levels of the agora.[12]

Recent excavations in the earliest structures on the plateau in the SE part of the city (Blocks C9, C4) seem to lead to similar conclusions. A sounding behind the large northern façade belonging to the second state of the *Strategeion* has determined, on the basis of numismatic evidence, that the façade cannot predate the beginning of the 2nd c. B.C.[13] My work in the Temple of Zeus Megistos, excavated in 1936-37 by F. E. Brown but never published, raises serious doubts about both the Hellenistic date of the first phase of the temple and its form.[14] Some of the foundation

8 A. von Gerkan, *Dura report* 7/8, 1-61 (summary on pp. 60-61); Rostovtzeff (supra n.1) 11-12, 34-35; Perkins, *Art* 10-12. Von Gerkan does not appear to specify a date within the Hellenistic period, but Rostovtzeff, Perkins, and Brown all assume that the walls were laid out shortly after the city's foundation.

9 Leriche, "Chreophylakeion" 165-67; id., "Chronologie du rempart de brique crue de Doura-Europos," *Syria* 58 (1986) (=*Doura-Europos Etudes* 1986) 61-82.

10 F. E. Brown, *Dura report* 9.1, 19-21; Brown's very circumspect language makes it clear that he realized that his evidence was not very strong. He is followed by Perkins, *Art* 14.

11 F. E. Brown, *Dura report* 9.1, 169-76.

12 Leriche, "Chreophylakeion" 166-68; n.51 clarifies the current interpretation of the ceramic evidence.

13 P. Leriche and A. Mahmoud, "Bilan des campagnes de 1986 et 1987 de la Mission franco-syrienne de Doura-Europos," *Doura-Europos Etudes* 2 (Paris 1988) 18-23; P. Leriche and A. Mahmoud, *CRAI* 1994, 403; M. Gelin, "Le Palais du Stratège à Doura-Europos. La fouille des pièces de la façade nord," *Doura-Europos Études* 4 (Beirut 1997) 61-76; the numismatic evidence from her excavations is discussed on 68-69.

14 For Brown's reconstruction of the first phase of the Temple of Zeus Megistos, see Perkins, *Art* 15, pl. 4,

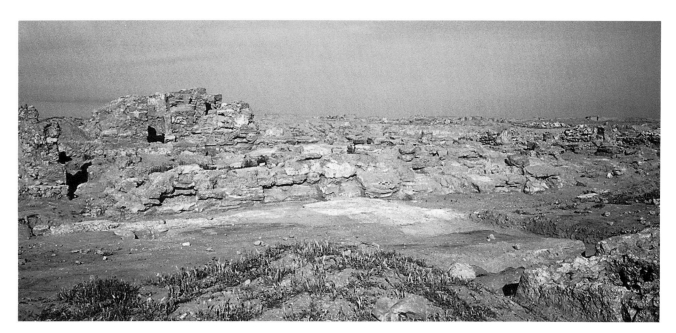

Fig. 4. Dura-Europos, Temple of Zeus Megistos, east façade (author).

blocks of this phase are patched or cut irregularly. Others show clear signs of being re-used, including cuttings for beams, showing that we must allow time for a structure to have been built and demolished before the construction of the temple. The irregularities in the alignment of the east façade may also be explicable by the hypothesis that fragments of earlier walls were re-used in its construction (fig. 4). Excavations on the E side of the temple revealed that gypsum blocks (which Brown interpreted as remains of paving) were instead part of the foundation course of a large structure, almost certainly Hellenistic, that predates the existing temple. A continuous section of a single course of a wall of well-cut gypsum headers and stretchers, founded partly on bedrock, partly on a hard-packed surface of red earth and stones used to level the uneven bedrock, is preserved for a N–S length of 8.50 m (figs. 5-6). The blocks are fresh from the quarry, and their measurements are typical of Hellenistic structures at Dura. Five meters to the north of this section of foundations, and aligned with them, are one header and one stretcher, but any construction between them was removed down to bedrock, presumably in antiquity. The northern end of the continuous section of foundation is flanked on the east and west by one row of headers, and two blocks of a second course are encased in the east façade of the Temple. A *sondage* undertaken in the SE part of the court of the temple, where the Yale team had already removed the later paving, revealed a paving of well-cut gypsum blocks whose surface lies just above the level of the blocks encased in the Temple façade. No independent dating evidence for the early remains in the Temple of Zeus Megistos was found. However, the fact that the wall is not aligned with the theoretical eastern limit of the block of the Hippodamian grid suggests that it predates the establishment of that grid, i.e., before the middle of the 2nd c. B.C.[15] The fragmentary state of the remains obviously makes determination of the form of the early structure impossible. A monumental court, perhaps connected with the Palace of the Strategos to the north, seems to me the most likely, but an earlier phase of the Temple is also possible.

and Downey, *Religious architecture* 79-86. There I accepted Brown's dating and interpretation, but my excavations in and around the temple, begun in 1992, have cast considerable doubt on both the date and the reconstruction. For reports on the 1992 excavations, see my "New soundings in the Temple of Zeus Megistos at Dura-Europos," *Mesopotamia* 28 (1993) 169-93, and "Excavations in the Temple of Zeus Megistos at Dura-Europos, 1992," *Doura-Europos Etudes* 4 (Beirut 1997) 107-16. The results of our 1994 season are reported in *Mesopotamia* 30 (1995) 241-50. For a brief summary of the results of the 1996 season, see *AJA* 101 (1997) 340. The implications of the first three seasons of work are analyzed by P. Leriche, *Topoi* 1997 (supra n.2) 980-92.

15 Ibid. 891-92.

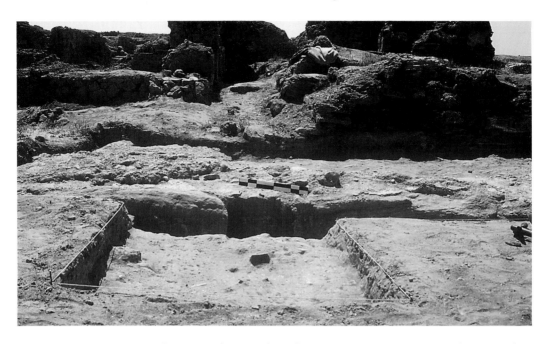

Fig. 5. Dura-Europos, Temple of Zeus Megistos, early wall to east of temple, view toward west (author).

Fig. 6. Dura-Europos, Temple of Zeus Megistos, early wall to east of temple, view toward south (author).

The evidence from the Temple of Zeus Megistos in turn casts doubts about the existence — at least as a temple — of F. E. Brown's heavily-restored plans of the early remains in the Temple of Artemis. In 1998, I cleaned one of the walls Brown used in his reconstruction of the earliest phase of the Temple of Artemis, which he dated to the 2nd or 3rd c. B.C.[16] (fig. 7). This wall, only 0.60 m wide, as reported by him, proved to be constructed of small, irregular chunks of gypsum, quite unlike the regular, well-cut stone blocks of the monumental structures of Hellenistic Dura (figs. 5-6). It is therefore unlikely to have served as the foundation for a temple precinct.

Thus, there is no clear evidence for the presence of temples at Dura during the Hellenistic period. One must also note the apparent absence of a theater, one of the essential components of a Greek city,[17] though one could have been placed on the hill facing the citadel (fig. 8) or that below the Temple of Zeus Megistos (fig. 9). There are traces of walls on both, but no clear pattern emerges from the remains. On the other hand, there is also no evidence of a gymnasium. This contrasts strikingly with the Greek colony of Ai Khanoum in Afghanis-

16 F. E. Brown, *Dura report* 6, 409-11; Downey, *Religious architecture* 78.
17 The absence of a theater has often been noted: see, e.g., Perkins, *Art* 15-16, and C. B. Welles, "The chronology of Dura-Europos," *Eos* 48.3 (1956) 467-68.

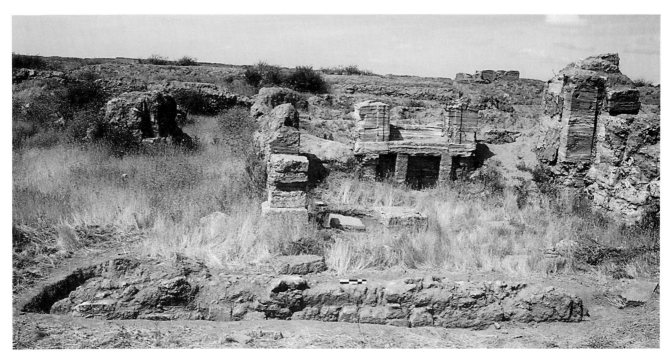

Fig. 7. Dura-Europos, early wall in precinct of Artemis, view toward west (author).

Fig. 8. Dura-Europos, hill opposite citadel to west (author).

tan, which has a large theater and gymnasium.[18] There is also a Greek theater at Babylon with portico behind, and epigraphical evidence there shows that a gymnasium continued to

18 Downey, *Religious architecture* 65. For Ai Khanoum, see P. Bernard, "Problèmes d'histoire coloniale grecque à travers l'urbanisme d'une cité hellénistique d'Asie centrale," in *150 Jahre Deutsches Archaeologisches Institut* (Mainz 1981) 108-20. For the theater, see Bernard, *CRAI* 1976, 314-22, figs. 19-21; ibid. 1978, 429-41, figs. 5-10. The gymnasium is discussed by S. Veuve and J.-Cl. Liger, "Le gymnase," *Bulletin de l'Ecole francaise d'Extrême-Orient* 68 (1980) 5-6.

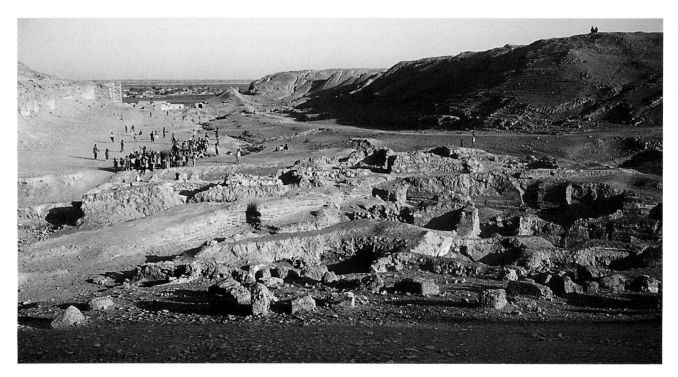

Fig. 9. Dura-Europos, hills below palace of Strategos and Temple of Zeus Megistos to southwest (author).

function into the Parthian period.[19] Welles also notes the lack of evidence at Dura for a *boule* or an *ekklesia*.[20] The paucity of epigraphical remains from the Hellenistic period urges caution here. In any case, there is no structure of any period that can be identified with certainty as a *bouleuterion*, although a small odeon built in the Roman period in an enlarged courtyard of the Temple of Artemis bears graffiti naming a man who served as *bouleutes*.[21]

Thus, in some respects Dura was not a 'typical' Greek city at the time of the Parthian conquest. As Leriche has pointed out, the chronological data provided by the Mission franco-syrienne de Doura-Europos suggest that the "Hippodamian" grid established toward the end of Seleucid rule was filled in under Parthian rule.[22]

2. Roman work in the city

It is generally agreed that the Roman presence at Dura can be divided into three stages: 1) Trajan's Parthian war, A.D. 115; 2) the conquest of Marcus Aurelius and Lucius Verus; and 3) a greatly-strengthened Roman garrison *c.*210.[23] The only apparent physical trace of Trajan's passage is a triumphal arch erected, apparently in 116, *c.*2 km to the north of the city.[24] There

19 Downey, *Religious architecture* 14; A. Mallwitz in F. Wetzel, E. Schmidt and A. Mallwitz, *Das Babylon der Spätzeit* (62. *WVDOG*, Berlin 1957) 16-17, 21: G. E. Kirk, "Gymnasium or Khan? A Hellenistic building at Babylon," *Iraq* 2 (1935) 223-31.

20 Welles (supra n.17) 467-68.

21 Perkins, *Art* 29; Downey, *Religious architecture* 90. The Temple of Artemis had long been a major civic shrine, so the inscriptions, as well as the dedication of a nearby chapel by a number of *bouleutai*, may simply reflect this fact.

22 Leriche, "*Chreophylakeion*" 166.

23 See, for example, Perkins, *Art* 5-7. The most detailed discussion of the effect of the Roman presence is Welles, "Population"; Rostovtzeff (supra n.1) 22-27, is somewhat less clear.

24 S. Gould, *Dura report* 4, 56-68; R. O. Fink, *Dura report* 6, 480-82; F. Millar, *The Roman Near East, 31 BC-AD 337* (Cambridge, MA 1993) 101-2, and the works cited in n.23. Welles, "Population" 253 and n.11 suggests that the people of Dura quickly destroyed the arch. He also speaks of "ruthless pillaging" at the time of Trajan's attack, but the evidence for this is one inscription dated to 116/17 stating that one Alexander renovated a shrine built by his father and made for it new doors to replace the ones taken

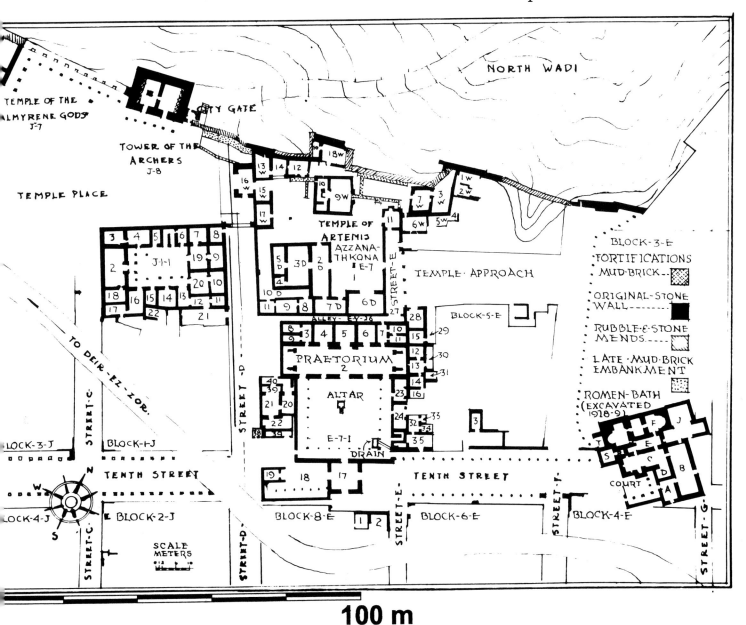

100 m

Fig. 10. Dura-Europos, plan of the Temple of Azzanathkona and surrounding area (courtesy Yale University Art Gallery, Dura-Europos Collection).

is little evidence of building connected with the increased size of the garrison after the conquest of Lucius Verus. One deity was introduced to Dura at this time. Members of the XX Palmyrene cohort built a Mithraeum near the city wall in the northern part of the city. The two cult reliefs, placed one above the other, were dedicated in 168 and 171.[25] The Mithraeum was presumably the result of private initiative, not an official structure connected with the position of the dedicants as members of the XX Palmyrene cohort. Nonetheless, the Mithraeum provides an early example of the introduction by soldiers of deities popular in the Roman empire but new

 away by the Romans (C. B. Welles, *Dura report* 7/8, 128-34, no. 868). This inscription and the original dedication of Epinicus were found in and near the Mithraeum, thus the shrine probably stood near the W wall of the city.

25 For the Mithraeum, see *Dura report* 7/8, 62-128 (various authors). For the reliefs and a discussion of the form of Mithraism at Dura, see S. B. Downey, *Stone and plaster sculpture: Excavations at Dura-Europos* (Monumenta Archaeologica 5, Los Angeles 1977) 23-29, nos. 7-8; 217-25, with references to earlier literature.

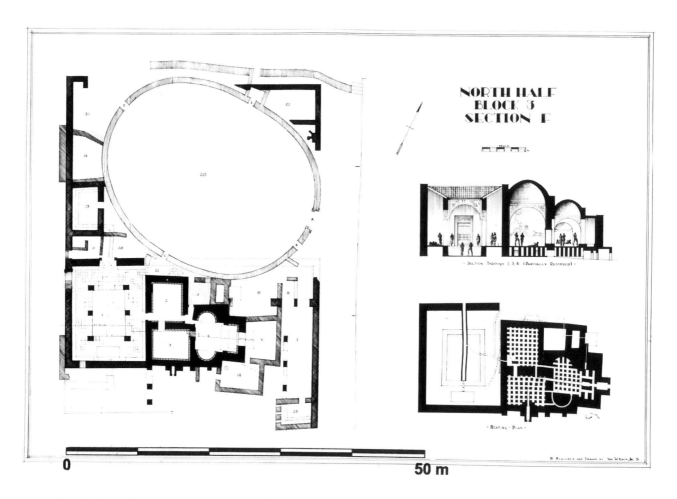

Fig. 11. Dura-Europos, bath and amphitheater in Block F 3, plan (courtesy Yale University Art Gallery, Dura-Europos Collection).

to Dura. Since Mithraism is so far unattested at Palmyra, it is probable that the dedicators learned of the religion during their military service.[26]

The great strengthening of the garrison in *c.*210 brought fundamental change to the architecture and life of the city. As Welles says, the whole city was to some extent turned into a fortress; the army was everywhere. The changes are most visible architecturally in the northern quarter of the city, which became army headquarters (fig. 10). Welles and others assume that this entailed the eviction of the original inhabitants, and that the military area was separated from the rest of the city by a mudbrick wall that could be followed for some 4 m east of Tower 21 on the West wall.[27] This area is generally called a camp, but it is unlikely to have been fully separated from the rest of the city, given the fact that many soldiers were billeted in houses outside the quarter.[28] It is, however, not clear whether civilians could enter the military area, to worship in the Temple of Bel, for example. The architectural conversion of the quarter into a Roman camp was only partial, since it lacks a number of the buildings that were normally present in camps built from scratch, notably barracks constructed on a standard

26 Welles, "Population" 254; Downey ibid. 217.
27 Welles, "Population" 258; Perkins, *Art* 25-28.
28 Pollard, "Roman army" 212-13. Pollard analyzes in detail the evidence or lack thereof for interaction between the army and the civilian population, a matter that will be discussed below.

plan, stables, and buildings for storing armaments (*armamentaria*).[29] It also includes some structures that normally were located outside the camp proper, such as baths and an amphitheater[30] (fig. 11). A further difference from the norm is the presence of temples within the military area. One of the two temples in the quarter that pre-dated the Roman take-over, that of Azzanathkona, presumably was no longer used for worship,[31] but it is not clear whether or not this is also true of the Temple of Bel (see below).[32] A temple to Jupiter Dolichenus and other deities was newly built near the Palace of the Dux Ripae, apparently by and for the use of members of the garrison.[33]

The *principia*,[34] built over the remains of earlier structures in front of the Temple of Azzanathkona, follows a traditional format. A pre-existing E–W street, which was apparently colonnaded to give it the form of a *via principalis*, leads to the *principia*. The *groma* mentioned in a papyrus of *c.*240 as being guarded by soldiers presumably lay within the military area and might be identified with entrance room 17 or with the arch over F Street at its intersection with Street 10[35] (fig. 10). The *principia* consists of: an open court surrounded by porticos on three sides and with an altar on axis; a basilical space behind this, entered through 5 doors, with raised tribunals on the short sides; and a suite of 5 rooms behind the basilica. The central, largest room has holes in the floor, indicating that it served as the shrine for the standards. There are other smaller rooms around this basic unit, and apparently a colonnade on the E side. Although the plan of the building corresponds to a standard Roman type (compare, for example, the *principia* at Lambaesis),[36] the construction materials (rubble, presumably with mudbrick above, and reeds and plaster in the ceilings) are typical for pre-Roman Dura.[37]

The Temple of Azzanathkona, slightly remodelled, served as the headquarters and record-office for the XX Palmyrene cohort. A house to the west of the Temple is generally identified as the residence of the commander on the basis of its location and the fact that it, alone of all the houses at Dura, has a full peristyle and thus represents a foreign intrusion[38] (fig. 10). A block (E 8) to the south of the *principia* was apparently remodelled into barracks,[39] and the same may be true of Block E 4. Apparently after 251, additional barracks of irregular plan were

29 C. Hopkins and H. T. Rowell, *Dura report* 5, 210-11, identify some rooms to the east of the entrance court of the *principia* as *armamentaria*, but not only are they small for that purpose but no projectile balls or weapons of any kind were found there. In contrast, more than 200 spear-points, arrow-heads, and other remnants of bronze weapons were found on a late floor of the newly-excavated sanctuary on Main Street near the Palmyrene Gate, as were several hundred stone projectile balls (Leriche and Mahmoud [supra n.2] 416-17). The apparent transformation of this sanctuary/house into an arsenal illustrates once again the pervasive militarization of the city in its final years.

30 The bath in Block E 3 can be seen in the lower right-hand corner of fig. 10. The bath (and later amphitheater) in Block F 3 straddle the projected line of the wall stretching eastward from Tower 21.

31 Welles, "Population" 258.

32 The Temple of Bel is located in the NW corner of the city beside Tower 1 (fig. 1). A small portion of it is shown in the upper left corner of fig. 10, labelled "Temple of the Palmyrene Gods".

33 Downey, *Religious architecture* 122-24; Pollard, "Roman army" 222. For the original publication of the building and the inscriptions, see A. Perkins and J. F. Gilliam, *Dura report* 9.3, 97-134.

34 The excavators called this building a *praetorium* (C. Hopkins and H. T. Rowell, *Dura report* 5, 201-18), but it should properly be called the *principia*: R. O. Fink in C. B. Welles, R. O. Fink and J. F. Gilliam, *The Excavations at Dura-Europos, Final report* 5.1: *The parchments and papyri* (New Haven 1959) 15, n.11.

35 Fink ibid. 377-82, no. 107; the identification of the *groma* is discussed on 378; Pollard, "Roman army" 214-15.

36 F. Rakob and S. Storz, "Die Principia des römischen Legionslagers in Lambaesis. Vorbericht über Bauaufnahme und Grabungen," *RömMitt* 81 (1974) 268, 275-76, fig. 7, pl. 147.1, 2; 148.1, 2.

37 C. Hopkins and H. T. Rowell, *Dura report* 5, 208, 214.

38 Ibid. 235-37; Welles, "Population" 258.

39 The Yale archives contain only one plan of this block with no accompanying notes, so it is impossible to chart the process of this transformation.

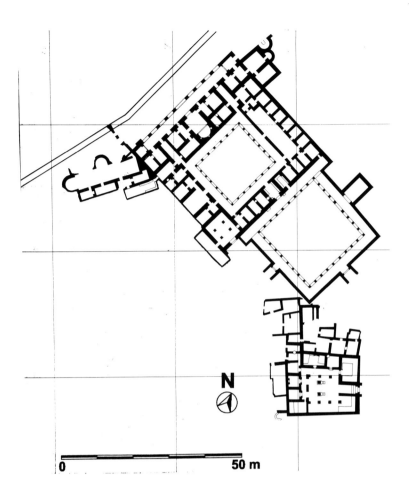

Fig. 12. Dura-Europos, Palace of the Dux Ripae, plan (courtesy Yale University Art Gallery, Dura-Europos Collection).

constructed around the *Dolicheneum*, even taking in what had been a sacristy in the temple.[40] Block F 3, to the south of E 4, lies partly within and partly outside the limit demarcated by the mudbrick wall mentioned above. This block contains a bath, which Brown dated with some reservations to the Parthian period (see below); it was destroyed by fire not long after its construction, and in 216 an amphitheater was built into the remains by members of the garrison[41] (fig. 11). These structures fit within the Hippodamian grid of the city plan and their rectilinear layout is also characteristic of Roman camps. Two structures built in this period within this northern sector deviate from the basic grid: the bath in E 3, and the Palace of the Dux Ripae, located on the eastern edge of the plateau.

With the exception of the *Dolicheneum*, which roughly follows the type of plan characteristic of the temples built at Dura during the Parthian period,[42] the structures built within the 'military quarter' during the 3rd c. show strong signs of Roman influence. The *principia* have already been discussed. That the Palace of the Dux Ripae combines a peristyle intended for military use with a residential section based on Roman villa types has been recognized since Rostovtzeff's publication in *Dura Report* 9 (fig. 12). The use of the Roman foot as a unit of measurement and the presence of ceilings consisting of false vaults in some important rooms also

40 A. Perkins, *Dura report* 9.1, 99, 103.
41 F. E. Brown, *Dura report* 6, 49-77.
42 A. Perkins, *Dura report* 9.1, 105-6; Downey, *Religious architecture* 122-24; Pollard, "Roman army" 222.

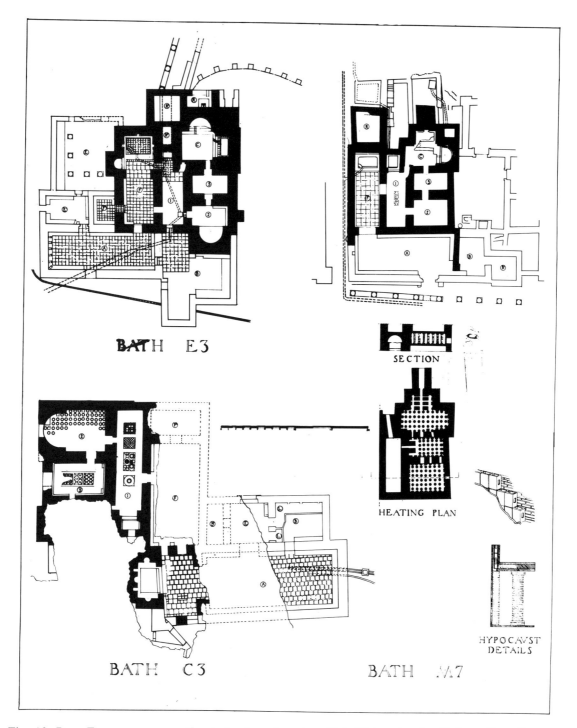

Fig. 13. Dura-Europos, comparative bath plans (courtesy Yale University Art Gallery, Dura-Europos Collection).

suggests an attempt to imitate Roman architecture, though the construction in rubble with mudbrick above conforms to local traditions.[43] The baths within the camp area, like those near the Palmyrene Gate and at the foot of the Redoubt which were also built in the Roman period,

43 M. I. Rostovtzeff, *Dura report* 9.1, 69-96. My excavations in the palace have shown that the reconstruction of the river wing of the palace published in *Dura report* 9.1 cannot be correct, but this does not change the fundamental interpretation of the building as based on Roman military and villa architecture: S. B. Downey, "The Palace of the Dux Ripae at Dura-Europos and 'palatial' architecture of late antiquity," in R. T. Scott and A. R. Scott (edd.), *Eius virtutis studiosi: Classical and postclassical studies*

Fig. 14. Dura-Europos, bath in Block E 3, heated room (author).

Fig. 15. Dura-Europos, House of Lysias, collapsed vault with unbaked bricks (author)

in memory of Frank Edward Brown (Studies in the History of Art 43, Washington 1993) 183-98. For the use of the Roman foot and the false vaults, see A. H. Detweiler, *Dura report* 9.1, 2-6.

Fig. 16. Dura-Europos, bath beside Palace of Dux Ripae, view toward river (author).

not only represent a new building type (fig. 13) but also use construction techniques, such as hypocausts and baked brick, that are unknown in pre-Roman Dura[44] (fig. 14). The bricks differ not merely in technique (baked as opposed to unbaked) but also in shape and dimensions from the bricks normally used at Dura (fig. 15). The new type of brick was apparently reserved for baths, since they do not appear in either the *principia* or the Palace of the Dux, but are used in a small bath next to the palace (fig. 16). The appearance of hypocausts and baked bricks in the bath in F 3 raises doubts about F. E. Brown's suggested dating to the Parthian period, a date that is based primarily on the fact that it was partially destroyed by fire and an amphitheater was built into its remains in A.D. 216 by troops of the IV Scythian and III Cyrenaican legions[45] (fig. 17). Perhaps the bath was burned shortly after being built. The best parallels to the plans of the Roman baths can be found among the smaller baths of N Africa.[46]

The baths in M 7 and C 3 may have been built primarily for the use of members of the garrison. Inscriptions and graffiti provide ample evidence for the presence of soldiers in and around the Palmyrene Gate, which they were charged with guarding, and soldiers were billeted in this area as well.[47] There are, however, no graffiti in the baths to provide evidence for the clientèle. The army also spilled down into the area just to the west of the citadel, as is attested by an inscribed altar in a temple dedicated by an officer of the IV Scythian legion on the occasion of the extension of the *campus* (*campo adampliato*), probably toward the end of the reign

44 For the baths, see F. E. Brown, *Dura report* 6, 49-105, pls. 3-4. The bricks are typically *c.*0.37-0.39 m square and *c.*0.045-0.05 m high (ibid. 52-53), in contrast to the mudbricks of normal Durene construction, which are typically *c.*0.12 m high and vary in length from 0.20 to 0.36 m. The mudbricks used in the Palace of the Dux were 0.0296 m long and 0.10 m high, according to A. H. Detweiler (*Dura report* 9.1, 4-5).

45 F. E. Brown, *Dura report* 6, 49-79. Perkins, *Art* 25 and n.1, places the bath late in the 2nd c., suggesting that it was built for the use of the garrison. N. Pollard informs me that Brown's notes in the Dura archives show that he had considerable doubts about the date of this bath.

46 F. Yegül, *Baths and bathing in classical antiquity* (Cambridge, MA 1992) 222-49. I owe this suggestion to J. DeLaine.

47 Welles, "Population" 259, with references; Pollard, "Roman army" 214-15.

Fig. 17. Dura-Europos, amphitheater as partially excavated, view to south west (author).

of Septimius Severus.[48] A small bath, only partially excavated but apparently of Roman date, built in Block A 5, perhaps fell within the limits of an expanded military area.[49]

The presence of baths and the billeting of soldiers outside the northern part of the city raise two difficult issues: that of the influence of Roman architectural forms in the city in general, and the question of contacts, or lack thereof, between the army and the civilian population. Little evidence for the use of Roman architectural forms remains outside of the buildings already mentioned. There was no attempt, for example, to turn Dura into a city with colonnaded streets like those of other cities of Roman Syria and Jordan, such as Apamea, Palmyra and Gerasa.[50] Late in the life of the city, however, some colonnades were erected in the area of the old agora, which had long been filled with shops and houses. For example, colonnades were erected around parts of the shops and houses in Block G 2, probably on the initiative of the owners. Block G 6 was made into a colonnaded market square (fig. 3). Brown argues that the intrusion of such a foreign type could only be due to outside influence, presumably Roman, an idea supported by the use of a Roman foot in the layout.[51] Additionally, an arch was placed across Main Street just before the drop from the plateau into the wadi (fig. 18). If a fragmentary inscription found nearby is correctly associated with the arch, it was dedicated in approximately 231 or 245 by one Antigonos son of Marion, a high priest (*archiereus*).[52]

Perhaps the most difficult issue is the question of relations between the army and the civilian population. That they inhabited the same parts of the city is beyond question, since soldiers

48 C. Hopkins, *Dura report* 2, 57-58, 83-86, pl. 8; Welles, "Population" 258.

49 C. Hopkins, *Dura report* 5, 289; F. E. Brown, *Dura report* 6, 84, n.1; 104, n.27.

50 These colonnaded streets have often been discussed and illustrated. For a general discussion of colonnaded streets in Roman architecture, including the cities of Syria and Jordan, see W. MacDonald, *The architecture of the Roman Empire* 2: An *urban appraisal* (New Haven 1986) 32-35.

51 F. E. Brown, *Dura report* 9.1, 60-64.

52 F. E. Brown, *Dura report* 9.1, 61. For the inscription, see A. McN. G. Little and H. T. Rowell, ibid. 72-74, no. 169. Welles, "Population" 259-60 suggests that the dedicant was a high priest in the imperial cult.

Fig. 18. Dura-Europos, arch over main street, view to east (author).

were billeted in houses owned by civilians, but the extent to which they interacted is the subject of some controversy. It would seem logical that the soldiers of the garrison would purchase goods and services from local merchants, especially since the evidence indicates that the languages most commonly spoken, Greek and various forms of Aramaic, were similar in the two populations.[53] N. Pollard's very judicious summary concludes, however, that there is little direct evidence for interaction.[54] Welles concludes, on the basis of prosopography, that the dominance of the Greco-Macedonian population ended after the Severan re-organization of the city. The most extreme view, that of Dabrowa, that the wealthier inhabitants, especially the Greco-Macedonian population, probably emigrated after the arrival of the increased garrison, is difficult to support.[55]

I wish here to address only the issue of access to the Temple of Bel. There is clear evidence for worship by both the civilian and the military population, though, as Pollard points out, not necessarily at the same time.[56] The most significant evidence for military worship is provided by the so-called "tribune fresco", showing members of the XX Palmyrene cohort, led by the tribune Julius Terentius; a priest in the painting is identified as Themes, the son of Mokimos. The painting can probably be dated to just before 239, the likely date of the tribune's death.[57] If, as Pekary argues, the deities to whom sacrifice is being offered are Roman emperors instead of, as is generally assumed, Palmyrene deities, then the sacrifice would be an official

53 This is assumed by Welles, "Population" 260.
54 Pollard, "Roman army" 211-27.
55 Welles, "Population" 260-74. E. Dabrowa pushes Welles' casual comment (273) that "[i]t would be interesting to know whether some of its members fled to cities still under Parthian protection" to extremes ["La garnison romaine à Doura-Europos. Influence du camp sur la ville et ses conséquences," *Zessyty Naukowe Universytetu Jagiellonskiego* 613, *Prace Historyczne* 270 [1981] = *Mélanges J. Wolski*, 61-74) (unfortunately, I did not have access to this article in preparing this paper so rely here on notes).
56 For a summary of the evidence from the Temple of Bel, see Downey, *Religious architecture* 105-10; Pollard, "Roman army" 213, 221.
57 F. Cumont, *Fouilles de Doura-Europos* (Paris 1926) 89-114, tableau VI; 363-64, inscriptions nos. 8a and b; Downey, *Religious architecture* 109. A tombstone found in the house presumably occupied by Julius Terentius and his wife does not carry a date, but other evidence points to A.D. 239: C. B. Welles, *Dura report* 9.1, 177-85, no. 939, pl. 21.

act, a representation of homage to the imperial cult in a temple.[58] But does this mean that only soldiers could now worship in the temple? The idea that by the time of this painting only members of the garrison could worship in the temple depends essentially on the chronology of the other paintings in the temple, which is by no means fixed. The dates of the Conon paintings in the *naos* have been established on the assumption that the family represented is the same as one known from other documents of *c*.A.D. 50, and the painting in a chapel showing Otes sacrificing to Palmyrene gods has been dated by its stylistic similarity to the fragmentary paintings in the Temple of Adonis, which F. E. Brown on circumstantial evidence dated to *c*.150-160.[59] Perkins, however, puts the Otes painting in the 3rd c. on the basis of the epithet *bouleutes* used to characterize one of the participants.[60] Even if Pekary's identification of the gods in the tribune fresco as emperors is accepted, as it probably should be, that does not seem to prove that the temple was reserved exclusively for the military after *c*.211. An apparent dedication to two unknown emperors was found in a subsidiary chapel in the Temple of Zeus Megistos, and there is no evidence to suggest that the general population no longer used the temple for worship.[61]

The continued existence of the Temple of Bel within the military area of Dura, even if it was only used by members of the garrison, brings me to my final point: the contrast between the camp area at Dura and the camp built by Diocletian at Palmyra. Both were constructed in an area previously occupied by other buildings, yet the camp of Diocletian is not only fully axial and symmetrical, but it also includes barracks laid in the fashion normal in Roman camps, and it has two wide streets that meet at right-angles, a junction marked by a *groma*. Furthermore, a venerable temple to an important Palmyrene goddess, Allat, was levelled to make way for the camp, while the Temple of Azzanathkona at Dura was merely remodelled for army use.[62] What explains this difference? The irregular and in some cases rather slipshod construction, particularly of the barracks, at Dura suggests a hasty response to an emergency. Economic factors may also make a difference; Diocletian apparently wanted to make a show. But the difference serves to reinforce my point that there does not seem to have been a deliberate attempt to romanize Dura, but only to build some buildings that were judged essential for the functioning of the military, including recreational facilities.

University of California, Los Angeles

58 T. Pekary, "Das Opfer vor dem Kaiserbild," *BJb* 186 (1986) 91-103. Pekary's identification seems generally convincing, though to my mind the small round shield held by the right hand 'statue' is an obstacle. This shield belongs to the type held by the gods of the desert in the art of Dura, Palmyra, and the surrounding region (see Downey [supra n.25] 195-207, with references). Surely an artist painting at Dura in the 3rd c. A.D. would have known what a Roman shield looked like.

59 F. E. Brown, *Dura report 7/8*, 158-63.

60 For the suggested dates of the various paintings in the Temple of Bel, see Downey, *Religious architecture* 107-8, with references. Perkins, *Art* 40-42 suggests a relatively late dating of the paintings.

61 For the inscription, see C. B. Welles, "Inscriptions from Dura-Europos," *YCS* 14 (1955) 142-43; the late phases of the temple are discussed in Downey, *Religious architecture* 92-96. Dabrowa relies to a great extent on an *argumentum ex silentio*, namely the absence in many temples of inscriptions dated to the 3rd c. He assumes, for example, that the end-date of inscribed seats in the small theaters in the temples of Artemis, Atargatis, and Azzanathkona marks the end of worship in these rooms, rather than, for example, a change in rites (on this subject see P. Arnaud, "Les salles W9 et W10 du temple d'Azzanathkona à Doura-Europos: développement historique et topographie familiale d'une 'salle aux gradins'," *Doura-Europos Etudes* 4 [Beirut 1997] 117-43, esp. 140). The relative paucity of dated inscriptions in a number of Dura temples would seem to caution against using inscriptions alone as an indication of dates of worship. The inscriptions of the Dura temples are summarized in Downey, *Religious architecture* 89-124.

62 M. Gawlikowski, "Tempel, Gräber, und Kasernen. Die polnischen Ausgrabungen im Diokletianslager," in A. Schmidt-Colinet (ed.), *Palmyra: Kulturbegegnung im Grenzbereich* (AntW 26, Sondernummer 1995) 21-27; M. Gawlikowski, "Le camp de Dioclétien: bilan préliminaire," in *Palmyre. Bilan et perspectives* (Strasbourg 1976) 153-63.

Urbanization in Roman Egypt

Alan K. Bowman

Introduction

The land of Egypt which Octavian constituted as a province of the Roman empire in 30 B.C. had been ruled for three centuries by the descendants of Alexander's Macedonian general Ptolemy and had been the longest surviving of the major Hellenistic kingdoms.[1] For most periods of its long history prior to the arrival of Alexander the Great it could hardly be described as a rural backwater. Yet until relatively recently most scholars would not have argued with the propositions that (1) Roman Egypt was neither heavily urbanized nor romanised (whatever those terms mean), and (2) the Roman administration was content to adopt a *laisser-faire* attitude and to leave most of the governmental institutions of Ptolemaic Egypt in operation. The first of those propositions owes a good deal to the summary judgement of Tacitus, who described Egypt in a famous passage (*Hist.* 1.11) as *annonae fecundam, superstitione ac lascivia discordem et mobilem, insciam legum, ignaram magistratuum* ("a fertile producer of food, divided and unstable because of superstitious cults and undisciplined behaviour, a stranger to the rule of law and unacquainted with government by civil magistrates").[2] The second proposition has been part of a wider currency concerning the nature of Roman provincial administration and the supposed tendency to avoid change in provinces where the pre-existing institutions worked well. It has become evident in recent years that these propositions will not stand up to close scrutiny, and more nuanced views have become fashionable. On the issue of continuity, a notable landmark came in 1970 with N. Lewis's analysis of the changes made by the Romans in the province of Egypt, challenging the appropriateness of the commonly used term 'Graeco-Roman Egypt'.[3] Like historians in other fields, historians of the ancient Mediterranean are now particularly sensitive to the balance of continuity and change and, in the case of Egypt, on the lookout for significant differences between Ptolemaic and Roman Egypt. As far as urbanization is concerned, it is now possible, despite Tacitus, to find authoritative scholars prepared to describe Roman Egypt as heavily urbanized, if not the most urbanized province of the Roman empire (though sometimes with the *caveat* that the 'cities' of Roman Egypt, Alexandria excepted, were really only 'country towns' by modern standards).[4]

1 References to publications of papyri follow the conventions to be found in J. F. Oates, W. H. Willis, R. S. Bagnall, K. A. Worp, *Checklist of editions of Greek papyri and ostraka* (4th ed., Atlanta 1992) and E. G. Turner, *Greek papyri, an introduction* (2nd ed., Oxford 1980). I am grateful to J. McKenzie for comment and discussion of the issues involved, and for allowing me to read and cite her forthcoming book on the architecture of Alexandria and Egypt. I am also grateful to P. Van Minnen for permission to cite his 1997 doctoral thesis, as two separate forthcoming monographs (*The economy of Roman Egypt* and *Roman Hermopolis. The society, economy and administration of an Egyptian town in the first four centuries AD*); and to D. Rathbone for his comments on an earlier draft of this paper. The once-fashionable notion that Egypt was not a regular province but some sort of private possession of the Roman emperor is to be firmly rejected: see A. K. Bowman and D. W. Rathbone, "Cities and administration in Roman Egypt," *JRS* 82 (1992) 107-27; A. K. Bowman, *Cambridge Ancient History* X (new edn., 1994) 679-81.

2 The phrases are used by N. Lewis, *Life in Egypt under Roman rule* (Oxford 1983) in the titles of his chapts. 5, 6, 9 and 10.

3 N. Lewis, "Graeco-Roman Egypt: fact or fiction?" *Proceedings of the Twelfth International Congress of Papyrology 1968* (American Studies in Papyrology 7, 1970) 3-14; cf. J. F. Gilliam, "Some Roman elements in Roman Egypt," *BICS* 3 (1978) 115-31; N. Lewis, "The Romanity of Roman Egypt: a growing consensus," *Atti del XVII Congresso Int. di Papirologia* (Naples 1984) 1077-84; Bowman and Rathbone (supra n.1).

4 R. S. Bagnall and B. W. Frier, *The demography of Roman Egypt* (Cambridge 1994) 54-56; D. W. Rathbone, "Villages, land and population in Graeco-Roman Egypt," *ProcCambPhilSoc* 36 (1990) 103-42; Lewis (supra n.2) chapt. 3.

It follows, if such views are leading us in the right direction, that what we should be considering in the case of Roman Egypt is the issue of transformation and the changing character and rôle of the cities or towns. The extent to which such transformations as occurred can be characterised as 'urbanism' or 'urbanization' naturally depends on what we mean when we use those terms. Complex matters of definition are involved, bearing on the nature of urbanism in antiquity (classical and near eastern) as a whole. Clearly there is no single set of criteria which offers a sufficient definition of the city or urbanization. Broadly speaking, the criteria for what constitutes a city are either symbolic or functional (or a combination of the two).[5] Symbolic features tend to be identified in physical, political and religious structures (e.g., walls, acropolis, palace, temple), functional ones in administrative, economic and social or socio-religious terms, although of course also physically located (governmental institutions, market-places, complex populations, and so on). In fact, there are those who are sceptical of both the usefulness of any attempt to define urbanism in complex terms (that is, beyond the simple question of size) and of theories about the ancient city.[6] Then there are always hierarchies of settlement that invite us to decide where to draw the line between urban and non-urban. A striking illustration from Egypt can be found in the Fayum of the Ptolemaic and Roman periods, where the larger villages are often described by modern scholars as more like small towns, relatively highly 'urbanized' under the influence of Greek immigration.[7] This ambiguity is also reflected in ancient documents: Philadelphia, for example, is sometimes described in Ptolemaic papyri as a 'polis'.[8] As regards the broader question of the balance of urban and rural population, there is no clear consensus as to what constitutes a high level of urbanization, in percentage terms, for the classical mediterranean world, and the variations, for example, from one Roman province to another will have been enormous. Perhaps there can be no consensus, given that (a) we have so few reliable population statistics and (b) there can be no clear and agreed definition of an 'urban community'. Recent calculations for Roman Egypt, where the dearth of statistics is a little less severe than elsewhere in the ancient world, are based on estimates of the population of Alexandria and the district capitals (metropoleis of the nomes), and include figures of 37% and 20% for the urban population, of which even the lesser seems relatively high.[9]

Egypt is of interest from the point of view of urbanization and not only because it offers better statistics than other areas of the ancient world, as recent work on its demography has emphatically demonstrated.[10] It is also of particular historiographical interest, because it throws into high relief the actual interaction between so-called 'classical' and 'oriental' civilisation in the ancient mediterranean world and the differences of approach to the subject

5 Cf., e.g., K. Lomas, "The idea of a city: élite ideology and the evolution of urban forms in Italy, 200 BC - AD 100," in H. M. Parkins (ed.), *Roman urbanism. Beyond the consumer city* (London 1997) 22-23.

6 P. Wheatley, " The concept of urbanism," in P. J. Ucko, R. Tringham and G. W. Dimbleby, *Man, settlement and urbanism* (London 1971) 601-37; C. R. Whittaker, "Do theories of the ancient city matter?' in T. J. Cornell and K. Lomas (edd.), *Urban society in Roman Italy* (London 1995) 9-26, whose approach is primarily economic; R. Laurence, "Writing the Roman metropolis," in Parkins (supra n.5) 1-20; Lomas (ibid.).

7 Note in particular P. Davoli, "Ricerche sull' archaeologia urbana nel Fayyum di epoca greco-romana," in *Atti del II Convegno Naz. di Egittologia e Papirologia* (Quaderni del Istituto Internazionale di Papirologia 1996) 35-58; id., *L'archeologia urbana nel Fayyum di età ellenistica e romana* (Naples 1998); cf. C. Anti, "Un esempio di sistemazione urbanistica nel III secolo av. Cr.," *Architettura e arte decorativa* 10 (1930-31) 97-107, writing of town planning ("sistemazione urbanistica") of Tebtunis, one of the larger Fayum villages, in the 3rd c. B.C.

8 E.g., *P.Lond*. VII 1954.6, *PSI* IV 341.3, 402.4-5 and cf. below p. 185. The foundation described in the Ptolemaic text published and analysed by B. Kramer, "Der κτιστής Boethos und die Einrichtung einer neuen Stadt. Teil I," *APF* 43 (1997) 315-39 and H. Heinen, "Der κτιστής Boethos und die Einrichtung einer neuen Stadt. Teil II," *APF* 43 (1997) 340-63, is also called a 'polis'; cf. p. 185 below.

9 Rathbone (supra n.4); Bagnall and Frier (supra n.4) 56, Van Minnen, *Economy* (supra n.1).

10 Principally Bagnall and Frier (supra n.4).

employed by modern classical historians and oriental specialists. This is no doubt a major reason for its high profile in recent influential works which address, *inter alia*, the issues of cultural relativism.[11] Much modern writing on ancient urbanization shows that classicists and historians of the ancient near east have treated the subject very differently. Historians of Pharaonic Egypt are certainly accustomed to describing Egypt as urbanized, but in so doing they often lay heavy emphasis on the symbolic features of the monumental buildings, the dominance of temple and palace, and the separateness or non-integration of residential areas — the disjunction of the sacred and the secular.[12] This is characteristic, for example, of descriptions of Amarna in the New Kingdom, which contained considerable suburban areas.[13] "Each Egyptian royal city — not just its temples and palaces, but the city as a whole — may reasonably be interpreted as an *axis mundi*, upon which divinely created power was focused, and from which that power was imagined to disseminate out into the worlds of men and nature."[14] This characterisation of the city is not one which would come easily from the pen of a classical historian, but it is striking that it does find echoes in the works of those who deal with Egyptian cities in the Ptolemaic and Roman periods. D. Thompson, for example, in her masterly work on Ptolemaic Memphis, rightly describes it as a "military, administrative, sacral and economic centre to the country" and adds that it is *above all* (my italics) a sacred city.[15] The symbolic significance of the religious character of Egyptian Memphis is not, of course, a modern invention: prophetic texts of a 'nationalist' or 'pro-Egyptian' tone, which were still in circulation in the Roman period and may reflect 'native' resistance to 'Greek' domination, contrast Egyptian Memphis and its gods with Alexandria, the epicentre of Greek culture and civilisation.[16] The crucial question, of course, is whether such different readings of these earlier Egyptian and classical urban communities reflect a historical reality. An illuminating parallel can be found in a recent study of urban communities in ancient Mesopotamia which suggests that this is very much a Eurocentric phenomenon and that they can be described very differently, in terms much less superficially alien than the 'oriental' model.[17]

Such an approach might well persuade historians of Pharaonic and Ptolemaic-Roman Egypt but, until it takes a firm hold, we are fixed in a prevailing fashion in which the contrasts are emphatically marked. With the coming of the Greeks and the establishment of Ptolemaic rule the contrast is heightened by the great new foundation of Alexandria, the Greek city which was always viewed by Greek and Roman eyes as not quite an integrated part of Egypt (thus in Latin, *Alexandria ad Aegyptum*). The extent of hellenization in the towns and villages of the *chora* was clearly uneven — less marked in Upper Egypt and more marked in the Fayum — and

11 E.g., E. Said, *Orientalism* (Harmondsworth 1995); M. Bernal, *Black Athena. The afroasiatic roots of classical civilisation. I* (London 1987).

12 In general see B. Kemp, "Temple and town in ancient Egypt," in P. J. Ucko, R. Tringham and G. W. Dimbleby (edd.), *Man, settlement and urbanism* (London 1971) 671 ff.; id., "The city of el-Amarna as a source for the study of urban society in ancient Egypt," *World Archaeology* 9 (1977-78) 123-37; id., *Ancient Egypt. Anatomy of a civilisation* (London 1989) chapt. 4; M. Bietak, "Urban archaeology and the "town problem' in ancient Egypt," in K. R. Weeks (ed.), *Egyptology and the social sciences. Five studies* (Cairo 1979) 97-144. I do not mean to suggest that there are not important studies of the issue of sacred space and the boundaries between civic and religious territory in Greek cities.

13 See Kemp ibid. (1971) 673-76 (the suburbs of Amarna, typical of urban layout in New Kingdom Egypt); id., ibid. (1977-78) 123-37. The reconstructions of S. Aufrère, J.-Cl. Golvin and J.-Cl. Goyon, *L'Égypte restituée. I. Sites et temples de Haute Égypte; II. Sites et temples des déserts; III. Sites, temples et pyramides de Moyenne et Basse Égypte* (Paris 1991-97) at III, 18-19 and 230-31, give a good idea of what Memphis and Amarna, among others, might have looked like in the Pharaonic period.

14 D. O'Connor, "City and palace in New Kingdom Egypt," *CRIPEL* 11 (1989) 82.

15 D. J. Thompson, *Memphis under the Ptolemies* (Princeton 1988) 3-4.

16 *P.Oxy.* XXII 2332 with L. Koenen, " Egyptian resistance against Greeks and Romans? The case of the Oracle of the Potter and other texts," in *Oxyrhynchus, a city and its texts* (London forthcoming).

17 M. Van de Mieroop, *The ancient Mesopotamian city* (Oxford 1997); cf. R. van der Spek, "The Babylonian city," in A. Kuhrt and S. Sherwin-White (edd.), *Hellenism in the East* (London 1987) 57-59.

the Egyptian traditions undoubtedly survived most conspicuously in Memphis and Thebes. Signs of 'urbanization' have been detected in the Fayum villages, heavily populated by Greeks, some of whom emerge as the prototypes of the 'urban élites'.[18] The streets of the village of Philadelphia were laid out on a characteristically Greek orthogonal plan, and there is evidence that it had a theatre.[19] A foundation with the institutions of a Greek *polis*, Ptolemais, was established in Upper Egypt in the reign of Ptolemy I, no doubt an upcountry counterpart to Alexandria; documentary rather than archaeological evidence shows that it had a theatre, a *boule* (and therefore presumably a *bouleuterion*), a *prytaneion* (magistrates' building), and *dikasteria* (courts).[20]

Unfortunately, we have to be alert to the possible skewing effect of the uneven preservation of evidence in all periods, and the available data for Ptolemaic Egypt will only take us so far. The major gap lies in our almost complete lack of evidence, both archaeological and documentary, for the development of the nome capitals (metropoleis) in the Ptolemaic period, although there are enough scattered references to indicate the spread of public buildings of Greek type.[21] By the Roman period, however, it is possible to see how the metropoleis developed (or continued to develop) as functional urban centres and to draw some contrast with the patterns of rural settlement in the outlying areas of the nomes. It is clear that there is a close connection between the physical and the institutional or governmental development of these 'urban centres'.[22] In the rest of this paper I consider four aspects of the subject: the size and demographic features of the urban communities of the *chora*; the nature of the buildings and the physical transformation of the towns; the connection between the physical features and the government of the communities; and the rôle of the élites in the dynamics of change in the towns of the *chora* and their relationship to Alexandria. This treatment can make no claim to comprehensive coverage of all aspects of urbanization and, in particular, it omits consideration of the important economic functions of the urban centre.[23]

Demography

Issues of population size and demography are surely fundamental, and many have naturally used numbers and occupation density as major criteria in identifying urbanized communities.[24]

18 J. Bingen, "Le milieu urbain dans le *chora* égyptienne à l'époque ptolémaïque," *Proceedings of the XIV International Congress of Papyrologists* (London 1975) 367-73. See further below pp. 185-87.

19 P. Viereck, *Philadelpheia: Die Gründung einer hellenistischen Militärkolonie in Ägypten* (Leipzig 1928); C. Préaux, *Les grecs en Egypte d'après les archives de Zénon* (Brussels 1947) 4-44; Davoli 1998 (supra n.7); J. S. McKenzie, *The architecture of Alexandria and Egypt* (forthcoming). See below n.56.

20 G. Plaumann, *Ptolemais in Oberägypten. Ein Beitrag zur Geschichte des Hellenismus in Ägypten* (Leipzig 1910); A. Calderini, *Dizionario dei nomi geografici e topografici dell'Egitto greco-romano* IV (Milan 1983); A. K. Bowman, "Public buildings in Roman Egypt," *JRA* 5 (1992) 495-503; McKenzie ibid. chapt. 6A.

21 There is virtually no archaeological evidence except for the temple at Hermopolis, but there are now unpublished remains of a theatre of the Ptolemaic period at Arsinoe (D. W. Rathbone, pers. comm.). In general see Davoli 1998 (supra n.7) and McKenzie ibid. chapt. 6, citing the hippodrome at Memphis (Thompson [supra n.15] 19), public baths at Arsinoe (*PSI* VI 584), and the hippodrome and agora at Herakleopolis Magna (*BGU* VIII 1854, XIV 2376).

22 Cf. J. Baines, "Temples as symbols, guarantors and participants in Egyptian civilisation," in S. Quirke (ed.), *The temple in ancient Egypt. New discoveries and recent research* (London 1997) 216-41.

23 Some aspects of this rôle are discussed by R. Alston, "Trade and the city in Roman Egypt," in H. Parkins and C. Smith (edd.), *Trade, traders and the ancient city* (London 1998) 168-202; R. Alston and R. D. Alston, "Urbanism and the urban community in Roman Egypt," *JEA* 83 (1997) 199-216; P. Van Minnen, "The volume of the Oxyrhynchite textile trade," *MBAH* 5 (1986) 88-95 and id., "Urban craftsmen in Roman Egypt," *MBAH* 6.1 (1987) 31-88. A more comprehensive treatment of one metropolis, Hermopolis, is given by Van Minnen (supra n.1, forthcoming).

24 Alston and Alston ibid. 200; cf. Wheatley (supra n.6).

Unfortunately, certainty is elusive, and for these aspects of Roman Egypt, as for many others, we rely mainly on evidence from a small number of metropoleis and Fayum villages. It is difficult to establish a secure foundation for an estimate of the overall population, since the relevant ancient sources give widely divergent figures: 3 million in the mid-1st c. B.C. (Diodorus Siculus 1.31.6-9) and 7.5 million (excluding Alexandria, variously estimated between 300,000 and 500,000[25]) in c.A.D. 75 (Josephus, *BellJ* 2.385). Modern estimates tend to give either high or low figures, the high at 7.5 to 8 million, the low around 4 or 4-5 million, and the choice is generally based on hypothetical assumptions.[26] What is certain is that there must have been growth between the Late Period (7th-4th c. B.C.), for which an estimate of 3 million might be of the right order of magnitude,[27] and the early Roman period. Key determinants of the rate of growth will have been immigration, particularly in the Ptolemaic period, and the capacity of an increasing agricultural base to feed a growing population with an increasing birthrate, but we cannot make accurate estimates of either. A growth rate of 0.2% *per annum* would produce an increase from 3 million to 7.5 million between the Late Period and the early Roman period; this hypothetical growth-rate lies half-way between two recent estimates,[28] but none of the figures can be rigorously tested. It is, however, worth bearing in mind the comparable increases in population in the 19th c. in the wake of the reforms of Muhammad 'Ali.[29] It is certain that the Antonine plague of the 160s will have effected a serious reduction in Egypt's population but, again, figures are uncertain, as is the rate of recovery.[30] The evidence for tax yields in late antiquity (6th c.) does not suggest an overall decline in agricultural productivity, which may indicate a strong rate of recovery in the longer term.[31] Despite the frustration and uncertainty, few would argue with the proposition that Egypt probably had a larger population than any other province of the Roman empire.

Egypt included a considerable number of large towns or cities. Alexandria, certainly the second largest city of the empire after Rome, was in a league of its own, with a population of perhaps 500,000. In the Roman period there were some 40-50 nome- or district-capitals. Some were evidently large, although there must have been considerable variation in size. Archaeological survey offers a reasonable spread of data for surface areas of metropolis sites scattered over most of the valley area. As can be seen from Table 1, which is entirely derivative, they range from well over 200 ha to about 90 ha (ignoring villages which might form quite large agglomerated communities, at least in the Fayum) and, given the tendency of ancient settlements to be fairly compact for obvious reasons, we might envisage a high density of housing with a good proportion of multi-storey buildings, frequently attested in the papyri.[32]

25 D. Delia, "The population of Roman Alexandria," *TAPA* 118 (1989) 275-92, opting for a high figure in the 500,000 to 600,000 range; cf. Bagnall and Frier (supra n.4) 54.

26 High: Bowman, *Egypt after the Pharaohs* (2nd paperback edn., London 1996) 17, Van Minnen, *Economy* (supra n.1); cf. Bowman and Rogan, *Agriculture in Egypt from Pharaonic to modern times* (London 1998) chapt. 1. Low: Rathbone (supra n.4); Bagnall and Frier (supra n.4) 53-57.

27 B. E. Trigger, B. J. Kemp, D. O'Connor and A. B. Lloyd, *Ancient Egypt, a social history* (Cambridge 1983) 190, giving estimates of 2.9-4.5 million for the New Kingdom; cf. K. W. Butzer, *Early hydraulic civilisation in Egypt* (Chicago 1976); T. Walek-Czernecki, "La population de l'Egypte à l'époque saïte," *Bulletin de l'Institut de l'Egypte* 23 (1941) 37-62.

28 See Bagnall and Frier (supra n.4) 56, n.16.

29 J. McCarthy, "Nineteenth-century Egyptian population," *Middle Eastern Studies* 12.3 (1976) 1-39; D. Panzac, "The population of Egypt in the nineteenth century," *Asian and African Studies* 21 (1987) 11-32. The comparison will be the more illuminating if Panzac is correct in arguing that the pre-Napoleonic figure is a serious underestimate.

30 R. P. Duncan-Jones, "The impact of the Antonine plague," *JRA* 9 (1996) 120-21.

31 D. W. Rathbone, "The ancient economy and Graeco-Roman Egypt," in L. Criscuolo and G. Geraci (edd.), *Egitto e storia dall'ellenismo all'età araba. Bilancio di un confronto, Bologna 1987* (Bologna 1989) 175.

32 Bowman 1996 (supra n.26) 144-50, R. Alston, "Houses and households in Roman Egypt," in A. Wallace-Hadrill and R. Laurence (edd.), *Domestic space in the Roman world* (JRA Suppl. 22, 1997) 28.

TABLE 1. DEMOGRAPHY AND POPULATION

Town	Area (ha)	Houses	Population (est.)
Alexandria	930 (approx.)		500,000
Ptolemais	120+		
Antinoopolis	200 (approx.)		
Herakleopolis	144		
Hermopolis	120 (160)	7000	40/50,000
Oxyrhynchus	100+	6000+	30,000+
Aphroditopolis	150		
Hibis	150		
Thmuis	90		3560
Tanis	177		
Athribis	190		
Arsinoe	236(?)		
Memphis	225(?)		
Syene	150 (Ptolemaic period: 122.5)		
Apollinopolis Heptakomias		1273	10,000

These figures must all be treated with very great caution and scepticism, but they may not be without some value. Those which inspire the most confidence are the surface areas tabulated in the first column, which are mostly derived from archaeological survey.[33] Of the figures for numbers of houses in the second column, only that for Apollinopolis is certain; the figures for Hermopolis, Oxyrhynchus and Thmuis are inferences on the basis of papyrological evidence which supplies numbers of houses in parts or 'quarters' of the towns.[34] The attempts to derive population sizes from these data do not inspire confidence. Population sizes derived from the surface area of the site will obviously depend on some notion of average population density, and there is, again, no consensus. A density of over 650 per ha has been suggested for Alexandria, which seems very high, even compared to the figure of c.540 per ha derived from the estimates in Table 1; another suggestion is an average of 375 per ha for Egypt including Alexandria, and 280 per ha excluding Alexandria; yet another is 200 per ha; figures of 398 per ha for Cairo in 1798 and 300 per ha for 18th-c. Aleppo have been adduced for comparison.[35] All of these might seem to point to something of the order of magnitude of 300 per ha (excluding Alexandria) and, as can be seen from the surface areas listed in column 1, this multiplier would yield figures in the range of 40,000 to 70,000 for many of the sites listed, which would probably seem on the high side to most ancient historians and demographers.[36] The use of houses and households as a basis for calculation, even allowing for the uncertainty of the totals quoted, is just as

33 The source for these is R. S. Bagnall, *Egypt in late antiquity* (Princeton 1993) 52, with the following exceptions: Alexandria, cf. area derived from dimensions given by McKenzie (supra n.20) chapt. 6B; Alexandria, population, Bagnall and Frier (supra n.4) 54; Ptolemais, larger than Hermopolis, see below n.36; Antinoopolis, my rough calculation from the maps of the excavations published in 1984-87 and updated in 1988 by the Istituto Papirologico 'G. Vitelli', Florence; Hermopolis, the larger figure of 160 ha is suggested by Van Minnen (supra n.1, forthcoming); Syene, H. Jaritz, "On three town sites in the Upper Thebaid," *CRIPEL* 8 (1986) 37-42.

34 Apollinopolis: *P.Brem.* 23; Thmuis: Wilcken, *Archiv für Papyrusforschung* 6 (1920) 381; Hermopolis: *SPP* V 101, cf. Van Minnen (supra n.1, forthcoming); Oxyrhynchus, *P.Osl.* III 111 (Van Minnen ibid. considers the figure of 6000 too low). There is necessarily an additional element of uncertainty in that we do not know the proportion of urban space occupied by temples and other public buildings.

35 Bagnall and Frier (supra n.4) 54-55.

36 This does not necessarily invalidate them, however, since the parameters within which most modern scholars work seem very impressionistic. I have not included in the table the following figures calculated by Alston and Alston (supra n.23) 202, which seem to me to be based in some cases on rather insecure evidence or inference: Hermopolis 58,429; Arsinoe 27,071; Thmuis 24,564; Oxyrhynchus 21,000 or 12,087 or 11,901; Apollinopolis Heptakomias 8784. It should be noted that, although we have no figures for Ptolemais in the Thebaid, Strabo (17.1.42), writing under Augustus, states that it is the largest city in the Thebaid (therefore larger than Hermopolis) and not smaller than Memphis.

tenuous, if not more so, since there is no agreement on the average household size that should be used as a multiplier; recent estimates work with multipliers of a minimum average of 5.3, going up to 6.9 and 7.7.[37]

The foregoing is intended to suggest that the appearance of precision should not deceive us into failing to recognise how impressionistic these calculations really are. In fact, we might derive just as much benefit from using figures which are in one sense more reliable *per se* and in another more palpably impressionistic. It has been calculated that the theatre at Oxyrhynchus may have had a capacity of about 12,500, but we cannot know what proportion of the total population it would have accommodated. We do know that 4000 adult males of the élite or relatively privileged classes were eligible for the corn distributions at Oxyrhynchus in the 270s, and that at Arsinoe the males of the élite 'Greek' class were originally known collectively as 'the *katoikoi* from the total of the 6475 Hellenic men in the Arsinoite'.[38] But we would need to know the likely proportion of élite males to ordinary people in order to calculate the total population size with any precision; the figures suggest that totals in excess of 30,000 for Oxyrhynchus and 50,000 for Arsinoe are not impossible.

Buildings

Disappointing though the quantitative evidence is, almost all of the towns in Table 1 were large enough to qualify as 'urban' on any reasonable criterion of size in the ancient world. It is well-known that size is not everything. What did these places look like in the Roman period?

We must beware of assuming that all developed uniformly. Some towns probably retained a strongly traditional Egyptian ambience. A look at Thompson's excellent description of Ptolemaic Memphis, and Vandorpe's of Ptolemaic Thebes, suggests townscapes very different from the metropoleis of the Roman period — still dominated by temple and cult activities; the former may have adapted somewhat in the Roman period (though there is little evidence), the latter seems to have withered (from a bustling temple town to a 'ville-musée'), declining in administrative and social importance as the epicentre of the Thebaid shifted, first to Ptolemais and later to Koptos, Hermopolis, and Antinoopolis.[39]

There were two towns constructed in the Ptolemaic period as Greek *poleis*, and we can gain some idea of what they will have looked like. First and foremost is Alexandria, which cannot be discussed in detail here.[40] Despite the patchiness of the archaeological evidence, there is

37 Bagnall and Frier (supra n.4) 67-69, Alston and Alston ibid. 201.

38 Theatre: capacity originally calculated by F. Petrie, *Tombs of the Courtiers and Oxyrhynkhos* (London 1925) 14-16, recalculated by Bailey forthcoming; perhaps equally telling is his observation that it is the largest known Roman provincial theatre with the exceptions of Ephesus and Miletus. Corn-dole: *P.Oxy.* XL, pp. 2-5. 'The 6475': Bowman and Rathbone (supra n.1) 121; this figure is of limited use since it must include people whose origins or residence lay in the nome outside the metropolis.

39 Thompson (supra n.15) citing the hippodrome at 19; K. Vandorpe, "City of many a gate, harbour for many a rebel," in S. P. Vleeming (ed.), *Hundred-gated Thebes* (Papyrologica Lugduno-Batava 27, 1995) 23-39

40 There is a huge bibliography, from which I have selected P. M. Fraser, *Ptolemaic Alexandria* (Oxford 1972); G. Grimm, "City planning?', in *Alexandria and Alexandrianism. Papers delivered at a symposium organized by the J. Paul Getty Museum ... April 22-25, 1993* (Malibu 1996) 55-74; C. Haas, *Alexandria in late antiquity. Topography and social conflict* (Baltimore 1997); W. Höpfner and E. L. Schwandner, *Haus und Stadt im klassischen Griechenland* (Munich 1994); J. S. McKenzie, "Alexandria and the origins of baroque architecture," in *Alexandria and Alexandrianism* (1996) 109-25; J. S. McKenzie, "The architectural style of Roman and Byzantine Alexandria and Egypt," in D. M. Bailey (ed.), *Archaeological research in Roman Egypt* (JRA Suppl. 19, 1996) 128-42; and ead. (supra n.19) chapt. 6B; P. Pensabene, *Elementi architettonici di Alexandria e di altri siti egiziani* (*Repertorio d'arte del Egitto greco-romano*, Serie C, III; Rome 1993); B. Tkaczow, *Topography of ancient Alexandria (an archaeological map)* (Travaux du Centre d'Archéologie Méditerranéenne de l'Académie des Sciences 32, Warsaw

enough, when combined with literary sources, to give us some idea of the main arterial streets, the grid plan and major public buildings, particularly the agora, the gymnasium and the Caesareum. The archaeological evidence for the later Roman period at Kom el-Dikka reveals a baths complex, a small theatre, a school or lecture-hall, and apartment blocks. The gymnasium, a quintessentially Greek civic institution, was clearly a major cultural and administrative centre in the Ptolemaic and earlier Roman periods, perhaps later replaced by the complex at Kom el-Dikka.[41] The connection between civic politics and government, and the character of public buildings, is amply attested here and can be inferred for the other comparable Ptolemaic foundation, Ptolemais in the Thebaid, despite the lack of any archaeological evidence.[42] A more coherent picture of the 'Greek city' in Egypt emerges in the Roman period with the foundation of Antinoopolis in A.D. 130, known from the drawings made by Jomard during the Napoleonic expedition, from modern excavations and from papyri. There is evidence for two massively colonnaded streets, tetrastyla, a triumphal arch, baths, a palaestra, monumental gate, theatre, hippodrome, and a circular gymnasium which was under construction in A.D. 263.[43] This last building is of particular interest for the papyrological evidence for the gilding of the coffered ceiling of its stoa and pylons, and the use of expensive imported timber.[44]

As for the metropoleis, there are sporadic signs in the documentary evidence of Greek civic buildings in the Ptolemaic period,[45] but the spread of classical architectural forms and buildings is much more heavily marked in the Roman period. Recent collections of the documentary and archaeological evidence highlight the under-emphasis on this phenomenon in earlier scholarly literature and make it unnecessary to review the material in detail, but it is evident that metropoleis such as Arsinoe, Hermopolis and Oxyrhynchus were extensively and increasingly adorned in the Roman period with theatres, baths, gymnasia, administrative buildings such as record-offices, temples of Greek (and eventually Roman) gods and cults, markets, stoas, procession houses (*komasteria*), *tetrastyla*, and so on[46] — in short, many of the physical

1993); R. Tomlinson, "The town plan of Hellenistic Alexandria," in *Alessandria e il mondo ellenistico-romano* 1995, *Atti del II Congresso internazionale Italo-egiziano* (Rome) 236-40. Recent underwater excavations in the harbour reveal several (imported) Egyptian monuments which perhaps suggest that the 'ville-musée' aspect was quite prominent: see J.-Y. Empereur, "The underwater site near Qaitbay Fort," *Egyptian Archaeology* 8 (1996) 7-10; id., "Raising statues and blocks from the sea at Alexandria," *Egyptian Archaeology* 9 (1996) 19-22; id., *Alexandrie redécouverte* (Paris 1998) 62-81.

41 F. Burkhalter, "Le gymnase d'Alexandrie: centre administratif de la province romaine d'Egypte," *BCH* 116 (1992) 345-73. For Kom el-Dikka see McKenzie (supra n.19) chapt. 6B, with full citation of relevant archaeological reports.

42 Haas (supra n.40); id. "Alexandria's *Via Canopica*: political expression and urban topography from Augustus to "Amr Ibn al-'Asi," *BSAA* 45 (1993) = Alexandrian studies in memoriam Daoud Abdu Daoud, 123-37; Ptolemais, supra n.20.

43 M. Zahrnt, "Antinoopolis in Ägypten: die Hadrianische Gründung und ihre Privilegien in der neueren Forschung," in *ANRW* II.10.1 (1988) 669-706; McKenzie (supra n.19) chapt. 6A; Aufrère *et al.* III (supra n.13) 226-27, 232-36.

44 *P.Köln* I 52-53.

45 See above n.21. There were also gymnasia, attested, for example, at Herakleopolis Magna (*BGU* VIII 1767-68) and (?)Thebes (*SB* III 7246); cf. Fraser, *JEA* 47 (1961) 145; but these were private associations and did not have the status of public institutions which they enjoyed in the Roman period.

46 D. M. Bailey, "Classical architecture in Roman Egypt," in M. Henig (ed.), *Architecture and architectural sculpture in the Roman empire* (OUCA Monograph 29, 1990) 121-37; Bowman (supra n.20); F. el-Fakharani, "The Graeco-Roman elements in the temples of Upper Egypt," in *Alessandria* (supra n.40) 151-55; A. Lukaszewicz, *Les édifices publics dans les villes de l'Egypte romaine* (Warsaw 1986); McKenzie (supra n.19) chapt. 6A, Pensabene (supra n.40). In addition, for particular sites: Arsinoe: L. Casarico, "La metropoli dell' Arsinoite in epoca romana," *Aevum* 69 (1995) 69-94; Davoli 1996 and 1998 (both supra n.7); Hermopolis: G. Roeder, *Hermopolis, 1929-39* (Hildesheim 1959); D. M. Bailey, "The procession-house of the Great Hermaion at Hermopolis Magna," in M. Henig and A. King (edd.), *Pagan gods and shrines of the Roman Empire* (Oxford 1986) 231-37; id., *Excavations at El-Ashmunein IV.*

features which are found in cities in the eastern provinces of the Roman empire. In some places it is possible to see, if not to analyse in detail, the ways in which the construction of Greek-type civic buildings, both secular and religious, modified the existing configuration of public space in towns where it had been dominated by the traditional Egyptian form of temple and processional route.[47] We do not need to labour the contrast between, on the one hand, the Egyptian public processional way and enclosed temple, and, on the other, the Greek agora.[48] The phenomenon is most clearly marked in the metropoleis, and may legitimately be taken as one of the clearest signs of 'urbanization' in the Roman period, but it is important to note that it is also reflected on a smaller scale in some of the villages, particularly those in the Fayum.[49] The much more plentiful evidence for all areas of Egypt in the Roman period may skew the picture in comparison with the Ptolemaic,[50] but it does seem likely that there was a move away from spending on native temples in favour of buildings of Graeco-Roman type.[51]

Until recently, the best detailed papyrological evidence we possessed for public buildings in a Roman metropolis came from Hermopolis. The so-called 'Repairs Papyrus' of c.A.D. 267 records details of extensive (and expensive) repairs to public buildings on a porticoed street which ran from the *tetrastylon* of Athena to the Moon Gate, including a *Hadrianeion*, a *macellum*, a stoa by the agora, a *Serapeum, Neileion, komasterion, nymphaion, Tychaion*.[52] This evidence has now been given a better context by the excavations of the 1980s which have, in particular, enabled a reconstruction of the *komasterion*, or procession house.[53] This type of

Hermopolis Magna: Buildings of the Roman period (London 1991); Oxyrhynchus, J. Krüger, *Oxyrhynchos in der Kaiserzeit. Studien zur Topographie und Literaturrezeption* (Frankfurt am Main 1990); D. M. Bailey, "Architectural blocks from the theatre at Oxyrhynchus,", R. A. Coles, "Oxyrhynchus," and J. Padró, "Report on the recent archaeological excavations at Oxyrhynchus," all in *Oxyrhynchus, a city and its texts* (forthcoming).

47 E.g., at Hermopolis, Bailey ibid. (1986 and 1991); at Athribis, L. Dabrowski, "La topographie d'Athribis à l'époque romaine," *ASAE* 57 (1962) 19-31; K. Mysliewicz, "Athribis entre Memphis et Alexandrie," in *L'Egypte du Delta: les capitales du nord* (= *Les dossiers d'archéologie* 213, 1996) 34-43; cf. P. Pensabene, "Il tempio di tradizione faraonica e il dromos nell'urbanistica dell'Egitto greco-romano," in *Alessandria* (supra n.40) 205-19. The theme is discussed by R. Alston, "Ritual and power in the Romano-Egyptian city," in Parkins (supra n.5) 147-72

48 Cf. E. Baraize, "L'"Agora" d'Hermoupolis," *ASAE* 40 (1940) 741-60; N. Litinas, "Market-places in Roman Egypt. The use of the word agora in the papyri," *Akten des 21. int. Papyrologenkongresses, 1995* (APF Beiheft 3, 1997) 601-6.

49 Archaeological evidence collected by Davoli (supra n.7). Philadelphia: Viereck (supra n.19), Préaux (supra n.19) 40-44; Tebtunis: Anti (supra n.7); id., "Gli scavi della missione archeologica italiana a Umm el Breigat (Tebtunis)," *Aegyptus* 11 (1931) 389-91; C. Gallazzi, "La ripresa degli scavi a Umm-el-Breigat (Tebtunis)," *Acme* 48 (1995) 3-24; C. Gallazzi and G. Hadji Minaglou, "Fouilles anciennes et modernes sur la site de Tebtynis," *BIFAO* 89 (1989) 180-202; P. Piacentini, "Excavating Bacchias," in Bailey (supra n.40) 57-60; cf. Bingen (supra n.18).

50 My impression is that the accumulation of archaeological evidence from excavations in the towns of the Delta might significantly modify the picture for the Ptolemaic period, cf. E. C. M. Van den Brink, *The Archaeology of the Nile Delta* (Amsterdam 1988); and for Naukratis cf. W. D. E. Coulson and A. Leonard Jr., *Cities of the Delta I: Naukratis: Preliminary report on the 1977-8 and 1980 seasons* (ARCE Reports 4, 1981); Thmuis: E. L. Ochsenschlager, "The excavations at Tell Timou," *JARCE* 6 (1967) 32-51. See also below p. 185 on Boethos the κτιστής.

51 This is what familiarity with the papyrological evidence would suggest, and it has been reinforced by J. McKenzie on the basis of her research on the buildings and architecture.

52 *C.P.Herm.* 127 verso = *SP* XX 68 = *SB* X 10299 = A. C. Johnson, *Roman Egypt* (T. Frank, *Economic survey of ancient Rome* II [Baltimore 1936]) no.435; cf. H. Schmitz, 'Die Bau-urkunde in P. Vindob. Gr. 12565 im Lichte der Ergebnisse der Deutschen Hermopolis-Expedition," in W. Otto and L. Wenger (edd.), *Papyri und Altertumswissenschaft. Vorträge des 3. int. Papyrologenkongresses* (Münchener Beiträge zur Papyrusforschung und antiken Rechtsgeschichte 19, 1934) 406-28

53 Bailey 1986 and 1991 (supra n.46); for the earlier excavations see Roeder (supra n.46). See also below p. 183.

information has been significantly augmented by the recent publication of a remarkable text from Oxryhynchus dating to A.D. 315/6 that includes reports made to the *logistes* (curator) of the city by guilds of builders and other craftsmen, detailing the repairs needed to various buildings, public and private, in the city. The information is arranged under four headings, Northern, Western, Eastern and Southern Stoa, and includes the following buildings in the Western and Eastern Stoas (the other sections are fragmentary): the surgery of Dioscorus, a stable, a school, Temple of Fortune, Temple of Achilles, record-office, market, proclamation-hall, Temple of Hadrian, public bath, beer-shop, Temple of Demeter, Temple of Dionysus; elsewhere the text mentions another bath, a gymnasium and an imperial palace.[54] The general impression made by this text, which attests the market and the imperial palace for the first time, reinforces that of the Hermopolite papyrus and another long-known text of about the same period from Oxyrhynchus listing watchmen guarding various areas and buildings of the city, including a gymnasium, baths, temples, the *Kaisareion*, tetrastyles, two churches, the theatre and the Capitolium.[55] I return to some of the financial and administrative implications of these texts below.

The impetus and the influences behind the spread of classical architectural forms in the towns of Egypt, which also have some idiosyncratic local features, have naturally been discussed in the context of the proximity and influence of Alexandria in the Ptolemaic and Roman periods. This discussion often focuses particularly on the development of a distinctive Alexandrian style in the Ptolemaic period, a topic to which I can make no contribution.[56] However, it is worth mentioning, as others have, the evidence for local Greek builders, architects and surveyors in the villages of the Ptolemaic Fayum using traditional Greek methods and architectural features which they presumably need not have derived directly from Alexandria; the evidence is mainly from the Zenon Archive, and concerns both public and private edifices in Philadelphia, where building activity seems to have been intense in the second half of the 250s B.C.[57]

Government

The development of buildings of the classical type is clearly connected with the spread of a particular kind of governmental, administrative, and religious institution in the metropoleis of Egypt. The following remarks about the connection between urbanization and local government rest on a view of the latter that has been argued in detail elsewhere.[58] Here I can only try to emphasise some salient points and some consequences of that view. The Romans introduced into Egypt a form of local government that was fundamentally new — that is, no sort of a continuation of Ptolemaic precedents — based on the creation in the Augustan period of a local magisterial class of élites, usually referred to by modern scholars as the 'gymnasial class' but known under various names in the different metropoleis. The ideology underlying the qualifications for membership of this group, however fictional, was some sort of 'Greekness', certified by the process of *epikrisis* which established ancestry going back to the original lists of members of the status group, drawn up in A.D. 4/5. The fullest realisation of the version of local

54 *P.Oxy.* LXIV 4441.

55 *P.Oxy.* I 43 verso.

56 See P. Pensabene, "Elementi di architettura alessandrina," *StMisc* 28 (1984-85 [1991]) 29-85; id. (supra n.40); and in particular the detailed and persuasive account of McKenzie 1996b and forthcoming (supra n.19).

57 Préaux (supra n.19) 40-44. McKenzie (supra n.19) chapt. 6, with further bibliography; theatre: *P.Cairo Zen.* 59823; gymnasium: *PSI* IV 391a; baths: *P.Cair.Zen.* 59665; royal residence; *P.Cair.Zen.* 59664; *Arsinoeion, P.Cair.Zen.* 59745; *P.Lond.* VI 2046; house of Diotimos: *P.Cair.Zen.* 59445, 59767, 59847; and the interesting brickmaker's account for the baths, *Arsinoeion* and royal residence in *P.Lond.* VI 1974.

58 Bowman and Rathbone (supra n.1).

autonomy which existed in the metropoleis of Egypt came with the creation of councils by Septimius Severus in A.D. 200, but it is clear that several key features — magistrates, local liturgies, etc. — were introduced from quite early in the Roman period, and by Hadrian's reign Oxyrhynchus is explicitly described corporately as a *polis*.[59] This form of relatively accessible, public local government — in which, in contrast to the Ptolemaic period, the gymnasium as a public institution plays a central rôle — has an obvious and intimate connection with the development of certain types of buildings in the metropoleis; and it is worth emphasising the similarly public nature of Greek religious cults, temples and priesthoods which also form a striking contrast to their Pharaonic counterparts. Agoras, stoas, record-offices, places for meetings and official proceedings (often temples of Greek deities) are integral to this development and increase in importance. By way of illustration, we can cite: a report of a contentious meeting of magistrates (*archontes*) in the *Kaisareion* at Hermopolis in A.D. 192; a report of a public meeting at Oxyrhynchus which adopts the language and expressions of acclamation that are characteristic of such proceedings in Greek *poleis*; and the day-book of a local nome official at Elephantine in the mid 3rd c. which attests him performing various duties, religious and secular, in a number of buildings including the *logisterion, gymnasium, Kaisareion, principia, praetorium* and *agora* (ἡ τῶν ὠνίων ἀγορά).[60]

By the 3rd c. A.D., hence rather later than the efflorescence of Greek civic culture which can be observed elsewhere in the Roman East, it is possible to see the metropoleis of Egypt, with their newly created councils, striving to achieve their version of 'Greek' civic life in the context of Roman patterns of local government, cultural, financial, and administrative: thus at Oxyrhynchus we find the council (*boule*) and magistrates, the association of elders (*gerousia*), the corn-dole, the Capitoline Games, pensions for athletes, Lollianus the public *grammatikos*, and so on.[61] Despite the alleged character and effects of the 'third century crisis', it does rather look as if the image of these urban communities was upbeat in several important respects, at least into the third quarter of the 3rd c., even if there is, as there surely must be, an element of rhetoric.[62]

There are considerable financial implications in all this, which suggest that we ought to consider how the costs were met, and by whom.[63] The irksomeness of the burden of liturgies, local and governmental, is one well-known feature of the picture.[64] Comparison with cities in other provinces of the empire leads us to consider whether we can identify in Egypt another of the important elements on which building and civic amenities depended: local munificence and euergetism. This is a phenomenon for which the Egyptian evidence has not been systematically collected and studied. It is certainly rather less obvious than elsewhere — perhaps because the

59 See now D. Hagedorn, "Municipal officials in Oxyrhynchus," in *Oxyrhynchus, a city and its texts* (forthcoming), rejecting the early introduction of some magistrates, though accepting the general line of argument. In *P.Oxy.* XLIII 3088, Oxyrhynchus has a corporate identity as a *polis*; in *P.Amh.* II 70 = WChr. 149 the magistrates (*archontes*) of Hermopolis also act as a body.

60 *P.Ryl.* II 77 (the text also mentions a tribunal [βῆμα]), *P.Oxy.* I 41, with M. Blume, "A propos de P. Oxy. I 41," in L. Criscuolo and G. Geraci (edd.), *Egitto e storia dall'Ellenismo all'età araba. Bilancio di un confronto, Bologna, 1987* (Bologna (1989) 271-90; WChr. 41 (A.D. 232); cf. H. Jaritz, "On three townsites in the Upper Thebaid," *CRIPEL* 8 (1986) 37-42.

61 The evidence for Oxyrhynchus is collected by Parsons, *P.Coll.Youtie* II, 169-73; see also D. Hagedorn, "'Οξυρύγχων πόλις und ἡ 'Οξυρυγχιτῶν πόλις," *ZPE* 12 (1973) 277-92; for Hermopolis see Van Minnen (forthcoming, supra n.1).

62 Already noted by A. C. Johnson, "Roman Egypt in the third century," *JJP* 4 (1950) 151-58. For comparable evidence of urban prosperity in Cyrenaica in the 3rd c., see J. A. Lloyd, "The cities of Cyrenaica in the third century AD," *Atti dei Convegni Lincei* 87 (1990) 41-53; for Asia Minor, S. Mitchell, "Greek epigraphy and social change. A study of the Romanization of SW Asia Minor in the third century AD," *Atti del XI Congresso int. di epigrafia greca e latina (Rome 1997)* forthcoming.

63 Cf. Duncan-Jones (infra n.68).

64 A. K. Bowman, *The town councils of Roman Egypt* (American Studies in Papyrology 11, 1971) 98-113.

epigraphic habit was less ingrained in Egypt than in Africa or Asia Minor — but there is in fact a certain amount of inscriptional evidence for it, and it also appears in the papyri. There are some notable Ptolemaic precedents, including the famous 1st-c. decree for Kallimachus, *epistrategos* of the Thebaid, recording in both language-traditions his restoration of the native temples.[65] The evidence for the ways in which this Greek habit insinuated itself into the Egyptian temple-building context in the Roman period is paralleled at Tentyra (Dendera), for example, where inscriptions record benefactions made from private resources (ἐκ τοῦ ἰδίου) and from a priest of Ammon and the σύνναοι θεοί named Philiscus who was *strategos* and πάτρων τοῦ νομοῦ, at Theadelphia, Narmouthis and elsewhere in the Fayum.[66] The papyri afford much evidence for gifts and bequests for buildings, contributions to civic amenities such as the gymnasium, feasts and games in the 2nd and 3rd c.[67]

Duncan-Jones has detected in the West from the 2nd and 3rd c. onwards an increase in the proportion of buildings paid for by the cities rather than individuals.[68] This may find an echo in Egypt, specifically in the evidence from Hermopolis and Oxyrhynchus discussed above. The Hermopolis text attests extensive repairs to public (and private) buildings in the 260s, the height of the alleged crisis. These repairs were quite costly, but the local authority in the form of the council was clearly concerned about upkeep, and the considerable expense was perhaps met by levying a special tax on a house-to-house basis.[69] The 4th-c. Oxyrhynchus text provides a remarkable parallel, although it is of a different kind: it contains estimates by guild officers of work and materials needed for the upkeep of the buildings with no indication of how the expense was to be met, but it is not unlikely that it came from public rather than private funds. This is suggested by the striking evidence, at least at Oxyrhynchus, for control of civic buildings, and other public services, through the *curator civitatis (logistes)*, in what looks like a coherent operation in the first half of the 4th c.[70] One might use this as a basis for arguing for a significantly different (and perhaps healthier) approach to the financing of public facilities than had been the case in the period which was characterised by a greater amount of private munificence and euergetism.

Transformations

What are the antecedents of this transformation of the metropoleis of Egypt? As I have already suggested, any discussion of urbanization in Egypt has to take account of Ptolemaic (and Roman) Alexandria as a possible source of influence. Imperfect though our knowledge is, we can grasp in outline the main features, physical and institutional (including a 'city law' or πολιτικὸς νόμος), of Ptolemaic Alexandria as a Greek city — though the import of Egyptian monuments from Heliopolis, as apparently indicated by recent discoveries, hardly makes it 'typical'.[71] The extent to which it was *the* model for urbanization in the *chora* in the Ptolemaic period seems difficult to demonstrate, and the mix of Greek- or Alexandrian-influenced architectural elements with idiosyncratic local detail does not tell us much about the dynamics.[72] One might imagine that Greeks in the *chora*, even if they had Alexandrian connections,

65 *SEG* XXIV 1217 (39 B.C.); also at Tebtunis, *IGFay* III 145.

66 Tentyra: *IGLouvre* 28, *Portes du désert* 33; *strategos*: *IGLouvre* 32; Fayum: *IFay*. I 25, 29; II, 103, 124; III 147, 167, 173.

67 Examples in *P.Oxy.* IV 705, XII 1496, XLIII 3088.

68 R. P. Duncan-Jones, "Who paid for public buildings in Roman cities," in F. Grew and B. Hobley (edd.), *Roman urban topography in Brtiain and the western empire* (CBA Res. Rep. 59, 1985) 28-33.

69 Suggested by Van Minnen (forthcoming, supra n.1), on the basis of *CPHerm.* 101.

70 See *P.Oxy.* LIV 3727-76. There is a striking parallel in the cities of 4th-c. Africa; see C. Lepelley, *Les cités de l'Afrique romaine au Bas-Empire* (Paris 1979-81) I, 59-120.

71 See above p. 175. For the city law, *P.Halle* 1; cf. Fraser (supra n.40) 109-12.

72 It is perhaps worth bearing in mind the much later (4th c.) evidence for compulsory labour drafted into Alexandria from the *chora*, *CPR* VI 5.1-9 (A.D. 336-37).

as did powerful men such as Apollonius the *dioiketes*, did not need to use it directly as a model. As we have seen, the notion of Fayum villages, especially Philadelphia, as micro-*poleis* is not a new one, and the Zenon archive supplies evidence for architectural tastes of a Greek kind, complementing the evidence for the growth of a 'gymnasial' culture which was private rather than public. The foundation of the Greek city of Ptolemais in the Thebaid, with Greek public buildings and civic institutions, provided a 'Greek' focus there, surely intending to counter-balance Egyptian Thebes, notoriously a centre of Egyptian 'nationalism' and resistance to foreign domination. It is particularly interesting, in connection with the rôle of religion in this, that a papyrus of the 2nd c. A.D. reveals that from its foundation Ptolemais was given an interest and a virtual presence in nearby Coptos by virtue of having been endowed with rights to the revenues of a temple of Ptolemy I Soter at Coptos.[73] At a much later stage, the foundation of another 'Greek city', Antinoopolis close to Hermopolis, will have had a similar effect, and it is noteworthy that it drew much of its original population from a combination of veteran soldiers and inhabitants of the more hellenised Fayum.[74] This suggests that these Greek cities were not simply isolated 'islands' of Greek culture and civic values but that they spread tentacles of influence further afield. The evidence for this phenomenon has recently been augmented in a most remarkable text which illustrates developments of a kind that fill a gap between the real 'Greek cities' and the already existing Egyptian towns. This text attests the foundation of a new town in Upper Egypt by a κτιστής named Boethos in 132 B.C.: this town did not have the juridical status of a 'Greek city' like Ptolemais, but it was evidently a foundation made with Greek soldiers in mind, and it reflects their privileged status and several of the physical attributes which were central to the Greek idea of a city: residential quarters (σταθμοί), agora and stoas.[75]

This suggests by implication the importance of another element in addition to buildings and institutions, namely people. It has already been argued that Alexandria provided some sort of a model for the local governmental institutions in the metropoleis of Roman Egypt.[76] I think this can be enriched and nuanced. The Alexandrian citizen populace, at first exclusive, was soon augmented by an influx of Greeks and Macedonians from the *chora*.[77] It is well known that Alexandrian citizenship was a route to Roman citizenship in Roman Egypt, thus making it quite unlike citizenship of any other provincial city — a qualification and sign of civic sophistication, marking out those who were suited to privileged status in much the same way as did the *ius Latii* in the municipalities of the western provinces.[78] It is evident that in the first century of Roman rule many of the higher officials in the nomes and towns of the *chora*, such as *strategoi* and *basilikoi grammateis*, were in fact Alexandrians, eventually displaced of course by members of the hellenised élite, the gymnasial class, of the metropoleis.[79]

The connections between the élites of the metropoleis and citizens of Alexandria is a matter of some importance in tracing the ways in which cultural and urban traditions might have spread. As Turner demonstrated in 1975, such connections lead to physical and cultural inter-change which help us to understand the development of a town like Oxyrhynchus and its links

73 *SB* VI 9016, still an issue in A.D. 160.

74 E. Kühn, *Antinoopolis. Ein Beitrag zur Geschichte des Hellenismus im römischen Ägypten* (Göttingen 1913); Zahrnt (supra n.43); F. Hoogendijk and P. Van Minnen, "Drei Kaiserbriefe Gordians III. an die Bürger von Antinoopolis," *Tyche* 2 (1987) 42-74; *P.Diog.* pp. 25-33.

75 Kramer (supra n.8); Heinen (supra n.8).

76 Bowman and Rathbone (supra n.1).

77 Fraser (supra n.40) I, 49-50, II, 133 n.104

78 Cf. D. Delia, *Alexandrian citizenship during the Roman principate* (American Classical Studies 23, 1991) 46, arguing that "it was not Alexandrian citizenship *per se* but the level of civilisation implied by citizenship in a Greek city in Egypt that qualified *peregrini* for the Roman franchise."

79 J. E. G. Whitehorne, "Recent research on the *strategi* of Roman Egypt (to 1985)," in *ANRW* II.10.1 (1988) 598-617.

to the wider world.[80] One well-known aspect of this phenomenon is the fact that at Oxyrhynchus and elsewhere, especially from the 2nd c. onwards, we find evidence of people bearing titles of magisterial office of Alexandria, including that of 'strategos of the city'.[81] It has been customary to regard such people as examples of members of wealthy Alexandrian families who owned land in the *chora*, and there can be no possible doubt that there were indeed many such in the towns of Egypt and in the villages of the Fayum.[82] It is surely the case, for example, that the well-known wealthy landowner Claudia Isidora was one such; the family of the Tiberii Iulii Theones, attested as having large estates in the Oxyrhynchite nome in the late 1st and the 2nd c. A.D., is another.[83] Notable texts connected with them show ownership of a very large *familia* of slaves, and one family member who became a tax-exempt member of the Museum of Alexandria.[84] It is impossible to be sure how much direct interest such people had in the metropolis, but the presence of important papers relating to their families is a clear sign that they maintained residences there. The origins of such local connections might, of course, go back to the early patterns of office-holding by Alexandrians in the *chora*, mentioned above.

Conversely, given the importance of Alexandrian citizenship as a prerequisite for Roman citizenship before the *constitutio antoniniana*, there must also have been members of leading Oxyrhynchite (and other) families who enriched themselves and acquired Alexandrian citizenship. I can see nothing that would have prevented them in principle from establishing residence at Alexandria and holding Alexandrian magistracies and offices, whilst maintaining their connection with their home town. This is a typical pattern for upwardly mobile members of aristocracies elsewhere in the empire (Pliny the Younger and Fronto, to name but two prominent examples), and there is no reason why it should not also have occurred, *mutatis mutandis*, in Egypt. Identifying or proving the local origins of such individuals or families is far from easy, however, and cannot be attempted in detail here. I offer only one suggestion (which remains to be worked out in detail) concerning a family prominent at Oxyrhynchus in the 3rd c.; the substantial evidence that its members held both local offices at Oxyrhynchus as well as Alexandrian magistracies seems to me to indicate a local family which made good, rather than a family of absentee Alexandrian landowners, and it suggests as a parallel the much later evidence for the wealthy Apiones of Oxyrhynchus, also a local family whose members achieved empire-wide prominence. The 3rd-c. family is one which held the *gentilicium* Calpurnius. It is impossible to demonstrate that all the Calpurnii attested at Oxyrhynchus belong to this family, and there may have been adoption at some time which will have connected it with another family. Nevertheless, it is likely that it included Aurelius (Calpurnius) Horion who made a generous benefaction to the town; Calpurnii with the *cognomina* Caius, Firmus, Horion, and possibly Lucius, who held offices at Oxyrhynchus, including responsibility for administering the corn-dole in the case of Horion; and Caius Aurelius Calpurnius Theon, another tax-exempt member of the Alexandrian Museum. Finally, there is a very wealthy female landowner, Calpurnia Heraklia, who declares possession of estates which seem to have been in the family since the reign of Tiberius.[85]

80 E. G. Turner, "Oxyrhynchus and Rome," *HSCP* 79 (1975) 1-24; cf. id., "Roman Oxyrhynchus," *JEA* 38 (1952) 78-93.
81 See *P.Oxy.* XII 1412.1-3 note.
82 See, e.g., *P.Chept.*, the land-list from Philadelphia forthcoming in *P.Yale* III (inv. 296), J. L. Rowlandson, *Landowners and tenants in Roman Egypt* (Oxford 1996) 104-15.
83 Isidora: Rowlandson ibid. 114-15 etc; Theones: P. J. Sijpesteijn, *The family of the Tiberii Iulii Theones* (Studia Amstelodamensia ad epigraphicam, ius antiquum et papyrogicam pertinentia 5, 1976); Rowlandson ibid. 107-8.
84 *P.Oxy.* XLIV 3197, LXII 4336.
85 Calpurnius Aurelius Horion: *P.Oxy.* IV 705, *PSI* XII 1255; C. Calpurnius Aurelius Theon: *P.Oxy.* L 3564; Calpurnius Gaius: *P.Oxy.* LI 3606; Calpurnius Firmus: *P.Oxy.* XXXIV 2723, XXXVIII 2848, *PSI* XII 1256; C. Calpurnius Lucius: *P.Oxy.* XLIV 3713, LI 3606.4 n.; Calpurnia Heraklia: *P.Oxy.* XLII 3047-8. There is also a Calpurnius Longus in an unpublished Oxyrhynchus text (inv. no. 62.3B/77/G(1-4)a).

Clearly such people are prominent in the civic aspirations and the urban landscape of the metropoleis of Egypt in the 2nd and 3rd c. Whether they are Alexandrians coming to the metropolis or metropolites on a path of upward mobility to Alexandria and beyond, it is not difficult to imagine that, like Zenon of Kaunos half a millennium before, they aspired to and promoted Greek urban culture in its various manifestations: buildings, public offices, literature and culture. Whether they were actually 'Greek', and if so in what senses, is another matter.

Christ Church, Oxford

The limited nature of Roman urbanism in Sardinia

Stephen L. Dyson

Even today, Sardinia is a place visited by relatively few Italians. The same was true in antiquity. The reputation of the island for disease and banditry during the Roman centuries is well known.[1] Yet Sardinia was, after Sicily, the oldest overseas province in the Roman empire. The Roman conquest of the island began in 238 B.C. and Sardinia remained in Roman hands until the Byzantine period.[2] Located close to the coast of Italy and exploited early on as a source of grain for the city of Rome, the island should have mirrored well the developments of Roman Italy.[3] One would expect to see emerging there that combination of small-town urbanism and rural life centered on villa-farmsteads that characterized so much of the western empire during the later Republic and early Empire.[4]

A superficial glance at maps of Roman Sardinia would seem to support the notion that significant small-scale urbanization did take place on the island.[5] Such maps, which are based on a combination of the evidence of ancient geographers and archaeological and epigraphical remains, show a well-developed network of intersecting roads penetrating most areas of the island. At key points are indicated towns, some bearing native names and others such appropriate Roman designations as *Forum Traiani* and *Augustis*. Such maps provide visual reinforcement to the idea that the Romanization of Sardinia followed the classic pattern of a symbiotic development of roads and towns.

The Roman roads were real enough. Bridges and sections of pavement are still visible in a number of places, and Sardinia has produced one of the largest collection of milestones of any province.[6] The development of such a road network demonstrates that the Romans wanted to assert at least minimal control throughout the island. The system in Sardinia can be contrasted with Corsica, where the Romans built almost no roads in the interior and also developed few towns beyond the coastal zone.[7]

However, the degree of urbanization of inland Sardinia is more problematic. Supposed Roman towns of the interior, when the full range of archaeological evidence is collected and analyzed, often prove to be more illusory than the evidence of ancient geography might suggest. Space does not permit a site-by-site review of all the interior Roman centers listed on itineraries. Suffice it to say that remains of Roman architectural indicators such as walls, temples, theaters, and mosaics are singularly lacking.[8] For the purposes of this paper, the centers of *Forum Traiani* and *Colonia Uselis* provide good case-studies.

The Roman community of *Forum Traiani* (mod. Fordongianus) is located on the Tirso, one of the larger rivers, some miles from the Mediterranean.[9] The settlement is first mentioned in an

1 S. L. Dyson, *The creation of the Roman frontier* (Princeton 1985).260-62.

2 P. Meloni, *La Sardegna romana* (Sassari 1975) and id., *La Sardegna romana* (2nd ed., Sassari 1988).

3 R. Rowland, "The production of Sardinian grain in the Roman period," *Mediterranean Historical Review* 5 (1990) 14-20; R. Rowland, "The case of the missing Sardinian grain," *AncW* 10 (1984) 45-48.

4 H. Jouffroy, *La construction publique en Italie et dans l'Afrique romaine* (Strasbourg 1986); T. Potter, *Roman Italy* (London 1987).

5 F. Casula, *La storia di Sardegna* (Sassari 1992) 113.

6 Meloni 1975 (supra n.2) 279-85; A. Boninu and A. U. Stylow, "Miliari vecchi e nuovi dalla Sardegna," *Epigraphica* 44 (1982) 29-56.

7 A. Berthelot, "La Corse de Ptolemée," *RA* 11 (1938) 28-49.

8 R. Rowland, *I ritrovamenti romani in Sardegna* (Rome 1981); S. L. Dyson, "Roman Sardinia and Roman Britain," in R. H. Tykot and T. K. Andrews (edd.), *Sardinia in the Mediterranean: A footprint in the sea* (Sheffield 1992) 484-92.

9 R. Zucca, *Fordongianus* (Sassari 1986).

inscription of the Augustan period, in which it is named *Aquae Hypsitanae*.[10] That name is clearly derived from the hot mineral springs that still flow. According to the inscription, the *civitates barbarae* assembled there regularly to declare their allegiance to the emperor, a sort of Sardinian durbar or a minor Sardinian version of the centers for the imperial cult that Augustus developed at places like Lyons or Cologne. The later Roman name of *Forum Traiani* implies that this diplomatic meeting place had by the early 2nd c. become a designated market-center for trade with the locals. To this period can be dated the remains of the bath complex built over the thermal springs by the Tirso river.[11] By the Byzantine period the town, now named *Chrysopolis*, had become the headquarters for the military command of Sardinia.[12] The literary and epigraphical evidence shows that *Forum Traiani* played an important administrative rôle for much of the Roman period.

From what is known about the architectural development of towns of the western empire during the Augustan and Julio-Claudian periods, some evidence for major public structures might be expected at *Forum Traiani*.[13] The impressive remains of the imperial bath complex do survive. They utilized the waters of the warm springs that had probably drawn settlers to that location long before the Romans appeared on the scene. Antiquarian sources mention a theater complex and town walls, but almost no remains of those structures survive today, and one wonders whether early writers were not exaggerating the extent of the evidence.[14] The lack of other evidence for the Roman presence at Fordongianus reinforces such doubts. Most Roman towns with the long history and administrative importance of *Forum Traiani* yield quantities of mosaic fragments, tombstones, and sculptural and architectural fragments which may be observed built into walls and gathered in the local antiquarium. They often serve as an indicator of relative levels of urban development. A fragment of a Roman barrel tomb is the sole surviving Roman artifact preserved in the Fordongianus municipality. Little or nothing is visible in other parts of the city or in public or private collections.

The contrast between civic status and physical remains of urbanization is even more stark at Usellus. The full name of the Roman town, *Colonia Julia Augusta Uselis*, suggests a colonial settlement of the Caesarian or Augustan period.[15] Roman colonies are not very common in Sardinia, and at such a place one would expect some signs of public building. The civic organization of *Uselis* survived into the Antonine period, for an inscription of 158 from Cagliari mentions civic officials of the Roman *colonia*.[16] Even the close correspondence between the ancient and modern names would suggest some traditions of continuity. However, the site generally identified as *Uselis* is marked only by the small mediaeval church of Santa Reparata and surface scatters of Roman pottery. There is nothing in the way of surviving Roman architectural remains or architectural and sculptural fragments built into the church or other structures in the immediate area.[17]

Space does not permit a discussion of the Roman remains found at every town in the interior of Sardinia,[18] but the overall picture is not that different from *Forum Traiani* and *Uselis*. Two examples must suffice. Roman *Valentia* (mod. Nuragus near Esterzili) bears a name based on an

10 *AE* 1921.86.

11 A. Taramelli, "Fordongianus. Antiche terme di Forum Traiani," *NSc* 1903, 469-92.; Zucca (supra n.9) 18-29.

12 Georg. Cypr., *Descr. Orb. Rom.* 682; *Notit. episcop. orient* (*PG* 107.344; Procop., *Aed.* 6.7.12.

13 Jouffroy (supra n.4); R. Bedon, R. Chevallier and P. Pinon, *Architecture et urbanisme en Gaule romaine* (Paris 1988).

14 Zucca (supra n.9) 12-18, 29.

15 E. Usai and R. Zucca, "Colonia Iulia Augusta Uselis," *Studi Sardi* 26 (1986).

16 *CIL* X 7845.

17 S. L. Dyson and R. J. Rowland, Jr., "Survey and settlement reconstruction in west-central Sardinia," *AJA* 96 (1992) 210-11.

18 For a site-by-site review of the evidence, cf. Rowland (supra n.8).

abstraction of a Roman military virtue, characteristic of Romanized centers of the middle years of the Republic.[19] *Valentia* was on a major trunk road and was the only city of *stipendarii* in the interior. However, it preserves no significant remains of the Roman period.[20] The same is true of *Augustis* (mod. Austis), whose ancient name again suggests some form of formal Roman civic intervention.[21] When all of the so-called Roman town sites of the interior are considered on the basis of the archaeological evidence, the picture of significant Roman urbanization derived from a limited number of inscriptions and ancient geographical information appears to be rather misleading.[22]

This is not to say that no urban centers existed in Roman Sardinia. Substantial remains of a number of Roman-period cities and towns have survived, but they are indicators of a limited and specialized urbanization centered on the coast, which either represented continuity from the Punic past or largely new centers that developed in response to Roman administrative and economic needs.

To the first category belong coastal towns like *Tharros, Sulcis, Bitia*, and *Nora. Tharros* was located on a headland west of Oristano, a site which provided access to the Gulf of Oristano and to the Tirso river valley and thus to the western interior of the island. It developed its beginning as a Nuragic coastal settlement to Phoenician entrepôt, to a Punic and then to a Roman city.[23] It had a long history as both a trading and a craft production center. *Sulcis* and *Bitia* were also Punic foundations that became *stipendarii* cities during the Roman period.[24] The remains of *Nora* visible today are mainly Roman, but scattered around the extensive though often poorly excavated site are traces of its Punic and even Nuragic past. *Nora* became, along with *Cariales* (Cagliari), a *municipium* of Roman citizens.[25]

The history of the coastal center at *Cornus* north of Oristano appears to have been somewhat different. At the moment when the Romans came on the scene, *Cornus* had a mixed population of Carthaginians and punicized Sards.[26] It is first mentioned in A.D. 215 when it was the focal point of the revolt of the punicized Sard, Hampsicora, against Rome.[27]

All of these Punic-Roman towns preserve characteristic features of Roman urbanism such as baths, theatres, planned streets, and well-designed houses. Those civic and domestic structures demonstrate the presence of a prosperous town élite who actively practiced patronage and displays of conspicuous consumption. Yet these and other similar communities clung to the shore much as they had in the days of the Phoenician traders. In some areas, as in the zone south of the Gulf of Oristano near *Neapolis*, there seems to have been some development of the immediate rural hinterland from the Roman period onward,[28] but this phenomenon appears to have been limited. The Phoenician-Punic settlers and then the Romans certainly traded with the natives in the hinterland, but, as will be shown shortly, they did not change their customs in significant ways.

The three major centers which developed as the result of what we may call Roman administrative urbanism were *Cariales* (mod. Cagliari), *Turris Libisonis* (mod. Porto Torres) and *Olbia. Cariales* on the south coast was the most important Roman administrative center

19 Dyson (supra n.1) 118-19.
20 Rowland (supra n.8) 74-76.
21 Rowland (supra n.8) 15-16.
22 Dyson (supra n.8).
23 E. Acquaro and C. Finzi, *Tharros* (Sassari 1986).
24 For *Sulcis*, cf. R. Bartolini, *Sulcis* (Rome 1989); for *Bitia*, cf. Meloni 1988 (supra n.2) 515-16.
25 C. Tronchetti, *Nora* (Sassari 1984).
26 P. Meloni, *La Sardegna romana* (Sassari 1990) 291-94.
27 S. L. Dyson, "Native revolt patterns of the Roman empire," in *ANRW* II.3 (1975) 144-46.
28 Zucca (supra n.9); Von Dommelen, *On colonial grounds* (Leiden 1998).

and the largest city on the island.[29] It was the natural outlet for the agricultural products of the fertile *Campidano*. The excellent harbour provided a trading and grain-export link with the wider Roman world. *Cariales* is represented among the trading cities illustrated by the mosaics of the *Piazzale degli corporazioni* at Ostia.[30] While the mediaeval and modern cities have engulfed many of the remains of their Roman predecessors, inscriptions, chance finds and excavated structures like the amphitheatre of the late 2nd c. A.D. (capacity estimated at 10,000) and the elegant house popularly associated with Tigellius, the Sardinian singer of the 1st c. B.C., show a prosperous and sophisticated Roman city.[31] It is clear that *Cariales* of the Roman period played a not dissimilar rôle to Cagliari in the Spanish period by providing an administrative center for its imperial masters and linking the island to the more sophisticated culture of the mainland.

Settlement at the site of *Turris Libisonis* can be traced back to at least the 2nd c. B.C. and occupation continued into the early mediaeval period.[32] Located on the north coast near the strait of Bonifacio, it was an important port-of-call on several maritime routes that linked Rome with the western provinces. It was the northern terminus of the main N–S road that united the island with *Cariales*. *Turris* was a planned Roman city with a number of impressive monuments.[33] Inscriptions of high imperial officials show it to have been an important administrative center. Its commercial importance is demonstrated by the mention of *navicularii Turritani* on one of the mosaics in the *Piazzale degli corporazioni* at Ostia.[34]

The third Roman urban center, *Olbia*, had a small hinterland and was isolated from the most productive regions of the island, although it did have a good harbor and an east-coast location facing Italy. A marginal Punic center, it became reasonably important under Roman occupation.[35] Again, there are significant Roman remains, including a number of villa sites.[36]

Roman cities and towns were supposed to stimulate the development of a penumbra of romanized rural centers in the areas around them, as was certainly the case in the countryside around Cosa.[37] The development of the typical villa/farmstead countryside around major towns has long been seen as one of the defining characteristics of Romanization in most parts of the western empire. It is a testimony to the way in which the Romans not only created urban structures, but also transformed rural life.[38] It is often assumed that similar transformations took place in Sardinia, and mention is often made of the existence of villas as though their remains were common on the island. Some villa sites have been found, and there is epigraphic evidence for villa communities.[39] However, most of the villa sites discovered to date are on the coast or near cities, suggesting that they were *villae suburbanae* or *villae maritimae*.[40] Substantial remains of villas in the interior are very rare.

29 Cagliari: Meloni 1988 (supra n.2), 496-503.

30 R. Meiggs, *Roman Ostia* (Oxford 1973) 209, 277, 288-89; C. Pavolini, *Ostia* (Rome 1983) 68-69.

31 Meloni 1988 (supra n.2) 496-503.

32 Meloni 1988 (supra n.2) 504-10; F. Villedieu, *Turris Libisonis. Fouille d'un site romain tardif à Porto Torres, Sardaigne* (BAR Int. Ser. 224, Oxford 1984).

33 Meloni 1988 (supra n.2) 504-10.

34 Pavolini (supra n.30) 68-69.

35 D. Paneddi, *Olbia nel periodo punico e romano* (Rome 1952).

36 Rowland (supra n.8) 78-88.

37 S. L. Dyson, "Settlement patterns in the *ager cosanus* The Wesleyan University Survey, 1974-1976," *JFA* 5 (1978) 251-68.

38 Transformation of the countryside in the West: J. Percival, *The Roman villa* (Berkeley 1979) 94-124.

39 R. Rowland, "The countryside of Roman Sardinia," in M. S. Balmuth and R. J. Rowland, Jr. (edd.), *Studies in Sardinian archaeology* (Ann Arbor 1984) 285-300.

40 Rowland, ibid.; Dyson (supra n.8).

Sardinia is often identified as an area where *latifundia* developed during the Roman period.[41] Various inscriptions, including *termini* associated with great estates, show that extended landholdings played a major rôle in the rural economy. However, they do not seem to be associated with major villa sites, and the extent of the phenomenon remains uncertain.[42] The interior parts have yet to produce the remains of a sumptuous residence like Piazza Armerina in central Sicily.

Intensive rural archaeological surveys are still rare in the interior of Sardinia. Two have been conducted by the author and R. J. Rowland around the Roman centers of *Forum Traiani* and *Uselis*. They were designed to investigate rural hinterlands of Roman towns as well as the Nuragic countryside at the border of these towns.[43] At *Forum Traiani*, in spite of a long history of Roman occupation and intensive investigation, there was little evidence for a rural settlement pattern of Roman farmsteads. The survey which we undertook in the area around Fordongianus, a town which had developed through interaction with the indigenous population, showed almost no evidence of rural Romanization.[44] Based on information and approaches used in the *ager cosanus* , the survey was designed to maximize the recovery of Roman rural sites. Our surveys in the immediately surrounding territory of *Uselis*. had similar negative results.[45]

These town hinterlands were clearly not transformed by long-term Roman occupation. However, it is important to remember that the agricultural products of Sardinia had some importance for the Roman economy and that Sardinia was expected to pay tribute to the Roman state. If the characteristically Roman pattern of rural land-use did not develop, the question becomes more important as to where and how people lived in the Sardinian countryside during the Roman era. The answer is increasingly clear: they lived where they had lived for centuries, in those ecological micro-niches of usable soil and reliable water that are highlighted today by the remains of Nuragic towers. The Late Bronze Age and Iron Age settlement-pattern of rural Sardinia was shaped by the lessons of survival in a harsh land and the need to sustain a small-scale mixed pastoral and agricultural economy within that environment.[46] There are a limited number of areas and a limited range of socio-economic organizations that allow for a productive rural society, and the Nuragic inhabitants had adjusted to those during the centuries prior to the arrival of the Romans.

The known structure of the indigenous society of the interior on the eve of the Roman conquest was based on small communities, probably of extended families located in scattered, fortified settlements. Toward the coast, some of the nuraghi had possibly been abandoned or destroyed during the Roman period, but the extent is hard to determine because of the lack of mass-produced Punic cultural indicators.[47] The literary sources suggest a brutal conquest of the countryside that involved systematic massacres and enslavements. A characteristic story is preserved in Zonares' epitome of Dio Cassius which tells how the Roman general M. Pomponius Matho imported hunting dogs to root out natives who had taken refuge in caves. So abundant

41 Meloni 1975 (supra n.2) 39 and 187.
42 Dyson (supra n.8) 484; A. Mastino, *Analfabetismo e resistenza alla romanizzazione nella Barbaria sarda (I-IV secolo d.C.)* (Sassari 1993).
43 Dyson and Rowland (supra n.17).
44 Ibid. 214-15.
45 Ibid. 215-16.
46 J. Webster and N. Cooper (edd.). *Roman Imperialism: Post-colonial perspectives* (Leicester 1996); E. Blake, "Constructing nuraghi: Settlement and construction of ethnicity in Roman Sardinia," *TRAC 96* (Oxford 1997) 114.
47 G. S. Webster and M. Teglund, "Toward the study of colonial-native relations in Sardinia from c.1000 BC-AD 456," in R. H. Tykot and T. Andrews (edd.), *Sardinia in the Mediterranean: A footprint in the sea* (Sheffield 1992) 448-62; Van Dommelen (supra n.28); 1998; E. Blake, "Sardinia's nuraghi: Four millennia of becoming," *World Archaeology* 30 (1998) 62-63.

were Sardinian captives on the slave markets after the campaigns of Ti Sempronius Gracchus in 177 B.C. that the expression *Sardi venales* came to mean cheap captives.[48] On a more general level, it has been assumed that the Romans, concerned about banditry and rural insecurity, would not have wanted an acephalous rural population living in isolated fortified towers in the Sardinian countryside. The inscription relating to the legal disputes of the *Pactulenses Campani* seems to confirm some type of resettlement schemes and native displacement in rural areas of Sardinia.[49]

All of this would appear to require a picture of a Romano-Sardinian countryside where extensive semi-Romanized areas were created and the indigenous population driven far into the interior.[50] Not all the evidence has supported this view. It is true that there is a lack of extensive villas, but there is scattered but increasingly persuasive evidence for Roman occupation at Nuragic sites.[51] This has been reinforced by the results of our survey[52] around *Forum Traiani* and *Uselis*. In both areas, a large sample of Nuragic sites was intensively surveyed for evidence of Roman occupation. In spite of less-than-ideal survey conditions at almost all sites, a high percentage of the nuraghi yielded evidence for Roman occupation.[53] The key datable indicators were black glaze, terra sigillata, and African red-slipped pottery. Around Fordongianus 83 of the Nuragic sites yielded Roman material and around Usellus 103. Twenty Fordongianus sites and 23 Usellus sites yielded evidence for occupation in the late Republic. Twenty-three Fordongianus sites and 25 Usellus sites produced material for occupation in an early Imperial phase. Fifty-five Fordongianus sites and 43 Usellus sites had African Red Slip Ware, an indicator of activity during the mid to late Empire. The problems and significance of this last type of evidence, with its very long period of use, have been discussed elsewhere.[54] However, even the most cautious interpretations confirm a significant continuation of indigenous rural settlement patterns into and through the Roman period.

The nature of these Romano-Nuragic settlements and the level of cultural continuity they represent can be partly reconstructed from the range of evidence found at the sites. The ceramics are normally the only significant evidence for interaction with the Roman economy. The relative lack of Roman structural materials such as cement and *cocciopesto* in the surface scatters, and the absence of evidence for change in architectural forms and building techniques, suggest that the Romans had a minimal impact on indigenous life. Finds of roof-tiles in scatters are not abundant and seem more related to burial than to building practices.

The surface surveys have produced much material that relates to the Nuragic cultural tradition. It includes quantities of obsidian and indigenous ceramics. It is logical to see these as remains from previous occupations, but the picture may be more complicated. Obsidian hydration dates obtained from samples recovered during the survey have shown that local obsidian remained in use during the Roman period.[55] The lack of significant wear on some of the indigenous ceramics raises the question of whether these wares too did not continue to be produced in the Roman period. Whatever the answer, from the Fordongianus-Usellus survey area it is clear that the indigenous population continued to live at their traditional sites and in a largely traditional manner during the Roman period.

48 Zonar. 8.18; Dyson (supra n.1) 246-59; Mastino (supra n.42).
49 Dyson (supra n.1) 258-61.
50 G. Lilliu, *La Sardegna* (Cagliari 1982) 37-39; Mastino (supra n.42).
51 Webster and Teglund (supra n.47) 462-69; Blake (supra n.47) 61, 63-64.
52 Conducted by the universities of Loyola, Wesleyan and SUNY Buffalo.
53 Dyson and Rowland (supra n.17) 211-14.
54 E. Fentress and P. Perkins, "Counting African Red Slip Ware," *L'Africa Romana* 5 (1988) 205-14; Dyson and Rowland (supra n.17) 212-13.
55 S. L. Dyson *et al.*, "Notes on some obsidian hydration dates in Sardinia," *Quaderni della Soprintendenza archeologica per le provincie di Cagliari e Oristano* 7 (1990) 25-42; Dyson and Rowland (supra n.17) 212.

A few years ago, these results would have been surprising and received with scepticism. However, recent research in various parts of the empire has highlighted the limits of Roman imperial power in extending control over and transforming indigenous societies, and has pointed to the complexity and ambiguity of the process that we call Romanization.[56] This fits well with ideological positions that stress resistance to imperialism and colonialism.[57] It also fits well into Sardinian historiographical debates, which define the true Sardinians as those in the interior who have successively resisted invaders, the Romans included, as opposed to the often conquered and assimilated coastal dwellers. This is a debate that is frequently framed by contrasts between farmers and shepherds.[58] The recent research discussed here suggests that the traditional Sardinian model has, if anything, underestimated the effectiveness of that resistance while not totally appreciating its complex nature.

In framing such discussions, one must keep in mind the nature of resistance and the ability of an imperial power like Rome to enforce its will. Roman historians have tended to focus on violent, generally futile and ineffective resistance and rebellion, often characteristic of the first stages of Romanization.[59] Increasing attention has been paid to banditry as a widespread phenomenon.[60] However, such resistance to imperial transformation need not be active to be effective. Scholars like J. Scott have highlighted the ability of peasant societies to engage in successful passive resistance strategies that allow them to maintain many aspects of their traditional lifestyles within imperial systems.[61]

It is also important that scholars not exaggerate the ability or even the desire of the Roman imperial administrators to project power. While initially the pursuit of loot and glory may have driven the Roman conquest, a desire to maintain relative peace and ensure the collection of tribute levied shaped the views of their more bureaucratic successors. Governors in Sardinia had limited administrative and military resources at their command as they attempted to control a large island with a very inaccessible terrain.[62] Their main interests in the countryside were that it remain relatively peaceful and that it produce the surpluses required for tribute.

These two primary considerations provided important support the idea that Roman policy left the indigenous rural system largely intact. The dispersed, small communities which remained centered on the nuraghi reflected centuries of adjustment to the ecology of Sardinia with its many scattered springs and small plots of arable land.[63] After the initial displays of Roman power and the destruction that followed in its wake, these small, politically-divided communities, even with their fortified towers, posed no significant threat to Roman security.

56 The literature on this subject is enormous. Some representative works include: T. F. C. Blagg and M. Millett (edd.), *The Early Roman Empire in the West* (Oxford 1990); P. W. M. Freeman, "'Romanisation' and Roman material culture," *JRA* 6 (1993) 438-54; J. Metzler, M. Millett, N. Roymans, and J. Slofstra, *Integration in the Early Roman West* (Luxembourg 1995); R. Hingley, "The 'legacy' of Rome: The rise, decline and fall of the theory of romanization" and other papers in J. Webster and N. Cooper (edd.), *Roman imperialism: Post-colonial perspectives* (Leicester 1996) 35-48; papers in D. J. Mattingly (ed.), *Dialogues in Roman imperialism: Power, discourse, and discrepant experience in the Roman empire* (JRA Suppl. 23. 1997); G. Woolf, "Beyond Romans and natives," *World Archaeology* 28 (1997) 339-50; id., *Becoming Roman: The origins of provincial civilization in Gaul* (Cambridge 1998); N. Terrenato, "The Romanization of Italy. Global acculturation or cultural bricolage," *TRAC 97. Proceedings of the Seventh Annual Theoretical Archaeology Conference* (Oxford 1998) 20-27.
57 M. Benabou, *La résistance africaine à la romanisation* (Paris 1976); Webster and Cooper ibid.
58 M. Le Lannou, *Pastori e contadini di Sardegna* (Cagliari 1979); Lilliu (supra n.50).
59 Dyson (supra n.1); Mastino (supra n.42).
60 B. D. Shaw, "Bandits in the Roman empire," *Past and Present* 105 (1984) 3-52.
61 J. Scott, *Weapons of the weak: Everyday forms of peasant resistance* (New Haven, CT 1985).
62 Meloni 1975 (supra n.2) 299-317; Y. Le Bohec, *La Sardaigne et l'armée romaine sous le Haut-Empire* (Sassari 1990).
63 G. Webster and M. Teglund, "Toward the study of colonial-native relations in Sardinia from c.1000 BC -AD 456," in Tykot and Andrews (supra n.8) 448-73.

They could continue as productive units, each yielding small surpluses which cumulatively met the demands for tribute and played a small rôle in the market economy. It is likely that for these groups the nuraghi had acquired a symbolic identity that contributed to social cohesion.[64] To accept this *status quo*, based on ecological and economic reality and social stability, made more sense than to disrupt existing patterns and attempt to create an *ager cosanus*-like rural structure ill-suited to the realities of the Sardinian environment.

Since town and country developed in complex symbiosis in the Roman world, the 'different' countryside of Sardinia was bound to create a very different system of towns. Their functions are represented by the three types of activities known from Fordongianus. A loosely-structured, acephalous indigenous society must have required constant, low-level diplomacy. The inscription that memorializes the rituals of loyalty carried out by the *civitates Barbariae* at *Aquae Hypsitanae* highlights what must have been an ongoing rôle for most Roman centers scattered throughout the interior of Sardinia. The designation of Fordongianus as a forum in the Trajanic era identifies its rôle as a market center. Such fora, well known from Republican Italy and elsewhere, often had limited architectural pretensions but, as in areas like Liguria and the Cisalpina, they played an important rôle in bringing scattered rural indigenous populations into the Roman economic system. Finally, the appearance of Fordongianus as the early Byzantine garrison town of *Chrysopolis* shows the ongoing rôle that such places played as garrison centers.

All of these important functions could be carried out without much in the way of physical structures. Towns in the interior of Sardinia were not there to provide models of civic Romanization or to help in the creation of an acculturated native élite. The lack of such an élite outside the older Punic coastal centers meant that there was neither a class capable of patronage nor the resources which made patronage possible. This differentiated Sardinia from most areas of the Roman empire;[65] hence the near-total absence of public monuments in towns of interior Sardinia.

In the past there has been a tendency to see a certain sameness in the activities of Rome in the West. What is becoming clear, as new evidence accumulates and new interpretations appear, is that the western Roman provinces saw a great diversity of patterns of development, especially in the countryside, as well as a complex dialectic between past and present in the local rural societies that developed during the centuries of Roman domination.

Roman urbanism in Sardinia has its own distinctive qualities. The coastal cities with their blend of Punic traditions and Roman development recall the Punic-Roman urban world of N Africa. Yet in the context of a countryside with a strong continuity, significant urban centers could not effectively develop, and the central places that did emerge provided minimal administrative, military, and economic functions. All of this took place within one of the oldest provinces of the Roman empire.

It is appropriate that this conference concentrate on the celebration of Roman urbanism, for mid-Republican Cosa provides an important example of that success. Yet late Republican and Imperial Sardinia highlights the limits of those urban processes. It is ironic that these two examples lie so close to each other on the Tyrrhennian sea.

Department of Classics, State University of New York Buffalo

64 Blake (supra n.46); id. (supra n.47).
65 R. P. Saller, *Personal patronage under the Early Empire* (Cambridge 1982).

Re-figuring colonial categories
on the Roman frontier in southern Spain
Mary E. Downs

Roman *Baetica* has long been considered one of the most Romanized and most urbanized provinces of the empire. Strabo claimed that the inhabitants of Turdetania had completely switched to the Roman mode of life (3.2.15), and reported some 200 cities within its territory (3.2.1). Modern historians have perpetuated this image. It was Rostovtzeff who coined a lasting epithet when he called *Baetica* "a little Italy".[1] Urban centers such as *Gades, Italica, Baelo, Malaca,* and *Corduba* indeed show widespread evidence of Roman building, Roman law and high levels of Latinization by the 1st c. A.D. The development of olive-oil production and the installation of Roman villas along the Guadalquivir river also attest to the integration of *Baetica* into the Roman imperial economy. Romans appear in prominent positions in the administration of the province from the earliest days of the conquest in the 3rd c. B.C., while native sons, the most notable of whom is Cornelius Balbus, worked their way into the ruling class at Rome.

Over the past two decades, however, the image of provinces transformed by the Roman model of urbanization has been significantly altered. Field surveys conducted throughout the Mediterranean — and in the Iberian peninsula, in particular — have demonstrated far greater continuity in indigenous settlement than had hitherto been acknowledged.[2] The data collected from surveys and excavations have also generated a new set of questions concerning the integration of provincial populations, the interaction between Romans and natives, and the adoption, adaptation and rejection of Roman cultural traditions by indigenous peoples.[3] The

The following abbreviations are used for frequently cited works:

Ponsich 1974, 1979, 1987	M. Ponsich, *Implantation rurale antique sur le Bas-Guadalquivir* (3 vols., Paris 1974, 1979, 1987).
Ruiz and Molinos 1987	A. Ruiz and M. Molinos (edd.), *Iberos. Actas de las I jornadas sobre el mundo ibérico, Jaén, 1985* (Jaén 1987).
Blagg and Millett 1990	T. F. C. Blagg and M. Millett (edd.), *The early Roman Empire in the West* (Oxford 1990).
Barker and Lloyd 1991	G. Barker and J. Lloyd (edd.), *Roman landscapes. Archaeological survey in the Mediterranean region* (London 1991).
Cunliffe and Keay 1995	B. Cunliffe and S. Keay (edd.), *Social complexity and the development of towns in Iberia* (London 1995).
Díaz-Andreu and Keay 1997	M. Díaz-Andreu and S. Keay (edd.), *The archaeology of Iberia. The dynamics of change* (New York 1997).
Mattingly 1997	D. Mattingly (ed.), *Dialogues in Roman imperialism* (JRA Suppl. 23).

1 M. Rostovtzeff, *The social and economic history of the Roman empire* (2nd edn, Oxford 1957) 211.

2 See, in particular, Ponsich 1974, 1979, 1987; A. Ruiz, M. Molinos and M. Castro, "Settlement and continuity in the territory of the Guadalquivir valley (6th century B.C. - 1st century A.D.)," in Barker and Lloyd 1991, 29-36; F. Burrillo, "The evolution of Iberian and Roman towns in the middle Ebro valley," in Barker and Lloyd 1991, 37-46; S. Keay, "Processes in the development of the coastal communities of Hispania Citerior in the Republican period," in Blagg and Millett 1990, 120-50; C. Haselgrove, "The Romanization of Belgic Gaul: Some archaeological perspectives," in Blagg and Millett 1990, 45-71; D. Vaquerizo, J. Murillo and F. Quesada, "Avance a la prospección arqueológica de la Subbética cordobesa: la depresión Alcaudete," *Anales de Arqueología Cordobesa* 2 (1991) 117-70; J. Edmondson, "Creating a provincial landscape: Roman imperialism and rural change in Lusitania," in J.-G. Gorges and M. Salinas de Frías (edd.), *Les campagnes de Lusitanie romaine. Occupation du sol et habitats* (Madrid 1994) 13-30.

3 See M. Millett, *The Romanization of Britain* (Cambridge 1990); S. Keay, "The Romanisation of Turdetania," *OJA* 11 (1992) 275-315; J. Webster and N. Cooper (edd.), *Roman imperialism: Post-colonial perspectives* (Leicester 1996); G. Woolf, "Beyond Romans and natives," *World Archaeology* 28 (1997)

notion of a Mediterranean-wide unity in Roman culture, or in Roman material culture, can no longer be sustained. Today, greater attention is focused on the multiple cultural and ethnic experiences across the empire, on the active rôle that indigenous populations played in the evolution of their own cultural landscapes, on regional variability, and on adaptations — in material culture, technology, language and forms of expression — on a local scale.

Here I will examine the rôle that the native Iberian population played in the urbanization process in southern Spain over the course of the 2nd and 1st c. B.C. and into the early Imperial period. The development of towns owes much to the pre-existing networks of power and to the new social dynamics that resulted from cultural interaction under colonial rule.[4] My concern is with the shaping of a new colonial society and with the ways that this hybrid society expressed its identity. After addressing the background to patterns of pre-Roman urbanization, I will look at the development of a new set of social dynamics among the groups who inhabited the province of *Baetica* in its formative period. This discussion is focused on the native élite, on their expressions of status, and on the motivations that lay behind the adoption of Roman customs. In order to provide some perspective on the colonial encounter and on the creation of a new colonial society, A comparative example from the Spanish frontier in central Mexico is used. Categories, such as 'urban', 'Roman', 'colony', which are used with great ease when referring to social formations in Roman Italy, become problematic when we attempt to use them in cultural and geographical settings on the periphery. The comparative material, in this case, assists in a re-figuring of colonial categories on the Roman frontier. In light of recent investigations of pre-Roman and Roman settlement, I hope to provide a re-assessment of the nature of urbanization in southern Spain and of the social dynamics that shaped its evolution.

The origins of towns and social ranking in pre-Roman southern Spain

Baetica, the area that is today Andalusia and was known under the Republic as *Hispania Ulterior*, had long been in contact with Phoenician and Carthaginian merchants and settlers (fig. 1). According to historical tradition, *Gades*, or Phoenician Gadir, was founded in 1100 B.C., although the archaeological evidence places the date closer to the 8th c.[5] Phoenician settlements along the southern coast, around the bay of Cádiz, and at the mouth of the Guadalquivir were well placed for transport and for access to the rich silver mines of Rio Tinto. Excavations at Phoenician settlements (Toscanos on the southern coast and Castillo de Doña Blanca near Huelva) show that the Phoenician population remained fairly isolated from the indigenous population, yet there is also evidence of mutual exchange.

Phoenician, and later Carthaginian, trade played a significant rôle in the development of social differentiation among the indigenous population. By the 6th c., the Iberian inhabitants had begun to construct their own urban environment.[6] Beginning in the 6th c., large, fortified

339-50; P. van Dommelen, "Colonial constructs: Colonialism and archaeology in the Mediterranean," ibid. 305-23; D. Mattingly, "Dialogues of power and experience in the Roman empire," in id. 1997, 7-24; P. van Dommelen, "Punic persistence: Colonialism and cultural identities in Roman Sardinia," in R. Laurence and J. Berry (edd.), *Cultural identity in the Roman empire* (London 1998) 25-48; G. Woolf, *Becoming Roman: The origins of provincial civilization in Gaul* (Cambridge 1998).

4 See Mattingly (supra n.3) who notes the importance of looking at the positive, creative uses of power.
5 For background on Phoenician and Carthaginian urbanization, see D. Ruiz, "La colonización fenicia en la península ibérica," in *Historia general de España y América* I.2 (Madrid 1987) 31-92; M. E. Aubet, *The Phoenicians and the West. Politics, colonies and trade* (Cambridge 1993); ead., "From trading post to town in the Phoenician-Punic world," in Cunliffe and Keay 1995, 47-65; H. G. Niemeyer, "Phoenician Toscanos as a settlement model? Its urbanistic character in the context of Phoenician expansion and Iberian acculturation," ibid. 67-88.
6 In general, I share the scepticism of G. Woolf regarding the urban status of *oppida* in the pre-Roman Iron Age world: see his "Rethinking the oppida," *OJA* 12 (1993) 223-34. On the urbanization process in Spain see, in particular, J. Santos, "The transition to a society with a state in the south-east of the

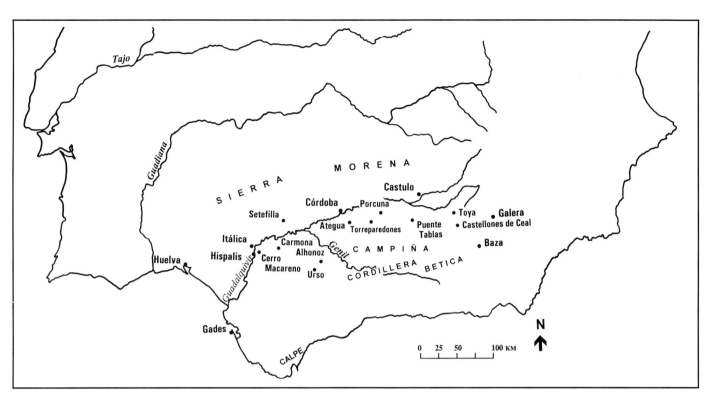

Fig. 1. Principal sites and geographical features mentioned in text.

settlements or *oppida* were constructed on defensible plateaus and throughout the fertile alluvial plain to the south of the Guadalquivir river. *Oppida*, such as Cástulo, Torreparedones, Puente Tablas and Tejada la Vieja, served as central places for the Iberian population, and many of them continued in occupation into the Roman period (fig. 1).[7] At the site of Cerro de la Cruz, high in the Subbetic mountain chain to the south of the river, clear evidence for zoning in residential and productive sectors is noted.[8] At Puente Tablas, the town was laid out on an orthogonal grid plan and included a central plaza.

In general, a complex settlement hierarchy may be noted throughout most of the Guadalquivir valley, with larger and smaller *oppida*, defensive towers and fortified farmsteads, as well as open rural sites, indicating a range of functions.[9] The settlement pattern varies greatly from one ecological zone to another and shows an economic interdependence between the mining areas of the upper valley (around Cástulo) and the lower valley (the Río Tinto area), the cereal-producing and grazing land of the alluvial plain known as the *campiña*, south of the river, and

Iberian peninsula (6th-4th century B.C.)," *OJA* 8 (1989) 213-26; J. Santos, "City and state in pre-Roman Spain: The example of Ilici," *Antiquity* 68 (1994) 289-99; A. Ruiz, "Plaza de Armas de Puente Tablas: New contributions to the knowledge of Iberian town planning in the seventh to fourth centuries B.C.," in Cunliffe and Keay 1995, 89-108; and G. Ruiz and J. Alvarez-Sanchís, "Las Cogotas: Oppida and the roots of urbanism in the Spanish Meseta," in Cunliffe and Keay 1995, 209-35.

7 In the following section, I am concerned with the general outlines of urban development and the expression of status in the pre-Roman Iron Age. Too few excavations and analyses of social organization have been done to permit greater chronological specificity: the attributes of chiefdom and intermediate-level, non-state societies to which I refer belong to the period of the 6th to 3rd c. B.C. For general summaries of excavations at these sites, see A. Ruiz *et al.*, "El poblamiento ibérico en el Alto Guadalquivir," in Ruiz and Molinos 1987, 239-56; J. Escacena, "El poblamiento ibérico en el Bajo Guadalquivir," in Ruiz and Molinos 1987, 273-97; J. Fernández, *Tejada la Vieja: una ciudad protohistórica* (Huelva Arqueológica 9, 1987); R. Harrison, *Spain at the dawn of history* (London 1988); Keay (supra n.3); M. Fernández, *Iberia in prehistory* (Oxford 1995).

8 D. Vaquerizo, J. Murillo and F. Quesada, *Fuente Tójar (Córdoba)* (Córdoba 1994).

9 See the discussion by Woolf (supra n.6).

Fig. 2. Pozo Moro monument (after A. Ruiz and M. Molinos, *The archaeology of the Iberians* [Cambridge 1998] fig. 74).

the upland zone of the Subbetic region which provided forest, summer grazing and limited arable lands (fig. 1).

Indigenous Iberian religion and burial customs also show regional variations. In the lower valley, social ranking is evident in *tumuli* burials where both locally produced and imported goods, including Greek vases, bronze weaponry, jewelry, glass and loom weights were displayed. In the upper valley, a similar repertoire of funerary goods appears in both chamber tombs and *tumuli* at sites such as Galera, La Toya, Castellones de Ceal, and Cástulo.[10] Only a few sanctuaries with architectural structures are known in Andalusia, though numerous small shrines, cave sanctuaries and sacred places have been identified from the presence of votive offerings.[11]

Social ranking is most evident in funerary monuments, where members of the indigenous aristocracy legitimized and expressed their status. In the region of Albacete, at Pozo Moro, an elaborately sculpted, 5-m-high stone funerary monument demonstrates a broad control of both ideology and of resources (fig. 2).[12] The tomb contained the cremated remains of an individual who was buried with a few ceramic items of Attic manufacture that aid in dating it to *c*.500 B.C. The iconography of the monument shows numerous oriental prototypes, including a master of the animals, a tree of life, an underworld scene, a voyage of a hero, and regal attributes such as a throne. The presence of divinities on the friezes may be seen as a legitimation of the divine or sacred, inherited power of the deceased. While there is an obvious borrowing of Phoenician iconography, it is also clearly a native monument to a native individual who had a supply of labor, talent and wealth at his disposal.

At the site of Cerrillo Blanco, near modern Porcuna, another elaborate sculptural group possibly intended as a funerary monument is known. It is slightly later — dating to *c*.450 B.C. — and is probably the work of Phocaean craftsmen. The scenes depicted show heroic warriors on horseback in pitched battle against mythical creatures. The style and imagery again show

10 See J. Pereira, "Necrópolis ibéricas de la Alta Andalucía," in Ruiz and Molinos 1987, 257-72.

11 For the sanctuary at Torreparedones, see M. Fernández and B. Cunliffe, "The Guadajóz project. Second interim report: excavations at Torreparedones 1988," *Report, Institute of Archaeology* (Oxford 1988); and J. Morena, *El santuario ibérico de Torreparedones (Castro del Río-Baena, Córdoba)* (Córdoba 1989); for a survey of sanctuaries, see L. Prados-Torreira, "Sanctuaries of the Iberian peninsula," in M. Balmuth, A. Gilman and L. Prados-Torreira (edd.), *Encounters and transformations: The archaeology of Iberia in transition* (Sheffield 1997) 151-59.

12 M. Almagro Gorbea, "Pozo Moro. El monumento orientalizante, su contexto socio-cultural y sus paralelos en la arquitectura funeraria ibérica," *MadMitt* 24 (1983) 177-293.

links with the eastern Mediterranean, but the monument represents an indigenous conception of the heroic and has been interpreted as an aristocratic heröon.[13]

Zoomorphic figures, mostly bulls, lions and boars, known from the Guadalquivir valley and from other areas of the Iberian peninsula may also have served as funerary markers.[14] The reconstruction of their function has been difficult since they are rarely found in context, but they may have formed part of complexes similar to that at Pozo Moro. Given their association with forms of portable wealth, and the expense of their production, they must be related to individuals of status.

The attainment of status in Iberian society of the 4th and 3rd c. B.C. appears to have been inherited and was legitimated through the display of prestige goods, such as gold, silver, weaponry and Greek vases, as well as through the control of territory. The control of redistribution of resources, and the existence of a tribute system, may be hypothesized on the basis of storage facilities, though it is not clear to what degree the distribution of staple items was controlled by political leaders.

Uneven access to resources lay at the root of status acquisition. In southern Spain, there was natural wealth based on minerals, fertile land for cultivation of grain, and natural harbors at *Gades, Carthago Nova, Malaca* and *Baria* (fig. 1). This natural wealth combined with a network of inland waterways enabled the development of production and exchange through commercial links, both on a regional and on a pan-Mediterranean level. The social ranking evident in the differentiated settlement hierarchy, mobilization of labor for the construction of defended settlements, and differentiation of status through material goods, marks these groups as chiefdoms or intermediate societies.[15]

Study of the Iberian Iron Age is in its infancy, and many more empirical case studies will be necessary before conclusions can be drawn about social organization and the acquisition of status in the pre-Roman period.[16] Since the basis of rank distinction is related to access to resources, there are likely to be variations in both the acquisition and the expression of status from one region to another, making it difficult to posit generalizations across regions. While Iberian social organization and settlement patterns appear to bear general similarities with the European Iron Age, we should be cautious before drawing analogies between northern and southern Europe.

The 'prestige goods model', which explained the rise of social ranking and urbanism in Europe as due to commercial links with the central cultures of the Mediterranean, has not met

13 For background on this monument, see J.-M. Blázquez and J. González, "The Phokaian sculpture of Obulco in southern Spain," *AJA* 89 (1985) 61-69; I. Negueruela, *Los monumentos escultóricos ibéricos del Cerrillo Blanco de Porcuna (Jaén)* (Madrid 1990); and A. Ruiz, "The Iron Age Iberian peoples of the upper Guadalquivir valley," in Díaz-Andreu and Keay 1997, 175-91.

14 T. Chapa, *La escultura ibérica zoomorfa* (Madrid 1985).

15 On social ranking in the Iron Age, see J. Bintliff, "Iron Age Europe in the context of social evolution from the Bronze Age through to historic times," in id. (ed.), *European social evolution: Archaeological perspectives* (Bradford 1984); T. Earle, "Chiefdoms in archaeological and ethnohistorical perspective," *Annual Review of Anthropology* 16 (1987) 279-308; K. Kristiansen, "Chiefdoms, states and systems of social evolution," in T. Earle (ed.), *Chiefdoms: Power, economy and ideology* (Cambridge 1991) 16-43; P. Wason, *The archaeology of rank* (Cambridge 1994); T. Earle, *How chiefs come to power* (Stanford 1997).

16 See P. Wells, "Iron Age temperate Europe: Some current research issues," *Journal of World Prehistory* 4 (1990) 452, where the author states: "Developing useful models for study of the social organization of different communities is perhaps the greatest challenge of Iron Age archaeology." Burial assemblages offer the greatest potential for the study of social organization and status: see B. Arnold, "Slavery in late prehistoric Europe: recovering evidence for social structure in Iron Age society," in D. Gibson and M. Geselowitz (edd.), *Tribe and polity in late prehistoric Europe* (New York 1988) 179-92; for an excellent study of social organization at an Iberian Iron Age site, based on demographic composition and analysis of burials, see Ruiz and Alvarez-Sanchís (supra n.6).

with general acceptance.[17] For Europe in general, and Spain in particular, status was unlikely to have been based on imported goods, which are unstable for an indigenous system.[18] Control of *local* production is more likely to have formed the basis of the acquisition and transmission of status. Though difficult to document, the institutions of kinship, patronage, gift-exchange and marriage alliance appear to have been central to Iberian élite behavior in the period immediately preceding the Roman conquest.[19] These institutions also governed relations between the Iberian aristocracy and Rome, both during and following the conquest, and at both an individual and a state level. The evolution of urban society and of urban institutions in early colonial Roman *Baetica* must, therefore, be viewed within the context of indigenous aristocratic behavior. In the following section, I will look at a number of ways in which the native élite made use of Roman institutions and forms of expression while at the same time maintaining an indigenous identity.

Iberian élite and Roman institutions: patronage, nomenclature and coinage

The relationship between patron and client formed the basis of Roman society. It encompassed the social relationship between former masters and their freedmen, binding both to an agreement of service (or *beneficia*) and protection. It also encompassed relations between conquerors and conquered in the provinces.[20] The terms *'in fidem'* and *'amicus'* efer to the client relationship established by the surrender of conquered communities. While the surrender appears to have granted to the commander the rôle of *patronus*, in some cases the surrender is considered to have placed the community *in fidem populi Romani*, indicating that the patron was the Roman state.

A similar patron-client relationship prevailed between members of the pre-Roman Iberian élite and the non-élite. Indeed, it has been suggested that at some point during the 5th c. B.C. a client system replaced the earlier aristocratic system based on kinship, although there were probably variations in social organization among the autonomous groups inhabiting southern Spain.[21] The archaeological correlates of this patronage system can be seen in the aristocratic houses and the layout and division of space at *oppida* such as Puente Tablas and at Cerro de la Cruz; it is also evident in the spatial distribution of tombs and the differentiation in burial goods at the cemetery at Baza.[22] In the period between the 5th and 3rd c., conflicts between the autonomous groups of southern Spain and their neighbors to the west, the Lusitanians, as well as conflicts with Carthage and Rome, contributed to the development of a warrior aristocracy. This class was probably even more dependent upon the client bonds, and it is in this period that

17 See D. Nash, "The growth of urban society in France," in B. Cunliffe and T. Rowley (edd.), *Oppida in barbarian Europe: The beginnings of urbanization in barbarian Europe* (BAR Int. Ser. 11, Oxford 1976) 95-134; P. Wells, *Culture contact and culture change* (Cambridge 1980); P. Wells, *Farms, villages and cities: Commerce and urban origins in late prehistoric Europe* (Ithaca 1984); B. Cunliffe, *Greeks, Romans and Barbarians: Spheres of interaction* (London 1985).

18 See C. Gosden, "Gifts and kin in early Iron Age Europe," *Man* 20 (1985) 475-93.

19 See R. Etienne, *La culte impériale dans la péninsule ibérique d'Auguste à Dioclétien* (Paris 1958) on the concept of *fides iberica*, the bond that tied lower social classes to their leaders. For the use of marriage alliances and gift exchange between states, note that the daughter of a Castulo chief was given in marriage to Hannibal (Livy 24.41). For the area of the Guadalquivir valley, see A. Ruiz in Cunliffe and Keay 1995, 100 and in Díaz-Andreu and Keay 1997, 182-83, where the author sees a transition in the 5th c. from a system based on consanguinal kinship to one based on clientelage. On patronage in the Iberian world and its continuity and use in the early Roman period, see also Keay (supra n.3); id., "Innovation and adaptation: The contribution of Rome to urbanism in Iberia," in Cunliffe and Keay 1995, 291-337; and id., "Urban transformation and cultural change," in Díaz-Andreu and Keay 1997, 192-210.

20 See E. Badian, *Foreign clientelae, 264-70 B.C.* (Oxford 1958).

21 See A. Ruiz in Cunliffe and Keay 1995, and in Díaz-Andreu and Keay 1997, 182-83.

22 See A. Ruiz in Díaz-Andreu and Keay 1997, 183-85.

there arose the institution of *fides iberica*, by which the non-élite were bound to service and protection.

The precise terms of agreement of service and protection that governed relations between individuals of different classes in the southern Iberian world and those in the Roman world of the mid- to late Republic may have differed. But it is also clear that the institution of patronage, which played such an important rôle in regulating social relations between conqueror and conquered, was not alien to the indigenous population. Between the late 3rd and mid-1st c. B.C., following the expulsion of Carthage, formal Roman provincial administration was minimal and rudimentary, and formal colonies were an exception, if they existed at all.[23] The informal ties of patronage between the indigenous élite and Roman commanders in *Hispania Ulterior* were, therefore, the primary bonds governing social and political relations between Rome and the indigenous population. These informal social ties between individuals themselves formed the core of a new colonial society. They represent a tangible form of continuity from the pre-Roman indigenous world and were influential in creating a new Hispano-Roman form of society.[24]

How did the indigenous élite make evident their acceptance and adaptation of the institution of Roman patronage? The pre-Roman Iberian system of naming individuals is known only from limited epigraphic evidence. Few individuals are named in Iberian inscriptions. Our evidence, therefore, comes from historical sources, from the few Republican-period Latin inscriptions, and from local, indigenous coinages instituted following the conquest.[25] The use of the Roman *tria nomina* by native Iberians appears to have been rare in the Republic down to Caesar.[26] But following the conquest of the late 3rd and early 2nd c. B.C., in both southern and central Spain, Iberian individuals began to take the family names of their Roman patrons. The most common names used by Iberian individuals include Cornelius, Fabius and Sempronius, reflecting the relationship with early commanders and governors.[27]

The adoption of Roman names may or may not indicate a client relationship, but of the native magistrates recorded for the Republican period in southern Spain, a large number bear a Roman name that appears to have been a conscious choice. The names are rarely *tria nomina*, indicating that they were probably native individuals. The names either consist of an Iberian name (that is, as a *praenomen*) and a Roman *nomen*, or of a Roman *praenomen* and *nomen*. An examination of the inscriptions on coins indicates that most of the magistrates in southern Spain were native, confirming that local government continued in the hands of the indigenous élite through the Republican period and into the Empire. In many cases, Iberian leaders, in the Latin sources bearing the name of *dux* or *regulus*, simply became the magistrates of a town

23 See J. Richardson, *Hispaniae. Spain and the development of Roman imperialism, 218-82 B.C.* (Cambridge 1986); and id., *The Romans in Spain* (Oxford 1996), on the lack of administrative structures during the mid- to late Republic.

24 The idea that Roman provincial social organization was a new, hybrid form that differed from its pre-Roman European and from its Italian Roman origins has been treated by Woolf (supra n.3).

25 Some Iberian individuals are named in the Latin and Greek sources for the Second Punic War and later. They are native leaders, for the most part, and are usually referred to by a single name: e.g., Culchas, Indibilis, Corribilis, Indo, etc. For the local, native coinages, see Keay (supra n.3) 288-92; and L. Villaronga, *Corpus nummum Hispaniae ante Augusti aetatem* (Madrid 1994). See F. Chaves Tristán, "The Iberian and Early Roman coinage of Hispania Ulterior Baetica," in S. Keay (ed.), *The archaeology of Early Roman Baetica* (JRA Suppl. 29, 1998) 147-71. The coinages were issued autonomously by towns and show great variation in style and language. Between the late 3rd and late 1st c. B.C. it is estimated that about 75 mints produced their own bronze coinage. Some mints include the name of the Iberian town in Latin script, some use Iberian script, while others make use of a Libyo-Phoenician script, and a few include the names of the individuals (or magistrates) by whose authority the minting took place.

26 See, in particular, L. Curchin, *The local magistrates of Roman Spain* (Toronto 1990).

27 For the practice of adopting Roman family names by natives, see S. Dyson, "The distribution of Roman Republican family names in the Iberian peninsula," *AncSoc* 11-12 (1980-81) 257-99; and Curchin ibid.

following the conquest, thus demonstrating continuity of function if not of name. Such was the case at *Castulo* where Scipio, at the close of hostilities with Carthage, installed the former leader as the first magistrate (Appian, *Hisp.* 6.32).

The recording of individual native magistrates on coinage represented a new medium for the expression of status: Roman offices in a Roman medium, but indigenous status in an indigenous context and in Iberian languages. The native élite were thus capable of using Roman ideological symbols for their own purposes, from which we can see the creation of new social categories within the context of colonial society.

The formation of a new colonial society

The ethnic composition of southern Spanish society was also evolving. In 171 B.C., a group of 4000 hybrid offspring, or a *novum genus*, appealed to the Roman Senate for the foundation of a new colony, *Carteia*, to accommodate them (Livy 43.2-3). The appeal resulted in the founding of a *colonia Latina libertinorumque* (a Latin colony and of freedmen). The *novum genus*, presumably the children of unions between Roman soldiers and Iberian women, must have felt themselves neither wholly of one ethnic world nor of the other, and so asked for special treatment. The request from the Carteians, and the granting of a colony to them by the Roman Senate, has been treated by modern historians as an exception.[28] It came early in the years following the conquest, at a time when few administrative regulations had been established, and it has few parallels, at least as reported in the sources. But the phenomenon itself was not at all exceptional. If there were 4000 hybrid offspring in the area of Carteia by 171 B.C., within little more than one generation of the conquest, how many were there in the area of *Italica* or *Corduba* or *Gades*? And how many were there a century later? The largely mixed component of those populations may not have taken their appeal to the Roman Senate, thereby to be recorded, as the Carteians' case was, but the bearing of children of mixed ancestry could not have occurred only in the area of Carteia. A brief consideration of the demographic composition of southern Spain during the 2nd and 1st c. B.C. leads to the conclusion that the greater part of the population was of mixed ethnic ancestry: Phoenician, Punic, Greek, Iberian, Latin, Italian and, only in small measure, Roman.

One of the difficulties of studying Roman frontier society is that we lack the documents that might help us restore either Roman colonial or indigenous voices. There are exceptions: the Vindolanda tablets and Egyptian papyri provide detailed and telling pictures of daily life on the frontier, and from them we can begin to reconstruct the social and ethnic complexity of life outside the Italian peninsula.[29] But, in general, apart from a few indecipherable scratches of Iberian inscriptions on bronze, and some later coins, we lack documents that tell us about Spanish frontier society from anything other than a Roman perspective.[30]

28 See J. Richardson, *The Romans in Spain* (Oxford 1996) 77-78.

29 See A. Bowman, *Life and letters on the Roman frontier* (London 1994).

30 Historians and sociologists of empires recognize the imbalance in documentary sources as a structural feature of dominance. See E. Wolf, *Europe and the people without history* (Berkeley 1982); M. Doyle, *Empires* (Ithaca 1986); S. Alcock, "Archaeology and imperialism: Roman expansion and the Greek city," *JMA* 2 (1989) 87-135; and C. Sinopoli, "The archaeology of empires," *Annual Review of Anthropology* 23 (1994) 159-80. In general, Roman historians have not attempted to use material from other, better-documented imperial or colonial settings to illuminate the processes of acculturation. There are a few exceptions: see R. Syme, *Colonial élites* (London 1958); M. Finley, "Colonies — an attempt at a typology," *Transactions of the Royal Historical Society* 1976, 167-88; P. Brunt, "Reflections on British and Roman imperialism," *Comparative Studies in Society and History* 7 (1965) 267-84. A few Roman archaeologists have noted the value of studies of comparative colonialism: cf. S. Dyson, "The role of comparative frontier studies in understanding the Roman frontier," in D. M. Pippidi (ed.), *Actes du 9e Congrès internationale d'études sur les frontières romaines* (Bucharest–Cologne 1974) 277-83; id., *The creation of the Roman frontier* (Princeton 1985); B. Bartel, "Comparative historical archaeology and

If we are to recover any sense of the indigenous experience in the Roman provinces, we must expand our inquiry to modern empires, where the historical documentation of social processes on frontiers is much richer. Spain's conquest of the New World, in particular, is well documented in the archives of legal transactions from both Mexico and South America.[31] Beginning with Cortés' arrival in central Mexico in 1519, numerous documents in native Nahuatl record the reaction of Aztec and other indigenous peoples to the conquest. Such documents allow us to observe, over the long term, the evolution of indigenous society and provide a perspective on colonial society in the Roman provinces. Inter-marriage and hybridity are pervasive frontier phenomena.[32] Yet they have received little attention in Roman provincial studies, despite the impact that they had on the composition, attitudes and behavior of colonial society. The mixed ancestry of the Hinojosa family in 17th-c. Cuernavaca may, for example, be taken as an analogy to situations, like the case of the Carteians, that must have been common on the Roman frontier. The following account is used to illustrate the complex issues of power and identity that motivate the behavior of indigenous élite family members in the context of their local society.[33]

In Cuernavaca, in central Mexico, between the 16th and 18th c., five generations of the Hinojosa family were involved in a legal dispute over the father's (don Antonio de Hinojosa's) embezzlement of the town's tribute monies (fig. 3). The ensuing court case produced volumes of both Spanish and Nahuatl witness testimony, as well as estate inventories that allow us to reconstruct both the public and private lives of this prominent Cuernavacan family. Since before the conquest, the family belonged to the native ruling élite. Throughout the 16th and 17th c., members of the native family inter-married with Spaniards, producing a family of *mestizos*. Members of the family demonstrate, over the years, a taste for both Spanish and native goods. Their household inventory includes items of both Spanish and native origin: religious images, daggers, and swords from Spain, but also pre-Hispanic noble insignia: feathered head-dresses and traditional musical instruments.

archaeological theory," in S. L. Dyson (ed.), *Comparative studies in the archaeology of colonialism* (BAR Int. Ser. 233, Oxford 1985) 8-37; and, more recently, C. Whittaker, *Frontiers of the Roman empire* (Baltimore 1994). J. Webster is one of the few scholars who has employed the documentary record of Spanish colonialism in the New World to illuminate the acculturation process on the Roman frontier, specifically in the study of syncretism: see her "A negotiated syncretism: Readings on the development of Romano-Celtic religion," in Mattingly 1997, 165-84, and "Necessary comparisons: A post-colonial approach to religious syncretism in the Roman provinces," *World Archaeology* 28 (1997) 324-38. The body of post-colonial literature that deconstructs western categories of knowledge is now growing: see E. Said, *Orientalism* (New York 1978); id., *Culture and imperialism* (New York 1993); J. Webster and N. Cooper (edd.), *Roman imperialism: Post-colonial perspectives* (Leicester 1996); and P. Schmidt and T. Patterson (edd.), *Making alternative histories: The practice of archaeology and history in non-western settings* (Santa Fe 1995).

31 Here I include only a few titles: S. Stern (ed.), *Resistance, rebellion, and consciousness in the Andean peasant world* (Madison 1987); P. Galloway, "The unexamined habitus: Direct historical analogy and the archaeology of the text," in J.-C. Gardin and C. Peebles (edd.), *Representations in archaeology* (Bloomington 1992) 178-95; S. Kellogg, "Hegemony out of conquest: The first two centuries of Spanish rule in central Mexico," *Radical History Review* 53 (1992) 28-46; S. Ortner, "Resistance and the problem of ethnographic refusal," *Comparative Studies in Society and History* 37 (1995) 173-93; T. Abercrombie, *Pathways of memory and power: Ethnography and history among an Andean people* (Madison 1997).

32 See the recent study by R. Young, *Colonial desire: Hybridity in theory, culture and race* (London 1995); and P. Carrasco, "Indian-Spanish marriages in the first century of the colony," in S. Schroeder, S. Wood and R. Haskett (edd.), *Indian women of early Mexico* (Norman 1997) 87-103.

33 See R. Haskett, "Living in two worlds: Cultural continuity and change among Cuernavaca's colonial indigenous ruling élite," *Ethnohistory* 35 (1988) 34-59; and R. Haskett, *Indigenous rulers: An ethnohistory of town government in colonial Cuernavaca* (Albuquerque 1991). Most of the documents relating to the Hinojosa family are held by the Archivo General de la Nación in Mexico City and are cited in full in Haskett's publications.

Fig. 3. Genealogical chart of the Hinojosa family (after R. Haskett, "Living in two worlds," *Ethnohistory* 35 [1988] fig. 1).

As in the Roman world, certain rules governed dress. Licences were required for the indigenous population to wear Hispanic dress, but this does not appear to have deterred members of the Hinojosa family — both male and female — from sporting Hispanic clothing. In 1714, don Melchor de Hinojosa was cited for not having obtained the necessary licence, but defended himself, claiming that he needed to set himself apart as a member of the élite and needed, as a town officer, to command authority. But beneath this patina this Indian family shows, in both its marriage and its career patterns, the continuity of indigenous traditions.

Antonio de Hinojosa, to judge from his name, was probably a *mestizo*, the son of a native woman and a Spaniard. His marriage to a woman of a noble Indian family produced two sons, don Juan and don Agustín, who both became governors of Cuernavaca, an office restricted to the highest élite. These two sons both married the daughters of local *caciques* (chiefs), thus cementing ties to the indigenous élite world. Both were bilingual and both appear to have openly admitted their mixed ancestry. Indigenous descent was a precondition for serving on the town council, so there was good reason to admit to their native background, and both sons appear to have boasted of their noble Indian ancestry. But there were also benefits to claiming mixed descent, since *mestizos* were exempt from tribute. Don Agustín also at times referred to himself as a Spaniard, thus indicating that ancestry was, for this upwardly mobile individual, something that one put on at will, depending on the benefits of the situation.

I do not imply by this comparison that the historical conditions of Roman colonialism and Spanish colonialism in the New World were identical, but the parallels are worth considering. First, it is clear that there were conflicts in individual identity regarding language, dress and self-representation that find analogies in the appeal of the Carteians for a colony to accommodate them. Secondly, comparable notions of nobility, status and patronage were operative in both the Iberian and Roman worlds, as in the Aztec and Spanish worlds. Thirdly, there were comparable conditions of bi-culturalism and of hybridity of the respective populations.

Colonization, colonialism and the adoption of Roman customs

The current generation of Roman historians and archaeologists working in the provinces has recognized that there was no active 'Romanizing' on the part of Rome. In recent years, scholars have stressed that the gradual adoption of Latin language and Roman customs, and assimilation to Roman institutions, varied greatly in time and space and was driven by the interests of the local indigenous aristocracy.[34] But, in the absence of documents that would provide more detail about the motivations and behavior of the indigenous élite in their relations with Rome, scholars have sought refuge in the creation of a stereotype, a vague construct with no historical flesh on his bones — the semi-Romanized native. The construct of the "semi-Romanized native" makes the analysis of frontier demographics much easier. If we accept that there were Romans (pure) and Iberians (also pure), all the difficult-to-classify members of society would make up this third, hybrid category. But cultural and ethnic identity cannot be so easily categorized. I have often wondered which parts of the semi-Romanized native were Romanized, and which parts native. Do these individuals use Roman goods, but worship native gods? Or do they take on Roman names, yet teach their children the Iberian language? The account of the Hinojosa family demonstrates that the indigenous élite of central Mexico consciously manipulated identity to suit its own needs; as historians of the Roman frontier, we must be aware of the position from which we ascribe such categories.

The construct of the "semi-Romanized native" comes very close to the kind of character observed by the anthropologist Haviland Scudder Mekeel among the Lakota Indians of South Dakota in the 1930s, where Mekeel traveled, recording his observations of an Indian nation in the process of transition. He found Indians who were: 1) Christian and acculturated; 2) pagan and living according to the 'old ways'; and 3) the majority, the riff-raff, the loafers, the delinquents and the criminals.[35] The last group was the one that did not fit Mekeel's image of what the Indian should be. In his search for the pure and the primitive, he created a category, not recognizing that the criteria were, in fact, the result of conflict and dominance.

The Iberians of southern Spain had, by the 3rd c. B.C., mixed with Phoenicians and Carthaginians, and throughout the 2nd and 1st c. continued to mix with Roman and Latin colonists. The resulting colonial society in Roman Spain was far from being purely Roman or purely Iberian. The colonial élite were not Iberians dressed up in Roman clothing, but rather a complex cultural and ethnic admixture; indeed, they were a new class that derived and expressed its status differently from their Iberian predecessors. Indigenous use of Roman material goods as an expression of status needs to considered within an indigenous context. The native élite used such expressions of status to identify themselves with the dominant ideology, as well as to distinguish themselves from the native non-élite.

This identification of the indigenous élite with Rome is what some have seen as "indigenously generated Romanization". This process, according to Millett, set up a "trickle-down effect", in which lower classes would have emulated the indigenous élite in the acquisition of Roman symbols. That the lower classes emulated the indigenous élite is, however, an *a priori* assumption that cannot be easily demonstrated in the archaeological record. While the indigenous élite may have been responsible for the marketing of a Roman message, it does not necessarily follow that the remainder of the population became subject to the same ideology.

34 Note Mommsen's assessment: "In no province under the imperial period was Romanising so energetically promoted on the part of the ruling power as in Spain," in his *The provinces of the Roman empire: The European provinces* (ed. T. Broughton, Chicago 1968) 70. But compare D. Saddington, "The parameters of Romanization," in V. Maxfield and M. Dobson (edd.), *Roman frontier studies 1989: Proceedings of the 15th International Congress on Roman Frontier Studies* (Exeter 1991) 413-18; and Haselgrove (supra n.2).

35 See T. Biolsi, "The anthropological construction of 'Indians': Haviland Scudder Mekeel and the search for the primitive in Lakota country," in T. Biolsi and L. Zimmerman (edd.), *Indians and anthropologists: Vine Deloria Jr. and the critique of anthropology* (Tucson 1997) 133-59.

Indeed, the long-lived continuity of indigenous traditions — in ceramic manufacture, settlement patterns, language, and agrarian practices — may be seen as a new and charged conflict between the indigenous élite and the rest of the native population.

The pre-Roman inhabitants of southern Spain — ethnically mixed, socially differentiated, and regionally diverse — were the creators of their urban world. The large numbers of native settlements in the province have received little attention because they do not show standard Roman features, yet these towns must figure in our assessment of the process of urbanization. Many indigenous towns, which show a limited repertoire of Roman goods, continued in occupation into the early Empire, even those *oppida* that in the 1st c. A.D. had attained municipal status. While towns such as *Gades, Italica* and *Corduba* did, by the end of the 2nd c. B.C., have both a Roman population and a Roman character to them, politically, socially and architecturally, many native towns did not. In fact, up to the period of Caesarian colonization there were few Roman colonies in southern Spain, and there were few Romans.[36] The founding of the veteran colony at *Italica* in 206 B.C. was a stark exception for the Republican period, the name itself a probable reference to the Italian, rather than Roman, background of the colonists. Estimating the number of Romans in southern Spain during the latter part of the Republic is fraught with difficulties. Commercial centers such as *Gades, Italica* and *Corduba* attracted traders, and a small number of colonies clearly had a Roman population. But the number of colonies, formal or informal (three by the end of the 2nd c.; two or three more under Caesar; another three under Augustus) is so small in comparison to the very large number of native settlements that we must accept a very limited Roman presence down to the period of the early Empire. K. Hopkins has estimated that for the western provinces, in general, the ratio of Roman administrators to the indigenous population was in the range of 1 : 350,000 or as high as 1 : 400,000.[37] Without entering into the statistical methods employed, or Iberian population estimates, given the size and number of continuously inhabited native settlements, the numbers are probably about right.

The image of a highly Romanized and urbanized *Baetica* rests on the number of towns reported in the texts of Strabo and Pliny, only some of which are known archaeologically.[38] The colonies include well-known and archaeologically well-documented centers like *Italica, Urso, Corduba, Astigi, Gades*, and *Malaca*, all located either on the southern coast, or on the navigable portion of the Guadalquivir river and its tributaries, that is, in the lower valley. The image of a very Roman landscape is compounded by the finds of luxury villas, again in the area of the lower valley, that are connected to the olive-oil and Dressel 20 amphora production, and for which *Baetica* is famed.[39] This city-country interdependence is, of course, one of the features of urbanism that has helped to shape the impression of a province that was thoroughly integrated into the Roman economy.

But this image needs to be qualified on quite a few counts. First, *Baetica* was only a military frontier for a short period of time, and it shows few of the military installations that are commonly found on the northern and eastern frontiers. Secondly, the colonies that were established in *Baetica* following the Civil Wars were not new foundations, but were native towns, like *Urso*, whose indigenous population probably remained a majority alongside the

36 The question of how extensive the Roman military/colonial presence was in southern Spain during the 2nd and 1st c. has been dealt with by others: see R. Knapp, *Aspects of the Roman experience in Iberia, 206-100 B.C.* (Valladolid 1977); Richardson, *Hispaniae* (supra n.23); and A. Fear, *Rome and Baetica: Urbanization in southern Spain, c.50 B.C.-A.D. 150* (Oxford 1996). None of the historical evidence supports a very large number; indeed, the small number of colonies established before the Caesarian period argues against there being a significant number of Romans.

37 K. Hopkins, "Taxes and trade in the Roman empire (200 B.C.-A.D. 400)," *JRS* 70 (1980) 101-25.

38 For *Baetica*, Strabo 3.2.1-3 and Plin., *NH* 3.1.7-15 report 9 colonies and some 100 *municipia*.

39 See Ponsich 1974, 1979, 1987; also J.-G. Gorges, *Les villas hispano-romaines. Inventaire et problématique archéologiques* (Paris 1979).

Roman colonists. Centers such as *Italica, Corduba* and *Urso* did adopt a town layout with the monumental architecture we associate with Roman colonies: theaters, amphitheaters, temples, baths and basilicas. But these centers are the exception.

Most of the towns reported by Pliny as *municipia* — places like *Iponuba, Iliturgicola, Sosontigi, Isturgi, Sacili Martialis* — only received their municipal status with the granting of the *ius Latii* in A.D. 70 by Vespasian (fig. 1). These centers continued with their indigenous populations and received no Roman or Latin colonists. Up to now, many of these *municipia* have been known only by name, but new archaeological investigations are revealing that into the 1st and 2nd c. A.D. there are few traces of what we would recognize as Roman architecture.[40] Roman material culture — especially *terra sigillata* and Roman amphorae — appears on these sites, but the *terra sigillata* is the locally-produced *hispánica* variety that came from the main production center of Los Villares de Andújar in the upper Guadalquivir valley. While Spanish *terra sigillata* made use of Roman models and technology, it was a locally produced ware, and its presence on sites indicates only that the inhabitants used a widely diffused type of locally produced Roman pottery. It cannot and should not be used to ascribe cultural or ethnic identity to the user.

Farmsteads belonging to the Roman period have also been identified in the upper Guadalquivir valley, from Cordoba eastwards, but very few are luxury villas, and very few are major production centers; rather, they are rural settlements that served local production needs.[41] The absence of agricultural villas in this area can easily be explained: the Guadalquivir was not navigable beyond *Corduba*. Nonetheless, these variations must figure in our consideration of the extent of urbanization and Romanization in the province of *Baetica*. The regional variations are great enough to be able to question the claims that *Baetica* was highly Romanized or highly urbanized. There were zones that were both Roman and urban — as in the lower Guadalquivir valley —, but much of the province remained grounded in indigenous and locally based networks of exchange and social hierarchies.

Conclusions

In an area such as Roman *Baetica* where much work is now being done, the questions are more easily raised than they are answered: what was the relationship between native leaders and their constituent populations? How much did the native élite encourage the adoption of Roman customs? Patronage between native leaders and their Roman representatives is likely to have played a significant rôle, but thus far issues such as the Roman education of native leaders and their children — as we know was the case in Gaul — have not yet been explored. These are the sorts of questions that are arising in post-colonial studies and that need to be posed in order to understand the power structures that functioned among a population that was clearly mixed, and that was expressing its hybridity in its material goods, its monuments, its dress, and its language. Once we have explored the indigenous background, the definition of 'Romanitas' — whether in town plans, architecture or material assemblages — becomes much more difficult. It becomes clear that categories such as Roman (and Romanized), native, and urbanized, are constructs that serve to obscure, rather than elucidate, the processes of cultural contact and adaptation. The image of *Baetica* as a highly Romanized province is a colonial image, produced by Rome and re-produced by modern historians. The asymmetry — in relations of power

40 See, in particular, A. Muñoz, "Excavaciones de Iponuba. Novedades arqueológicas," in *Symposium de arqueología romana, Segovia* (Barcelona 1977) 279-83; O. Arteaga and M. Blech, "Untersuchungen auf dem Cerro de Maquiz. Vorbericht der Kampagne Mai 1984," *MadMitt* 26 (1985) 177-84; and O. Arteaga and M. Blech, "La romanización en las zonas de Porcuna y Mengíbar (Jaén)," in *Los asentamientos ibéricos ante la romanización* (Madrid 1987) 89-99.

41 M. Castro, "El poblamiento romano de las campiñas occidentales del Alto Guadalquivir. El imperio," in *Actas del 1er Congreso peninsular de Historia Antigua* II (Santiago de Compostela 1988) 315-31; and Ponsich 1974, 1979, 1987.

between Rome and provincial populations, and in the representation of those relations — needs to be incorporated into our models, so that we come to know Iberian material culture as well as we know Roman material culture, and so that we understand the power structures that operated in both of these worlds.

Washington, D.C.

Acknowledgements

Comments on this paper from, and discussions with, S. Alcock, J. Edmondson, M. McDonnell, S. Dyson and E. Fentress have helped me to clarify a number of points. The paper, in slightly different form, was also presented at the Theoretical Roman Archaeology Conference (Leicester) in April, 1998, and comments made there by J. Webster and D. Mattingly are gratefully acknowledged.

L'odéon dans la basilique: mutation des modèles ou désagrégation des programmes?

Pierre Gros

La difficulté principale à laquelle se heurte l'historien pour suivre l'évolution des villes d'Italie au cours de la période impériale réside dans l'absence de modélisation. Si les "modèles" qui régissent l'ordonnance des agglomérations urbaines au cours des siècles antérieurs — ceux des colonies maritimes,[1] de la "municipalisation" consécutive à la Guerre sociale[2] ou du premier urbanisme augustéen[3] — sont, dans leurs grandes lignes, précisément définis et se laissent en général repérer sur le terrain, les normes observées au long du Haut-Empire, si tant est qu'elles aient jamais existé, nous échappent pour l'essentiel.[4]

L'un des cas les plus démonstratifs, indépendamment des vicissitudes propres à ce site, est celui de Cosa. Les travaux de F. E. Brown et de son équipe ont magistralement reconstitué les étapes de l'implantation de cette colonie de droit latin au cours des phases initiales des IIIe-IIe s. av. J.-C.[5] La mise en place et l'équipement monumental des deux centres, le civique et le religieux, s'achèvent dans les années 150 av. J.-C., et le fait qu'un couloir urbain, à la fois viaire et visuel, soit maintenu entre le forum et l'arx témoigne, pour cette période, de l'importance de l'axe qui relie le sacré au politique, le capitole au comitium, la basilique, dernière venue dans la panoplie, constituant le complément indispensable de la place publique et de ses annexes administratives.[6] Même si le caractère d'exemplarité de l'urbanisme de Cosa s'avère, à l'examen, un peu moins patent que ne donnait à croire F. E. Brown, cette première ville répondait du moins à un projet d'une continuité et d'une cohérence indéniables; l'exploitation du relief naturel y contribuait à la hiérarchisation des espaces et à la complémentarité des fonctions, dans une conception d'ensemble qui apparaît pleinement maîtrisée.

Très vite, toutefois, les dommages subis par la région engagent un mouvement de repli qui semble bien irréversible, et le désastre situé par les fouilleurs dans les années 70 av. J.-C., peut-être imputable à un raid de pirates, entraîne une diminution durable de la population avec une stagnation de l'activité édilitaire.[7] Dans sa récente étude sur Cosa à l'époque impériale, E. Fentress relève que dès lors la fortune de la ville est inversement proportionnelle à celle de son territoire: à la fin de la République, l'installation, sur les terres des anciens colons appauvris, de riches propriétaires exploitant une main-d'œuvre servile sur de vastes domaines, dont Sette Finestre reste l'exemple le mieux connu, fait perdre au centre urbain, avec sa fonction originelle, une grande part de sa raison d'être.[8] La mise en évidence d'une reconstruction partielle du forum et des îlots adjacents (9 *insulae*), apparemment voulue par le pouvoir central à l'époque d'Auguste, constitue l'un des acquis des fouilles de ces dernières années; elle s'inscrit dans la série des opérations dues à ce qu'on a appelé avec quelque raison le paternalisme philo-italique du Princeps, et plus généralement dans le programme de restauration sociale, politique et religieuse de l'Italie dévastée,[9] qui a conduit, entre autres, à la création, sur le site de Veii, d'un *municipium*

1 H. von Hesberg, "Zur Plangestaltung der coloniae maritimae," *RömMitt* 92 (1985) 127-150.

2 M. Torelli dans P. Gros, M. Torelli, *Storia dell'urbanistica. Il mondo romano* (Rome–Bari 1988) p. 147 sq.

3 Gros ibid. p. 209 sq.

4 Voir, par exemple, les Actes du Colloque de Trieste, *La città nell'Italia settentrionale in età romana* (CollEFR 130, 1990) et ceux du Colloque de Rome, *L'Italie d'Auguste à Dioclétien* (CollEFR 198, 1994). Cf. aussi F. Millar, "Italy and the Roman Empire," *Phoenix* 40 (1986) p. 295-318; dans cet article F. Millar rappelle que "l'Italie sous l'Empire n'a pas d'histoire"; la remarque vaut pour l'urbanisme.

5 F. E. Brown, *Cosa, the making of a Roman town* (Ann Arbor 1980).

6 Torelli (supra n.2) p. 140 sq.

7 Brown (supra n.5) p. 72-73; F. E. Brown, E. H. Richardson, L. Richardson, jr., *Cosa III: The buildings of the Forum* (MAAR 37, 1993) p. 237 sq. (infra cité *Cosa* III).

8 E. Fentress, "Cosa in the empire: The unmaking of a Roman town," *JRA* 7 (1994) p. 208-222.

9 Gros (supra n.2) p. 210 sq.

Augustum Veiens.[10] Mais, outre qu'elle n'a pas la même ampleur, la "résurrection" de Cosa, timide et partielle, n'a été que de courte durée. On n'y enregistre au demeurant aucune de ces structures qui définissent les nouveaux lieux du consensus dans les villes du début de l'Empire, quel que soit leur statut, à savoir le théâtre et le temple du culte impérial.[11] Ces monuments qui enrichissent les équipements antérieurs et qui dominent désormais les nouveaux axes reliant le sacré et le juridique, selon une formule parfaitement (bien que peut-être inconsciemment) définie par Vitruve, font défaut à Cosa.[12] Et l'antique basilique, l'une des plus anciennes de l'Italie centrale, à la différence des autres annexes judiciaires du forum dans de nombreux centres urbains de la péninsule, ne fonctionne plus, apparemment, comme un pôle de convergence dans un espace désormais amorphe.[13] Les riches propriétaires de l'ancien *ager Cosanus* n'ont manifestement pas éprouvé le besoin de déployer dans la ville qui en constituait encore le centre administratif un évergétisme comparable à celui dont bénéficient à la même époque dans cette Étrurie devenue partie intégrante de la *VII regio* augustéenne, les sites de Veii, Vulci, Ferento ou Falerii Novi.[14] On peut certes arguer du fait que l'identité romaine de Cosa était inscrite dès l'origine dans sa qualité de colonie et qu'à ce titre il n'était pas nécessaire de renouveler ou d'améliorer sa dotation monumentale; le respect de la trame initiale était même, dans ce cas, imposé par une lotisation infrangible qui explique la scrupuleuse inscription des reconstructions augustéennes dans l'ancien carroyage. Mais pour être autre chose qu'une dignité théorique, la *romanitas* doit subir des mises à jour périodiques: même si Cosa ne meurt pas, elle reste désormais étrangement dépourvue de tout "aggiornamento" urbanistique ou monumental.

Pour autant l'agglomération en tant qu'entité administrative et politique continue d'exister: même si la richesse des villas de son territoire n'a guère d'incidences sur la vie urbaine, même si l'activité de son port est désormais presque tout entière confisquée par l'exportation des produits des mêmes villas, la situation de Cosa sur la via Aurelia lui assure toujours un rôle qui pour être modeste n'en est pas moins un gage de survie.[15] En ce sens Cosa connaît un sort qui n'a rien d'exceptionnel; il est partagé, dans d'autres contextes, par plusieurs agglomérations urbaines dont le déclin a commencé après la Guerre sociale. Mais chaque site est en ce domaine un cas d'espèce. En apparence, le destin de *Tusculum* est assez semblable: rudement châtié par Sylla, ce municipe ne doit plus son renom qu'à la proximité des somptueuses villas suburbaines de la *nobilitas*.[16] Les fouilles récentes de l'équipe espagnole ont montré cependant que, contrairement à une idée longtemps reçue, le théâtre et la place adjacente (le forum?) de *Tusculum* connaissent encore à la fin du Ier et au début au IIe s. des aménagements importants.[17] C'est que *Tusculum*

10 P. Liverani, *Municipium Augustum Veiens. Veio in età imperiale attraverso gli scavi Giorgi (1811-13)* (Rome 1987). Voir aussi M. Torelli, *Etruria* (Guide archeologiche Laterza, Rome–Bari 1980) p. 13 sq.

11 Importantes sont à cet égard les remarques de M. Pfanner, "Modelle römischer Stadtentwicklung am Beispiel Hispaniens und der westlichen Provinzen" dans W. Trillmich, P. Zanker (edd.), *Stadtbild und Ideologie. Die Monumentalisierung hispanischer Städte zwischen Republik und Kaiserzeit* (Munich 1990) p. 84 sq. Voir aussi M. Verzár Bass, "I teatri nell'Italia settentrionale," dans *La città nell'Italia settentrionale* (supra n.4) p. 411-440; P. Gros, "Les théâtres en Italie au Ier s. de notre ère: situation et fonctions dans l'urbanisme impérial," dans *L'Italie d'Auguste à Dioclétien* (supra n.4) p. 287-307; M. Luni dans *Architettura nelle Marche* (Florence 1995) p. 27-29. Sur le temple du culte impérial voir H. Hänlein-Schäfer, *Veneratio Augusti. Eine Studie zu den Tempeln des ersten römischen Kaisers* (Rome 1985).

12 Vitr. 5.1.7.

13 Sur les basiliques civiles d'Italie à l'époque républicaine, P. Gros, *L'architecture romaine. I. Les monuments publics* (Paris 1996) p. 235 sq.

14 Voir sur ces villes les listes établies par H. Jouffroy, *La construction publique en Italie et dans l'Afrique romaine* (Strasbourg 1986) p. 78 sq., 90 sq.; sur le théâtre de Ferento, P. Pensabene, *Il theatro di Ferento. Architettura e decorazione scultorea* (Rome 1989).

15 Sur les villas et l'activité économique de l'*ager Cosanus*, A. Ricci, "Cosa e il suo territorio," dans *Società romana e impero tardoantico* III (Rome–Bari 1986) p. 83 sq.; A. Carandini dans *Storia di Roma. IV. Caratteri e morfologie* (Turin 1989) p. 118 sq.

16 F. Coarelli, *Dintorni di Roma* (Guide archeologiche Laterza, Rome–Bari 1981) p. 66 sq. et 115 sq.

17 J. Arce *et al.*, *Excavaciones arqueológicas en Tusculum. Informe de las campañas de 1994 y 1995* (Rome

reste — et en cela son histoire diffère tout de même sensiblement de celle de Cosa — un centre de représentation politique de l'aristocratie, au moins jusqu'à la dynastie flavienne; d'où une série d'actions édilitaires de prestige qui font presque totalement défaut à Cosa, immergée dans un terroir beaucoup plus rustique où les riches propriétaires ont tendance à résider de plus en plus rarement. Un autre exemple de ce type de situation avec, là aussi, des variantes dues à l'histoire antérieure et à l'environnement régional est offert par Paestum, la colonie — sœur de Cosa, puisque fondée, selon la tradition, la même année qu'elle en 273. Avec un certain retard mais selon un processus tout aussi irréversible, Paestum décline à partir du début du Ier s. de l'Empire et, malgré la déduction d'une nouvelle colonie de vétérans à l'époque flavienne, se trouve rapidement réduite au rang d'un centre secondaire, relégué, lui, hors des grands axes, puisque le tracé de la via Popilia l'ignore.[18] Malgré cela, l'activité édilitaire ne cesse pas brusquement à Paestum; elle prend seulement des formes qui n'entrent que difficilement dans les catégories convenues du développement urbain et ont de ce fait posé des problèmes à tous ceux qui ont tenté de les interpréter: elles ne sont pas sans rapport avec ce qu'on observe dans la colonie d'Étrurie; nous aurons à nous en souvenir.[19]

Revenons d'abord à Cosa. Il semble qu'à la fin du règne de Tibère plusieurs édifices autour du forum aient été endommagés: la basilique, dont s'écroule toute la partie centrale du mur nord-ouest, ce qui rend l'ensemble de la construction inutilisable et dangereuse; et le temple B (dit de la Concorde) adjacent au comitium.[20] La quasi simultanéité de ces épisodes et la façon dont la paroi de l'édifice basilical s'est effondrée, d'un seul tenant, ont fait songer à un séisme;[21] la date de celui-ci, ou du moins le *terminus post quem*, en serait fourni par les monnaies les plus récentes retrouvées dans les décombres de la basilique, des *as* de 34-37 apr. J.-C.[22] S'il n'est pas recensé parmi les tremblements de terre qui ont affecté l'Italie au Ier s., c'est peut-être parce qu'il est resté très localisé ou que son intensité n'a pas été bien grande. Quand on connaît le caractère périlleux de l'échafaudage que constituent les ordres superposés des basiliques du type de Cosa, on sait du reste qu'il faut peu de choses finalement pour qu'une telle construction connaisse la ruine: des négligences dans les opérations de contrôle et d'entretien des superstructures peuvent suffire à provoquer de graves désordres.[23] En ce cas la chute de la paroi basilicale serait plutôt le signe d'une dégradation de la vie urbaine, ou du moins des organes qui avaient en charge la maintenance des édifices les plus représentatifs de l'autonomie de la communauté.

Or c'est dans ce contexte qui se situe, moins de 20 années plus tard, un épisode édilitaire inattendu: l'établissement d'un odéon dans les ruines de la basilique judiciaire.[24] L'étrangeté de cette intrusion n'a pas retenu, à notre connaissance, l'attention qu'elle méritait. Elle est pourtant attestée par l'archéologie: l'édifice a été remarquablement décrit et restitué; les éléments de datation qui permettent de le situer au début des années 50 apr. J.-C. semblent incontestables. L'épigraphie confirme et le fait et sa datation, puisqu'une inscription lacunaire a été retrouvée *in situ* qui, sans parler nommément d'un *odeum* (car la partie qui désignait l'édifice manque), évoque une "restitution" du monument (soit de la basilique elle-même, soit de la basilique transformée en odéon) par les soins et avec l'argent du jeune Néron.[25]

1998) p. 49 sq.

18 E. Greco, *Magna Grecia* (Guide archeologiche Laterza, Rome–Bari 1980) p. 20 et 57.

19 Infra p. 218 f.

20 *Cosa* III, p. 241; Fentress, *JRA* 7 (1994) p. 212.

21 Fentress, ibid. n.12.

22 T. V. Buttrey, *Cosa: The coins* (MAAR 34, 1980): CE 1201 et CE 1050.

23 Cf. P. Gros, "La basilique de forum selon Vitruve, V, 1: la norme et l'expérimentation," dans *Bauplanung und Bautheorie der Antike* (Berlin 1983) p. 49-69; id., *L'architecture romaine* (supra n.13) p. 240-241.

24 *Cosa* III, p. 241-244.

25 *Cosa* III, p. 243. On notera toutefois que la restitution et la lecture proposées par les auteurs de cette publication, si l'on en juge par les fragments retrouvés de l'inscription, tels qu'ils sont présentés à la pl. 252, posent un certain nombre de questions. D'abord, le mot *odeum* n'apparaît pas dans ce qui reste du texte; ensuite on voit mal pourquoi le *F* de la troisième ligne est développé en un *fecit* alors qu'il pourrait

Fig. 1. Plan restitué du forum de Cosa entre 30 av. et 270 ap. J.-C. (d'après *Cosa* III, fig. 76, p. 239).

Comment s'explique le choix d'un tel monument, relativement rare dans l'Italie de l'époque, et qui ne se conçoit de toute façon, tant à Pompéi qu'à Naples, que comme le complément d'un équipement plus lourd, le *theatrum tectum* ou *odeum* constituant l'annexe d'un grand "théâtre à ciel ouvert"?[26] La question est d'autant plus prégnante à Cosa que la dite construction n'intervient nullement dans un quartier réservé aux spectacles — lequel n'a jamais existé dans cette ville — mais en bordure d'une place publique dont les archéologues américains ont montré qu'elle était dès lors partiellement désertée ou "ruralisée", certains des *atria publica* qui l'entouraient étant détruits ou transformés en basses-cours, en dépôts de matériaux, etc. (fig. 1).[27] La restitution élaborée par G. Izenour propose une interprétation ingénieuse de la double opération mentionnée par l'inscription déjà citée, si du moins on retient la lecture des éditeurs:[28] la basilique aurait été partiellement relevée puisque ses nefs latérales y apparaissent reconstruites et/ou consolidées, et l'espace central y est occupé par l'odéon. Celui-ci est à vrai dire bien singulier: seul de sa catégorie, il possède une *cavea* rectiligne et non courbe, avec des *tribunalia* isolés latéralement et réduits ainsi à des estrades placées entre les gradins et le bâtiment de scène; ce dernier, fort large compte tenu des dimensions de l'ensemble, paraît avoir été pourvu de colonnes libres à l'extrémité d'un *pulpitum* plutôt bas (fig. 2). De telles particularités, fondées sur l'observation des vestiges, disent assez qu'on a voulu exploiter au mieux, avec un évident souci d'économie, l'espace disponible et les structures utilisables en retenant, de préférence à une charpente de comble qui avait fait la preuve de sa vulnérabilité, le parti de quatre arcades dont la base des piles a été conservée à la limite de la *cavea* et de la *scaenae frons*. Les trois

plus opportunément être considéré comme désignant la filiation (*filius*) de Nero Caesar dont le père adoptif Claude est mentionné auparavant; dans ces conditions, le *restituit* de la dernière ligne s'appliquerait à l'ensemble de l'opération, et non pas seulement, comme le supposent les auteurs, à la partie de la basilique transformée en odéon.

26 Sur les odéons d'Italie, Gros, *L'architecture romaine* (supra n.13) p. 308 sq.

27 *Cosa* III, p. 238 sq. et fig. 76, p. 239.

28 G. C. Izenour, *Roofed theaters of classical antiquity* (New Haven 1992) p. 114-118 et fig. 2-10.

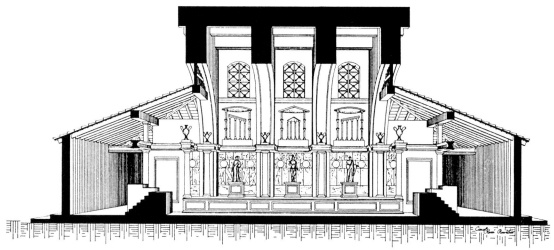

Fig. 2. Coupe de l'odéon de Cosa (d'après Izenour [supra n.28], fig. 210, p. 118).

statues retrouvées dans l'orchestra, qui semblent avoir représenté Claude en *divus*, Néron en *togatus* et Agrippina Minor, devaient figurer dans les niches du mur de scène;[29] elles n'appartiennent pas à la phase de la construction, antérieure à la mort de Claude, mais témoignent du fait que la *scaenae frons* avait été conçue dès le début comme celle d'un théâtre en réduction.

Même si, de l'extérieur, la masse de l'édifice basilical apparaît globalement restaurée, la rupture avec la finalité initiale de l'édifice d'accueil est complète. Certes, on peut rappeler la vocation traditionnelle de la basilique de forum à servir de refuge ou de support à des sièges pour les spectateurs des *munera* qui, à Cosa comme en tant d'autres villes, devaient se dérouler sur le forum; si l'on en croit Vitruve, les choix planimétriques et structurels dont procède la *basilica forensis* s'expliquent en grande partie par cette fonction.[30] Et avec raison les éditeurs de la basilique de Cosa ont défini la terrasse au-dessus de la nef latérale qui longe la place publique comme un *maenianum* destiné à augmenter le nombre des *spectacula*.[31] Mais dans la nouvelle disposition, la relation organique avec le forum n'existe plus: non seulement l'odéon est clos sur

29 Présentées pour deux d'entre elles, mais non commentées dans *Cosa* III, pl. 266. Je dois les identifications de ces statues à J. Collins-Clinton, qui prépare une étude sur le programme sculptural de l'odéon de Cosa. Qu'elle soit remerciée ici pour la générosité avec laquelle elle m'a fourni, oralement et par voie épistolaire, ces précieuses indications.

30 Vitr. 5.1.1-5. En fait Vitruve évoque les *spectacula* à propos des portiques latéraux des forums, mais la basilique, en tant qu'annexe de ceux-ci, répond aux mêmes exigences. Voir maintenant le commentaire de A. Corso, *Vitruvio. De architectura* (Turin 1997) p. 617 sq.

31 *Cosa* III, p. 223-227.

lui-même, mais les spectateurs tournent résolument le dos à la place. C'est là un indice certain de la disparition du tropisme exercé par celle-ci; elle a désormais perdu sa vocation centripète, comme le prouve par ailleurs l'orientation des boutiques sur l'autre long côté: toutes, à l'exception d'une seule, sont ouvertes sur la rue; les autres, qui étaient tournées vers le forum, sont fermées. Il n'est donc pas exagéré de dire que cette prétendue restauration de la basilique l'a en réalité détruite: en tant qu'annexe couverte du forum elle n'a, apparemment, plus de raison d'être.

Il est difficile d'apprécier la portée d'une telle mutation pour la communauté. En ce milieu du Ier s., la destruction ou la mise hors d'usage, partielle ou totale, d'un forum et d'une basilique n'entraînent pas de conséquences dramatiques dans le fonctionnement d'un organisme urbain: songeons seulement à Pompéi dont les édiles se sont peu souciés, après le séisme de 62, de relever les ruines qui rendaient inutilisables leur forum, leur capitole et leur basilique; ils avaient manifestement des soucis bien différents puisqu'ils firent porter tous leurs efforts, pendant les 17 dernières années avant la catastrophe finale, sur l'amphithéâtre et les thermes.[32] Du reste, à Cosa, la curie et ses annexes semblent avoir été, au moins dans un premier temps, préservées, et la présence de deux gradins plus larges que les autres à la base de la *cavea* de l'odéon témoigne du fait que les hiérarchies administratives traditionnelles restaient en vigueur, puisqu'on peut admettre, avec les auteurs de la publication, qu'il s'agissait des places d'honneur réservées aux décurions.[33] L'odéon n'est donc pas le signe ou le symbole de la dégradation totale d'un complexe civil et administratif en un espace ludique; il procède, sous une forme qui porte la marque de son temps, d'une nouvelle façon de vivre la ville. Compte tenu de l'ambiguïté formelle et fonctionnelle qui est celle de tous les odéons-bouleutéria, il dut être en fait rapidement utilisé pour les réunions du sénat local, sans perdre sa fonction initiale de salle de conférences, de déclamation ou de concert.[34] Le phénomène est trop connu pour que nous nous y attardions: la double définition de l'odéon de Pompéi, qui fut en son temps, si l'on en croit P. Zanker, la curie coloniale de la ville syllanienne en même temps que son auditorium,[35] celle du "théâtre" (couvert, selon toute apparence) de la colonie maritime de *Liternum* qui, sur le même alignement que le capitole et la basilique, jouait aussi le rôle d'un véritable bouleutérion, témoignent de cette ambivalence.[36] On n'expliquerait pas, en fait, que la réfection de l'odéon de Cosa ait été encore, en 236, jugée indispensable par Maximin, s'il n'avait pas, dans un délai que nous ne pouvons pas évaluer, été utilisé comme un véritable édifice administratif, indispensable au bon fonctionnement des institutions de la ville.[37]

Même si l'on peut admettre, sur la foi de l'inscription de 50-54, que le jeune Néron, adopté par Claude après son mariage avec Agrippine, aurait obtenu de son impérial beau-père l'autorisation de se faire construire une salle pour s'y adonner, entre autres, à son goût du chant, on ne saurait donc considérer, comme le croit G. Izenour, que dès lors Cosa est devenue une sorte de "colonie d'artistes".[38]

Néron, n'est là, en réalité, que le représentant — le plus illustre et le plus riche assurément — d'une classe de propriétaires établis dans l'ancien territoire colonial: son père Cn. Domitius Ahenobarbus possédait de vastes domaines dans le voisinage immédiat, sur le Monte Argen-

32 P. Zanker, *Pompeji. Stadtbilder als Spiegel von Gesellschaft und Herrschaftsform* (9. Trierer Winckelmannsprogramm, Mayence 1987) p. 41 sq.

33 *Cosa* III, p. 241.

34 Sur les odéons-bouleutéria, voir J.-Ch. Balty, *Curia ordinis. Recherches d'architecture et d'urbanisme antiques sur les curies provinciales du monde romain* (Bruxelles 1991) p. 431 sq. (partic. p. 498 et p. 562).

35 Zanker (supra n.32) p. 19.

36 Cf. W. Johannowsky dans *Hellenismus in Mittelitalien* (Göttingen 1976) p. 274-275; S. De Caro, A. Greco, *Campania* (Guide archeologiche Laterza, Rome–Bari 1981) p. 90-91; Balty (supra n.34) p. 595.

37 R. T. Scott, "A new inscription of the emperor Maximinus at Cosa," *Chiron* 11 (1981) p. 309-314; *Cosa* III, p. 245.

38 Izenour (supra n. 28) p. 114. On notera toutefois que du point de vue de l'environnement culturel la présence d'un odéon à Cosa n'est pas plus étonnante (ni saugrenue) que celle d'une bibliothèque (*CIL* XI, 2704) à Volsinii.

tario et près d'Orbetello, qui revinrent à sa femme après sa mort et entrèrent ainsi dans les possessions impériales.[39] Les villas de rendement établies sur ces sites ne se prêtant pas au développement de secteurs "urbains" très élaborés, il est probable que certains de ces *domini* ont éprouvé le besoin de disposer, pendant leurs séjours (souvent brefs) sur leur terres, d'un local commun, adapté à des réunions mondaines, voire même éventuellement à de modestes représentations théâtrales; le jeune Néron, qui avait sans doute vécu une partie de son enfance dans la région, a servi en quelque sorte un projet commun, caractéristique d'une période où la déclamation, devant un public choisi, de textes littéraires, plus encore que les auditions musicales, tendaient à se substituer à des activités judiciaires et politiques en constant déclin. Il suffit de lire la correspondance de Pline le Jeune pour mesurer la place occupée par ce genre de manifestation dans la vie des aristocrates fortunés de la fin du Ier s. apr. J.-C. et du début du IIe:[40] les *recitationes*, introduites selon la tradition sous le règne d'Auguste par Asinius Pollion,[41] deviennent rapidement une cérémonie de classe et de compensation, à laquelle on s'adonne avec passion. Ces lectures ou déclamations publiques concernent surtout, au Ier s., les poèmes (lyriques, épiques, didactiques), les œuvres dramatiques et les ouvrages d'histoire (ou les biographies); plus tard on "récitera" aussi des plaidoyers, réels ou fictifs.[42] Les lieux où se donnent ces spectacles sont des *auditoria*, privés ou publics, et plus souvent encore, au Ier s., des *stationes*, c'est-à-dire des salles où l'on est à l'aise pour causer entre soi et écouter tel ou tel de ses amis présenter une de ses œuvres.[43] Juvénal énumère ces *stationes* parmi les lieux publics les plus fréquentés de son temps, et les met sur le même plan que les bains ou les théâtres.[44] L'odéon de Cosa ne fut selon toute vraisemblance, au moins dans sa première phase, que l'*auditorium* ou la *statio* des riches propriétaires non résidents de la région: ceux-ci n'avaient certainement pas eu beaucoup de mal à convaincre les *Cosani* de leur concéder le *spatium medium* de leur basilique plus ou moins désaffectée parce que déjà partiellement effondrée; d'autant qu'ils leur ont évidemment accordé la jouissance du nouvel édifice pour leurs propres réunions administratives ou délibératives. Très vite, d'ailleurs, comme l'attestent les statues recueillies sur place, l'odéon devint un édifice où certaines liturgies du culte impérial pouvaient aisément se déployer dans un cadre architectural digne — le seul sans doute encore disponible à Cosa.[45]

L'odéon de la basilique ne nous paraît donc pas fondamentalement différent, au moins dans son projet initial, de celui de la villa de l'île de *Planasia* (Pianosa), datable du milieu du Ier s. apr. J.-C., ou de celui de la villa de Vedius Pollion sur le Pausilippe; cette dernière tomba du reste rapidement dans le domaine impérial.[46] Malgré les apparences, la récupération à des fins

39 *Cosa* III, p. 243-244. A vrai dire, la localisation et l'extension exactes de ces propriétés des Domitii Ahenobarbi ne sont pas connues, mais la présence, sur la côte de l'Argentario, d'une escale dite *Domitiana positio*, est un indice important du poids économique de la famille dans la région. Cf. D. Manacorda, "L'Ager Cosanus tra tarda repubblica e impero: forme di produzione e assetto della proprietà," *MAAR* 36 (1980) p. 173 sq.; id., "Produzione agricola, produzione ceramica e proprietari nell'Ager Cosanus nel I secolo a.C.," *Società romana e produzione schiavistica* II (Rome–Bari 1981) p. 44-47. Voir aussi M. Pasquinucci, "Contributo allo studio dell'*ager Cosanus*: la villa dei Muracci (Porto Santo Stefano)," *SCO* 32 (1982) p. 141 sq.

40 Plin., *Ep.* 1.13.1-2; 2.18.2; 2.19.1; 3.18.4; 5.3.7 sq.; 5.12; 6.17; 7.17; 7.21.4; 8.12; 8.21; 9.27; 9.34. Sur les *acroemata*, 6.31.13.

41 Sén., *Controv.* 4, *praef.* 2; Isid., *Etym.* 6.52.

42 Cf. G. Funaiolo, dans *RE* I.A.1 (1914) col. 435-446; J. Malitz, "Claudius (FGr Hist 276) — Der Princeps als Gelehrter," *Die Regierungszeit des Kaisers Claudius (41-54 n. Chr.). Umbruch oder Episode?* (Mayence 1994) p. 133-141.

43 Sur la notion de *statio*, voir par ex. Pline, *Ep.* 1.13.2. Cf. A. N. Sherwin-White, *The Letters of Pliny: A historical and social commentary* (Oxford 1966) p. 115-116.

44 Juv., *Sat.* 9.3-5.

45 Supra n.29.

46 Cf. G. Schmiedt, *Il livello antico del Mar Tirreno. Testimonianze dei resti archeologici* (Rome 1972) p. 38 sq.; De Caro et Greco (supra n.36) p. 34-35; H. Mielsch, *Die römische Villa. Architektur und Lebensform* (Munich 1987) p. 66 sq. et p. 115 sq.; Izenour (supra n.28) p. 73-76 et p. 169 sq.

ludiques ou spectaculaires de la basilique de Cosa ne saurait être, dans ces conditions, assimilée aux opérations qui, dans d'autres villes, à la fin du Ier et au cours du IIe s. apr. J.-C., ont consisté à établir des édifices de spectacle dans des monuments plus anciens: à *Carsulae*, en Ombrie, l'implantation d'un amphithéâtre dans le quadriportique situé derrière le théâtre,[47] ou à Epidaure, en Argolide, l'aménagement d'un *theatrum tectum* dans la palestre du gymnase[48] illustrent bien cette pratique qui, autant que nous en puissions juger, répond aux exigences de populations dont les goûts se modifient et qui n'éprouvent aucun scrupule à réoccuper sous une autre forme des espaces ou des constructions désormais privés à leurs yeux de toute signification. On voit bien que de telles attitudes témoignent plutôt de la vitalité d'une ville dont les mentalités évoluent et qui se donne les moyens de satisfaire des aspirations nouvelles.[49] À Cosa, en revanche, la mise en place de l'odéon, dans les conditions que nous avons tenté de définir, plaide plutôt pour la mainmise d'une aristocratie venue de l'extérieur sur un centre monumental en voie de désertification.

Mais — et c'est là le second enseignement de l'opération — ce nouvel édifice sera progressivement "récupéré" par les responsables locaux qui en feront leur local d'assemblée.[50] On mesure, à l'aune de ces remarques qui peuvent sembler partiellement contradictoires, l'ambiguïté d'une situation qui n'entre dans aucun schéma reconnu. L'important, dans cet épisode urbanistique ponctuel qu'on jugera peut-être infime, c'est finalement la faculté d'absorption d'une population affaiblie, qui trouve tout de même le moyen d'annexer à son profit une structure dont l'initiative revenait à un groupe de privilégiés dont les intentions étaient tout autres que civiques. L'*hodium* de l'inscription de 236 déjà citée apparaît comme l'une des composantes essentielles de la ville, une de celles qui assurent encore l'identité des *Cosani*.[51] Toutes proportions gardées, le complexe du théâtre et de la place de *Tusculum* appartiennent peut-être à la même catégorie de ces fondations voulues et réalisées par et pour des *gentes* de la *nobilitas* ou au moins de riches possédants qui, à terme, constituent le noyau autour duquel va se réorganiser une vie civique.

Ces considérations peuvent nous aider à entrevoir la portée d'un autre épisode édilitaire qui a fait l'objet d'investigations récentes, celui de la "curie" de Paestum.

47 J.-Cl. Golvin, *L'amphithéâtre romain. Essai sur la théorisation de sa forme et de ses fonctions* (Paris 1988) p. 112 et pl. XXVI.2.

48 Balty (supra n.34) p. 478, n.266.

49 Ces mutations peuvent prendre des formes violentes et la superposition ou la substitution d'un édifice à un autre peut s'apparenter à une destruction pure et simple, comme on l'observe au théâtre de Tarragone. Cf. R. Mar dans *Die römische Stadt im 2. Jahrhundert n.Chr.* (Cologne–Bonn 1992) p. 163 sq. Cf. P. Gros, dans *Villes et campagnes en Gaule romaine* (Paris 1998) p. 11 sq.

50 Il est malheureusement impossible de dire, fût-ce d'une façon approximative, quand le processus de récupération commence et quand il se termine. Nous avons suggéré que l'odéon pouvait servir occasionnellement de local pour les réunions civiques dès le moment de sa construction; l'important est de savoir quand il devient l'équivalent d'une curie-bouleutérion à part entière et d'une façon irréversible. Un moment décisif de cette évolution peut se situer à la fin du Ier s. apr. J.-C., lorsque s'établissent, sur le littoral, des villas maritimes et particulièrement celle dite de la Tagliata, dont l'implantation coïncide avec le déclin de l'activité portuaire; c'est l'époque où, dans l'arrière-pays, la villa de Sette Finestre subit une profonde restructuration et se dote d'aménagements "urbains" plus développés qu'auparavant. Il semble que dès lors les riches propriétaires disposent, dans leurs propres villas, des installations d'accueil qui rendent inutile l'odéon de Cosa en tant qu'équipement "collectif" destiné à compenser la relative austérité de leurs résidences antérieures. Une consolidation des possessions impériales dans la région, postulée par des recherches récentes, pourrait expliquer cette soudaine vogue du littoral de Cosa, et l'accroissement du luxe des villas. Cf. sur ces questions D. Manacorda, "Considerazioni sull'epigrafia della regione di Cosa," *Athenaeum* 57 (1979) p. 73 sq.; id. (supra n.39) dans *Società romana e produzione schiavistica* II; A. Carandini et A. Ricci, *Settefinestre. Una villa schiavistica nell'Etruria romana* I (Modène 1985) p. 171 sq.; A. M. McCann *et al.*, *The Roman port and fishery of Cosa* (Princeton 1987).

51 Voir à ce sujet A. Kolb, "Die Einflussnahme des Kaisers auf das städtische Bauwesen," dans *La politique édilitaire dans les provinces de l'Empire romain IIe-IVe siècles après J.-C.* (Berne 1995) p. 280-281.

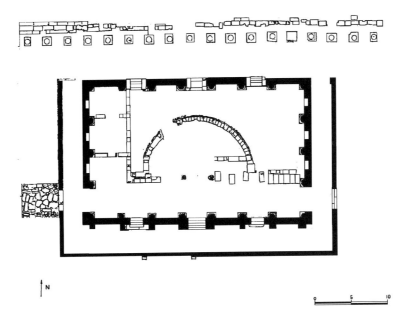

Fig. 3. Plan de la curie-bouleutérion de Paestum, d'après Greco–Theodorescu et Balty (supra n. 52 et 53) (= fig. 244, p. 500 de *Curia ordinis*).

On connaît le problème: sur la frange sud du forum colonial s'édifie au début du Ier s. apr. J.-C. un monument à trois nefs qui se transforme ensuite, à une date indéterminée (au IIe ou au début du IIIe s.) en un édifice à hémicycle inscrit auquel la tradition archéologique a donné le nom de curie. La publication récente de E. Greco et de D. Theodorescu a permis de préciser les phases successives de ces énigmatiques constructions et d'en déterminer la chronologie relative.[52] Il reste à cerner leur définition fonctionnelle. J.-Ch. Balty, reprenant le dossier, propose de voir effectivement, dans le dernier état, une salle comparable par ses dimensions, sa conception et son organisation interne à celles de *Nicopolis ad Istrum*, d'Alabanda ou de Sélinonte de Cilicie;[53] l'épaisseur des murs du rectangle qui encadre l'hémicycle, les points d'appui que constituent les colonnes engagées sur leur face interne autorisent techniquement la restitution d'une couverture pour une galerie de circulation en Π; l'hémicycle quant à lui serait l'élément résiduel d'une *cavea* de cinq gradins dont les substructions ont entièrement disparu, peut-être parce qu'ils étaient en bois; face à elle se dressait une estrade adossée au mur sud du rectangle et qui correspondait à la largeur des cinq travées centrales. Trois portes, celle du milieu plus large que les autres, complétaient l'aménagement qui, dans cette hypothèse, peut parfaitement correspondre à une curie de plan semi-circulaire (fig. 3). Dès lors le parallèle s'impose avec l'épisode de Cosa: à plus d'un siècle de distance se reproduit l'annexion d'un édifice de plan basilical par un "odéon" ou "bouleutérion" qui, de surcroît, comme dans l'ancienne colonie d'Étrurie, tourne le dos au forum.

L'empiètement du temple du "Capitole" sur l'hémicycle du *comitium*, de l'autre côté de la place, et plus encore le déclin des formes traditionnelles de la vie civique avaient apparemment fini par entraîner l'abandon des anciens lieux ou monuments de réunion et de délibération.

Que conclure de cette similitude formelle dans l'évolution des sites de Cosa et de Paestum? Rien d'assuré, et de toute façon aucune filiation directe entre les deux villes, trop éloignées et immergées dans des contextes trop différents pour que la moindre influence ait pu exercer de l'une à l'autre. On ne manquera pas de noter toutefois que l'analogie observée dans les phases tardives reproduit celle qui, depuis longtemps, avait été relevée au début de leur histoire, puisque l'ensemble *comitium-curia* relevait du même modèle, au IIIe s. av. J.-C., à Paestum comme à Cosa.[54] Ce n'est donc pas le fait du hasard si le ralentissement des activités collectives

52 E. Greco et D. Theodorescu, *Poseidonia-Paestum I. La "Curia"* (CollEFR 42, 1980).
53 Balty (supra n.34) p. 174 sq. et p. 498 sq.
54 Cf. E. Greco et D. Theodorescu, *Poseidonia-Paestum III. Forum Nord* (CollEFR 42, 1987) p. 27 sq.; *Cosa*

liées à la vie coloniale ou municipale, et la désagrégation progressive du milieu social, ont abouti, à Paestum plus tardivement qu'à Cosa mais finalement de la même façon, à une mutation radicale des lieux de décision et à une désaffection patente de l'ancien forum. Il n'est pas exclu d'ailleurs que la présence de grandes villas sur le territoire de l'ancienne colonie lucanienne, dont de nombreux vestiges ont été retrouvés, à *Agropolis* ou dans le voisinage de San Marco di Castellabate,[55] ait suscité la création d'un type d'auditorium qui pouvait, comme à Pompéi ou à Larinum, avoir une double définition, ludique et civique.

Je ne pousserai pas plus loin l'analyse comparative, qui paraît sans doute déjà plutôt hasardeuse. Il me semble cependant que, si nous essayons de répondre, à travers ces deux exemples, à la question que nous posions dans le titre de cette communication, il n'est pas impossible de risquer les formules conclusives suivantes: la faillite des programmes originels, qui sont liés à des conditions socio-politiques par définition transitoires, n'entraîne pas l'annulation du phénomène urbain; certes, ce que l'archéologue lit sur le terrain est plutôt négatif, et témoigne d'une évolution en apparence catastrophique, qui le conduit souvent à considérer comme des phases d'occupation sporadique les périodes correspondant à une destruction partielle des structures organisatrices initiales. Le fait est surtout sensible dans le cas de Cosa où la période augustéenne, si féconde par ailleurs, n'apporte aucune mutation décisive et où l'on observe l'investissement plus rapide qu'ailleurs du centre monumental par un monument de spectacle qui n'entre pas dans la panoplie ordinaire des organes administratifs, surtout dans cette partie de l'Italie centrale. Mais le recouvrement des instances de décision par des édifices à vocation ludique est en lui-même hautement symbolique de l'évolution qui s'opère, à une toute autre échelle, à Rome et dans les autres grandes villes italiennes où, dès les années 50, les *ludi* et les *munera* sont considérés comme les formes les plus accomplies de la vie collective: l'engouement de Claude pour les spectacles, si prolixement attesté par Suétone, et les largesses dont l'épigraphie ou la papyrologie nous apprennent qu'il combla les synodes artistiques ou athlétiques;[56] les *Neronia* institués par son successeur dès le début des années 60, qui voient à Rome le déploiement fastueux des premiers *agones* de type grec, avec des concours musicaux dans le théâtre de Pompée, sont les signes évidents de cette évolution.[57] On ne saurait donc s'étonner outre mesure que sur des sites urbains relativement oubliés, mais cernés par une aristocratie hautement réceptive aux tendances de l'époque, des manifestations monumentales de cet ordre, assurément bien modestes, constituent, précocement à Cosa, plus tardivement à Paestum, les rares signes d'une reprise de l'activité édilitaire dont les groupes dirigeants de ces communautés urbaines sauront ensuite tirer profit. Dans chacun de ces cas, un même processus de déshérence, qu'on ne doit pas interpréter forcément comme un signe de décadence irréversible, débouche, avec un décalage sensible entre les deux exemples, sur une récupération partielle, qui sera d'autant plus durable que l'on peut imaginer sans grand risque de se tromper que ces nouvelles structures seront annexées rapidement par les liturgies du culte impérial.[58]

Maison méditerranéenne des Sciences de l'Homme, 5, rue du Château de l'Horloge,
F 13094 Aix-en-Provence

III, p. 11 sq., p. 107 sq., p. 253 sq.; F. Coarelli, *Il Foro Romano. Periodo arcaico* (Rome 1983) p. 144 sq. On n'oubliera pas à ce propos les observations fondamentales de C. Krause, "Zum baulichen Gestalt des republikanischen Comitiums," *RömMitt* 83 (1976) p. 31-69.

55 Greco (supra n.18) p. 20.

56 Suét., *Claud.* 21. Cf. H. von Hesberg dans *Die Regierungszeit des Kaisers Claudius* (supra n.42) p. 256 sq.; M. A. Cavallaro, *Spese e spettacoli. Aspetti economici-strutturali degli spettacoli nella Roma giulio-claudia* (Bonn 1984).

57 Cavallaro ibid. p. 55 sq.; M. L. Caldelli, *L'Agon Capitolinus. Storia e protagonisti dall'istituzione domizianea al IV secolo* (Rome 1993) p. 99 et p. 104.

58 Comme en témoignent les statues ci-dessus mentionnées, retrouvées dans l'odéon de Cosa. La maison récemment fouillée par E. Fentress semble avoir du reste possédé, dans sa phase du début de l'Empire, un petit *Augusteum*.

Heroic myths, but not for our times

Susan E. Alcock

As E. Fentress somewhat wistfully remarks, there is something inspiring about the story Frank Brown tells of Cosa: the quest for a better land and a better life, the trundling ox-carts, the taking of the auspices, the implied equality of colonists, the colony influencing the right people in the right way, the unproblematic reading of Rome through Cosa and Cosa through Rome — all persuasively rooted in Brown's confident belief in archaeology's redemptive ability to recover and recount such strong narratives. Not only does Cosa become a rattling good story, but it both built off, and further bred, heroic myths — about the power of colonial cities "inevitably destined to become vital centers for the dissemination of Roman attitudes, institutions, law and language",[1] and about the ability of the archaeologist to tell such tales.

The conference that spawned this volume was dedicated to celebrating the 50th anniversary of the Cosa excavations. It also witnessed a gentle unmasking and re-assessment of Brown's conclusions, in part through the results of further fieldwork in the 1990s by the American Academy in Rome and through architectural re-examinations such as that of P. Gros (above, p. 214). Certain cherished aspects of Brown's version of the site — its resounding vocabulary (*arx*; *atria publica*); its claim of colonial equality; its assertion of the 'premeditated' quality of its design, based on the (as-yet-unexcavated) prototype of Rome; its emphasis on the perfect 'heyday' of the colony at the expense of other periods — have been countered, or balanced, with alternative, and convincing, data. It is to Fentress' credit that the deconstruction has been relatively thorough, yet the treatment of previous work and the tone of this volume remain respectful, even celebratory. Beyond such 'new information', however, even more compelling challenges to the myth of Cosa have arisen from intense scrutiny of its central elements, leading to changes in our perceptions of the nature of Roman colonization, of what a city can be and can do, and of the phenomenon called Romanization.

At various levels and in various guises, this volume explores myth-making and myth-breaking about cities and their rôle in the Roman world. Like the re-assessment of Cosa's organization, some of this myth-breaking works at the level of the individual site and relies on information derived from additional fieldwork. For example, F. Rakob, using a battery of archaeological results (not least from the UNESCO Save Carthage Project), attacks misconceptions about the "modest present" of Augustan Carthage, the notion that the early colony was but a shadow of its later self. S. Downey, with her careful re-examination of Dura-Europos (like Cosa, here following in F. E. Brown's footsteps), skewers any notion that the Romans felt the need "to romanize Dura, only to build some buildings judged essential for the functioning of the military".[2] Especially encouraging (and salutary in the context of this volume) is the fact that this 'failure' does not make Dura's undoubted Roman-period transformation any less significant in Downey's eyes.

Myths encompassing larger geographical regions are also recognized in this collection of papers, myths which frequently emerge as the offspring of a modern-day scholarship too heavily reliant ('piggybacking') on ancient élite representations. Dyson, for example, argues that a previous archaeological emphasis on mapping certain prominent 'imperial' elements of the Sardinian landscape (notably roads) provided "visual reinforcement to the idea that the Romanization of Sardinia followed the classic pattern of a symbiotic development of roads and towns,"[3] a conclusion that more detailed examination of the island, not least through archaeological survey, does much to overturn. A rather similar revisionism is undertaken in M.

1 F. E. Brown, *Cosa, the making of a Roman town* (Ann Arbor 1980) 5.
2 Downey, above p. 156.
3 Dyson, above p. 189.

Downs' review and expansion of the Baetican data set: "The image of Baetica as a highly Romanized province is a colonial image, produced by Rome and reproduced by modern historians."[4] And A. K. Bowman reports on the astonishing recent transition in scholarly thinking about Egypt, from envisioning it as a province without cities to finding "authoritative scholars prepared to describe Roman Egypt as heavily urbanised, if not the most urbanised province of the Roman empire ...".[5] A contemporary disinclination to believe everything Tacitus tells us, together with rejection of Egypt's mythic status as a unique 'land apart', go far to explain this remarkable turnaround, which Bowman pursues across a constellation of topics — demography, buildings, governance — to observe metropolitan transformations.

One final regional myth, also already well on the way to meeting its *quietus*, is the fable of the unromanized East. The Greek provinces of the empire were long thought to have been little altered by imperial expansion, not least because of their relatively slow adoption (or simple refusal) of many of the type-artifacts used to measure 'the coming of Rome'. So authoritative has this myth been that, even when more 'normal' Roman features did appear, they were not always perceived; only very recently, for example, have the multiple centuriation systems at Corinth been fully recognized, despite decades of archaeological work at and around the site (D. Romano, above). If there remains uncertainty about what to call the changes observed following the wake of Roman annexations in the east, indisputably change there was — even if, to eyes accustomed to the western provinces, it could assume unpredictable forms.[6] For example, one aspect of the 'Romanization' of Athens was, if anything, an 'over-Athenianization' of the city, making it, as J. Burden wryly noted, "possible that Athens was becoming more Athenian than many Athenians wanted it to be ... ".[7] F. Yegül, in his discussion of cities in Asia Minor, also tries to nuance readings of cultural contact in the eastern provinces. Reviving G. M. A. Hanfmann's question about the urban florescence of Asia Minor — "What is Anatolian, what is Greek and what is Roman...?"[8] — Yegül dismisses such categories as unhelpful reifications that serve only to mask more important movements (toward innovation, co-optation, and hybridity of cultures) which are revealed in these newly-configured urban landscapes.

Larger, more over-arching myths also come under fire. Chief among these, of course, is the notion that concepts such as 'the city' and 'Romanization' are still, as they were for Brown, relatively unproblematic constructs. 'Romanization', for his scholarly generation, by and large meant an injection of Roman ways and means into areas non-Roman, a spreading steady progression, a firm and positive trajectory. The borderline between 'Roman' and 'native' was relatively clear-cut, allowing the process of imperial unfurling to be archaeologically visible, even quantifiable. Similarly, what was considered important about cities was more readily agreed upon, and the presence or absence of certain urban forms and architectural elements allowed their division into different categories for study. The archaeological production and promulgation of 'type sites' was perceived as a useful way forward in analyzing the phenomenon of Roman urbanism.

Such calm certainties, of course, were exploded long before the Cosa conference in May 1998. A critical outburst, fuelled to a great extent by post-colonial readings and concerns, ripped through the concept of 'R(r)omanization' — now variously capitalized and punctuated, and

4 Downs, above p. 209.
5 Bowman, above p. 173.
6 See, for example, S. E. Alcock, *Graecia capta: The landscapes of Roman Greece* (Cambridge 1993); ead., "The problem of Romanization, the power of Athens," in M. Hoff and S. Rotroff (edd.), *The Romanization of Athens* (Oxford 1997) 1-7.
7 Burden, at conference. For a related study, see K. Clinton, "Eleusis and the Romans: Late Republic to Marcus Aurelius," in Hoff and Rotroff ibid. 161-81.
8 Yegül, above p. 139.

often evaded altogether in favor of words such as acculturation, reconfiguration or negotiation.[9] Whatever 'Romanization' may be (and it has been nibbled and torn to the point that it may well end, as Cosa supposedly did, in a pestilence of mice, it is not uncomplicated. The city — in idea and reality — has also been destabilized as an unequivocally dominant and fixed entity; the creation of 'type-sites' is no longer a popular goal, as differences between cities (now also often considered in their regional setting) are found more intriguing than their supposedly universal Roman characteristics. It does seem that, the closer one looks, the more distinctions in urban layout, internal organization, and local politics one can discern — even, for example, within a subset of sites as small and (one might have thought) unified as Hurst's British fortress-*coloniae*.

As the references cited in these papers attest, many of the volume's contributors had followed, and participated in, these often-heated debates. Not surprisingly, perhaps, and mirroring the situation within the wider scholarly world of Roman studies, no single consensus emerged on how to discuss 'Romanization and the City', let alone what to do with the subtitle, 'Creation, Dynamics, Failures'. Rather unhappily, what people mean by these basic (and much utilized) words is rarely made explicit, but different interpretative paradigms are clearly at work among the various contributors. 'Romanization' is here variably represented as the transmission of recognizably 'Roman' forms of building or material culture; as the establishment or maintenance of élite social status ('auto-Romanization'); as the development of a positive hybridity of cultures; as the reconfiguration of new colonial categories; as the creation of entirely new imperial cultures with their own cultural logic; as meaning only whatever follows in the wake of imperial incorporation — a safe, if bland, formulation. And while everyone addressed the subject of cities, the focus constantly shifted between such elements as urban landscapes and physical remains, civic institutional structures, the composition and behavior of urban populations, the experiences of urban dwellers and builders. Artistic representations, rightly, are part of the mixture, and indeed many will find the recently-discovered and astounding urban image from the Oppian Hill — judiciously presented by E. La Rocca and carefully contextualized by G. Caruso and R. Volpe — the most riveting feature of the entire volume. In defining their cities, some analyses drew the line firmly at boundary walls or at the edges of urban sprawl, while others inserted the cities within a larger landscape setting. To put it in a nutshell, if this celebratory volume has certainly undergone a kind of Brownian motion away from early ideas of 'Romanization' and 'the city', its participants are moving in a variety of directions.

This is all fine: attempting to find and impose some kind of 'lowest-common-denominator' agreement on terminology or definitions would hardly be the most constructive way to proceed. Nor would that be the best way to utilize papers as validly diverse as these in their approach, emphasis and principal data employed, ranging as they do from 'hardcore' dirt archaeology, to appraisals of built environments (real and represented), to textual analyses, to blends of all of the above. What might be more useful is to identify innovative strategies within the volume, elements that work either to undo out-dated (but often still pervasive) myths about Rome and its empire, or — equally — that work to prevent the emergence of more novel, but perhaps just as unfortunate, approaches.

One prevailing snobbery in the study of classical antiquity, for example, has been the myth of cultural uniqueness, the belief that understanding of the Greeks and Romans could in no wise be aided by the contemplation of other cultures. Such shibboleths are today falling by the

9 For a short introduction to recent studies, see the papers in D. Mattingly (ed.), *Dialogues in Roman imperialism* (JRA Suppl. 23, 1997), especially those of Mattingly, P. W. M. Freeman and J. C. Barrett; and those in J. Webster and N. Cooper (edd.), *Roman imperialism: post-colonial perspectives* (Leicester Archaeology Monograph 3, 1996), particularly J. Webster, P. W. M. Freeman and R. Hingley.

wayside, and not surprisingly it is the volume's younger contributors who point out the advantages of comparative research, employing data drawn from well beyond the bounds of the Roman empire. M. Downs reiterates the now-familiar plaint about the 'voicelessness' of indigenous populations within the empire, but has something to offer beyond that usual *mea culpa*. She says firmly, "If we are to recover any sense of the indigenous experience in the Roman provinces, we must expand our inquiry to modern empires, where the historical documentation of social processes on frontiers is much richer."[10] The saga of the Hinojosa family in central Mexico is not transplanted wholesale to Roman Baetica, but is mined for a range of possible enlivening parallels and provocative analogies. Perhaps the most important point to emerge (and a familiar theme in other disciplines) are the serious games the Hinojosa family organized with elements of their indigenous *and* Spanish identities, manipulating and shifting them as needed through the way they played their cards and wore their clothes. For Roman archaeologists or historians who still employ the identity categories of 'Roman', 'native', or 'semi-Romanized native', this insistence on lability and mobility, and its material implications, should be unnerving.[11] A slightly different form of comparison is employed by G. Woolf, who contrasts the long-term, expensive and messy construction of Roman cities with that of Gothic cathedrals — again using a much-better-documented process to illuminate dark corners. It is a persuasive and stimulating juxtaposition on several levels, not least when boiled down to blunt statements: "Explaining Gallo-Roman urbanism in terms of the civilizing process alone would be like accounting for Gothic cathedrals solely as a product of Christian piety."[12] Put like that, such 'sole' explanations do sound foolish, leaving more traditional Romanists to squirm and perhaps to begin searching for other, if more hidden, motivations.

If comparative studies help to combat old unhelpful myths, there remains the danger of new ones cropping up, not least as the result of an over-exuberant paradigm swing. For example, reacting to previous overly-uniformitarian views of the empire, one recent trend has been to seek out, and indeed to expect, great regional variations and tenacious local identities. This can slide toward an unwillingness to contemplate, or even an out-of-hand rejection of, any form of 'top-down' models. P. Zanker's paper here might seem to fly in the face of that emerging modern paradigm in his quest for "the external characteristics that mark the 'typical' Roman city."[13] This paper serves as an elegant exercise in not, as it were, throwing out the baby with the bathwater, for — however politically correct one wishes to be — there is no denying shared features in city design in Italy and the west. Studying the early *coloniae*, Zanker neatly boils these down to certain abstracted elements such as roads, a central sanctuary, and a central gathering place (the Capitolium-Forum complex, intertwining sacred and political spaces); leisure buildings become a later Imperial addition. Providing examples, he reviews and traces through time how these characteristics "reflect not only practical considerations but certain ideologically-tinged notions",[14] carrying with them a clear and present sense of 'looking Roman'. What is also helpful about his paper is a sense of evolving dialogue between Roman policy and local desires and needs. If basic plans came 'from above', subsequent choices — for example, the decision to construct a basilica — emerged rather from internal requirements for such a multi-functional space: in other words, not necessarily the appearance of the basilica itself, but rather "the *need* for a basilica expressed the Roman character of a city".[15] This search for the social and political motivations responsible for the 'urban furniture' left for us to observe is a praiseworthy characteristic shared by several other papers in this volume, as well

10 Downs, above p. 204.
11 See also, e.g., G. Woolf, "Beyond Romans and natives," *World Archaeology* 28 (1997) 339-50; R. Laurence and J. Berry (edd.), *Cultural identity in the Roman empire* (London 1998).
12 Woolf, above p. 125.
13 Zanker, above p. 23.
14 Zanker, above p. 28.
15 Zanker, above p. 35 [my emphasis].

as by the impressive survey by E. Papi, who embarked on a quest in the epigraphic evidence for élite conduct and munificence in the early Imperial cities of southern Etruria (to be published elsewhere).

If upsetting, or regretting, certain scholarly myths has been the subject of discussion so far, one major argument of this volume may — paradoxically — be the need to consider more intently the myths of those we are studying. Links between peoples dwelling within the empire and their own histories, myths and memories recur in several different contexts here. Indigenous peoples can be observed drawing upon particular aspects of their past as they adapted and adjusted — or perhaps better to say 're-invented themselves' — to fit and fill their new position. In some instances this led to major social transformation, elsewhere (as S. Dyson suggests for Sardinia) to significant continuity with traditional lifeways. Local or native traditions were clearly employed as resources for internal and external negotiations over power and status: this can be seen from east to west, from F. Yegül on Asia Minor to M. Downs on Baetica.

More central, imperial forces were also deeply, and variably, influenced by such factors. In some cases, aspects of a provincial past were seized upon, celebrated, and thereby annexed; in this volume this is most ostentatiously seen at Athens, where architectural interventions, notably along the Panathenaic Way, led to "an antiquarianism of urban proportions" that triumphally wove the imperial family into the processional narrative.[16] Yet J. Burden also points to the existence of internal Athenian concerns, here overridden by imperial preferences. Annexation of memories could take other forms. At Carthage, Rome's Punic rival was literally buried in the colonial foundations; hundreds of thousands of cubic meters of débris were shifted in "extravagant preparation" so that the new city could obscure the old which was buried but (F. Rakob avers) never forgotten. Rakob also argues for the continued presence, from Carthage's very foundation, of numerous indigenous inhabitants: "Clearly they were meant to reside in the same urban spaces as the colonists."[17]

Apposite to cases such as Athens and Carthage is the meditation by G. Woolf on allowing for multiple ways of seeing and feeling the impact of Roman cities. Woolf likewise discusses the manner in which myths, in his case the myth of the "civilizing process", determined Gallic reception, and indeed promulgation, of Roman values and thus urban structures. While his contention — that some individuals might swallow such a myth whole, others reject it totally, while still others lay muddled in the middle — may appear self-evident, its ramifications remain perilously absent from many archaeological or historical reconstructions and interpretations. It seems time to recognize, as a basic premise, that the inhabitants of the Roman empire must have had their own views on what we today try to label and understand as 'Romanization', and that they would have had their own plural and discrepant experiences and attitudes towards cities and civic life: "it all depends on the inhabitant's point of view".[18] At the end of his paper, Woolf quotes the urban sociologist Philip Abrams on the history of towns as a "history of appropriation and resistance, internal and external war, defiance and monopoly ...":

> The founders of Autun and Saintes, the schoolboys reading "how great a toil it was to found the Roman race", the silent commons labouring on the building of these huge monuments, and the Roman governors watching in approval as the vast energies and resources of the Gauls were expended on the urbanistic project, all, in their different ways, would have understood what Abrams meant.[19]

This conclusion has something to it of the rhetorical ring of Frank Brown but without that heroic sense of the modern scholar dictating the full story. As G. Woolf's presentation suggests, the full story belongs to the ancients, not to us.

16 Burden, at conference.
17 Rakob, above p. 82.
18 Woolf, above p. 120.
19 Woolf, above p. 121.

Reading *Cosa, the making of a Roman town* in close temporal conjunction with some of the latest Anglo-American, post-colonial diatribes about Romanization is enough to make one dizzy over the many and strategic changes in our perceptions of the Roman world. Returning to F. E. Brown's evocative vignettes — the settlers off to the "promised land" for a "fresh start, with a grubstake" — it is now necessary to dismiss them as traditional, benevolent, 'white-bread' views of Roman expansion. Yet, with Fentress, it is difficult not to have a lingering envy for Brown's optimism and his skill in "imaginative reconstruction and representation". Indeed, in her eyes, the powers of the archaeologist are what have made this site so valuable: "It is Brown's ability to build on the evidence he recovered, as well as to publish it clearly, that makes Cosa an enduring example of Roman colonization."[20]

Heroic archaeology of this sort is far from our contemporary style: Roman archaeology has, for better or worse, assuredly lost its innocence. In the wake of that loss, however, Romanists need to consider the legacy of such work and where to proceed from it. If we cannot retreat to those old certainties, neither is there anything to be gained from being churlish or dismissive of them. But the value of Cosa today lies not so much in its rôle as 'type site' or universal paradigm, but in a new capacity well demonstrated by this volume — as a certain provocative 'idea of the city' against which we can model key problems of Romanization (however we may decide to define and employ the concept) and the city (whatever it might look like and wherever it may be).

Department of Classical Studies, University of Michigan

20 Fentress, above p. 24.

INDEX TO PLACES

INDEX TO PEOPLE AND SUBJECTS